FCH LEARNING CENTRE
UNIVERSITY OF GLOUCESTERSHIRE
Swindon Road
Cheltenham GL50 4AZ
Tel: 01242 714600

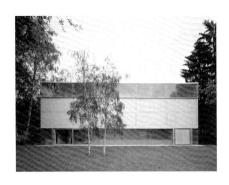

Sammlung Goetz

Matthew Barney

Sammlung Goetz

Dank

Ingvild Goetz – Stephan Urbaschek

Im Herbst 1996 zeigte die Sammlung Goetz erstmals Werke von Matthew Barney im Rahmen einer Gruppenausstellung. Seither hat er ein umfassendes und komplexes Œuvre geschaffen, sodass er heute als einer der wichtigsten Vertreter der internationalen Gegenwartskunst angesehen werden kann. Seine Werke sind zu Ikonen der zeitgenössischen Kunst geworden, die in den bedeutendsten Museums- und Privatsammlungen der Welt vertreten sind und die mit zahlreichen Ausstellungen geehrt werden. Sie sind stilbildend, impulsgebend und innovativ in vielerlei Hinsicht – in Bezug auf ihre Themen, auf ihre Bildsprache und auf die Materialität ihrer Kunstwerke und wirken deshalb auch über den Bereich der Kunst hinaus.

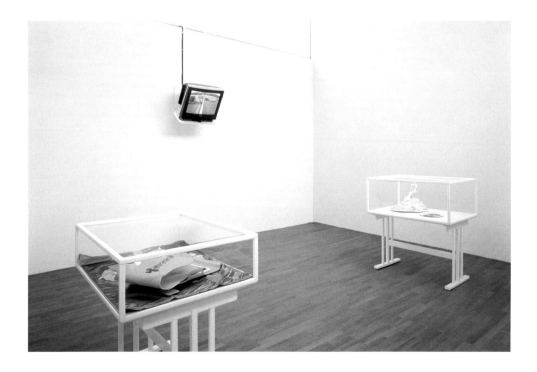

Das Werk Barneys wurde zu einem der wichtigsten und umfassendsten Komplexe innerhalb der Sammlung Goetz erweitert. Es wird jetzt in einer retrospektiven Einzelausstellung gezeigt, in der alle Facetten von Barneys vielseitigen und ineinander verschränkten Arbeiten beleuchtet werden. Matthew Barney sei daher nicht nur für die Schaffung dieser großartigen Kunstwerke herzlich gedankt, sondern auch für seine Bereitschaft, selbst ein Konzept für unsere Ausstellung und den Katalog zu entwickeln.

Bei allen inhaltlichen und Sachfragen zu seinen Werken hat er uns sehr unterstützt. Ebenso bereitwillig hat er zudem mit Brandon Stosuy Gespräche geführt, die in dessen Aufsatz für diesen Katalog Eingang gefunden haben. Für diesen spannenden Beitrag, der Barneys *CREMASTER Cycle* als simultane Video-Klang-Installation untersucht, bedanken wir uns ebenso bei Stosuy.

Wir danken Domenika Szope für die freundliche Erlaubnis, ihren Text über Matthew Barneys *CREMASTER Cycle*, der erstmals in unserem Katalog *fast forward* 2003 erschien, abzudrucken.

Unser Dank gilt ferner dem gesamten Team von Matthew Barney, insbesondere Ann Gale und Michael Bellon, die mit Schnelligkeit und akribischer Genauigkeit all unsere zahlreichen Fragen beantwortet und von ihrer Seite ebenso zum Gelingen dieser Ausstellung samt Publikation beigetragen haben wie Barneys Galeristin Barbara Gladstone und ihre Mitarbeiterinnen Rosalie Benitez und Bridget Donahue, denen wir genauso zu Dank verpflichtet sind.

Auf unserer Seite hat das gesamte Team der Sammlung Goetz wieder einmal hervorragende Arbeit geleistet, welche diese Ausstellung und den Katalog ermöglicht hat. Jedem Einzelnen sei dafür herzlich gedankt:

Nora Wagner wurde von Christoph Kölbl in die Bildredaktion eingearbeitet und von ihm dabei unterstützt. Sie betreute ferner die Pressearbeit und die Webseite. Christoph Kölbl organisierte außerdem alle Abläufe rund um die Ausstellungseröffnung. Die umfassende Literaturrecherche wurde von Claudia Seelmann und Karsten Löckemann durchgeführt, der die Bibliothek leitet und den Katalog redaktionell mitbetreute. Er erstellte zudem das Glossar. Außerdem ist er als Kurator für die Vorbereitung der fotografischen Werke in dieser Ausstellung genauso verantwortlich wie die Kuratorin für Grafik Katharina Vossenkuhl für die Arbeiten auf Papier. Sie sorgte gemeinsam mit Anita Peintinger für die reibungslosen Arbeitsabläufe in allen Sammlungsbereichen. Katharina Vossenkuhl organisierte zudem als Registrarin nicht nur termingerecht alle Transporte, sondern gewährleistet auch die Korrektheit aller Angaben in unserer Datenbank, welche in die ebenfalls von ihr erstellte umfangreiche Publikations- und Ausstellungsliste Eingang fanden. Susanne Touw ist als kuratorische Assistentin im Medienkunstbereich der Sammlung als auch in der Bibliothek tätig.

Installationsaufnahme | Installation view
Matthew Barney – Tony Oursler – Jeff Wall
München: Sammlung Goetz 22.07.–20.12.1996

Marianne Parsch betreut als Restauratorin die Kunstwerke in der Sammlung und ist verantwortlich für deren sachgerechtes Handling. Den Ausstellungsaufbau hat Alexander Kammerhoff, der ebenfalls für unser Lager zuständig ist, organisiert und mit der Unterstützung unseres externen Teams Daniel Becker und Gerhard Lehenberger sowie Lorena Herrera und Björn Wallbaum durchgeführt. Für alle Bereiche, welche die Haustechnik des Museums betreffen, ist Marc Pultke zuständig.

In allem tatkräftig und geduldig unterstützt wurden die Mitarbeiter der Sammlung von unserer Praktikantin Sabine Weingartner.

Für seine technische Expertise und kompetente audio-visuelle Beratung danken wir Charlie Nedeltschev.

Wir danken besonders unseren bereits bewährten Lektorinnen Kirsten Rachowiak (deutsche Texte) sowie Sarah Trenker (englische Texte), welche mit großem Einfühlungsvermögen und Sachkenntnis die Texte betreut haben. Für die sensiblen Übertragungen der Texte ins Englische durch Ishbel Flett und ins Deutsche durch Nikolaus G. Schneider danken wir beiden Übersetzern sehr.

Nicht zuletzt möchten wir für das kreative Engagement des Grafikbüros WIGEL mit Fred Feuerstein, Rainer Linnemann und Petra Lüer danken. Ihnen ist es mit dem vorliegenden Katalog ebenfalls auf bewährte Weise gelungen, auf das Werk Barneys ästhetisch einzugehen und es zu dokumentieren. Darüber hinaus bedeutete es dieses Mal eine Herausforderung in buchkünstlerischer Hinsicht eine besondere Gestaltung zu finden.

Installationsaufnahme | Installation view
Matthew Barney – Tony Oursler – Jeff Wall
München: Sammlung Goetz 22.07.–20.12.1996

Acknowledgements

Ingvild Goetz – Stephan Urbaschek

It was in the autumn of 1996 that the Goetz Collection first showed the work of Matthew Barney as part of a group exhibition. Since then, the artist's oeuvre has become so far-ranging and complex that he is rightly regarded as one of the most important representatives of emerging international art. Some of his works have become icons of contemporary art in their own right, and are included in the world's foremost public and private collections. Widely exhibited, they are stylistically groundbreaking, inspirational and innovative in many respects – not only in relation to the themes they address and the visual language they use, but also in the material make-up of the works themselves, which is why they have an impact beyond the confines of the art world.

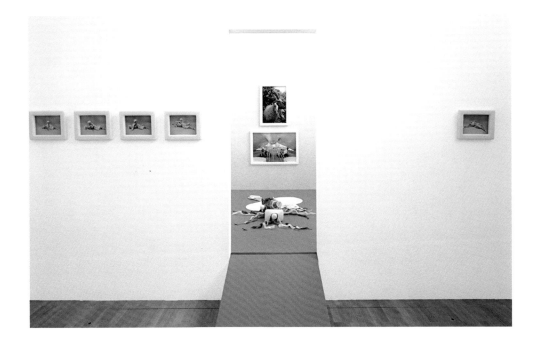

Barney's work has become one of the most important and extensive sections within the Goetz Collection. Now, a retrospective solo exhibition showcases every facet of the artist's creative endeavour and the intricate relationship between the works. We would like to express our sincere thanks to Matthew Barney, not only for having created these magnificent works of art in the first place, but also for his generosity in personally developing an exhibition concept and catalogue for us.

He has been enormously supportive in every aspect of content and material and in all issues arising in connection with his works. He has willingly given of his time to speak at length with Brandon Stosuy in preparation for the essay published in this catalogue. The resulting text, which examines Barney's *CREMASTER Cycle* as a simultaneous video and sound installation, makes for compelling reading, and for this our thanks also go to Brandon Stosuy.

We are grateful to Domenika Szope, for so kindly permitting us to reprint her text about Matthew Barney's *CREMASTER Cycle* which was first published in our catalogue *fast forward* in 2003.

A further debt of gratitude is owed to Matthew Barney's team, especially to Ann Gale and Michael Bellon, who responded so promptly and so precisely to our many questions, and who have thereby contributed greatly to the success of the exhibition and publication, as indeed have Barney's gallerist Barbara Gladstone together with her assistants Rosalie Benitez and Bridget Donahue, to whom we are no less grateful.

The team at the Goetz Collection has once again proved outstandingly capable of working together to bring about this exhibition and the accompanying catalogue. Each and every one deserves our sincere gratitude.

We are grateful to Christoph Kölbl, for organizing the exhibition opening while also finding time to introduce Nora Wagner to the picture editing department, giving her every support while she was already so capably handling the PR duties and running the website. Thanks also go to Claudia Seelmann for her extensive literary research in collaboration with Karsten Löckemann, who, in turn, is in charge of the library and who has co-edited the catalogue and compiled the glossary in addition to acting as curator of the photographic works in this exhibition. We also thank Katharina Vossenkuhl, curator of the prints collection, for supervising all the works on paper and, together with Anita Peintinger, ensuring that everything has kept running smoothly in all areas of the collection, while at the same time organizing punctual transportation and keeping the database, including the extensive list of publications and exhibitions, up to date. And we are obliged to Susanne Touw for her curatorial assistance in the media section of the collection and the library. Thanks to Marianne Parsch, conservator of works in the collection, for ensuring that all the works were handled appropriately. And thanks to Alexander Kammerhoff, who is in charge of our storage depot, for his installation and organizational work, supported by our external team Daniel Becker and Gerhard Lehenberger as well as Lorena Herrera and Björn Wallbaum. We would also like to express our appreciation to Marc Pultke, for taking

care of every aspect of the museum's technical infrastructure, and to our intern Sabine Weingartner, for her patience and hands-on approach in assisting the team in every field.

For his technical expertise and support in audio-visual questions we are grateful to Charlie Nedeltschev.

We owe a special debt of gratitude to our long-standing copy editors Kirsten Rachowiak (German texts) and Sarah Trenker (English texts), who have handled the texts with such perspicacity and well-founded understanding. We are also very grateful indeed for the sensitive translation of the texts into English by Ishbel Flett and into German by Nikolaus G. Schneider.

Last but not least, we wish to thank the WIGEL graphic design team, with Fred Feuerstein, Rainer Linnemann and Petra Lüer. They have, as ever, succeeded admirably in finding an attractive and fitting design for this particularly challenging book project.

Translation: Ishbel Flett

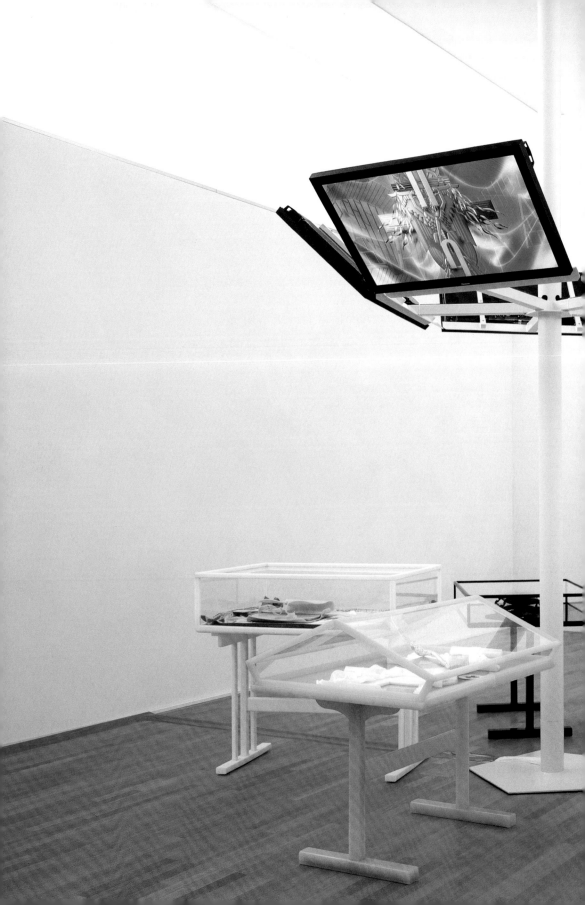

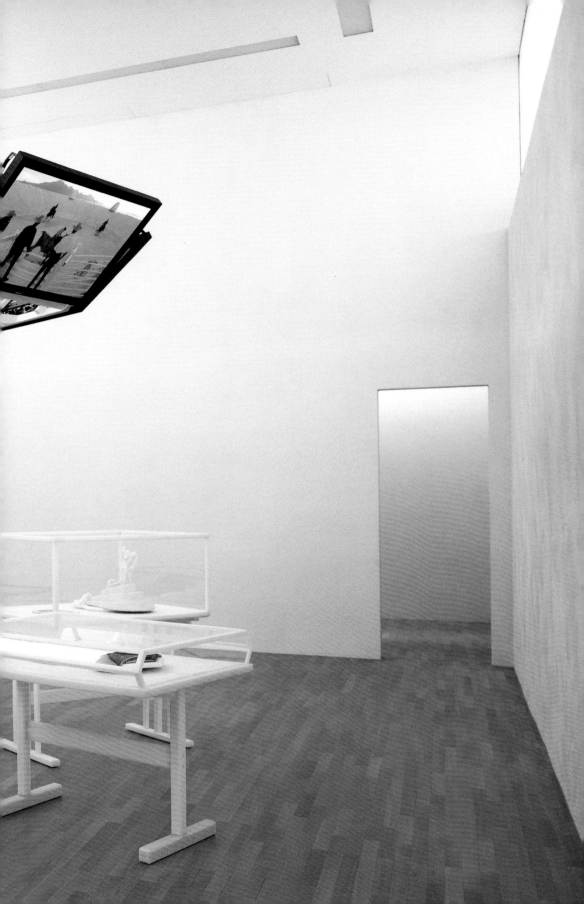

Begegnung

Ingvild Goetz

Auf der DOCUMENTA IX im Jahr 1992 fielen mir Werke von fünf Künstlern besonders auf, die ich allesamt vorher nicht recht kannte, nämlich Matthew Barney, Robert Gober, Mike Kelley, Jonathan Lasker und Cady Noland. Alle verfolge ich seitdem und habe sie zu wichtigen Positionen in meiner Sammlung ausgebaut.

Ich freue mich also ganz besonders, einem von ihnen, Matthew Barney, eine Einzelausstellung in unserem Haus geben zu können. Die hier gezeigten Arbeiten wurden allesamt seit der DOCUMENTA IX angekauft und von Matthew selbst in ein Ausstellungskonzept eingebunden. Er hat ebenso den Aufbau vor Ort vorgenommen. Dafür gilt ihm mein herzlicher Dank. Ich weiß aber auch, dass dies ein persönliches Anliegen für ihn ist. Er ist gewissenhaft, ein Perfektionist, der seiner eigenen Arbeit am meisten traut und ganz offenbar im jeweiligen Arbeitsprozess Inhalte weiterentwickelt. So entspricht es ihm, jede seiner Ausstellungen selbst präzise vorzubereiten und umzusetzen. Diese Arbeitsweise konnte ich schon im Rahmen seiner Filmarbeit beobachten.

Mein Mann und ich hatten die Chance, bei seinen Dreharbeiten zu *CREMASTER 5*, der als dritter Film des Zyklus gedreht wurde, im Privathaus einer New Yorker Galeristin anwesend zu sein. Die betreffende Szene – eine Verlagerung jener Szene im Gellért-Bad in Budapest – wurde im privaten Pool der Galeristin gedreht. Immer und immer wieder mussten die rosa angemalten Wassernymphen für die Unterwasserszenen eintauchen. Matthew war extrem auf die Szene fokussiert, nicht ansprechbar und nicht abzulenken, mit geduldiger und motivierender Intensität ging er vor. Uns hatte er wohl wahrgenommen, sich aber keineswegs unterbrechen lassen. Eben diese vollständige Hingabe an die Arbeit fasziniert mich an ihm neben anderen prominenten Eigenschaften. Wenn er etwas tut, gibt es nur das, sei es ein Aufbau, ein Gespräch oder eine Aufnahmesequenz. Mit derselben Disziplin

CREMASTER 5
1997
Filmstill

14

bereitet er sich auch auf seinen Part in den Filmen vor. Sei es das Steppen in *CREMASTER 4*, die Klettereinlagen in *CREMASTER 3*, *4* und *5*, das Rodeo in *CREMASTER 2* – immer hat er die jeweiligen Bewegungsabläufe perfekt gelernt, bevor er sich selbst in die Arbeiten einbringt.

Bei einem Besuch in New York hatte ich ihn noch blond und kurzhaarig gesehen, den bärtigen Dunkelhaarigen habe ich kaum wieder erkannt. Er lebt seine eigene Rolle schon lange, bevor er sie spielt. Alles geschieht mit einer Intensität, die einer Verinnerlichung der jeweiligen Identität gleichkommt: die sportliche Vorbereitung, die äußerliche Veränderung, die wie eine optische Entfesselung seines Dauerthemas Harry Houdini wirkt.

Von ihm auf Detailfragen eine Antwort zu erhalten, ist nahezu unmöglich. So interpretiere ich seine Filme auf meine Weise. Auf der einen Seite sehe ich die zahllosen kollektiven Symbole, häufig der abendländischen Mythologie entlehnt, auf der anderen Seite die ungewöhnlichen und immer auch zeitkritischen Anwendungen für diese Themen.

Seinen ersten Film *CREMASTER 4* habe ich circa fünfzehn Mal gesehen und jedes Mal eine weitere Interpretation entdeckt. Schwieriger wurde das schon bei dem letzten, *CREMASTER 3*, wegen seiner Länge von drei Stunden (im Gegensatz zu *CREMASTER 4* mit 42 Minuten).

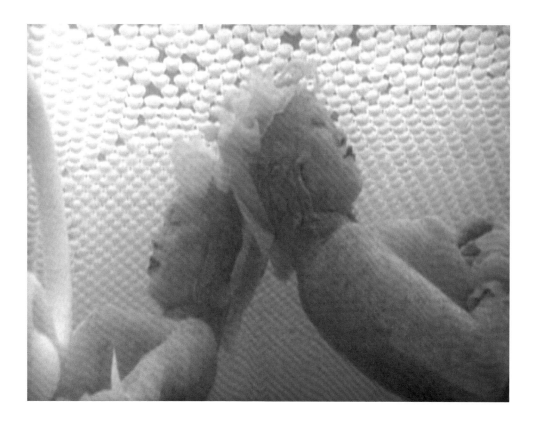

Wegen ihrer breit gefächerten Bezugnahmen sind die Filme ohne Erklärung nur in Bruchstücken zu verstehen, auf der anderen Seite finde ich das gerade bei ihnen nicht so wichtig, weil Matthew die Bilddeutung bewusst offen lässt und genügend Spuren in unser kollektives Unterbewusstes und die uns allen vertraute Mythologienwelt hineinlegt. So können wir unsere eigene Fantasie entfalten, während wir immer wieder von seiner mächtigen Bilderwelt gelenkt werden.

An Matthew Barney ist vieles faszinierend, nicht nur seine fast penible Arbeitsweise im Kontrast zu der extremen Themenvielfalt, die schon in seinen ersten Filmen zu bewundernde körperliche Geschicklichkeit und Perfektion im Unterschied zu der ständigen Thematisierung von genetischen Abweichungen (das dritte Geschlecht) oder körperlicher Dysfunktion und der Ästhetisierung von Prothesen. Faszinierend ist auch das Spannungsfeld einer bei fast keinem gegenwärtigen amerikanischen Künstler so deutlichen Bezugnahme auf die großen abendländischen Mythen und der häufig sehr amerikanischen, streckenweise fast kitschigen Bildsprache und Dramaturgie. Ein Athlet und ein Intellektueller, ein Geschichtenerzähler und gleichzeitig ein detailverliebter Skulpteur sowie Kostümgestalter – bei Barney treffen sehr viele gegensätzliche Eigenschaften aufeinander.

Eine ganz besondere Kostbarkeit bedeuten für mich seine zarten Zeichnungen, die in verschlüsselter Form Details aus seinen Filmen thematisieren. Ein interessanter Besuch in seinem Studio in New York brachte mir nicht nur diese Arbeiten nahe, sondern auch die zahllosen Requisiten, die dort aufbewahrt sind, und die Skulpturen, die in den Filmen vorkommen und eigenständige Kunstwerke sind. Auch bei diesen Arbeiten wird erneut klar, welch ein genialer Künstler er ist. Er benutzt Materialien, mit denen zuvor wohl niemand künstlerisch gearbeitet hat, die häufig in ihrer konkreten Gestaltung futuristisch anmuten. Sogar jede noch so kleine Requisite wird in präzisester Verarbeitung hergestellt. Nebenbei vermittelt einem der Anblick dieser Arbeiten eine Ahnung von dem immensen Zeitaufwand, mit dem Barney seine jeweiligen Werke erstellt.

Ich freue mich auf diese Ausstellung, darauf, auch die längeren Filme erneut mehrmals anschauen zu können, weiß ich doch, dass ich noch vieles bei diesen Wiederholungen entdecken werde.

Encounter
Ingvild Goetz

At the 1992 DOCUMENTA IX exhibition, I was particularly struck by the work of five artists, all of whom were relatively new to me. They were Matthew Barney, Robert Gober, Mike Kelley, Jonathan Lasker and Cady Noland. I have been keenly following their development ever since, and they have become major players in my collection.

It now gives me enormous pleasure to be able to present a solo exhibition by one of these artists: Matthew Barney. The works shown here have all been acquired since the DOCUMENTA IX and Matthew himself not only came up with the exhibition concept, but even undertook the actual installation in situ. For this, I cannot thank him enough. I do know, however, that he has taken a great personal interest in this project, even though I know such involvement is an important part of his work. He is conscientious to the point of perfectionism, preferring to take matters into his own hands, and evidently developing ideas as he works. And so it is hardly surprising that he undertakes the painstaking preparation and realization of his exhibitions personally. I have been able to observe his approach to work within the context of his films.

My husband and I had the opportunity of being at the home of a New York gallerist while Matthew was filming *CREMASTER 5,* the third in the Cycle. The scene in question – a transposition of the scene in the Gellért Baths in Budapest – was shot in the gallerist's private pool. Time and time again, the pink-painted water nymphs had to dive in for the underwater scene. Matthew was extremely focused, patient and so intensely involved in his work that he could not be distracted in any way. Although aware of our presence, he did not let it disturb him. Quite apart from his other outstanding qualities, it is his complete dedication to the task in hand that I find so fascinating. Whatever he does, he does with undivided attention, be it installing an exhibition, filming a scene or engaging in conversation. He prepares for his parts in the films with the same discipline. From the tapdancing in *CREMASTER 4* to the climbing in *CREMASTER 3, 4* and *5* or the rodeo in *CREMASTER 2* – he has always studied the sequence of movements to perfection before he starts work.

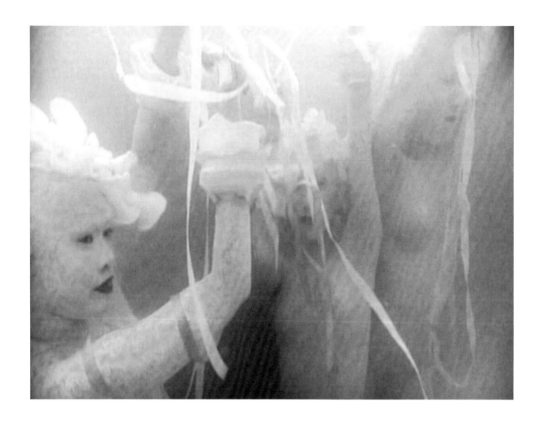

Having met the short-haired blond artist on a visit to New York, I barely recognized him with dark hair and a beard. He lives in each role for quite some time before he plays it. Everything is done with an intensity that involves internalizing the respective character: the preparatory training and the changes in outward appearance are akin to a visual unbridling of his recurring Harry Houdini theme.

Getting an answer to a question of detail is almost impossible and so I interpret his films in my own way. On the one hand, I see the countless collective symbols, many of them borrowed from western mythology, while on the other hand I see the unusual and invariably critical slant he puts on his themes.

I have watched Matthew Barney's first film, *CREMASTER 4,* about fifteen times. Each time, I have discovered some new interpretation or angle. Matters became even more difficult with his last film in the Cycle, *CREMASTER 3,* which is three hours long (as opposed to the 42 minutes of *CREMASTER 4*).

As there is such a broad array of references, the films can be understood only fragmentarily without explanation. Yet, I feel that explanation is not so important in this case because Matthew deliberately leaves them wide open to interpretation and triggers plenty of associations in our collective subconscious and the mythological world we know so well. This allows us to develop our own fantasies while at the same time being guided by his potent visual world.

There is much about Matthew Barney that is fascinating: the contrast between his painstakingly detailed working approach and the extraordinary breadth of themes he addresses, or the way that, even in his earliest films, an astonishing physical prowess and perfection is set against the constant insistence on genetic aberrations (the third sex), body dysfunction and the aestheticism of prostheses. Another fascinating aspect is the highly charged discrepancy between the references to the great myths of the western world, which hardly any contemporary American artist deploys with such clarity, and the often thoroughly American use of camped-up visual language and staging. An athlete and an intellectual, a storyteller, a sculptor with an eye for detail and a costume designer – Matthew Barney is a man of many contradictory qualities.

I personally find his delicate drawings, which contain details from his films in coded form, particularly outstanding. I was first introduced to these works during an interesting visit to his New York studio, where I also saw the countless props and sculptures that crop up in his films and which are works of art in their own right. They are a reminder of just what a brilliant artist he is. He uses materials nobody has used in an art context before, and which often take on futuristic forms. Every prop, no matter how small, is crafted with the utmost precision. To see them is to realize what an enormously time-consuming process is behind every work by Matthew Barney.

I am looking forward to this exhibition and to having an opportunity of viewing the films, including the longer ones, several (more) times. I know already that when I do, I am going to discover so much more that I had not seen before.

Translation: Ishbel Flett

CREMASTER 5
1997
Filmstill

… der Versuch, Objekten, diesen größeren Strukturen, emotionale Wirkmacht zu verleihen[1] – ein Ausstellungsrundgang

Stephan Urbaschek

Nach einer Gruppenausstellung in der Sammlung Goetz ist Matthew Barney nun die erste Einzelausstellung gewidmet, der das gesamte Museumsgebäude zur Verfügung steht. Dafür hat er selbst das Konzept entwickelt und seine Werke aus der Sammlung in enger Verschränkung miteinander installiert. Diese Einführung erläutert die einzelnen Arbeiten und ihre Bezüge untereinander, indem sie dem Rundgang durch das Haus folgt.

Von Brandon Stosuy nach den Beziehungen zwischen den Aktionen in seinen Arbeiten zu den größeren Strukturen oder Anordnungen befragt, antwortete Barney, dass es sein Bestreben sei, den Maßstab des Körpers auf einen architektonischen oder sogar geologischen Maßstab auszudehnen. Dies geschähe, indem er allen Portalen, Durchgängen und Räumen Bedeutung verleihe, um die organische Natur dieser Bauwerke zu betonen. Ziel seiner Aktionen sei es, den Menschen als alleinigen Träger von Emotionen zu befreien und diese Funktion auch auf die Architektur auszuweiten.

Mit ähnlichem Anspruch scheint sich Barney der Ausstellung seiner Werke in den Räumen der Sammlung Goetz genähert zu haben. Die Arbeiten in der Sammlung decken verschiedene Werkgruppen seines Œuvres ab. Es handelt sich dabei um Zeichnungen, Fotografien, Skulpturen und Filme, beginnend mit der Zeichnung *OTTOshaft (manual) F*, 1992 (Abb. S. 25), aus der gleichnamigen Serie. Chronologisch folgt ihr die siebenteilige Fotoreihe *ENVELOPA: Drawing Restraint 7 (Guillotine)*, 1993 (Abb. S. 22–23, 90–91 u. a.), entstanden zu dem Video *Drawing Restraint 7*, 1993, die Filme, Vitrinen und Fotografien zum kompletten fünfteiligen *CREMASTER Cycle*, 1994–2002, und schließlich die Skulptur und der Film zu *DRAWING RESTRAINT 9*, 2005 (Abb. S. 77–78, 141–143).

DRAWING RESTRAINT 7: Storyboard drawing
1993
7 Zeichnungen, je | 7 drawings, each
7,62×12,5 cm

ENVELOPA: Drawing Restraint 7 (Guillotine)
1993
Rahmen | Frame 7-teilig, je | 7 parts, each
28,6×36,5×3,8 cm

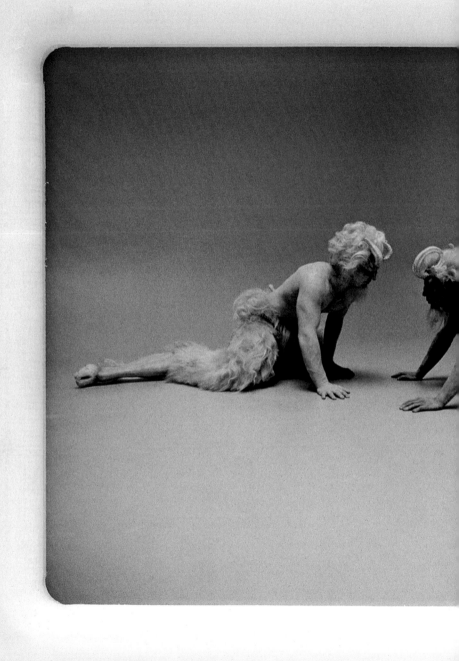

Barney hat diese Werke, im ersten Raum des Obergeschosses beginnend und im BASE 103 abschließend, installiert. Er präsentiert die zum *CREMASTER Cycle* gehörenden Objekte jedoch nicht in chronologischer, sondern in nummerischer Reihenfolge. Der Zyklus entstand in folgender Reihe: *CREMASTER 4*, 1994, *CREMASTER 1*, 1995, *CREMASTER 5*, 1997, *CREMASTER 2*, 1999, und *CREMASTER 3*, 2002. Bei der Hängung gibt es einige wenige thematische Überschneidungen zwischen den Räumen und immer wieder spannende Durchblicke von Raum zu Raum. Diese werden vor allem durch die als Bindeglieder eingesetzten sieben Fotografien der *ENVELOPA*-Serie hergestellt, die einzeln auf die verschiedenen Bereiche verteilt bzw. in die Werkgruppen implantiert sind. Diese Anordnung der Werke weist zudem darauf hin, wie sehr die einzelnen Arbeiten des Werks ineinander verschränkt sind: Seit Barneys Anfängen mit *DRAWING RESTRAINT 1*, 1987, bauen sie aufeinander auf und entwickeln sich zum Teil aus sich selbst heraus weiter.

Es ist das Charakteristikum einer jeden Kunstsammlung – sei sie öffentlich oder privat –, dass sie die individuellen Strategien des Sammlers sowie dessen Persönlichkeit reflektiert. Er selbst ist, nach Jean Baudrillard, als abschließendes Element in einer Reihe einzelner Glieder zu betrachten, aus denen eine Sammlung besteht.[2] Barney war mit der Aufgabe und den Möglichkeiten konfrontiert, einerseits einen konkludenten ‚Erzählzusammenhang' für seine Werke, die sich in der Sammlung Goetz befinden, im Kontext des von Jacques Herzog und Pierre de Meuron konzipierten minimalistischen Sammlungsgebäudes zu entwerfen und andererseits diese Werke innerhalb seines Œuvres zu positionieren. Da die Sammlung Goetz zu den nur vier Sammlungen[3] weltweit zählt, die im Besitz aller fünf *CREMASTER*-Filme und der dazugehörenden Vitrinen (Abb. S.170–179) mit den darin befindlichen Objekten sind, kann deren simultane sowie skulpturale Präsentation im Untergeschoss des Museums als einer der Höhepunkte innerhalb der Ausstellung angesehen werden. Die folgende Beschreibung beleuchtet anhand der Werke aus der Sammlung, wie die von Barney entwickelte Ausstellungskonzeption alle Bestandteile – Sammlung, Œuvre und Architektur – als begehbare Skulptur zu einem organischen Ganzen verschmilzt.

Gleich wenn man vom Treppenhaus den ersten Raum des Obergeschosses betritt, hängt an der linken Wand die kleinformatige Zeichnung *OTTOshaft (manual) F*. Sie gehört zu der Werkgruppe *OTTOshaft*, 1992, die wiederum das Ende von Barneys erstem Projektzyklus von 1991, dem *OTTO Cycle* – mit *The Jim Otto Suite*, *[facility of INCLINE]*, *OTTOshaft*, *[facility of DECLINE]* und *RADIAL DRILL* – markiert. Benannt wurde der Zyklus nach Jim Otto, dem legendären Mittelmann des Footballteams Oakland Raiders. Die Erzählung des Zyklus basiert auf dem ambitionierten Wesen Ottos und seiner für einen Footballspieler ursprünglich ungewöhnlich schmächtigen Physiognomie. Auch der Entfesslungskünstler Harry Houdini wird an dieser Stelle bereits in Barneys Werk eingeführt. *OTTOshaft* umfasst verschiedene organische Materialien, Kunststoffobjekte sowie drei Videofilme mit den Titeln *OTTOdrone*, *OTTOshaft* und *AUTOdrone*, die kontinuierlich auf Monitoren, die an der Decke hängend montiert sind, gezeigt werden. Zuerst ist *OTTOshaft* anlässlich der DOCUMENTA IX, 1992, entstanden und wurde in einer Tiefgarage in Kassel gezeigt. Nicht nur wegen der vergleichbaren Präsentationsform als einer hängend vorgeführten Dreikanal-Videoinstallation wird *OTTOshaft*

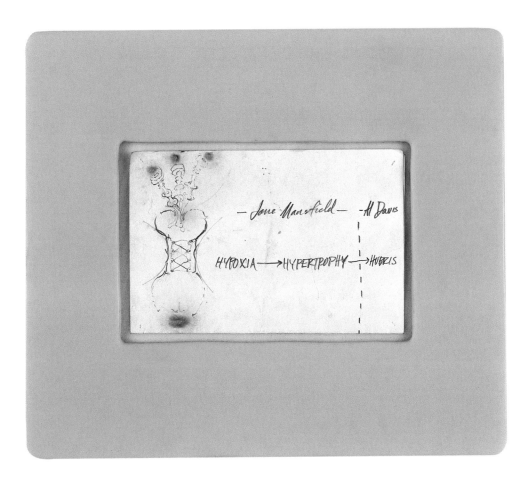

OTTOshaft (manual) F
1992
Rahmen | Frame 33 × 38,1 × 1,9 cm

zu einem „Tor in den *CREMASTER*-Zyklus"[4]. Nancy Spector hält fest: „Barney erweitert mit dieser performativen Skulptur (oder skulpturalen Performance) […] seinen für die damalige Zeit typischen Repräsentationsstil."

In der *OTTOshaft*-Zeichnung der Sammlung Goetz sind in Schreibschrift die Namen von Jayne Mansfield und Al Davis sowie in großen Druckbuchstaben die Begriffe ‚Hypoxia', ‚Hypertrophy' und ‚Hubris' neben einer kleinen Zeichnung zu lesen. Diese erinnert an einen Hundeknochen und kann einerseits als Ausschnitt eines in ein Korsett geschnürten weiblichen Torsos oder andererseits als Dudelsack interpretiert werden. Inhaltlich gliedert sich *OTTOshaft* in die *Jayne Mansfield Suite* und die *Al Davis Suite*, die laut Barney gegensätzliche physikalische Zustände repräsentieren.

Bevor *OTTOshaft* weiter erläutert werden kann, ist es notwendig, einige allgemeine Grundmotive zu Barneys Werk zu erläutern. Da sich kein anderer außer Spector so eingehend mit seinem Werk beschäftigt hat, greife ich auf ihre akribische Recherche zurück: „Die erste und wohl grundlegendste Spielregel besagt, dass die Form nur dann Gestalt annehmen oder mutieren kann, wenn sie gegen einen Widerstand ankämpft. Diese Idee geht auf Barneys Erfahrung als Sportler zurück, der durch Belastungstraining Stärke und Ausdauer gewinnt. Das Überschreiten physischer Schwellen durch Training ist ein Grundkonzept seiner Arbeit. Dasselbe gilt für die psychosoziale Dimension des Leistungssports – eine ritualisierte Arena des Wettbewerbs, des Exhibitionismus und des Heldenkults, die das kollektive Unbewusste unserer Kultur mit der maskulinen Identität assoziiert. Barneys These der Formwerdung baut auf dem Prinzip der Hypertrophie auf, einer Technik des Muskeltrainings, die das Gewebe durch wiederholte Belastung aufbricht, um Körperregionen zu vergrößern […] Im sportlichen Wettstreit werden alle Triebe unterdrückt, die dem Siegeswillen im Wege stehen. Sexualität, Sozialisierung und andere Bedürfnisse verfallen der Sublimierung, um den Körper in Topform zu bringen. Barneys Interesse gilt weniger dem eigentlichen Spiel als der Aufnahme, Speicherung und Abgabe von Energie unter kontrollierten physischen Bedingungen. Seine Kunst unter-

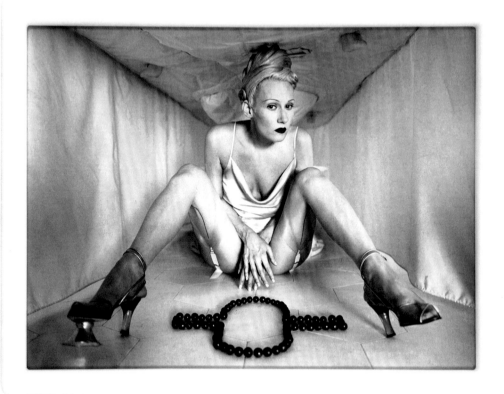

sucht die Möglichkeit, durch ‚kreative Verdrängung' neue ‚innere Schwellen' zu definieren, neue innere Prozesse, die Kräfte binden und Formen bilden können [...] Barneys frühe Objekte und Installationen sind eine Vision des perfekt gestylten Körpers. Als Kulisse für die Rituale des Fitnesstrainings spielen sie alle Stücke: Ringermatten, Hanteln und Flachbänke laden zum hypertrophen Bodybuilding ein [...] Wir befinden uns in der Arena des Körperkults. Bewerber um die Idealfigur unterziehen sich der Tortur des extremen Konditionstrainings und dopen sich mit Cocktails aus Schmerzstillern und Aufputschmitteln [...] Barney bekennt sich zu diesem athletischen Willen zur Macht, diesem Zwang, das menschlich Unmögliche innerhalb der allzu menschlichen Grenzen des Körpers zu realisieren [...] Das Jenseits der stets in die Ferne rückenden Leistungsgrenze verlockt den Sportler, ungeachtet aller Risiken Übermenschliches zu wagen. Das brennende Verlangen, Gott auf Erden zu werden, ist reine Hybris – eine Seelenkrankheit, die auch die ehrgeizigsten, kreativsten und wissbegierigsten Geister nicht verschont. Sie ist die Energie, die durch den hypertrophen Körper strömt, der Stachel, der zur übertriebenen Selbstdisziplin antreibt. In Barneys plastischer Imagination nimmt sie die Form einer Pille an [...] Steroid, Hormon oder Placebo – die Hybrispille ist in jedem Fall ein Katalysator des Konflikts."

In *OTTOshaft* verkörpern Jim Otto und Harry Houdini beide das athletische Prinzip, allerdings unter entgegengesetzten Vorzeichen. Spector dazu: „Der Entfesselungskünstler Houdini symbolisiert die hermetische Praxis. Er ist der ‚Character of Positive Restraint', der sich der Differenzierung verweigert und stattdessen durch extreme Disziplin den Körper isoliert und transformiert. Houdinis Metamorphosen [...] sind das Resultat rigorosen Körpertrainings, kombiniert mit einem intuitiven Verständnis der Fesselmechanismen [...] Jim Otto [...], der seine fünfzehnjährige Karriere mit zwei Plastikknien beendete, ist das Spiegelbild Houdinis: Obwohl ebenso fanatisch in seinem Metier und anschließend völlig schmerzunempfindlich, hatte er ein offenes, extrovertiertes, theatralisches Naturell. Was Houdini durch innere Kräfte zuwege bringt, erreicht Otto – laut Barney ein ‚hyperthermaler Penetrator' – durch nach außen gerichtete Aggression [...] Otto und Houdini sind zwei Inkarnationen eines inneren Horizonts, der sich zur Hybris spannt. Der extrovertierte Otto will in einer maßlosen Einswerdung die gesamte Außenwelt verschlingen. Sein Rivale, der introvertierte Houdini, greift mit einem reinen Willensakt nach der ersehnten Omnipotenz. Beide ringen um die Entwicklungstendenz des Organismus. Ihr Wettstreit bringt die Geschichte ins Rollen [...] Die Schlacht zwischen Otto und Houdini thematisiert den unaufhaltsamen Differenzierungskurs des Fötus [...] Zu den Bildern, mit denen Barney den Gang der anatomischen Differenzierung umschreibt, zählen Temperaturschwankungen und deren Auswirkung auf den männlichen Körper [...] In der bizarren Biolandschaft Barneys rufen Temperaturveränderungen das Heben und Senken der Hoden hervor, ein Körpervorgang, für den der Cremastermuskel zuständig ist [...] Obwohl noch unbenannt, figurieren der Cremaster und seine Wirkung bereits seit frühesten Jahren in Barneys Œuvre [...] Die Bewegung des Hoden und ihre Rolle

CREMASTER 1: Goodyear
1995
Rahmen | Frame 83,3×109,2×2,5 cm

in der sexuellen Differenzierung des Fötus kann durchaus als Ursymbol in Barneys mythologischer Konstellation aufgefasst werden. Das Hinuntergleiten der Hoden in den Hodensack im siebten Entwicklungsmonat ist in vieler Hinsicht die letzte Phase der Mannwerdung. Aber die Verweise auf die männliche Anatomie täuschen. Denn es geht dem Künstler nicht primär um das Finale der embryonalen Evolution, sondern um den zurückgelegten Weg zwischen dem Zustand des Aufstiegs (weiblich) und dem Zustand des Abstiegs (männlich) und all den möglichen Um- und Abwegen dazwischen […] Die sexuelle Mutabilität ist eine narrative Schlüsselkonstante in Barneys Kunst, wird aber nie selbst zum Erzählgegenstand […] Barney versteht Geschlecht als Rohmaterial. Er formt es genauso wie den Raum. Das Weibliche, das Männliche und alle möglichen Kombinationen bilden Zonen der Artikulation innerhalb der Erzählung."

In der frei erfundenen Geschichte zu seinen Videofilmen *OTTOshaft* ebnet Barney zahlreichen Metaphern und Assoziationen aus dem Bereich des Bodybuilding, des Football und internen Körperfunktionen den Weg. Diese werden ergänzt durch die beiden Charaktere des 1950er-Jahre-Kinostars Jayne Mansfield und des 1960er-Jahre-Footballtrainers Al Davis der Oakland Raiders, jenes Teams, für das Jim Otto spielte. In ihrer Gesamtheit betrachtet, werden alle diese Bestandteile zu verschiedenen Facetten von Jim Otto herausgebildet und definieren die Parameter der Filmhandlung. Die *Jayne Mansfield Suite* verkörpert Hypoxie – einen Zustand von Sauerstoffknappheit im arteriellen Blut oder Gewebe –, ihr Gegenstück, die *Al Davis Suite*, den Zustand der Hypertrophie – eine unnatürliche Vergrößerung von Organen oder Gewebe. „Alle Aktionen innerhalb von *OTTOshaft* repräsentieren eine Spannung und ein Changieren zwischen diesen Zuständen. Beide Zustände, Hypoxie und Hypertrophie, führen zu einer zeitweiligen oder dauerhaften Umformung des Körpers und reflektieren die simultanen Prozesse der Degeneration und Regeneration, die sich im Körpergewebe ständig abspielen."[5] Mansfield war für ihre schmale Taille und großen Brüste berühmt, die durch ein Korsett, das sie beim Anlegen zwang, die Luft anzuhalten, zusätzlich nach oben gepresst und so betont wurden. Al Davis repräsentiert ein anderes Extrem: Er versuchte als Trainer durch harte Disziplin insbesondere die Muskeln seines Mittelfeldspielers Jim Otto aufzubauen. Spector erläutert: „Gemeinsam personifizieren sie die Anwendung der Disziplin auf das reine Potenzial […] Allerdings ist Al ‚Just win, baby' Davis alles andere als eine gutmütige Vaterfigur. Er heckt die Entführung der Hybrispille aus und erzwingt ihre metabolische Transformation, komme was wolle. Als Personifikation der Hybris treibt er Otto in den äußersten hypertrophen Zustand, die völlige Körperbeherrschung, die in einer Implosion enden muss. (Teflon und rostfreier Stahl, die Materialien, die schrittweise die Bänder, Knorpel und Gelenke in Ottos Knien ersetzten, werden zum Grundstoff von Barneys Skulpturen.)" Al Davis erteilt im Film Jim Otto zudem Dudelsackunterricht, und er bringt ihm *Amazing Grace*, 1760–70, eines der beliebtesten amerikanischen Spirituals bei, das „vom Freidenker, Sklavenhändler und späteren anglikanischen Priester John Newton komponiert" wurde. Es fügt sich in *OTTOshaft* als musikalische Verkörperung der höchsten Hybris ein. Otto selbst splittert sich in ein Trio von Dudelsackpfeifern auf. Der Dudelsack wird zur unerwarteten, aber treffenden – und in Barneys Werk immer wieder auftauchenden – Metapher für den menschlichen Körper im Allgemeinen und den von Jim Otto im Speziellen. Der Blasebalg des Dudelsacks wird in der Regel aus Tiermägen her-

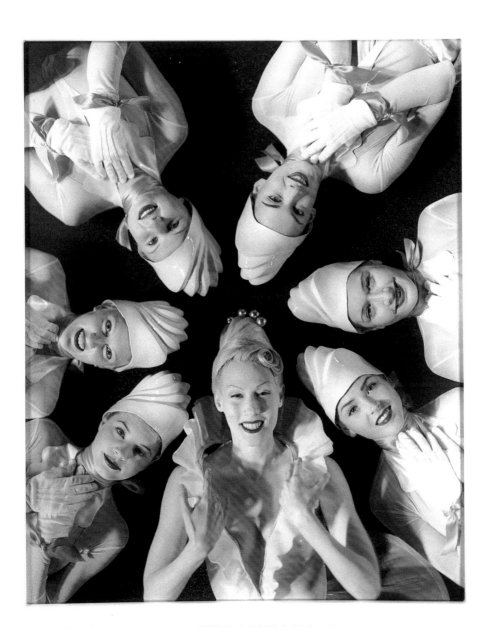

CREMASTER 1: Orchidella
1995
Rahmen | Frame 136,5×111×2,5 cm

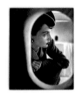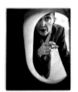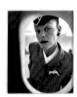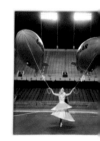

gestellt und hat drei Pfeifen, so wie sie auch auf der Zeichnung abgebildet sind. Wann immer der Dudelsack im Film auftaucht, sind seine Pfeifen eingeklemmt, der Blasebalg ist mit Luft gefüllt und steht unter Druck – so wie die Organe eines Athleten im Training oder in Momenten größter Anspannung vor oder während des Spiels. Dieser Druck wird jedoch nie abgelassen und damit ein Ende der Narration im Film ermöglicht.

Direkt neben dieser Zeichnung hängt die erste der sieben *ENVELOPA: Drawing Restraint 7 (Guillotine)*-Fotografien (Abb. S. 22–23), die in ihrer Gesamtheit von Barney als Skulptur bezeichnet zu dem Video *Drawing Restraint 7* gehören, das in engem Zusammenhang unmittelbar nach *OTTOshaft* entstand. Wie dieses Werk kann auch *Drawing Restraint 7* als Vorspiel für das spätere *CREMASTER*-Projekt eingeschätzt werden. In den Fotografien sind verschiedene Zustände des Kampfes zweier Satyrn nachgestellt, der im Video zu sehen ist.

Barney begann nach *OTTOshaft*, sich nicht nur für Teflon und rostfreien Stahl als Prothesenmaterialien, sondern auch für Kunststoffe, die ähnlich eingesetzt werden können und vor allem ihre körpererweiternden Eigenschaften, zu interessieren: „Es waren die Kunststoffe, die mich anzuziehen begannen, die im Körper als innere Prothesen leben und außerhalb des Körpers als prothetische Erweiterung. Damit ließ sich dieser Begriff der Beschreibung eines Narrativs formalisieren, das zwischen Innen- und Außenräumen hin und her springen kann und so eine Beziehung zum Körper hat. Ich glaube, es wurde für mich mit dem Übergang vom figurativen zum architektonischen, ja zum geologischen Maßstab wahrscheinlich befreiender und interessanter. Das geschah in der Zeit, als ich begann, mich wohlzufühlen, wenn ich meine Methode unter dem Gesichtspunkt des Geschichtenerzählens begriff. Das war irgendwann um 1992, nach *OTTOshaft*, aber bevor *Drawing Restraint 7* entstand. Ich kam nach *OTTOshaft* auf *DRAWING RESTRAINT* zurück und beschloss, ein *DRAWING RESTRAINT* zu machen, das kein buchstäblicher Zwang [restraint] war, sondern ein theatralischer. Es war ein großer Schritt für mich, den physischen Zwang durch einen eher metaphorischen oder projizierten, von einem Narrativ getragenen Zwang zu ersetzen."[6] Und an anderer Stelle meint Barney: „*Drawing Restraint 7* war, glaube ich, ein Versuch, mir selbst zu beweisen, dass das *DRAWING RESTRAINT*-Projekt auch mit neuen Werkzeugen funktionieren konnte."[7]

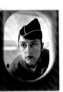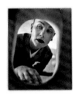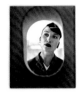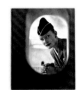

CREMASTER 1: The Goodyear Waltz, 1995
Rahmen | Frame 9-teilig | 9 parts:
85,7×70×2,5 cm (1×), 64,1×54,6×2,5 cm (8×)

Dementsprechend greift *Drawing Restraint 7* mit seinen Charakteren nicht mehr auf reale Personen zurück, sondern bezieht sich – als Erfindung einer völlig neuartigen Formensprache – mit seinen drei Figuren der Satyrn auf die griechische Mythologie. Der Film wird wie *OTTOshaft* als Dreikanal-Videoinstallation auf von der Decke herabhängenden Monitoren präsentiert. Auch in musikalischer Hinsicht sieht Spector sowohl einen Vorgriff als auch eine Verbindung zwischen den beiden Werken: In *Amazing Grace* – einer Anrufung Gottes –, sieht sie „den Mythos des Marsyas anklingen, der durch seine Flötenkunst den Zorn Apolls erregt.“

Ort der Handlung ist eine Limousine, die bei Nacht über die insgesamt sechs Brücken bzw. durch die Tunnel, welche die Halbinsel Manhattan mit dem Umland verbinden, jeweils in die Stadt fährt und die einem „Niemandsland zwischen Erde und Olymp“ gleicht. Im azurblauen Fond des Wagens duellieren sich zwei erwachsene männliche Satyrn – der eine halb Ziegenbock, der andere halb Widder – bis zur Zerfleischung. Es ist ihre Aufgabe, in das Kondenswasser auf dem Glasdach des Wagens eine Zeichnung zu schreiben. Bei jeder Fahrt in die Stadt entsteht so – im Kampf – ein eigenes Werk. Allerdings haben beide Satyrn mit der Erreichung des Fahrtziels gewonnen und zugleich verloren, da die Rache der Hybris – wie im Marsyas-Mythos – unmittelbar folgt: „Am Ende des Films legen sie Achillessehne an Achillessehne und ziehen sich gegenseitig die Haut ab.“ Klaus Kertess interpretiert diesen Akt folgendermaßen: „Hier ziehen sich die Ringer zur Strafe für ihr jeweiliges Streben nach der Vollkommenheit des Vollendeten gleichzeitig gegenseitig die Haut ab.“[8]

Vorn im Wagen übernimmt der geschlechtslose Kid, gespielt von Barney selbst, die Rolle des Fahrers. Spector erläutert: „Seine verzweifelten Versuche, den eigenen Schwanz zu fassen – um den Kreis seines Seins zu schließen und seinen prädifferenzierten Zustand zu fixieren – liefern den Antrieb, der

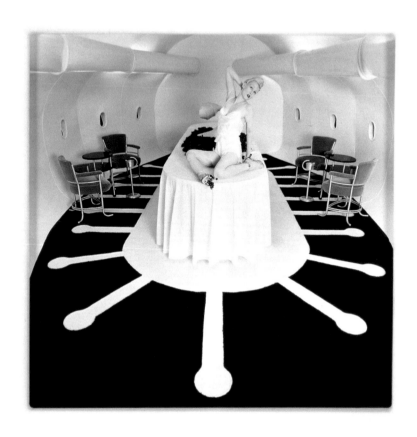

das Auto auf Endlosschleifen durch die Anatomie New Yorks steuert." Sie geht ferner davon aus, dass im Versuch, den Kreis zu schließen, den eigenen Körper zu verschließen und abzuschließen, der Kid nach dem nebulösen Raum der Hybris, der Sphäre des Unsterblichen auf Erden, strebt. Und sie weist darauf hin, dass auch nach biblischen Maßstäben die Schöpfung auf dem Prinzip der Teilung, der Differenzierung und der Kategorisierung beruht. Die Paarung von Tier oder Mensch sei strikt untersagt, da jede Auflehnung gegen die Differenzierung eine Auflehnung gegen das Wort Gottes darstelle. Wer dennoch neue Formen hervorbringe, maße sich die Rolle des Schöpfers an: „Dies und nichts anderes ist aber das unabänderliche Ziel des Demiurgs […] Der Künstler/Demiurg Barney kombiniert den Mythos der Hybris mit dem biologischen Modell der prägenitalen Indifferenz. Das Resultat ist *Drawing Restraint 7.*"

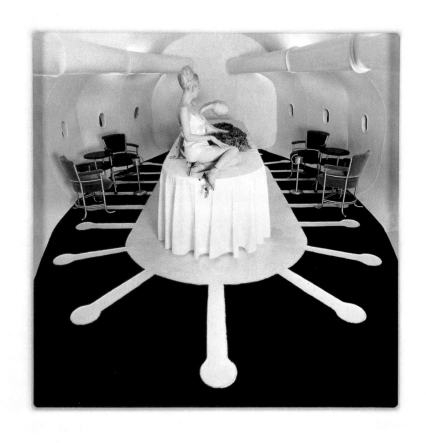

CREMASTER 1: Goodyear Lounge
1995
Rahmen | Frame 2-teilig, je | 2 parts, each 60,3×65,4×2,5 cm

Hybris, eine Nymphe, zeugt mit Zeus den Satyr und Halbgott Pan, der häufig mit dem Satyr Marsyas –
Letzterer allerdings ohne göttliche Attribute – gleichgesetzt wird. Beide stehen für die verstandslosen
Triebe und fleischliche Lust des Menschen. Gleichzeitig gilt der Satyr als physiologische Anomalie,
als „Verstoß gegen die kosmische Weltordnung. Das Mischwesen aus Mensch und Tier war in der
Antike ein Bote des Chaos, das unter der Fassade der Realität lauert." Marsyas fühlte sich den Göttern

CREMASTER 2: The Executioner's Song
1998
Rahmen | Frame 71,1×61×2,5 cm

überlegen und – seiner Begierde und Lust auf Anerkennung folgend – forderte Apoll mit seinem Flötenspiel heraus. Als im Wettstreit Unterlegener wurde ihm von Apoll die Haut abgezogen. Die Musen als Schiedsrichter und Apoll bestraften den Ehrgeiz des Marsyas, der sich in der vermeintlich vollendeten Ausführung eines Werks über das Göttliche zu erheben versuchte. So gilt der Marsyas-Mythos auch als Variante der Hybris-Allegorie, in der Halbgötter bzw. Sterbliche sich über Götter erheben und zum Teil grausam bestraft werden. Der Mythos wendet sich nicht gegen das Kunstwerk an sich, sondern nur gegen den Künstler, der das Werk nicht in Demut schafft.

Die Fotografien der *ENVELOPA*-Serie beziehen sich in ihrer Bildsprache ebenfalls auf die griechische Mythologie. Allerdings scheint Barney bei ihnen wiederum ein athletisches Modell, wie in früheren Werkgruppen, anzuwenden. Sie zeigen die beiden Satyrn, bereits bekannt aus dem Fond des Wagens, isoliert vor einem neutralen türkisfarbenen Hintergrund in sieben verschiedenen Positionen eines Ringergriffs. Diese Haltungen sind nicht identisch mit denjenigen, die im Auto eine Rolle spielten. Vielmehr handelt es sich um einen im Bodenkampf ausgetragenen Würgegriff, den sogenannten ‚Guillotine Choke‘. Dessen Ziel ist es, die Luftzufuhr in die Lungen des Gegners zu unterbinden, was bei dem unterlegenen Ringer sogar zur Bewusstlosigkeit führen kann – ein Zustand der Sauerstoffknappheit, wie er auch bei Jayne Mansfield vorkommt.

Im ersten Bild belauern sich die beiden Satyrn, jeder Muskel ist angespannt. Wie bei *OTTOshaft* steht der ganze Körper unter Druck, jeder ist bereit, jede Sekunde auf den anderen loszugehen, befindet sich aber noch in einem Zustand unangetasteten Gleichgewichts. Im dann einsetzenden Kampf gelingt es einem der beiden relativ schnell, Obermann zu werden und den anderen bäuchlings niederzuwerfen. Diesem gelingt es, sich im weiteren Verlauf nochmals herumzudrehen – eine Aktion, die aufgrund des angewandten Guillotine Choke als extrem schwierig anzusehen ist. Der Unterlegene reißt seinen Kombattanten nach oben – und landet neben ihm, reglos wie dieser auch, auf dem Rücken. Die Bilder wirken nicht wie Schnappschüsse eines schnellen Kampfes, sondern eher wie inszenierte Illustrationen des besagten Griffs.

Die Fotografien stehen stellvertretend für alle Teile der Serie *Drawing Restraint 7*, die Barney selbst als Vorläufer zum *CREMASTER Cycle* sieht. Sie bilden formal den Übergang zu diesem: Im ersten Raum des Obergeschosses ist eine Einzelaufnahme sowie eine Gruppe von Fotos zu *CREMASTER 1* als auch ein Triptychon zu *CREMASTER 2* installiert. Im Zentrum der Abbildungen gegenüber des Eingangs steht die Hauptfigur Goodyear, eine starlethaft gestylte Blondine – ein voll aufgestiegenes Wesen –, die in den beiden im Film gezeigten Goodyear-Zeppelinen gleichzeitig lebt. In *CREMASTER 1: Goodyear*, 1995 (Abb. S. 26), sitzt sie in einem der beiden Luftschiffe mit gespreizten Beinen unter dem Tisch und ordnet Trauben zu Mustern an – hier Barneys Feldzeichen –, die wiederum den Tanz der Revuegirls im darunterliegenden Stadion choreografieren. Da Weintrauben als Attribute des Gottes Dionysos gelten, besteht auch hier wieder eine Referenz zur griechischen Mythologie und zu *Drawing Restraint 7*. In der neunteiligen Gruppe *CREMASTER 1: The Goodyear Waltz*, 1995 (Abb. S. 30–31), ist die Figur Goodyear im zentralen Foto zu sehen, wie sie in der Mitte des Stadions

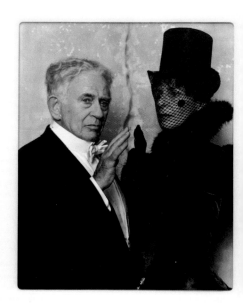

stehend, die beiden Zeppeline an langen Schnüren schwebend in Balance zusammenhält, während rechts und links angeordnet Einzelporträts der jeweils vier Stewardessen folgen, die mit strengem Blick aus den Fenstern der Zeppeline auf das Spielfeld schauen. Nur mit Aufwand gelingt es Good-year, die beiden Zeppeline im Gleichgewicht zu halten, wie man auf dem mittleren Foto erkennt, denn es kommt immer wieder zu kleinen Schwankungen der Luftschiffe. Damit entsprechen die beiden ersten *ENVELOPA*-Fotografien (Abb. S. 22–23, 90–91), die in diesem Raum hängen, am ehesten dem undifferenzierten Zustand von *CREMASTER 1*.

Als Ausblick auf den nächsten Raum und Einstieg in den nächsten Film befindet sich hier auch das Triptychon *CREMASTER 2: Genealogy*, 1999 (Abb. S. 36–37): die Begegnung und Vereinigung zwischen Harry Houdini, dargestellt von Norman Mailer, – einschließlich dessen als Erlösung geplante Geschlechtsumwandlung – und Baby Fay La Foe. In der Geschichte von *CREMASTER 2* deutet dies auf den End- und eventuell den Anfangspunkt der Erzählung hin. Bei den beiden Personen handelt es sich möglicherweise um die Großeltern des Doppelmörders Gary Gilmore, dessen Geschichte Norman Mailer in seinem Tatsachenroman *The Executioner's Song* (*Gnadenlos*) als Ausgangspunkt für seine Erzählung genommen hat. Die beiden zum Triptychon gehörenden Landschaftsaufnahmen verorten *CREMASTER 2* in die Salzebenen von Bonneville sowie in das Columbia Icefield. Spector beobachtet weiter: „Durch Drehung um neunzig Grad werden diese Bilder zu vertikalen Rorschach-Figuren – ein formaler Hinweis auf die psychologische Dimension der Erzählung."

CREMASTER 2: Genealogy
1999
Rahmen | Frame 3-teilig | 3 parts:
55,2×55,2×2,5 cm (2×)
71,1×60,3×2,5 cm (1×)

Im nächsten Ausstellungsraum im Obergeschoss finden sich hauptsächlich Fotografien zu *CRE-MASTER 2* und *CREMASTER 3* sowie als Rück- und Ausblick jeweils eines zu *CREMASTER 1* und *CREMASTER 4* und zwei weitere *ENVELOPA*-Fotografien (Abb. S. 102–103, 112–113), auf denen der Sieg des einen Satyr über den anderen noch offensichtlich scheint und damit der undifferenzierte Zustand aufgehoben wäre.

Die Werke werden hier entsprechend ihrer thematischen Zugehörigkeit vorgestellt. Abschließend zu *CREMASTER 1* findet sich auf der linken Wand das Diptychon *CREMASTER 1: Goodyear Lounge*, 1995 (Abb. S. 32–33), das die gestylten Aufenthaltsräume in den Zeppelinen abbildet und darin Goodyear in ihrer simultanen Existenz in beiden Luftschiffen zeigt. Daneben hängt *CREMASTER 2: The Royal Cell of Baby Fay*, 1998 (Abb. S. 39), das Baby Fay La Foe (Gilmore) als Bienenkönigin inmitten eines Wabenmusters zeigt. Wenn auch in dieser Fotografie nicht sichtbar, ist Baby Fay La Foe, wie bereits Jayne Mansfield in *OTTOshaft,* in ein Korsett eingeschnürt, das ihre Wespentaille betont. Dieser eingeschnürte Zustand weist wiederum Parallelen zum Zustand des Griffs Guillotine Choke auf, wie er in den *ENVELOPA*-Fotografien zu sehen ist.

Auf die zwei daneben hängenden Werke sei hier gesondert hingewiesen. Bei ihnen handelt es sich um die für Barney typischen, delikat und mit sicherem Strich ausgeführten Bleistiftzeichnungen *The Ballad of Nicole Baker*, 1999 (Abb. S. 41), und *The Nuptual Flight*, 1999 (Abb. S. 40), inhaltlich beide

CREMASTER 2 zuzurechnen. Auf ersterer findet, metaphorisch in den Schnitt durch eine hügelige Landschaft eingebettet, die Vereinigung von Gary Gilmore und Nicole Baker statt: Ein phallischer Schacht durchdringt die Horizontlinie vom Untergrund her kommend. Auf ihm ist der Name Gary zu lesen und in dem darüberliegenden Gebirge der Name Nicole. An der Schwelle der Durchdringung erkennt man ein Pferd im Galopp, dessen vier Beine gerade in der Luft zu sein scheinen. Um dieses Zentrum auch formal noch zusätzlich zu betonen, scheint in der Mitte eine ganze dünne Vaseline-schicht aufgetragen zu sein. Noch deutlichere sexuelle Anspielungen erkennt man auf der zweiten Zeichnung, die, wie das Foto *CREMASTER 2: The Royal Cell of Baby Fay*, Waben als Grundmuster aufweist. Vertikal im Zentrum befindet sich ein erigierter Penis, der in Richtung eines mit gespreizten Beinen dargestellten Frauenkörpers weist. Anstelle einer Eichel hat Barney einen Bienenstock ge-zeichnet. Wie all seinen Zeichnungen ist auch diesen gemeinsam, dass sie trotz ihrer relativ kleinen Abmessung im Grunde monumental wirken. Sie gleichen Bildern aus einer Parallelwelt, die man nur bei ganz genauer Betrachtung in ihrer tatsächlichen Größe erkennen kann. Barney ist das Medium der Zeichnung äußerst wichtig. In Form von detaillierten Storyboards begleiten sie seine Projekte von Anfang an. Er skizziert sowohl den Handlungsverlauf als auch die Werke vor, die eigenständig im Umfeld einer Arbeit entstehen.

Auf der letzten Fotografie zu *CREMASTER 2: The Executioner's Song*, 1998 (Abb. S. 34), ist Gary Gilmore bei dem fiktiven letzten Tanz mit seiner Freundin Nicole Baker vor seiner Hinrichtung zu sehen. Der Song dazu wurde anscheinend tatsächlich per Telefon von Johnny Cash am Vorabend der Hinrichtung gesungen.[9]

Zum längsten und auch vielleicht komplexesten Film des Zyklus, *CREMASTER 3*, 2002, gehören die beiden Arbeiten *CREMASTER 3: Plumb Line*, 2001 (Abb. S. 60), und *CREMASTER 3: Mahabyn*, 2002 (Abb. S. 62–63). In *CREMASTER 3* ist der im Zyklus bevorstehende Kampf zwischen Entropie und Wachstum – die nicht mehr aufzuhaltende Trennung der Geschlechter – angelegt. Er ist verortet im New Yorker Chrysler Building sowie u. a. durch den Prolog, der am Giant's Causeway in Irland spielt und damit als verwandter Ausblick auf *CREMASTER 4* zu verstehen ist, und in der keltischen Mythologie. Die Giganten können ebenfalls als mythologische Verwandte der griechischen Satyrn gesehen werden.

Das monumentale Fototriptychon *CREMASTER 3: Mahabyn* bezieht sich auf Riten der Freimaurerloge und zeigt im linken Bild auf der rechten Seite den ,Entered Apprentice', den Lehrling – gespielt von Barney –, sowie seinen weiblichen Modell-Schwarm, die ,Entered Novitiate', gespielt von Modell Ai-mee Mullins, – gleichzeitig das Alter Ego des Apprentice. Die Darstellung bezieht sich auf den Mo-ment, in dem der Lehrling durch das Einflüstern des Begriffs ,Maha byn' in den dritten und höchs-ten Freimaurergrad aufsteigt. Das Modell verwandelt sich anschließend in eine Gepardin und greift ihn an. Schließlich erschlägt der Apprentice das Mischwesen mit einem Steinmetzwerkzeug: „Ein Schlag auf die Schläfe mit dem Senkblei […]; ein Schlag auf die andere Schläfe mit der Was-serwaage […]; ein Schlag auf die Stirn mit dem Hammer" – die Stellen der Wundmale, die man

CREMASTER 2: The Royal Cell of Baby Fay
1998
Rahmen | Frame 71,1×50,8×2,5 cm

The Nuptual Flight
1999
Rahmen | Frame 24,1 × 29,8 × 3,8 cm

The Ballad of Nicole Baker
1999
Rahmen | Frame 23,3 × 29,8 × 3,8 cm

auch im mittleren Foto erkennen kann. „Nach diesem Ritualmord an seinem Spiegelbild steigt der Apprentice zum Meister auf." Diese Mordszene wiederholt als Initiation in den dritten Grad den Tod des Hiram Abiff, des sagenhaften Erbauers des Tempels Salomons. Nach der Überlieferung der Freimaurer wurde dieser jedoch durch König Salomon mit dem Meistergriff wieder zum Leben erweckt. „Dabei wendet er die fünf Punkte der Bruderschaft an: Fuß auf Fuß, Knie auf Knie, Brust auf Brust, Hand auf den Rücken und Mund aufs Ohr." Als Verweis darauf lässt das Kostüm des Modells auf der mittleren Fotografie diese Stellen frei.

CREMASTER 3: Plumb Line mit der auf dem Tresen sitzenden Katze stellt eine Szene dar, die in der Bar Cloud Club im Chrysler Building zu dem Zeitpunkt spielt, kurz bevor das Gebäude durch den im Foto nicht zu sehenden Bartender aus seinem Gleichgewicht gebracht wird. Die Bar selbst ist in der Aufsicht in Form eines Senkbleis konstruiert – wie es ähnlich über der Katze hängt. Diese –

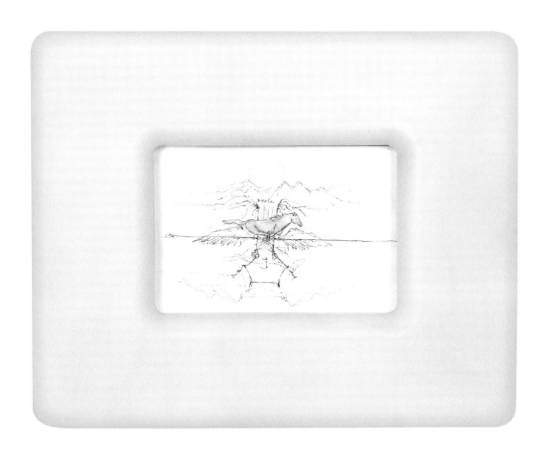

als Referenz auf die Gepardin und damit als Reflektion des verwandelten Freimaurer-Lehrlings/Modells – befindet sich genau an der Stelle, an dem das Senkblei des Lots die zu verortende Oberfläche berühren würde.

Einen Ausblick auf den nächsten Film bildet im zweiten Raum *CREMASTER 4: LOUGHTON RAM*, 1994 (Abb. S. 64). Zwischen dieser Fotografie und *CREMASTER 2: The Executioner's Song* stellt eine weitere Fotografie aus der *ENVELOPA*-Serie einen Beziehungsbogen her. Der Titel *LOUGHTON RAM* bezieht sich auf das auf der Isle of Man, dem Ort der Handlung, beheimatete Loughton-Schaf, dessen Charakteristikum darin besteht, dass es vier Hörner besitzt, von denen zwei nach oben und zwei nach unten gebogen sind. Barney sieht in ihm den idealen Zustand der Indifferenz angezeigt. Spector erläutert: „Auf- und Abstieg ruhen in völliger Harmonie. Der konzeptuelle Raum zwischen dem ‚Candidate' und seinem Bock ist das ‚Loughton-Feld', ein Feld des reinen Potenzials an der Grenze zur Hybrisschwelle, an der das Unmögliche möglich wird." Der Loughton Candidate, der Hauptdarsteller des Films, ist ein rothaariger Satyr in weißem Anzug: „Er ist ein Verwandter der Mischwesen in *Drawing Restraint 7* […] Der Candidate übertüncht seine Bocksnatur mit einer geckenhaften Politur. Er hat vier Einbuchtungen im Kopf, die sich zu ebenso vielen Hörnern auswachsen werden."

In direkter Blickachse der Türdurchgänge im Obergeschoss hängt im hintersten Raum der Ausstellung die fünfte Fotografie der *ENVELOPA*-Serie (Abb. S. 122–123) und bildet den Auftakt zu dem vollständig *CREMASTER 4* gewidmeten Raum. Dort findet sich die fünfteilige Fotoserie *CREMASTER 4: The Isle of Man*, 1994 (Abb. S. 66–67), *CREMASTER 4: T⊥: ascending HACK descending HACK*, 1994 (Abb. S. 68) (auf der linken Wand), *CREMASTER 4: Three Legs of Man*, 1994 (Abb. S. 9, 69), sowie die Skulptur *[PIT] Field of Descending Faerie*, 1995 (Abb. S. 9). Die fünfteilige Fotoserie zeigt zum einen den Candidate, rechts und links flankiert von jeweils zwei Motorradfahrern, die sich in den beiden in *CREMASTER 4 T⊥: ascending HACK descending HACK* abgebildeten Motorrädern mit Beiwagen auf der berühmten Motorradrennstrecke auf der Isle of Man, der Tourist Trophy, ein Rennen liefern. Ferner zeigen zwei kleine Aufnahmen das Triskelion-Emblem, das auf den Beiwagen der Motorräder angebracht ist. Das gelbe Team umkreist die Insel im Uhrzeigersinn. Da es im Tiefland startet, durchquert es der Geografie folgend ein aufsteigendes weibliches Feld, während die Route des blauen Teams im Hochland beginnt, gegen den Uhrzeigersinn verläuft und ein absteigendes männliches Feld beschreibt.

Die Skulptur *[PIT] Field of Descending Faerie* umfasst eine Rampe mit einer feldartigen Öffnung im Zentrum sowie Nachbildungen zweier Requisiten aus dem Film: den Wagenheber sowie den weißen Vinylkeil, die beide während des Reifenwechsels durch die Faeries, die Feen, zum Einsatz kommen. Diese androgynen Fabelwesen nehmen im Film verschiedene Rollen ein und können anhand ihrer Frisuren unterschieden werden. So trägt z. B. die Figur Descending Faerie zwei nach unten weisende Haarknoten.

CREMASTER 4: Three Legs of Mann bildet als Filmstill der abschließenden Szene einen Endpunkt im Ausstellungskonzept des Obergeschosses: „In der letzten Aufnahme blickt die Kamera zwischen zwei gespreizten Beinen […] An einem voll eingezogenen Hodensack sind weiße Plastikklammern befestigt, von denen Vinylschnüre bis zu den wartenden *Hacks* laufen. Die losfahrenden Motorräder werden die Schnüre straffen. Ein voller Abstieg ist garantiert […] Ganz folgerichtig ist auch die Anzahl der Plastikklammern in der Schlussszene ungerade (vier links, drei rechts). Das *Ascending Hack* wird nach dem Start auf der rechten Seite nach oben ziehen, der *Descending Hack* auf der linken nach unten […] Am Tor zur echten kreativen Form steht die Einsicht, dass eine perfekte Lösung (oder Symmetrie) trotz schärfster Disziplin ein Ding der Unmöglichkeit bleibt."

Der Ausstellungsrundgang findet seine Fortsetzung im ersten Raum des Untergeschosses. Dort sind die drei Zeichnungen *Ereszkedés*, 1998 (Abb. S. 70), das Triptychon *CREMASTER 5: Elválás*, 1997 (Abb. S. 72–73), das Einzelfoto *CREMASTER 1: Orchidella*, 1995 (Abb. S. 29), sowie das sechste *ENVELOPA*-Foto (Abb. S. 128–129) zu sehen. Darauf rafft sich der scheinbar schon besiegte Satyr nochmals auf, wirft den Oberkörper nach hinten und zieht dabei seinen Gegner fast zum Sitzen hoch – ein letztes Aufbäumen im Kampf, ein letzter Versuch, die Freiheit wiederzuerlangen. Dies ist vergleichbar dem Versuch von ‚Her Magician' – einer der Hauptfiguren in *CREMASTER 5*, die Harry Houdini gewidmet ist – der durch einen Sprung von der Budapester Kettenbrücke, seinem hypertrophen Trieb

folgend, Transzendenz und Freiheit durch Selbstbezwingung sucht. Zudem verspricht er sich eine Unabhängigkeit von dem deterministischen Zwang. Spector vergleicht dies mit den Zeppelinen in CREMASTER 1 sowie den vier gekrümmten Hörnern des Loughton-Schafs in CREMASTER 4.

Auf dem mittleren Foto des Triptychons sieht man die Queen of Chain – dargestellt von Ursula Andress – beim zärtlichen Abschiedskuss von Her Magician, bevor dieser davonreitet, um von der Kettenbrücke in die Donau zu springen. Die Fotos an den Wänden rechts und links zeigen die Paginnen der Queen.

Die drei Zeichnungen sind auf gleich große Bogen eines geprägten Papiers mit einem an Jugendstilornamente erinnernden Muster gezeichnet. Prägung und Zeichnung verschmelzen zu einem abstrakten Muster, das entfernt an eine schematische Eierstockdarstellung erinnert und ästhetisch fast als Variation oder Weiterentwicklung des Landschaftsthemas in der Zeichnung The Nuptual Flight erscheint. Eine Besonderheit stellen die durchsichtigen Rahmen sowie die liegende Präsentation in einer Vitrine dar, die den Zeichnungen eine Aura besonderer Kostbarkeit verleiht.

Das dritte Foto im Raum CREMASTER 1: Orchidella zeigt die heitere Goodyear sehr dekorativ im Zentrum einer Gruppe von sechs Revuegirls auf dem blauen Kunstrasen liegen. Das Motiv steht symbolisch als Verweis auf den Anfang des Zyklus und das Schließen des Kreises zum CREMASTER-Loop.

Im großen Saal des Untergeschosses befindet sich die simultane Audio-Videoinstallation aller CRE-MASTER-Filme auf Flachbildschirmen, wie sie ähnlich bereits in der großen Barney-Retrospektive 2003 im New Yorker Solomon R. Guggenheim Museum zu sehen war. Hier werden zusätzlich alle fünf zugehörige Vitrinen unter dem entsprechenden Monitor gezeigt. Der Beitrag von Brandon Stosuy in diesem Katalog beschäftigt sich ausschließlich mit dieser beeindruckenden und alle Sinne einnehmenden Installation.

Im hintersten Raum des Untergeschosses bildet die siebte Fotografie der ENVELOPA-Serie (Abb. S. 138–139) den Anschluss an Barneys neuesten Film DRAWING RESTRAINT 9. Für den Künstler bedeutete Drawing Restraint 7 in Bezug auf die Erzählstruktur einen Übergang zu seiner neuesten Arbeit, die nicht mehr von einem physischen Zustand der Einschränkung ausgeht. Ohne erkennbaren Sieger liegen beide Satyrn reglos auf dem Boden und erinnern an ein erschöpftes Paar nach dem Liebesakt.

Wie schon im CREMASTER Cycle bilden alle ästhetischen Elemente von DRAWING RESTRAINT 9 ein Gesamtkunstwerk. Dazu gehören die Skulptur ebenso wie die beiden Zeichnungen Pacific, 2006 (Abb. S. 74), und Inner Roji, 2006 (Abb. S. 75).

Die Skulptur aus Kunststoff umfasst Abgüsse von Utensilien wie Harpunen, wie sie im Walfang benutzt werden, aber auch beispielsweise Filmdosen, und verweist damit eigenständig auf die

Entstehung des Films. Die beiden Zeichnungen illustrieren in fantastischer Manier fiktive Szenen, zum einen um das Thema ‚Meer': *Pacific* zeigt den dramatischen Kampf einer riesigen Krake mit einem Wal, die Zeichnung ist verwandt mit ähnlichen Darstellungen japanischer Künstler des 19. Jahrhunderts.

Zum anderen verweist *Inner Roji* auf die japanische Teezeremonie – die auch im Film zelebriert wird – und stellt symbolisch vier in Form eines buddistischen Manji-Zeichens in der Mitte zusammenlaufende Gartenwege dar, die zum Eingang eines Teehauses führen. Das Manji-Zeichen repräsentiert im Zen-Buddismus die ideale Harmonie von Liebe und Intellekt. Jeder Stein auf dem Pfad ist so arrangiert, dass der ankommende Gast seine Schritte sorgfältig setzen muss. Diese vorsichtige Form der Annäherung ist als Vorbereitung des Gasts auf den Übergang von der alltäglichen Umgebung in die Welt der Teezeremonie zu verstehen. Angelegt ist der Weg in einem Steinbruch, der jedoch an die Aufsicht auf eine kleine felsige Insel mit steiler Küstenlinie erinnert, die an romantische Seeräubernester oder geheime Schatzinseln denken lässt.

Der Film *DRAWING RESTRAINT 9* wird im BASE 103 in einer kinoähnlichen Situation gezeigt.

Barney erläutert, dass *Drawing Restraint 7* „sowohl eine Art Vorläufer zum *CREMASTER Cycle* als auch eine Art Übergangswerk innerhalb der Sprache von *DRAWING RESTRAINT* [war]. Nummer *7* bot einen narrativen Übergang zu *DRAWING RESTRAINT 9*, woran ich gerade arbeite. Beide Werke beschreiben Widerstand als einen psychologischen Zustand oder als Konflikt innerhalb eines größeren Narrativs und nicht einen buchstäblichen, physischen Zustand des Zwangs."[10]

Barneys Ausstellungskonzept lässt es plausibel erscheinen, dass er in vergleichbarer Weise, wie er seine Filme konzipiert und dort seine Darsteller dirigiert, auch an die Realisierung seiner Ausstellung und ihre Besucher herangeht: „Ich neige dazu, es unter organischen Gesichtspunkten zu begreifen; ich neige dazu, es als einen Körper zu begreifen. Ich glaube, bei vielen Entscheidungen, die im Hinblick auf Dauer und Gleichgewicht getroffen werden, geht es um den Versuch, einen Organismus zu beschreiben, der seine eigene Vitalität und sein eigenes Verhalten hat."[11]

1 Brandon Stosuy: „Matthew Barney", in: *The Believer*, Dezember 2006–Januar 2007, S. 63 (Übersetzung: Nikolaus G. Schneider).

2 Jean Baudrillard: *Das System der Dinge*, Frankfurt am Main 1991, S. 116.

3 Bei den drei anderen Sammlungen handelt es sich um die Pamela and Richard Kramlich Collection/New Art Trust, San Francisco, die Rachel and Jean-Pierre Lehmann Collection, New York, und die Emanuel Hoffmann-Stiftung, Depositum in der Öffentlichen Kunstsammlung Basel.

4 Im Folgenden werden Auszüge aus Nancy Spectors umfassendem Aufsatz „Nur die perverse Phantasie kann uns noch retten" aus dem Ausstellungskatalog der Matthew-Barney-Retrospektive von 2002/03 zitiert, die seine künstlerischen Ansätze sehr gut formulieren. Alle wörtlichen Zitate in diesem Text, die nicht mit einer Fußnote versehen sind, stammen von Nancy Spector.
Nancy Spector: „Nur die perverse Phantasie kann uns noch retten", in: *Matthew Barney: The CREMASTER Cycle*, Ausst.-Kat. Museum Ludwig, Köln; Musée d'Art Moderne de la Ville de Paris, Paris; Solomon R. Guggenheim Museum, New York, Ostfildern-Ruit 2002, S. 4–89.

5 N.N., „Art Now: Matthew Barney: OTTOshaft", London: Tate Britain, http://www.tate.org.uk/britain/exhibitions/artnow/matthewbarney/default.shtm, Stand: 23.08.2007 (Übersetzung: Nikolaus G. Schneider).

6 Wie Anm. 1, S. 62.

7 Hans-Ulrich Obrist: „Interview mit Matthew Barney", in: *Matthew Barney: Drawing Restraint*, Bd. 1, Köln 2005, S. 90 (Übersetzung: Nikolaus G. Schneider).

8 Klaus Kertess: „F(r)iction", in: *Drawing Restraint 7*, hrsg. von Cristina Bechtler, Ostfildern 1995, o.S.

9 Wie Anm. 4, S. 36f.

10 Wie Anm. 7, S. 90.

11 Wie Anm. 1, S. 61.

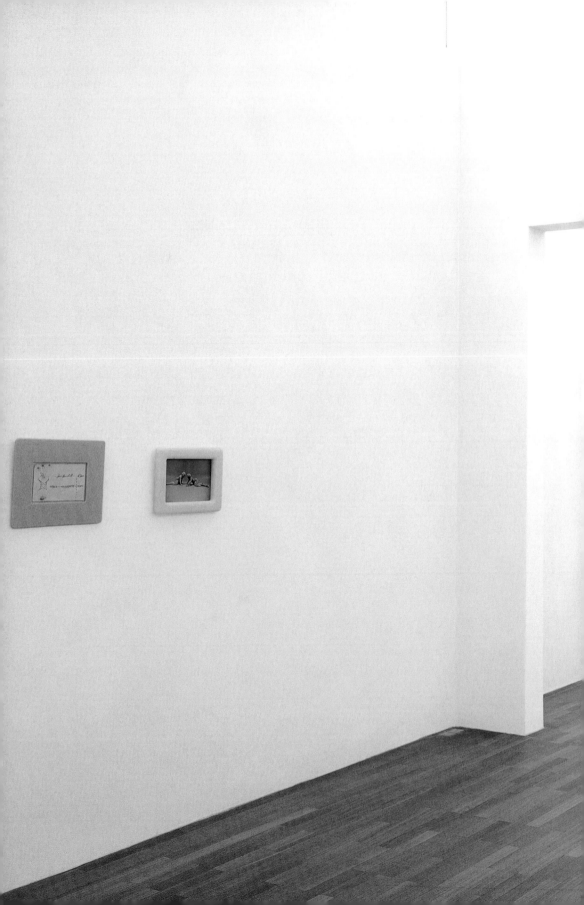

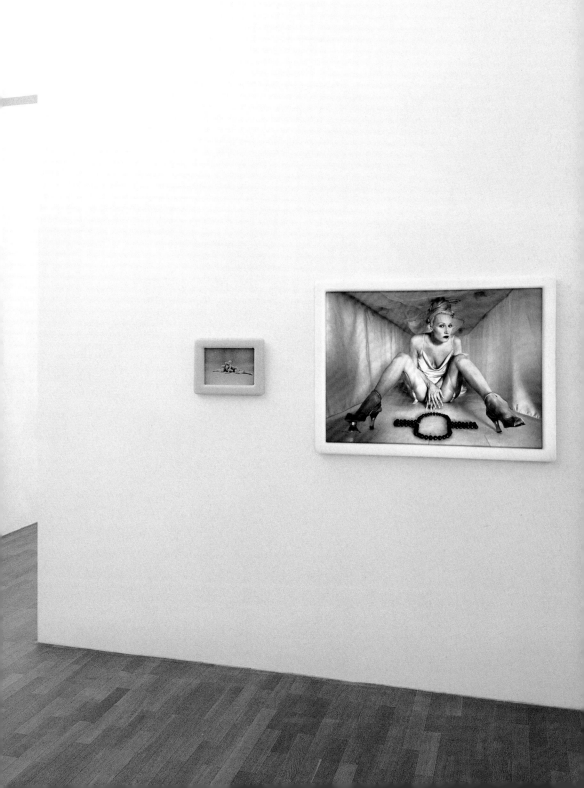

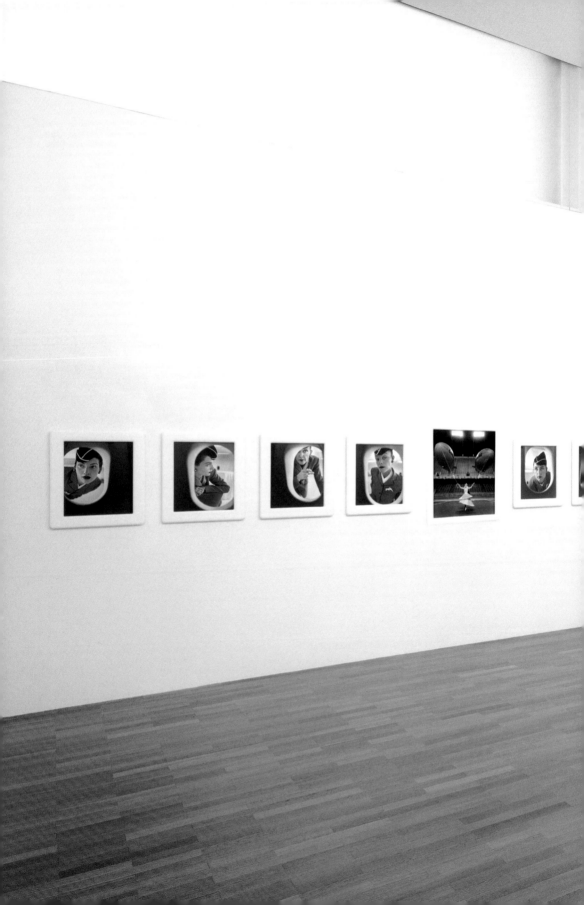

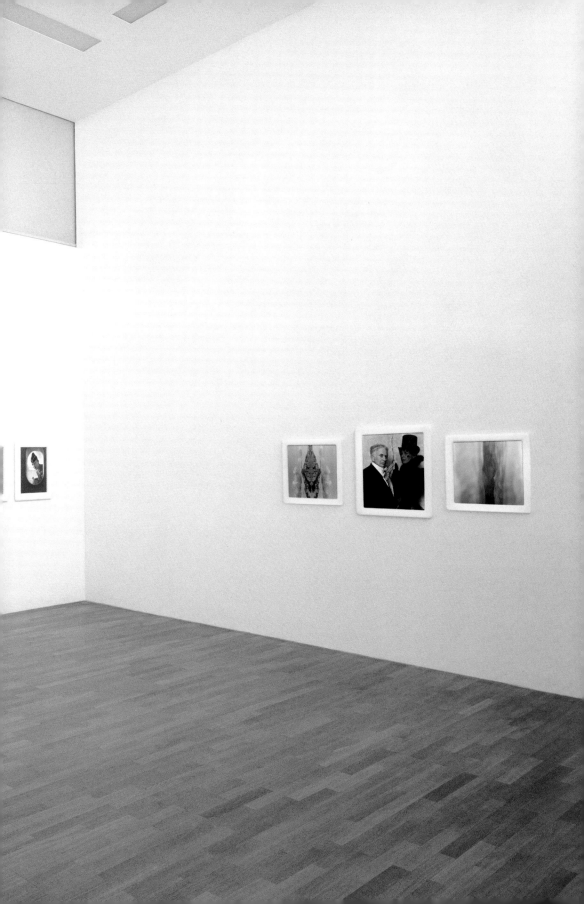

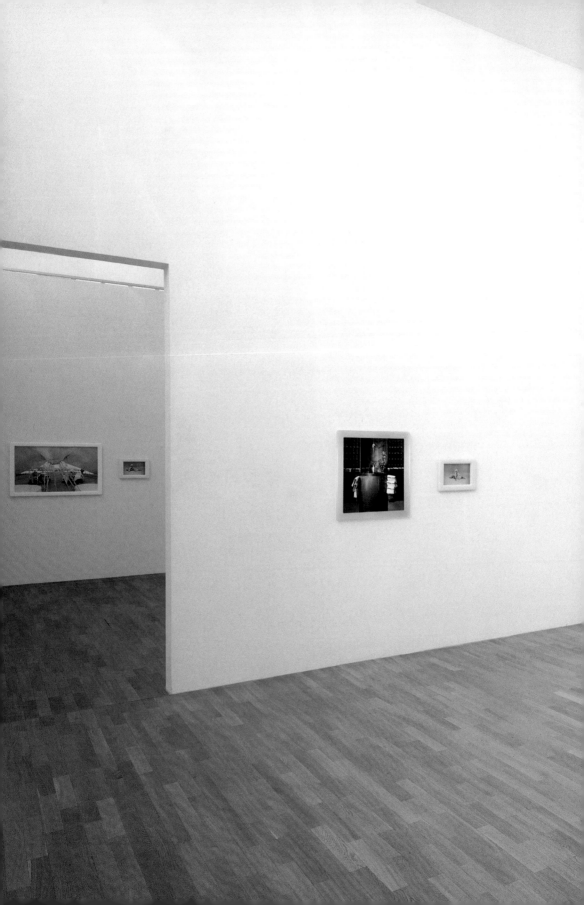

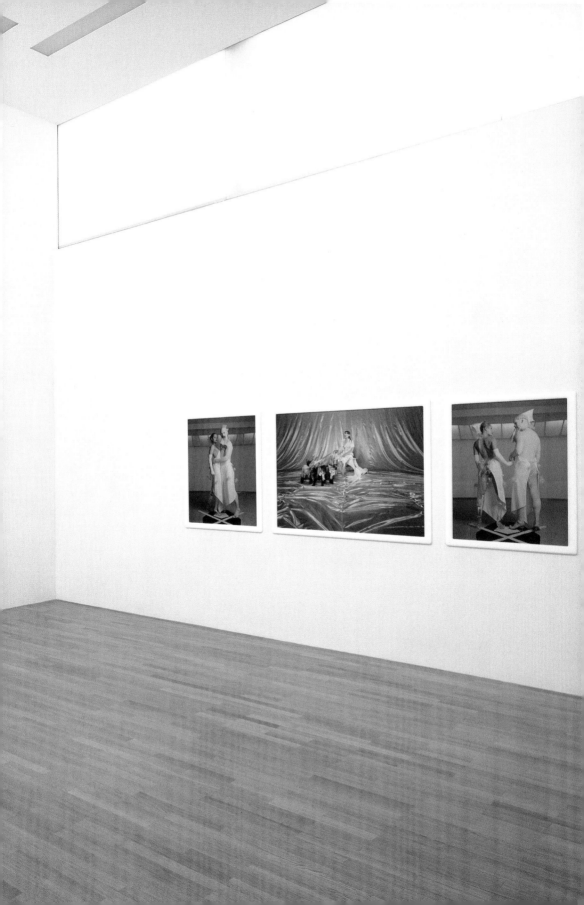

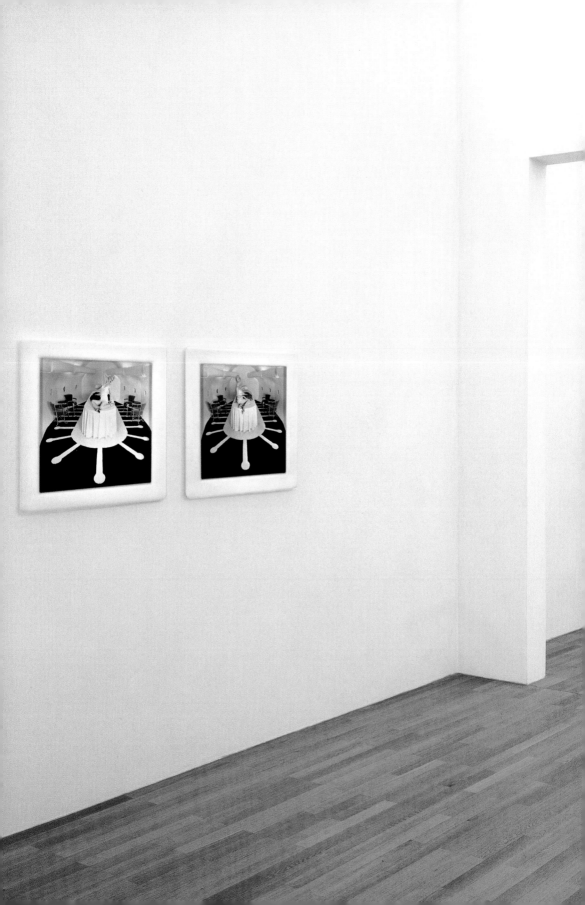

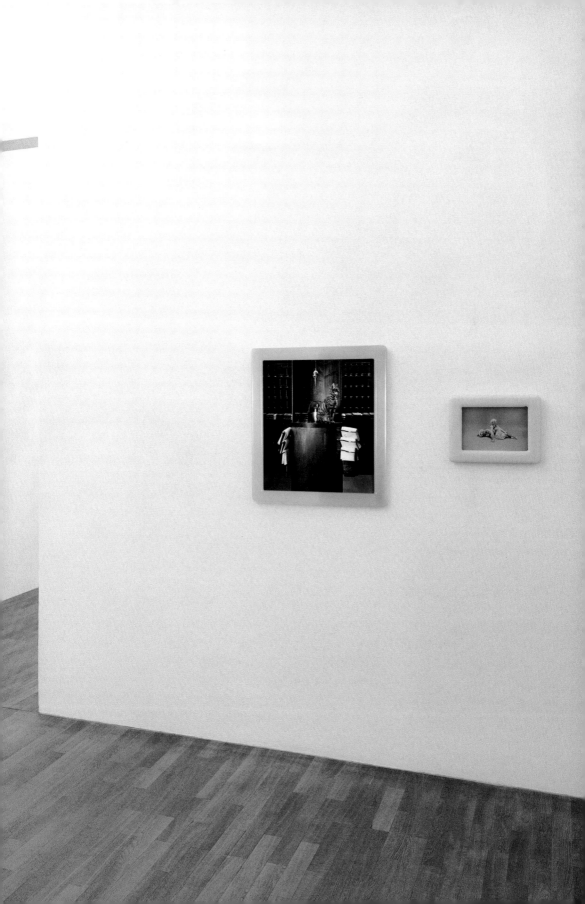

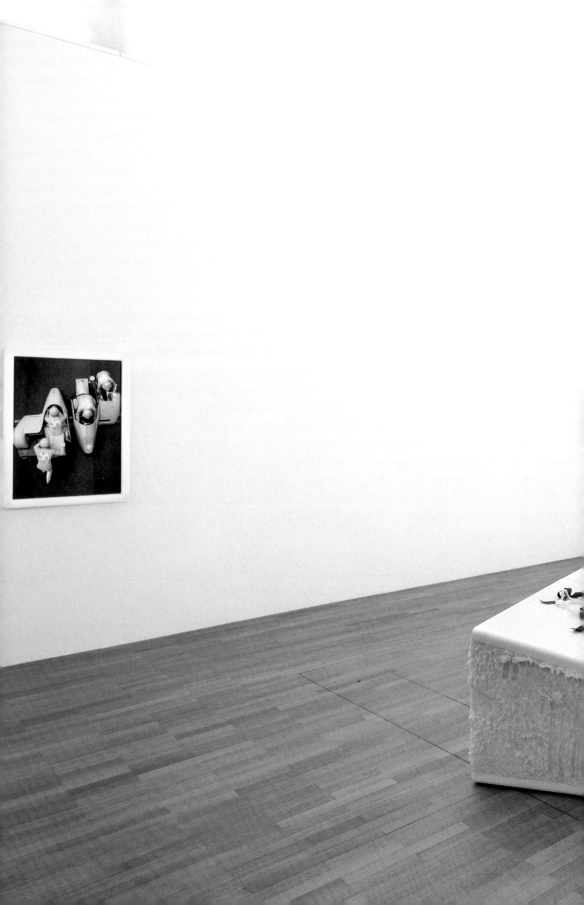

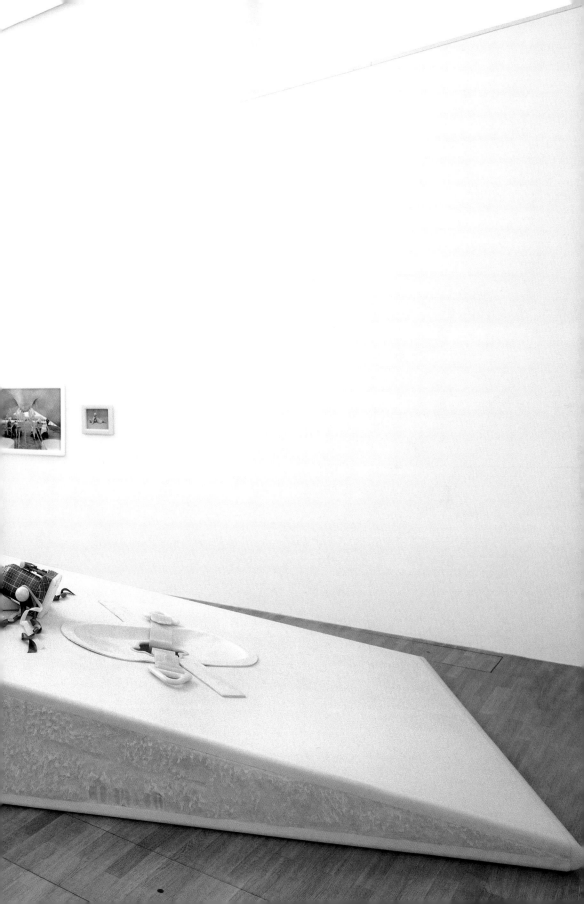

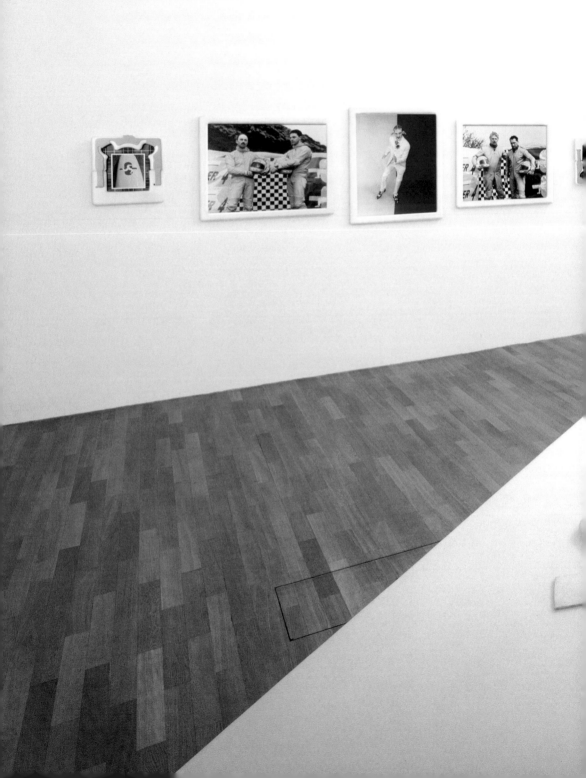

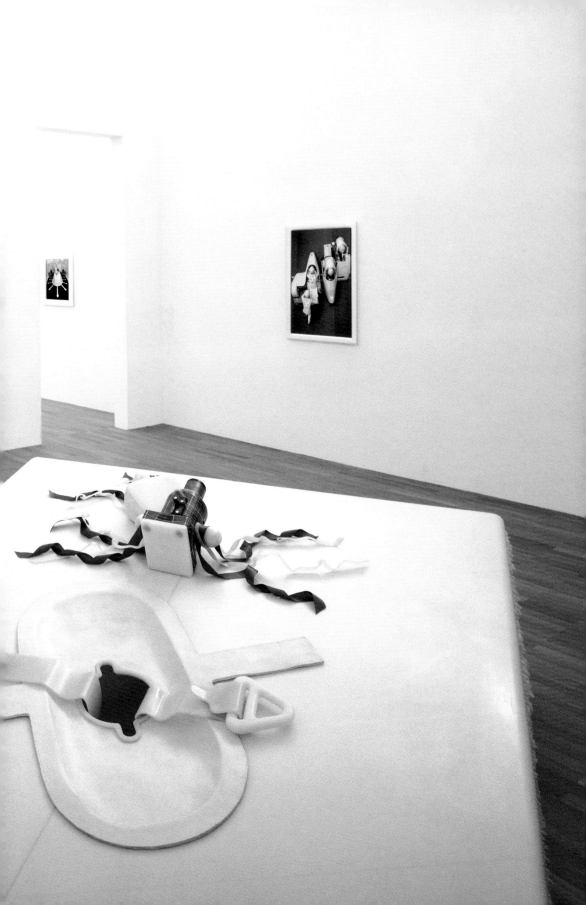

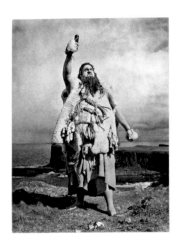

CREMASTER 3: Eisléireacht Garbh Mar Bhunsraith
2002
39,2×58,8 cm

... to try to give emotional agency to objects, to these larger structures[1] – a tour of the exhibition
Stephan Urbaschek

In this, his second exhibition at the Goetz Collection, the entire museum building is dedicated to Matthew Barney. He has personally developed the exhibition concept and has installed the works held by the collection so that they relate closely to one another. This introductory text is intended to guide visitors through the exhibition, and aims to elucidate the individual works and show their relationship to one another.

When asked by Brandon Stosuy about the relationship between the actions in his works and the larger structures or arrangements, Matthew Barney replied that he endeavored to extend the scale of the body to an architectural or even geological scale. He does so, as he explains in the interview, by lending meaning to every portal, passageway and room, in order to emphasize the organic nature of these structures. The aim of actions, he goes on, is to liberate the individual as the sole bearer of emotions and to extend this function to architecture as well.

Barney appears to have taken a similar approach to exhibiting his works in the rooms of the Goetz Collection. The works in the collection come from a number of different groups within his oeuvre. There are drawings, photographs, sculptures and films, starting with the drawing *OTTOshaft (manual) F*, 1992 (ill. p. 25), from the series of the same name. This is followed, chronologically, by the seven-part photo cycle *ENVELOPA: Drawing Restraint 7 (Guillotine)*, 1993 (ill. pp. 22–23, 90–91 et al.), created in conjunction with the video *Drawing Restraint 7*, 1993, the films, showcases and photographs relating to the complete five-part *CREMASTER Cycle*, 1994–2002, and finally the sculpture and film relating to *DRAWING RESTRAINT 9*, 2005 (ill. pp. 70–78, 141–143).

Barney has installed these works – beginning in the first room of the upper floor and ending in BASE 103. However, instead of presenting the *CREMASTER*-related works in chronological order, he presents them in numerical order. The cycle was created in the following order: *CREMASTER 4*, 1994, *CREMASTER 1*, 1995, *CREMASTER 5*, 1997, *CREMASTER 2*, 1999 and *CREMASTER 3*, 2002. There are a few thematic overlaps between the rooms and, from room to room, there are many surprising vistas. For the most part, these overlaps are created by the seven photographs from the

CREMASTER 3: *Plumb Line*
2001
Rahmen | Frame 71×61×3 cm

CREMASTER 3: *Chrysler Imperial*
2001
Rahmen | Frame 61×71,1×3,8 cm

ENVELOPA series, which are deployed as links, distributed individually through the various zones of the exhibition or implanted into the groups of works. This arrangement also indicates the extent to which the individual works in Barney's oeuvre are interlinked: Ever since his early *DRAWING RESTRAINT 1*, 1987, his works have built on one another, sometimes evolving out of themselves.

It is in the nature of any art collection, be it public or private, that it reflects the individual strategies of the collector and his or her personality. According to Jean Baudrillard, the collector is the final element in the series of which the collection consists.[2] Barney was faced with the challenge and the potential of creating a cohesive narrative context within the framework of the minimalist museum building of the Goetz Collection, while at the same time positioning these works within his own oeuvre.

As the Goetz Collection is one of only four collections[3] in the world to own all five *CREMASTER* films and the associated display cases (ill. pp. 170–179) with their objects, their simultaneous and sculptural presentation on the lower floor of the museum can be seen as one of the highlights of this exhibition. By way of example of the works in the collection, the following description elucidates how Barney's exhibition concept melds all the components involved – collection, oeuvre and architecture – to create an organic whole that forms a walk-through sculpture.

Entering the first room of the upper floor from the stairway, on the left wall the small drawing *OTTOshaft (manual) F* can be found. The drawing is part of the 1992 group of works *OTTOshaft*, which, in turn, marks the end of Barney's first project cycle of 1991, the *OTTO Cycle* – including *The Jim Otto Suite, [facility of INCLINE], OTTOshaft, [facility of DECLINE]* and *RADIAL DRILL*. The cycle takes its name from Jim Otto, the legendary center of the Oakland Raiders football team. The cycle's narrative is based on Otto's ambitious personality and his remarkably slight build for an American foot-baller. Escape artist Harry Houdini also appears in Barney's work at this point. *OTTOshaft* comprises different organic materials, plastic objects and three video films with the titles *OTTOdrone, OTTOshaft* and *AUTOdrone*, projected continuously on monitors suspended from the ceiling. Originally created for the 1992 DOCUMENTA IX, *OTTOshaft* was first shown in an underground parking garage in Kassel. Not only because of its similar presentation in the form of a suspended three-channel video installation, *OTTOshaft* is regarded as "a gate to the *CREMASTER Cycle*"[4]. As Nancy Spector notes, this performative sculpture (or sculptural performance) extended Barney's then-signature mode of presentation."

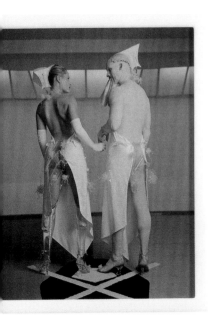

CREMASTER 3: Mahabyn
2002
Linkes und rechtes Foto | Left and Right Panels:
Rahmen | Frame 107 × 86 cm
Mittleres Foto | Center Panel:
Rahmen | Frame 112 × 137 cm

In the *OTTOshaft* drawing in the Goetz Collection, the names of Jayne Mansfield and Al Davis appear in handwritten form, while the terms 'hypoxia', 'hypertrophy' and 'hubris' appear in large printed letters alongside a small drawing. The drawing is redolent of a dog's bone and can also be interpreted as a detail of a tightly corseted female body or as a bagpipe. *OTTOshaft* is divided into the *Jayne Mansfield Suite* and the *Al Davis Suite*, which, according to Barney, represent opposite physical states.

Before discussing *OTTOshaft* further, we need to consider some general basic motifs in Barney's work. Given that nobody has studied Barney's work as intensely as Nancy Spector, I shall take her painstaking research as a point of reference, quoting from her authoritative essay *Only The Perverse Fantasy Can Still Save Us*, published in the exhibition catalogue of the 2002/03 Matthew Barney retrospective, which succinctly outlines the artist's set of creative rules:

"The first and perhaps most fundamental of these rules involves the proposition that form cannot materialize or mutate unless it struggles against resistance in the process. This idea developed out of Barney's own experience as an athlete, when he built strength and endurance by withstanding repetitive stress. The phenomenon of athletic training, in which the body strives to surpass threshold after threshold of corporeal limitation, plays a central role in the conceptual underpinnings of his work. So does the psychosocial dimension of organized sports, a ritualized realm of competition, exhibitionism and idolization that is associated in our collective cultural unconscious with masculine identity. Barney premises his approach to the creation of form on the technique of his hypertrophic muscle development, which involves the tearing down of tissue through repetitive stress in order to enlarge

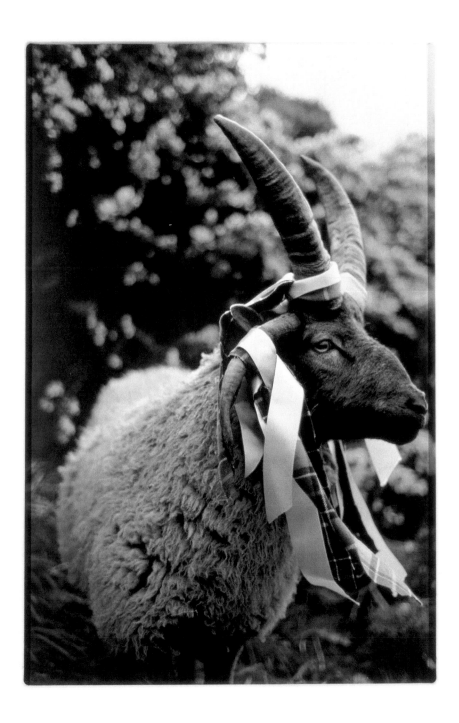

specific areas of the body […]. Strenuous athletic competition requires the suppression of any drives extraneous to the goal of winning. Sexual desire, the quest for socialization, and other appetites must be sublimates in order for the body to operate at peak performance level. For Barney the game itself is of lesser interest than the accumulation, storage and release of energy in this controlled corporeal environment. His art contemplates the potential of 'creative repression' to define new 'internal thresholds, new inner processes by which force may be harnessed and form generated […] Barney's early objects and installations imagine the perfectly engineered body. Well-equipped mis-en-scènes for the rituals of athletic training, they offer wrestling mats, curl bars, dumbbells, and weightlifting benches as so many propositions for hypertrophic development […]. This is the arena in which the body is sculpted, where contenders for the ultimate physique subject themselves to extreme regimens of resistance and training, doping their bodies on cocktails of painkillers and performance-enhancing stimulants […]. Barney acknowledges this athletic will-to-power, this compulsion to achieve the humanly impossible within the very human confines of the physical body […]. It is the other side of the always receding performance wall that lures an athlete into attempting the suprahuman, whatever the risks. The mad desire to become a deity on earth is pure hubris, a disease of the soul that afflicts the most ambitious, creative and inquisitive. It is the power that surges through the hypertrophic body, the psychic drive behind the excess of extreme self-discipline. And it finds form in Barney's sculptural imagination in the shape of a pill […]. Whether steroid, hormone or placebo, the hubris pill is a catalyst for conflict."

In *OTTOshaft,* Jim Otto and Harry Houdini both embody the athletic principle, albeit under very different premises. As Spector puts it, "Escape artist extraordinaire, Houdini symbolizes hermetic practices; he is the 'Character of Positive Restraint' who refuses differentiation, seeking instead to seal off and transform his body through extreme discipline […]. Houdini's metamorphoses […] were the result of rigorous physical preparation coupled with intuitive understanding of the forms that would shackle him […] Jim Otto, […] who finished his fifteen-year career with two artificial knees, is for Barney an inverted mirror to Houdini: though equally fanatical about his métier, and as seemingly immune to pain, he is open, extroverted, theatrical. If Houdini operates through internalization, Otto – whom Barney describes as the 'hypothermal penetrator' – achieves through outward aggression […]. Otto and Houdini are two incarnations of an internal horizon that arcs towards hubris. The outward-looking Otto seeks to consume or incorporate what is separate from him in a mad fusion with the universe. His foil, the introspective Houdini, strives for omnipotence through the exercise of sheer will. They enter into combat over which direction the organism will take. Struggle ensues and the narrative unfolds […]. The battle between Otto and Houdini circulates around the notion of an embryo's inevitable drift towards differentiation […]. Barney represents the path of anatomical differentiation

CREMASTER 4: LOUGHTON RAM
1994
Rahmen | Frame 84,5 × 59,7 × 3,8 cm

through a metaphoric device that involves fluctuating temperatures and their effect on the (male) body […]. In the biosphere of Barney's art, temperature change invokes the ascension or descension of the testicles, a normal biological function governed by the cremaster muscle […]. Though still unnamed as such in Barney's metaphoric universe, the cremaster muscle and its effects operate as a symbol in his earliest works […]. Testicular migration and its role in prenatal sexual differentiation may well be the ur-symbol of Barney's entire conceptual practice. The downward developmental slide of the testes into the awaiting scrotal sac, which occurs during the seventh month of fetal growth, is in many ways the final somatic stage in the making of a man. It is not the conclusion of this embryonic evolution, however, that is of foremost interest to the artist, even though his references to male anatomy may seem to suggest otherwise. Rather, it is the path travelled between the states of ascension (female) and descension (male) – and all the possible detours that can occur along the way […]. Gender mutability has a key narrative function in Barney's art, but it is not subject matter in itself […]. Gender is raw material for Barney. He molds it much as he molds space. The feminine and the masculine, or some combination thereof, become zones of articulation within the narrative."

In the fictitious tale behind his *OTTOshaft* videos, Barney deploys numerous metaphors and associations from the field of bodybuilding, football and internal body functions. These are complemented by the characters of 1950s film star Jayne Mansfield and 1960s football coach Al Davis of the Oakland Raiders, the team that Jim Otto played for. Seen as a whole, all these components reflect different facets of Jim Otto and define the parameters of the plot. The *Jayne Mansfield Suite* portrays hypoxia – a state of oxygen shortage in the blood or tissues – while its counterpart, the *Al Davis Suite*, illustrates the state of hypertrophy – an unnatural enlargement of organs or tissues.

"All actions within *OTTOshaft* represent a tension and oscillation between these conditions. Both conditions hypoxia and hypertrophy, result in a temporary or permanent reshaping of the body and

CREMASTER 4: The Isle of Man
1994
Rahmen | Frame 5-teilig | 5 parts:
42×38,1×3,8 cm (2×)
70×84,5×3,8 cm (2×)
84,5×70×3,8 cm (1×)

reflect the simultaneous processes of degeneration and regeneration that occur constantly in body tissue."[5] Mansfield was famous for her wasp-waisted hourglass figure, which she achieved by wearing a corset that emphasized her bust by pushing her breasts upwards and was so tight that she had to hold her breath to fasten it. Al Davis represents another extreme: he tried to build up the muscles of his center player Jim Otto through strict discipline. Spector explains: "Combined, they suggest the process of discipline applied to raw potential […] But Al-'Just win, baby'-Davis is no benevolent father figure. He is the one who masterminds the theft of the hubris pill and forces the metabolic conversion, regardless of the consequences. The embodiment of hubris, he compels Otto to strive for the ultimate hypertrophic condition, a total mastery of the body that, in the end, can result in an implosion from within. (The Teflon and stainless steel that gradually replaced the ligaments, cartilage and joints in Otto's knees have migrated to become the primary materials for Barney's sculptures.)" In the film, Al Davis also gives Jim Otto bagpipe lessons, teaching him to play one of America's favorite spirituals, *Amazing Grace*, 1760–70, which was "written by John Newton, an ex-libertine and ex-slave trader who became a minister in the Anglican church […]" In *OTTOshaft* this music embodies the highest hubris. Otto himself splits into a trio of bagpipers. The bagpipe – a recurrent motif in Barney's work – becomes an unexpected, though apt, metaphor for the human body in general and that of Jim Otto in particular. The bagpipe usually has an airbag made from the stomach of an animal and has three pipes, as portrayed in the drawing. Whenever the bagpipe appears in the film, the pipes are fixed in place and the airbag is filled with air and under pressure – like the organs of an athlete during training or at the point of greatest tension before or during a game. But the pressure is never released to allow any resolution of the filmic narrative.

Directly beside this drawing hangs the first of the seven *ENVELOPA: Drawing Restraint 7 (Guillotine)* photographs (ill. pp. 22–23), which, in their entirety, Barney describes as a sculpture belonging to the closely related video *Drawing Restraint 7* that was created immediately after *OTTOshaft*. Similarly,

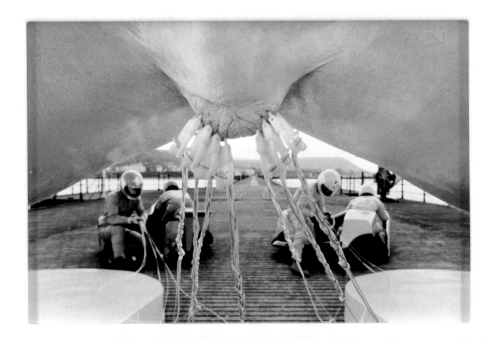

Drawing Restraint 7 may be regarded as anticipating the later *CREMASTER* project.[6] The photographs present the various stages of a struggle between two satyrs, which can be seen in the video.

After *OTTOshaft*, Barney began exploring the use not only of Teflon and stainless steel as prosthetic materials, but also of plastics that could be used in a similar way. He was interested primarily in their potential for extending the body:

"They were these plastics that began to attract me, that could live inside the body as internal prosthetics and could function outside the body as a prosthetic extension. This became a way of formalizing this notion of describing a narrative that could jump between internal spaces and external spaces and would have a relationship to the body that way. I think it probably became more liberating and more interesting for me when it started to leap in scale from the figurative to the architectural scale, and even to the geological scale. That happened around the time when I started to feel comfortable with thinking about my practice in terms of storytelling. This was sometime around 1992, after *OTTOshaft*,

CREMASTER 4: T1: ascending HACK descending HACK
1994
Rahmen | Frame 100,3 × 70 × 3,8 cm

CREMASTER 4: Three Legs of Mann
1994
Rahmen | Frame 71,1 × 101,6 × 2,5 cm

but before *Drawing Restraint 7* was made. I went back to the *DRAWING RESTRAINT* project after *OTTOshaft* and decided to make a *DRAWING RESTRAINT* that wasn't a literal restraint, but a theatrical restraint. That was a big step for me – to replace the physical restraint with a more metaphorical or projected restraint carried by a narrative."[7] On another occasion, Barney remarks that "*Drawing Restraint 7*, I guess, was an attempt to prove to myself that the *DRAWING RESTRAINT* project could still function with a new set of tools."[8]

Accordingly, the characters in *Drawing Restraint 7* are no longer based on real individuals, but use the form of the three satyrs to refer instead – as the invention of an entirely new formal language – to Greek mythology. Like *OTTOshaft,* the film is presented as a three-channel video installation on monitors suspended from the ceiling. Musically, too, Spector sees a link between these works, maintaining that *Amazing Grace* – an appeal to God – "evokes the myth of Marsyas [...] who elicited the wrath of Apollo by playing all too well upon the flute."

The action takes place in a limousine driving into town by night across six bridges and through the tunnels that link Manhattan to the surrounding area, appearing like "a fluid region between the terrestrial world and the domain of the gods." In the azure blue interior of the car, two adult male satyrs – one of them half ram, the other half goat – duel viciously. Their task is to inscribe a drawing in the condensation of the car's glass roof. And so, on each journey into town, a unique work is created in the struggle. By the time they reach their destination, the satyrs have both lost and won, for their hubris is immediately avenged, as in the myth of Marsyas: "In the end they align their Achilles tendons and flay one another." Klaus Kertess interprets these acts as follows: "Here the wrestlers simultaneously flay each other for their attempts at the perfection of completion."[9]

In the front of the car, the ungendered kid, played by Barney himself, takes the role of driver. As Spector explains, "His frantic attempts to catch his own tail – in an effort to close the circle of his

being, to secure his predifferentiated condition – is what powers the car in its endless loops through the anatomy of New York." She also says that, "Attempting to complete the circle, to close off and complete his own form, the kid pursues the intangible space of hubris, the elusive sphere of im-mortality on earth." Spector points out that, biblically, creation is based on the principle of division, differentiation and categorization, prohibiting the hybridization of animals or humans, and that to go against this principle is to go against the word of God. Those who bring forth new forms dare to usurp the role of the Creator. "This is the uncontainable will of the demiurge in action [...] Playing the role of artist-cum-demiurge, Barney grafted the quintessential myth of hubris onto the biological model of pregenital undifferentiation to render *Drawing Restraint 7*."

The god Zeus and the nymph Hubris beget Pan, the satyr and demigod who is often equated with the satyr Marsyas, albeit without the latter's divine attributes. Both represent the irrational drives and carnal desires of humankind. At the same time, the satyr is regarded as a physiological anomaly, as a "disruption in the cosmic order of things. Part man, part beast, this mongrel creature existed in ancient thought as a reminder of the chaos lurking behind the façade of reality." Marsyas, who felt superior to the gods and – following his desires and his wish for recognition – challenged Apollo to a flute competition and, on losing, was flayed by him. The muses and Apollo punished Marsyas for daring to attempt to surpass the gods in the supposed perfection of a work. The Marsyas myth, then, is another variation on the allegory of hubris, in which demigods and mortals seek to better the divine and meet with cruel punishment. The myth is not directed against the work of art as such, but against the artist who has failed to create it humbly and subserviently and whose work is not an expression of humility.

The visual language of the photographs in the *ENVELOPA* series also refers to Greek mythology. Here, however, Barney seems to deploy an athletic mode, as in some earlier groups of works. The photographs show the two satyrs, already featured in the car, isolated against a neutral turquoise background in seven different wrestling positions. The poses are not identical to those in the car scenes. Instead, what we see is a ground position, the so-called guillotine choke, aimed at preventing the air flow to the opponent's lungs, and which can result in unconsciousness. We are reminded of the oxygen restriction of the corseted Jayne Mansfield. In the first picture, the two satyrs watch each other, every muscle tensed, ready to pounce at any moment, but still in a state of uninterrupted equilibrium. In the struggle that ensues, one of the two satyrs manages to gain the upper hand fairly quickly, wrestling the other to the ground face down, only for him to succeed in turning over – a move that is extremely difficult when caught in the guillotine choke. He pulls his opponent up and

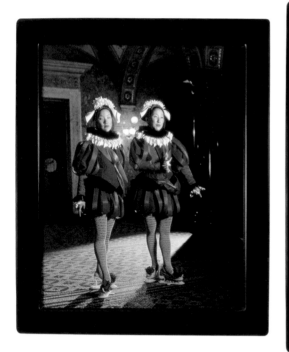 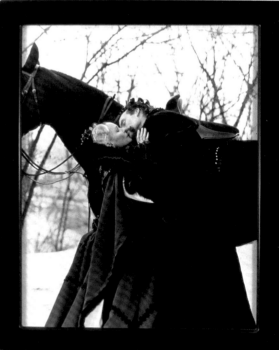

then both land side by side on their backs, motionless. The pictures do not look like snapshots of a quick fight, but more like staged illustrations of the wrestling move in question.

The photographs represent all parts of the series *Drawing Restraint 7*, which Barney himself regards as the precursor of the *CREMASTER Cycle*. Indeed, in formal terms, they create the transition: in the first room of the upper floor there is one individual shot and a group of photos from *CREMASTER 1* as well as a triptych from *CREMASTER 2*. At the center of the photograph opposite the entrance is the Goodyear figure – a stylish, starlet-like blonde, an utterly sublime creature – who lives simultaneously in both the Goodyear zeppelins in the film. In *CREMASTER 1: Goodyear*, 1995 (ill. p. 26), she is sitting in one of the zeppelins, legs spread wide apart under the table, arranging grapes in patterns (here Barney's field emblem) which echo the choreography of the revue girls dancing in the stadium below. Grapes being attributes of Dionysus, god of wine, this is also a further reference to Greek mythology and to *Drawing Restraint 7*. In the nine-part group *CREMASTER 1: The Goodyear Waltz*, 1995 (ill. pp. 30–31), the Goodyear figure can be seen in the central photo, standing in the middle of the stadium, holding the hovering airships in their delicate balance by two long lines. To the left and right, individual portraits of the four stewardesses from each crew show them looking out of the windows of the zeppelin onto the playing field: all have a strict mien. As we can see in the central photo, the Goodyear figure has difficulty keeping the two zeppelins in balance, for the airships keep shifting slightly. In this respect,

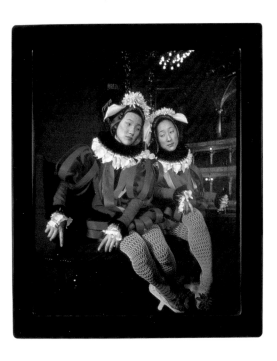

CREMASTER 5: Elválás
1997
Rahmen | Frame 3-teilig | 3 parts:
90 × 75,2 × 2,5 cm (2);
105,1 × 87,6 × 2,5 cm (1)

the first two *ENVELOPA* photographs (ills. pp. 22–23, 90–91) that are hanging in this room correspond most closely to the undifferentiated state of *CREMASTER 1*.

As a reference to the next room as well as an entry into the next film in the series there is also the trip-tych *CREMASTER 2: Genealogy*, 1999 (ill. pp. 36–37), installed here. In the story of *CREMASTER 2* this indicates the end point and possibly also the starting point of the narrative and it shows the en-counter and union between Harry Houdini played by Norman Mailer – including his redemptive gender change – and Baby Fay La Foe. These two figures are possibly the grandparents of double murderer Gary Gilmore, whose story forms the basis for Norman Mailer's novel *The Executioner's Song*. The two landscapes featuring in the triptych place *CREMASTER 2* in the Bonneville Salt Flats and the Columbia Icefield. Spector explains: "Rotating these views ninety degrees to create abstract vertical images that recall Rorschach shapes, Barney alludes by mere form to the psychological dimensions explored in the narrative."

In the second room on the first floor there are mainly photos relating to *CREMASTER 2* and *CRE-MASTER 3* and, as a retrospective and outward-looking view, one each relating to *CREMASTER 1* and *CREMASTER 4* as well as two further *ENVELOPA* photographs (ills. pp. 102–102, 112–113) in which one satyr is clearly defeating the other, thereby cancelling out the undifferentiated state.

Pacific
2006
Rahmen | Frame 34,3×29,2×3,2 cm

Inner Roji
2006
Rahmen | Frame 34,3×29,2×3,2 cm

The works are ordered thematically here. *CREMASTER 1* is rounded off with the diptych *CREMASTER 1: Goodyear Lounge*, 1995 (ill. pp. 32–33), on the left wall which shows the stylish public rooms in the zeppelins and demonstrates Goodyear's simultaneous existence in both airships. Next to this is *CREMASTER 2: The Royal Cell of Baby Fay*, 1998 (ill. p. 39), showing Baby Fay La Foe (Gilmore) as queen bee in a honeycomb pattern. Even though not visible in this image Baby Fay La Foe, like Jayne Mansfield in *OTTOshaft*, has a strongly corseted hourglass figure. This, in turn, bears parallels with the particular state of the guillotine choke in the *ENVELOPA* photographs.

Let us dwell now for a moment on two other works next to Baby Fay La Foe: They are pencil drawings executed in Barney's typically sure and delicate hand: *The Ballad of Nicole Baker*, 1999 (ill. p. 41), and *The Nuptual Flight*, 1999 (ill. p. 40), both of which are related in content to *CREMASTER 2*. The former portrays the union of Gary Gilmore and Nicole Baker, embedded metaphorically in a rolling landscape. A phallic battle penetrates the horizon line from below ground – the name Gary Gilmore can be read here – into the mountains above, where we read the name Nicole. On the threshold of this penetration, we see a galloping horse, its legs all simultaneously in the air. This center is further emphasized by what seems to be a thin layer of vaseline in the middle. Even more explicitly sexual connotations are evident in the second drawing which, like the photo *CREMASTER 2: The Royal Cell of Baby Fay*, has an underlying honeycomb pattern. Vertically aligned in the center is an erect penis pointing towards the body of a woman with her legs spread apart. Here, Barney has drawn a beehive in place of a glans. As in all his drawings, this one, too, appears monumental in spite of its small format. These are like drawings from a parallel world, whose true greatness can be discerned only on closer inspection. Drawing is an extremely important medium for Barney, and accompanies his projects right from the start in the form of detailed storyboards that outline the plot, or as independent works relating to a project.

In the last photograph relating to *CREMASTER 2: The Executioner's Song*, 1998 (ill. p. 34), we see Gary Gilmore in a fictitious last dance with his girlfriend Nicole Baker before his execution. Allegedly, Johnny Cash actually sang to him over the phone on the night before he died.

The two works *CREMASTER 3: Plumb Line*, 2001 (ill. p. 60), and *CREMASTER 3: Mahabyn*, 2002 (ill. pp. 62–63), relate to the longest and arguably most complex film in the cycle: *CREMASTER 3*, 2002, in which the seeds are sown for the forthcoming struggle between entropy and growth – the unstoppable division of the sexes. Set in the New Yorker Chrysler Building and, as in the prologue, on the Giant's Causeway in Ireland – hence, rooted in Celtic mythology – it can be seen as a further take on *CREMASTER 4*. The giants can also be seen as being mythologically related to the Greek satyrs.

The monumental photographic triptych *CREMASTER 3: Mahabyn* relates to Freemasonry. It depicts in the left image on the right side the Entered Apprentice – played by Barney – as well as his female counterpart the Entered Novitiate, played by fashion model Aimee Mullins, – at the same time the

Alter Ego of the Apprentice. The image refers to the moment where the model whispers the divine words "Maha byn" into the Apprentice's ear and he in the course of the following events reaches the level of Master Mason: "She then abruptly transmutes into the cheetah and attacks. An intense struggle ensues, which continues intermittently throughout the Order, until the Apprentice uses the stonemason's tools to slay the hybrid creature: with a blow of the plumb to her temple [...]; hit with the level in the other [...]; and struck in the forehead with the maul" – those parts of the body which carry bleeding wounds in the center photograph. This murder reenacts as an initiation into the Third Degree of Freemasonry the death of the purported chief architect of Solomon's Temple Hiram Abiff. "When the body was found, King Solomon disinterred it, using the grip of a Mason Master, which incorporates the Five Points of Fellowship: foot is placed to foot, knee to knee, breast to breast, hand to back, and mouth to ear. So embraced, Hiram Abiff came back to life and whispered the phrase "Maha byn". As a reference to these five points the costume of the model in the center photograph reveals the equivalent body parts.

CREMASTER 3: Plumb Line which depicts a cat sitting on a bar, is set in the Bar Cloud Club in the Chrysler Building. It takes place shortly before the moment when the entire building is lifted out of

level by the bartender. The bar itself is in the shape of a level – as hanging above the cat – if regarded from an aerial view. The cat – as a reference to the cheetah above and thus a reflection of the transformed Apprentice/Novitiate – sits on that spot where the plumb line would meet the surface.

In the second room, *CREMASTER 4: LOUGHTON RAM*, 1994 (ill. p. 64), functions as a starting point into *CREMASTER 4*. Between this photograph and *CREMASTER 2: The Executioner's Song* yet another photograph from the *ENVELOPA* series creates a connection. The title refers to the Loughton Ram, a breed native to the Isle of Man, which has four curved horns, two pointing upwards and two downwards. Barney sees this ram as embodying the ideal state of undifferentiation, explains Spector, "with ascension and decension coexisting in complete equilibrium. The conceptual space between the Candidate and his ram is the 'Loughton Field'. It is the realm of pure potential that borders on the hubristic threshold of achieving the impossible." The Loughton Candidate – the main character in the film – is a red-haired satyr in a white suit: Clearly a relative of the hybrid creatures in *Drawing Restraint 7*, […] the Candidate, a dandified gentleman of a satyr, has two sets of impacted sockets in his head – four nascent horns, which will eventually grow into those of the mature, multi-horned Loughton Ram."

In the farthest room of the exhibition, directly in line with the doorway apertures, is the fifth photograph in the *ENVELOPA* series (ill. pp. 122–123), introducing the room dedicated entirely to *CREMASTER 4*. Here we find the five-part photo series *CREMASTER 4: The Isle of Man*, 1994 (ill. pp. 66–67), *CREMASTER 4: T⊥: ascending HACK descending HACK*, 1994 (ill. p. 68) (on the left wall), *CREMASTER 4:*

Three Legs of Man, 1994 (ill. pp. 9, 69), and the sculpture *[PIT] Field of Descending Faerie*, 1995 (ill. p. 9). The five-part photo series shows the Candidate, flanked on either side by two bikers undertaking the famous Isle of Man Tourist Trophy race on motorbikes with sidecars which feature in *CREMASTER 4: T1: ascending HACK descending HACK*. There are also two small shots of the triskelion emblazoned on the sidecars. The yellow team circumnavigates the island clockwise. Starting in the lowlands, they ride up through a rising female field, whereas the blue team starts in the highlands, traveling anticlockwise through a descending male field.

The sculpture *[PIT] Field of Descending Faerie* comprises a ramp with a field-like aperture in the center and models of two props from the film: the carjack and a white vinyl wedge, both of which are used by the faeries for the wheel-change. These androgynous creatures take different roles in the film. They can be distinguished by their hairstyles: the Descending Faerie, for instance, has two downward-pointing buns of hair.

CREMASTER 4: Three Legs of Man is a film still reflecting the closing sequence as an end point in the exhibition concept of the upper floor: "In the closing image, the camera peers through an open crotch […] A tightly retracted scrotum is pierced with white plastic clasps connected to vinyl cords, which trail off to the awaiting Ascending and Descending Hacks, who will drive toward the island to pick up the slack. Full descension is guaranteed […] In the final scene of the film, the number of plastic clips attached to the scrotum is an odd number: four on the left, three on the right. The Ascending Hack on the right will pull up as it drives away, and the Descending Hack on the left will pull down […] true creative form may only emerge from the understanding that total resolution (or total symmetry) is never really possible regardless of the amount of discipline applied."

The exhibition continues in the first room of the lower level. Here, we find the three drawings titled *Ereszkedés*, 1998 (ill. p. 70), the triptych *CREMASTER 5: Elválás*, 1997 (ill. pp. 72–73), the single photograph *CREMASTER 1: Orchidella*, 1995 (ill. p. 29), alongside the sixth *ENVELOPA* photo (ill. pp. 128–129). In this photo, the seemingly defeated satyr rises again, throwing back his torso to pull his opponent up into a near-sitting position – one final effort in the struggle, one last attempt to regain freedom. This compares with the attempt of Her Magician – one of the main figures in *CREMASTER 5*, which is dedicated to Harry Houdini – to achieve transcendence and freedom through self-restraint, following a hypertrophic impulse, while seeking emancipation from the constraints of definition. Spector equates this with the zeppelins in *CREMASTER 1* and with the four curved horns of the Loughton Ram in *CREMASTER 4*.

In the central photo, we see the Queen of Chain – played by Ursula Andress – tenderly kissing Her Magician goodbye before he rides away to leap from the chain bridge into the Danube. The photos on the walls to the right and left show the Queen's attendants.

The three drawings are on identical sheets of paper embossed with a pattern reminiscent of Art Nouveau ornaments. The pattern and the drawing meld to create an abstract pattern vaguely reminiscent of a diagram of the ovaries and aesthetically akin to a variation on or further development of the landscape shown in the drawing *The Nuptual Flight*. The transparent frames and the presentation of the drawings lying in a vitrine lend them a particularly precious aspect.

The third photo *CREMASTER 1: Orchidella* shows the cheerful Goodyear figure decoratively posed amidst a group of six revue girls, reclining before the blue astroturf. The motif relates symbolically to the beginning of the cycle and the closing of the *CREMASTER* loop circle.

In the audiovisual installation in the main room of the lower floor, all the *CREMASTER* films are shown simultaneously on flatscreen monitors, as they were in the major Matthew Barney retrospective at the Guggenheim Museum, New York, in 2003. Here, we have added all five appurtenant vitrines, each positioned below the corresponding monitor. Brandon Stosuy's essay in this catalogue focuses solely on this powerful installation which engages all senses.

In the farthest room of the lower floor, the seventh photograph of the *ENVELOPA* series (ill. pp. 138–139) introduces Barney's latest film *DRAWING RESTRAINT 9*. For the artist, the narrative structure of *Drawing Restraint 7* marks the transition to his latest work and is no longer based on the physical state of restraint as such. Both satyrs are lying motionless on the ground, with no recognizable victor, like exhausted lovers.

As in the *CREMASTER Cycle*, all the aesthetic elements of *DRAWING RESTRAINT 9* together form a gesamtkunstwerk. This includes the sculpture and the two drawings *Pacific*, 2006 (ill. p. 74), and *Inner Roji*, 2006 (ill. p. 75).

The plastic sculpture comprises casts of whaling accoutrements such as harpoons, as well as film canisters representing the creation of the film. The two drawings illustrate fantastic fictitious scenes revolving around – on the one hand side – the theme of the sea: In *Pacific* this takes the form of a dramatic struggle between a giant octopus and a whale. The drawing is related to illustrations that have a similar topic from Japanese artists from the 19th century.

On the other hand side *Inner Roji* relates to the Japanese tea ceremony which is also being celebrated in the film. It is the garden path that leads to the entrance of the teahouse. The stones are arranged in such a way that the guest must consider each step carefully, and they are situated so that he can easily view the beauty of the garden. This is meant to prepare the guest for the experience in

the tearoom to transition from the outside world into the inner world of the tea ceremony. The drawing *Inner Roji* is the plan view of a garden path cut into a stone quarry with four converging paths which meet in the middle, forming the buddist manji. It is notable that in Zen Buddhism, the Manji represents the ideal harmony between love and intellect. However, the bird's eye view in the drawing reminds us also of a rugged little island with sheer cliffs and we cannot help but think of romantic pirate coves or treasure islands.

The film *DRAWING RESTRAINT 9* is screened in BASE 103 in a cinema-like situation.

Matthew Barney says, "I guess *Drawing Restraint 7* was both a precursor to the *CREMASTER Cycle*, and some sort of transitional piece within the Drawing Restraint language. Number 7 provided a narrative transition to *Drawing Restraint 9*, which I'm working on right now. Both pieces described resistance as psychological condition, or as conflict within a larger narrative, rather than describing a literal, physical condition of restraint."[10]

We hope that this tour of the museum helps to elucidate Barney's exhibition concept, and shows how he guides his audiences through the exhibition in much the same way as he composes his films.

"I tend to think of it in organic terms," he says. "I tend to think of it as a body. I think a lot of the decisions that are made in regards to duration and balance are about trying to describe an organism that has its own pulse and that has its own behavior."[11]

Translation: Ishbel Flett

1 Brandon Stosuy: *Matthew Barney*, in: *The Believer*, Dec. 2006–Jan. 2007, p. 63.

2 See Jean Baudrillard: *Das System der Dinge*, Frankfurt am Main, 1991, p. 116.

3 The other collections are The Pamela and Richard Kramlich Collection/New Art Trust, San Francisco, The Rachel and Jean-Pierre Lehmann Collection, New York, and the Emanuel Hoffmann-Stiftung, Depositum in der Öffentlichen Kunstsammlung Basel.

4 The following excerpts are from Nancy Spector's comprehensive essay *Only The Perverse Fantasy Can Still Save Us*, from the exhibition catalogue of Matthew Barney's retrospective from 2002/03. Spector explains Barney's artistic approach most meticulously. All citations in this text which are not followed by a footnote refer to Spector's essay.
Nancy Spector: *Only The Perverse Fantasy Can Still Save Us*, in: *Matthew Barney: The CREMASTER Cycle*, exh. cat. Museum Ludwig, Cologne; Musée d'Art Moderne de la Ville de Paris, Paris; Solomon R. Guggenheim Museum, New York, Ostfildern-Ruit 2002, pp. 4–89.

5 N.N., *Art Now: Matthew Barney: OTTOshaft*, London, Tate Britain, http://www.tate.org.uk/britain/exhibitions/artnow/matthewbarney/default.shtm, date 23.08.2007.

6 Cf. note 1, p. 62.

7 Hans Ulrich Obrist: *Interview with Matthew Barney*, in: *Matthew Barney: Drawing Restraint Vol. I*, Cologne, 2005, p. 90.

8 Klaus Kertess: *F(r)iction*, in: *Drawing Restraint 7*, ed. by Cristina Bechtler, Ostfildern 1995, unpaginated.

9 Cf. note 4, p. 36.

10 Cf. note 7, p. 90.

11 Cf. note 1, p. 61.

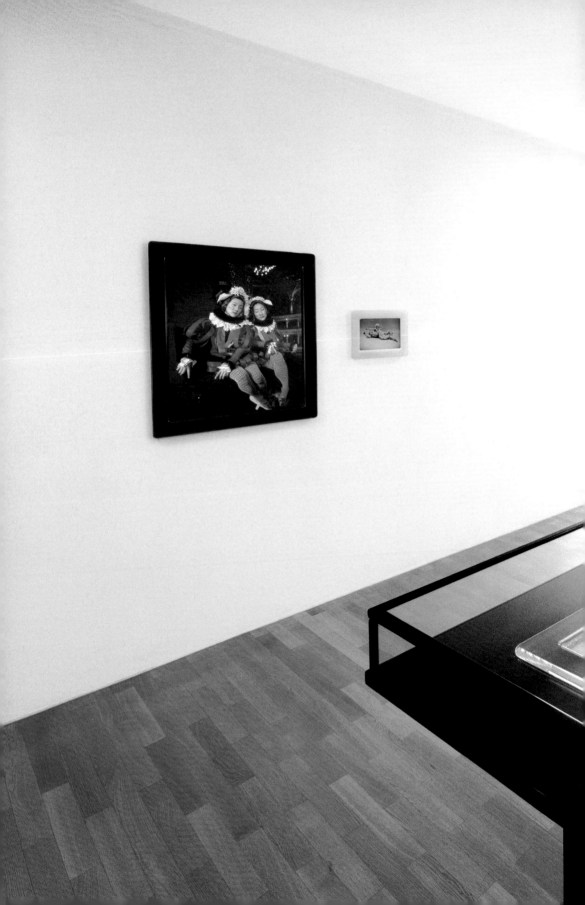

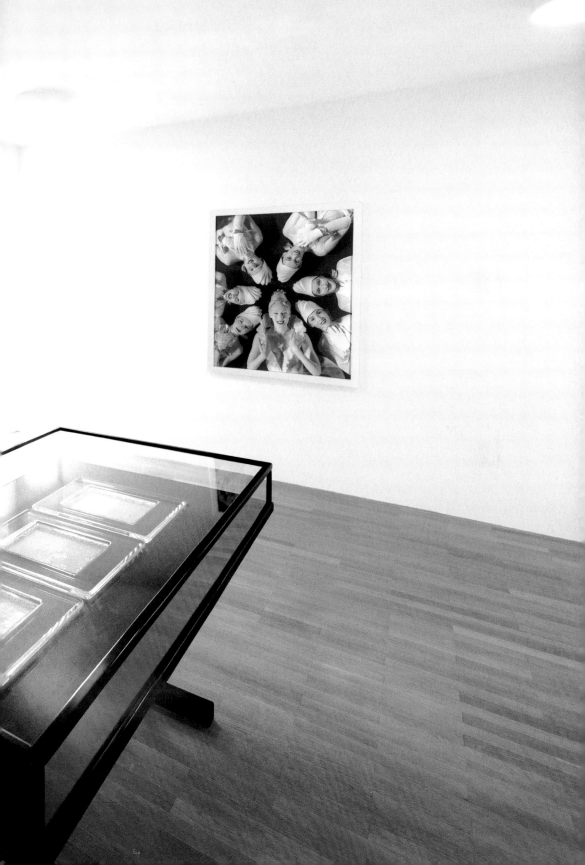

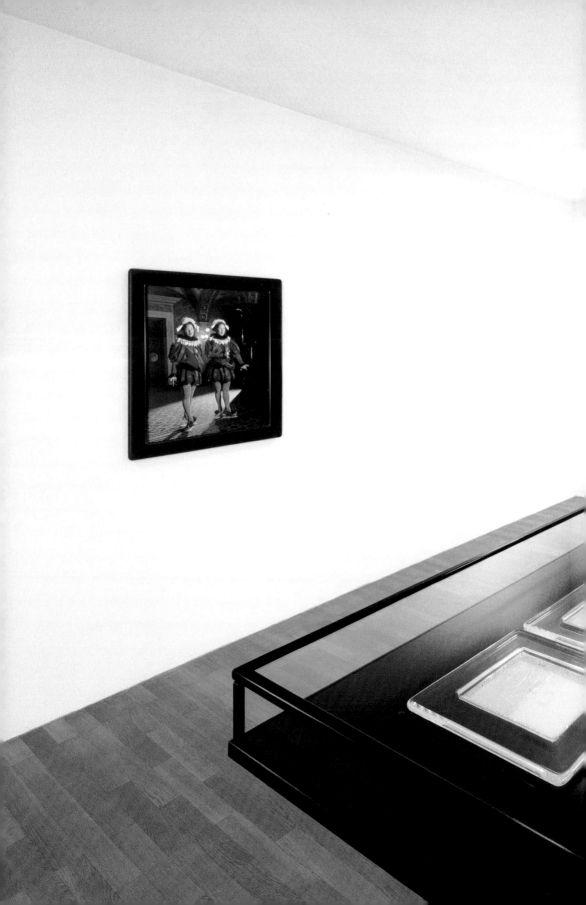

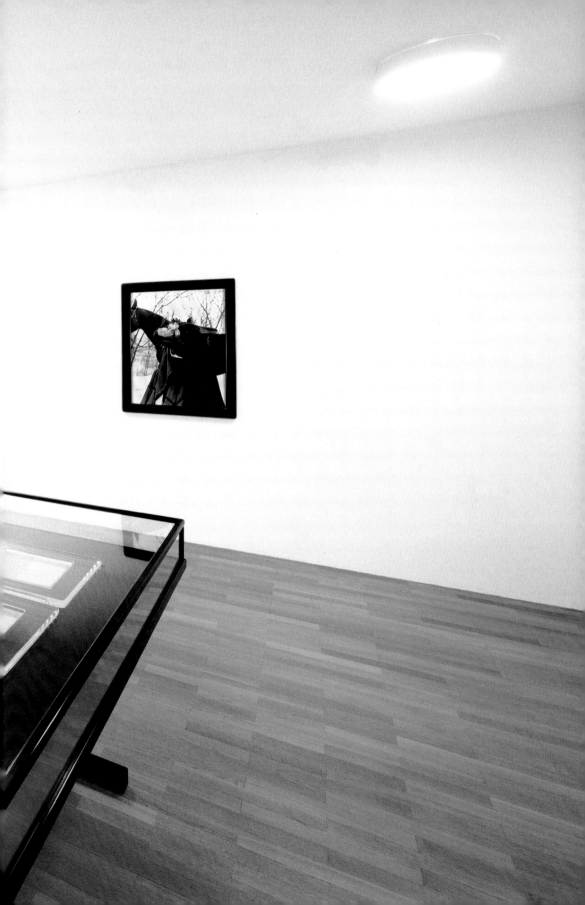

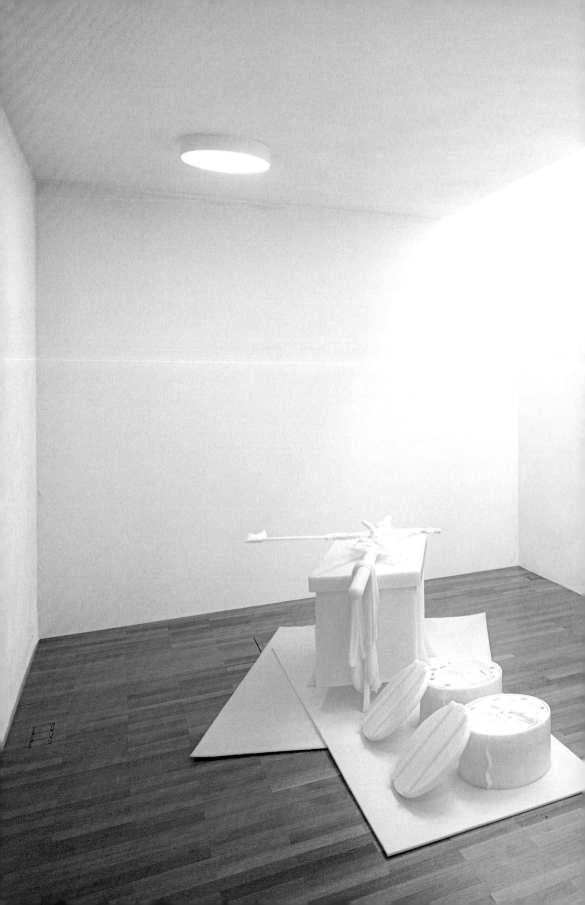

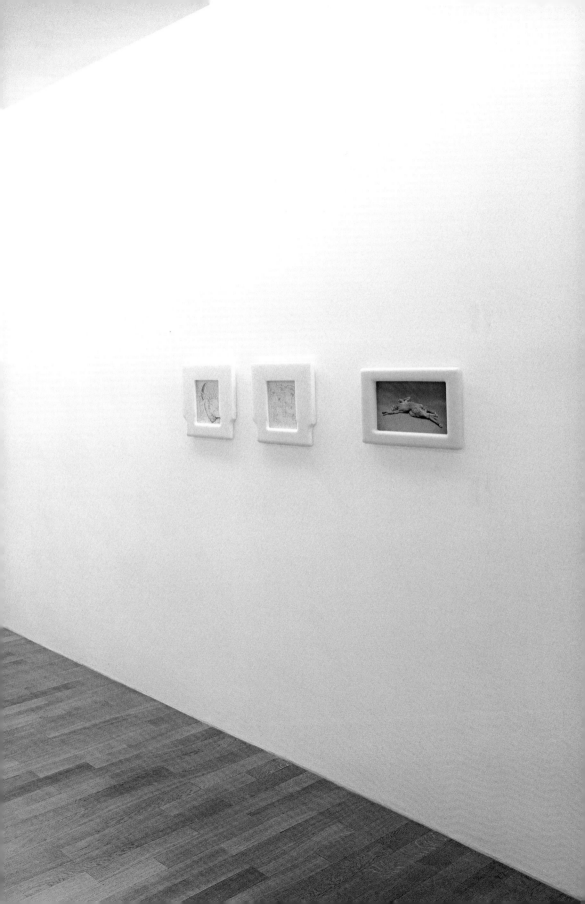

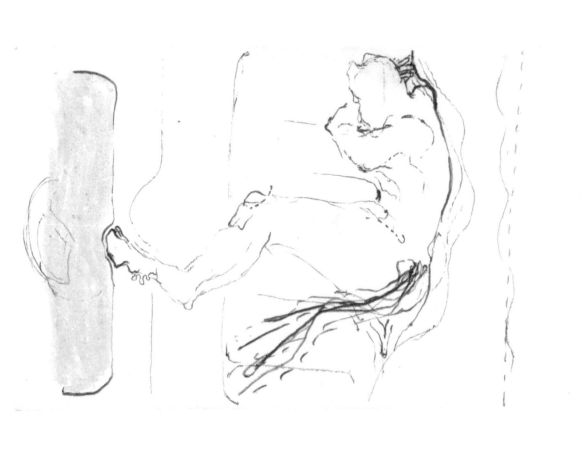

Zu CREMASTER 1 bis 5

Domenika Szope

CREMASTER 1

Der fünfteilige *CREMASTER Cycle* von Matthew Barney, produziert in den Jahren 1994 bis 2002, zeigt die Auseinandersetzung des Künstlers mit Prozessen der biologischen als auch psychologischen Formwerdung. Aus ästhetisch heterogenen Elementen bestehend, konfrontieren die Filme den Betrachter mit einer komplexen Ikonografie, die immer wieder auf historische und mystische Ereignisse Bezug nimmt und narrativ auf mehreren Bedeutungsebenen operiert. In seinem strukturellen Aufbau auf einem biologischen Modell basierend, wurde der Zyklus nicht in chronologischer Reihenfolge produziert und weist für den Betrachter gleich mehrere Einstiegsmöglichkeiten auf. Im Jahre 1994 entstand *CREMASTER 4*, gefolgt von *CREMASTER 1* (1995), *CREMASTER 5* (1997) und *CREMASTER 2* (1999). 2002 produzierte Barney *CREMASTER 3,* den letzten und mit einer Dauer von drei Stunden längsten Teil des Zyklus.

In Matthew Barneys Werk kristallisiert sich die Idee, dass eine Form nur dann Gestalt annehmen kann, wenn sie mit einem Widerstand konfrontiert wird. Diese Überlegung leitet der Künstler aus seinen Erfahrungen als Sportler her und überträgt das Überschreiten physischer Grenzen durch Belastungstraining in das Grundkonzept seiner künstlerischen Arbeit[1]. Den Körper definiert Barney als ein zu modifizierendes Feld, das gänzlich dem menschlichen Willen unterworfen werden kann. Um Muskelmasse neu bilden zu können, ist der Sportler versucht, bestehende Muskeln zu zerstören, um sie im Sinne der Hypertrophie durch ein höherwertiges Gewebe zu ersetzen[2]. Der sportliche Anspruch, Bedürfnisse wie Sexualität und Sozialisierung zugunsten des Siegwillens zurückzustellen, rückt den Blick auf die Aufnahme und Abgabe von körperlicher Energie unter kontrollierten Bedingungen. Die Kunst eröffnet Barney in diesem Kontext die Möglichkeit, innere Prozesse, die sowohl Kräfte binden

DRAWING RESTRAINT 7: Storyboard drawing
1993
7 Zeichnungen, je | 7 drawings, each
7,62×12,5 cm

ENVELOPA: Drawing Restraint 7 (Guillotine)
1993
Rahmen | Frame 7-teilig,
je | 7 parts, each 28,6×36,5×3,8 cm

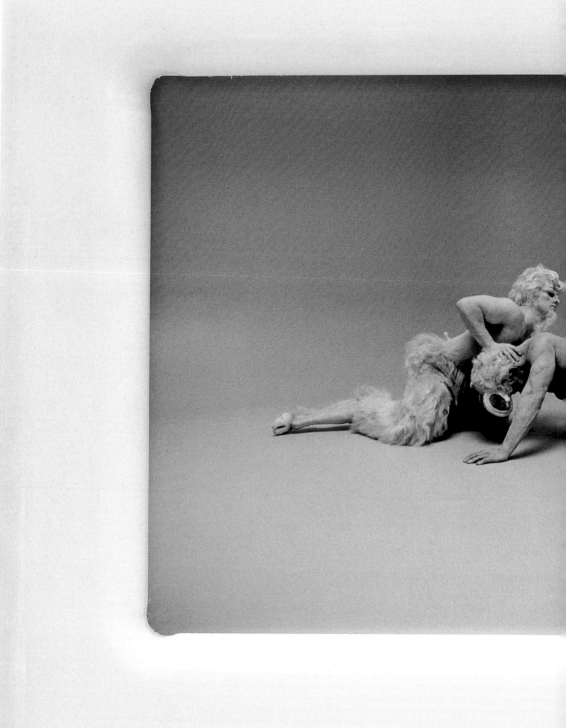

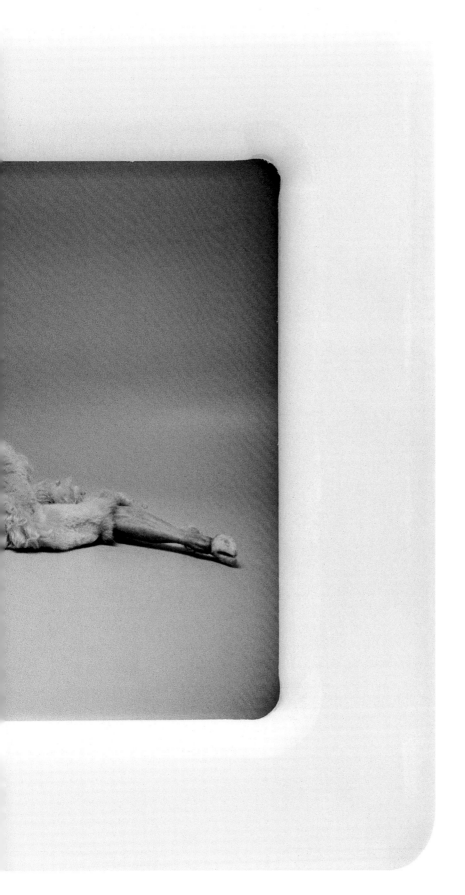

als auch Formen ausbilden können, zu definieren. Bereits zwischen 1988 und 1993 entwickelt der Künstler die Serie *DRAWING RESTRAINT*, für die er Situationen schafft, die ihm bei der Produktion von Illustrationen Beschränkungen und Hindernisse auferlegen. Diesem Ansatz legt Barney ein dreiteiliges Diagramm als Leitmotiv seiner Arbeit zugrunde, das er bereits in seinem Frühwerk entwickelt. Die Fluktuation der Körperenergien beginnt dabei in einer ersten Ebene, die der Künstler als ‚Situation‘ bezeichnet und mit der Metapher der embryonalen Entwicklung belegt. Sie konzentriert sich auf den reinen Trieb, ist somit sexueller Natur und in ihrem Zustand ungeordnet. Barney nimmt hier Bezug auf die sexuelle Anatomie des Fötus vor der geschlechtlichen Differenzierung. In den ersten sechs Wochen nach der Befruchtung ist der Embryo noch geschlechtsneutral und wartet auf die Einleitung der Trennung durch die Geschlechtschromosome. In diesem Stadium bilden sich zwei undifferenzierte Geschlechtsdrüsen entweder zu Eierstöcken oder zu Hoden aus. Anschließend übernehmen die Sexualhormone offensive und defensive Funktionen, indem sie das Wachstum bestimmter Organe stimulieren und andere verkümmern lassen.

Auf der zweiten Ebene, dem ‚Zustand‘, wird die Rohenergie des Körpers nutzbar gemacht. Diese durchläuft das Verdauungssystem, wo sie abgebaut, zersetzt und destilliert wird, um schließlich in der dritten Ebene, in der Zone der ‚Produktion‘ über anale und orale Kanäle nach außen zu treten.[3] Insbesondere die erste Ebene, der Zustand der genitalen Unbestimmtheit, liefert dem Künstler das metaphorische Vokabular, mit dem er das ästhetisch geschlossene System des *CREMASTER Cycle* umschreiben wird.

Der *CREMASTER Cycle* fokussiert den unbestimmten Zustand der ‚Situation‘, in der der neu entstandene Fötus in einem Moment geschlechtlicher Indifferenz verweilt und sich somit für eine kurze Zeit in einem Raum des Möglichen einrichtet. Sich gegen den bevorstehenden Teilungszwang auflehnend, versucht der Film-Zyklus diesen Moment endlos auszudehnen und zeigt in fünf Teilen den inneren Kampf gegen die Bestimmung sowie die Zustände des ‚Aufstiegs‘ und ‚Abstiegs‘. Ausgehend von dem ‚Cremaster-Reflex‘ bzw. dem ‚Cremaster-muscle‘, der in Abhängigkeit von äußeren Reizen Kontraktionen im Hoden bewirkt, nimmt der Zyklus anatomisch Bezug auf die Anhebung der Geschlechtsdrüsen während der sexuellen Bestimmung des Embryos. Dabei stellt *CREMASTER 1* den ‚aufgestiegensten‘, *CREMASTER 5* den ‚abgestiegensten‘ Zustand dar[4]. Im Verlauf der Produktion des Zyklus rückten neben dem biologischen Modell zunehmend biografische, geografische sowie geschichtliche Motive in den Vordergrund. Die unchronologische Folge der Entstehung lässt einen eindeutigen Einstieg in den Zyklus nicht erkennen, sondern verweist vielmehr auf die Absicht des Künstlers, im Sinne der grundlegenden Idee des biologischen Modells eine Schleife zu generieren.

Den biologisch undifferenzierten Zustand und damit den ‚Aufstieg‘ zeigt *CREMASTER 1*. Im ersten Moment an eine Tanzrevue erinnernd, stellt sich der in Barneys Heimatstadt Boise, Idaho, gedrehte Film als ein fantastisches Moment dar. Zwei Goodyear-Zeppeline gleiten über die Arena des mit blauem Astroturf ausgelegten Bronco-Stadions. In jedem Luftschiff sind, um einen mit Trauben überhäuften Tisch, vier uniformierte Stewardessen zu sehen, die immer wieder durch die kleinen

Fenster nach außen spähen. Das Summen der Motoren wechselt sich beständig mit der Musik-einlage der Tanzrevue ab. Unter den Tischen der beiden Zeppeline lebt ‚Goodyear', eine Frau, die in ihrer simultanen Präsenz in beiden Luftschiffen als ein Doppelwesen auftritt. Unbemerkt zieht sie, unter dem Tisch liegend, Trauben durch die Tischdecke und ordnet sie in verschiedenen Formationen zu ihren Füßen an, womit sie die Choreografie der Tänzerinnen in dem blau strahlenden Stadion zu bestimmen scheint. Goodyear und die zwei Zeppeline bilden einen Organismus, der lediglich auf das Lustprinzip ausgerichtet zu sein scheint. In der Choreografie der Tänzerinnen und der ästhetischen Anordnung der Szenerie wird einzig das Bemühen um ein Aufrechterhalten des vorherrschenden Gleichgewichts deutlich: „[Goodyears] Verlangen besteht daraus, die beiden Zeppeline in dieser bestimmten Position zu halten, als ein Symbol für das Reproduktionssystem, bevor die Organe niedergehen, um sich geschlechtlich zu differenzieren. Ihr Ziel ist also das Aufrechterhalten der Indifferenz. Auf der anderen Seite des Vorhangs befinden sich die Stewardessen, deren Aufgabe vollkommen diametral zu jener von Goodyear ist: Sie sollen die Landung des Fluggeräts vorbereiten und damit dessen Fortpflanzung in Gang bringen. Goodyear wiederum dirigiert ihr Traubenteam und ihre Tänzerinnen auf dem Football-Feld, um das zu verhindern."[5] Das Vorherrschen der weiblichen Rolle im *CREMASTER 1* mag sich aus der Tatsache erklären, dass jeder Embryo zu Beginn weiblich ist, bevor die Verbindung mit einem Y-Chromosom und den entsprechenden Hormonen den Zustand der Indifferenz aufhebt.[6]

1 Nancy Spector: „Nur die perverse Phantasie kann uns noch retten", in: *Matthew Barney: The CREMASTER Cycle*, Ausst.-Kat. Museum Ludwig, Köln; Musée d'Art Moderne de la Ville de Paris, Paris; Solomon R. Guggenheim Museum, New York, Ostfildern-Ruit 2002, S. 4. Spector liefert in der Kölner Publikation eine äußerst gründliche Aufarbeitung und Beschreibung des *CREMASTER*-Zyklus, die zahlreiche Perspektiven einschließend, einen ausgezeichneten Überblick über die Filme bietet.

2 Norman Bryson: „Matthew Barneys gonadotrope Kavalkade", in: *Parkett*, Nr. 45, 1995, S. 38.

3 Wie Anm. 1, S. 6.

4 Ebd.

5 Matthew Barney: „Der Körper als Instrument. Ein Gespräch mit Christoph Doswald", in: *Kunstforum*, Nr. 135, 1997, S. 318.

6 Ebd., S. 34.

CREMASTER 1
1995
Filmstills

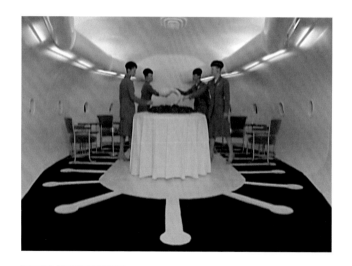

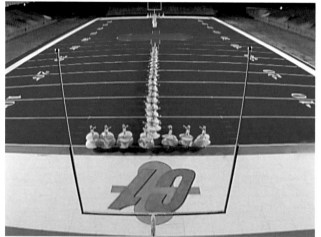

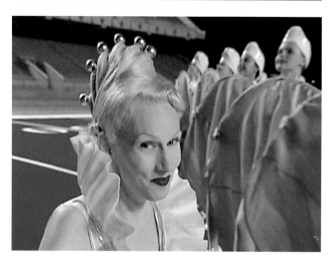

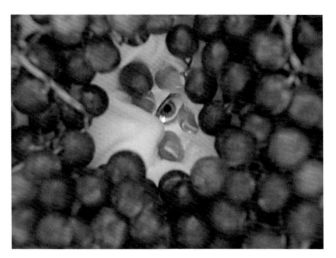

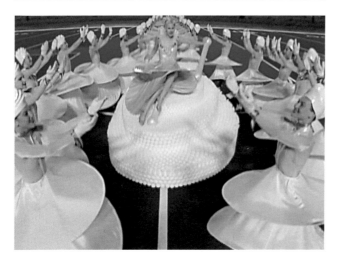

On CREMASTER 1 to 5

Domenika Szope

CREMASTER 1

Matthew Barney's five-part *CREMASTER Cycle*, produced between 1994 and 2002, is the artist's analysis of both biological and psychological formation. Consisting of aesthetically heterogeneous elements, the film presents a complex iconography with constant references to historical and mystical events and a narrative that operates on several levels. Using a biological model as a basis, the cycle is not produced in chronological order and offers the viewer several possibilities of entry. *CREMASTER 4* appeared in 1994, followed by *CREMASTER 1* (1995), *CREMASTER 5* (1997) and *CREMASTER 2* (1999). In 2002 Barney made *CREMASTER 3,* the last and, with a duration of three hours, the longest part of the cycle.

Matthew Barney's work develops the idea that a form only takes shape when confronted with resistance. The artist derives this idea from his career as an athlete and translates the pushing of physical limits in athletic training into the fundamental concept of his artistic work.[1] Barney defines the body as a modifiable array which can be completely subjugated to human will. In order to build new muscle mass, the athlete attempts to destroy existing muscle, so as to replace it through hypertrophy with higher-grade tissue.[2] The athletic demand to sacrifice the needs of sexuality and sociability to sporting ambitions directs attention to the intake and output of bodily energies under controlled conditions. In this context, Barney regards art as providing an opportunity to define inner processes that can both bind powers and shape forms. Starting already in 1988 the artist developed the series *DRAWING RESTRAINT,* for which he creates situations that set him restrictions or hindrances in the production of illustrations. A three-part diagram, which Barney developed in his early productions, forms the basis for this approach and is a leitmotif of his entire work. The fluctuation of bodily energies begins on the first level, which the artist calls the 'situation' and to which he attaches the metaphor of embryonic development. This level is focused on pure drive, is of a sexual nature and in random order. Barney is here referring to the sexual anatomy of the fetus before sexual differentiation. In the first six weeks after fertilization, the embryo is still sexually neuter and awaits the separation by the sexual chromo-

somes. At this stage, two undifferentiated sexual glands either form into ovaries or testicles. The sexual hormones then assume offensive or defensive functions, which stimulate or neglect the growth of certain organs.

At the second level, the 'state', the raw energy of the body is developed. It passes through the digestive system where it is taken down, decomposed and distilled, to finally break out externally at the third level, through anal or oral canals, in the zone of 'production'.[3] Particularly the first level, the state of genital indeterminacy, supplies the artist with the metaphorical vocabulary which is used for the aesthetically closed system of the CREMASTER Cycle.

The CREMASTER Cycle focuses on the indeterminate state of the 'situation', in which the newly formed fetus dwells in a moment of sexual neutrality and thus installs itself for a short time in a space of possibility. Rebelling against the imminent compulsion to division, the film cycle attempts to extend this moment endlessly, and shows in five parts the inner struggle against determination and the states of 'ascent' and 'descent'. Proceeding from the cremaster reflex or the cremaster muscle – which depends on external stimuli to produce contractions of the testicles – the cycle makes anatomical reference to the activation of the sexual glands during the sexual determination of the embryo. CREMASTER 1 presents the 'most ascended' state, CREMASTER 5 the 'most descended'.[4] In the course of the production of the cycle, beside the biological model, biographical, geographical and historical motifs moved increasingly into the foreground. The non-chronological order of the production does not offer an explicit entry into the cycle, but on the contrary indicates the artist's intention to generate a loop, in accordance with the fundamental idea of the biological model.

CREMASTER 1 shows the biologically undifferentiated state, and so the 'ascent'. At first, reminiscent of a dance revue, the film, shot in Barney's home town of Boise, Idaho, presents itself as a fantastic moment. Two Goodyear blimps glide over the arena of the Bronco Stadium, which is laid out with blue astroturf. In each airship, four uniformed stewardesses can be seen round a table piled high with grapes. Each of the women repeatedly peer out of a small window. The humming of the motors alternates constantly with the musical interlude of a dance revue. Under the table lives 'Goodyear', a woman whose simultaneous presence in both airships makes her appear to be a double being. Lying beneath the table unnoticed, she draws grapes through the tablecloth and arranges them in various formations at her feet, which seems to determine the choreography of the dancers in the radiant blue stadium. Goodyear and the two blimps form an organism that appears to be directed solely by the pleasure principle. In the choreography of the dancers and the aesthetic arrangement of the scenery, the single-minded effort to maintain the prevailing equilibrium becomes plain: "[Goodyear's] wish is to hold the two blimps in this defined position by way of a symbol of the reproductive system before the organs descend to become sexually differentiated. Her goal is thus the maintenance of neutrality. On the other side of the curtain are the stewardesses whose task is diametrically opposed to that of Goodyear: they are to prepare for the ship's landing and thereby set its reproduction into motion. To prevent this, Goodyear in turn directs her 'grape-team' and her

dancers on the football field."[5] The predominance of female roles in *CREMASTER 1* may be explained by the fact that every embryo begins as a female before the combination with a Y-chromosome and the corresponding hormones abolish the state of neutrality.[6]

1 Nancy Spector: *Nur die perverse Phantasie kann uns noch retten*, in: *Matthew Barney: The CREMASTER Cycle*, exh. cat. Museum Ludwig, Cologne; Musée d'Art Moderne de la Ville de Paris, Paris; Solomon R. Guggenheim Museum, New York, exh. cat., Ostfildern-Ruit: Hatje Cantz Verlag, 2002, p. 4. In this essay, Spector provides a highly thorough discussion and description of the *CREMASTER Cycle*, which includes numerous perspectives and offers an excellent overall view of the films.

2 Norman Bryson: *Matthew Barneys gonadotrope Kavalkade*, in: *Parkett*, no. 45, 1995, p. 38.

3 Cf, note 1, p. 6.

4 Ibid.

5 Matthew Barney: *Der Körper als Instrument – Ein Gespräch mit Christoph Doswald*, in: *Kunstforum*, no. 135, 1997, p. 318.

6 Ibid., p. 34.

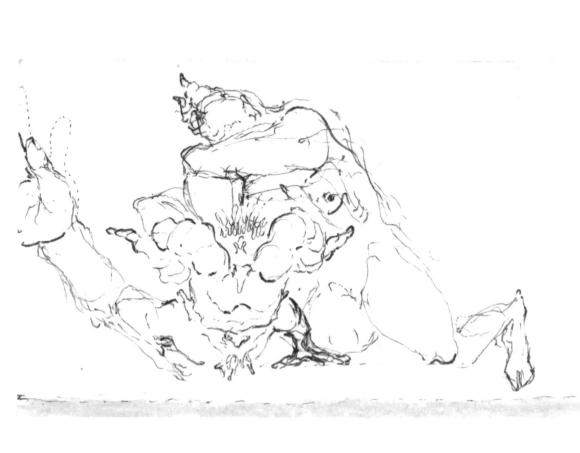

CREMASTER 2

Ein Widerstand und damit ein möglicher Konflikt, der im ersten Teil noch nicht zu erkennen ist, treten in *CREMASTER 2* ein. Vor dem Hintergrund des Columbia Ice Field in Kanada und den Bonneville Salt Flats in Utah orientiert sich die Handlung an der Lebensgeschichte von Gary Gilmore, eines in den 1970er-Jahren in Utah hingerichteten Mörders. Barney stellt Gilmores Biografie und dessen Ermordung eines mormonischen Tankstellenbesitzer in Orem, Utah, in einer Reihe fantastischer Szenen dar. In Form von zwei miteinander verbundenen Autos an einer Tankstelle visualisiert der Künstler die Annahme, Gilmore sei von einem perversen Verlangen nach einer Wiedervereinigung mit seiner Freundin Nicole Baker getrieben gewesen. Die Verbindung der beiden Mustangs gleichen Baujahrs, die Gilmore und Baker damals beide zufällig besaßen, verdeutlicht Gilmores Konfrontation mit seinem eigenen Trieb. Im Verlauf des Geschehens steigt er aus dem Wagen und führt den Tankstellenbesitzer auf die Toilette, wo er ihm zweimal in den Hinterkopf schießt. Die von Gilmore erwartete innerliche Befreiung bleibt aus, und die Tat führt zum Todesurteil, das Gilmore einst ohne Berufung annahm. Er entschied sich für eine Hinrichtung durch ein Exekutionskommando, entsprechend der Überzeugung des mormonischen Glaubens, dass zur Erlösung das Blut eines Sünders vergossen werden müsse. Barney verlagert die Urteilsverkündung in das Salt Lake City Tabernacle und inszeniert die Hinrichtung als ein Rodeo in den Salzebenen von Bonneville. Seiner Darstellung der Hinrichtung folgend – das Zusammensinken des Stiers und der gleichzeitige Tod Gilmores – ließe sich jedoch vermuten, dass es Gilmore weniger darum gegangen sein könnte, im mormonischen Sinne Erlösung zu finden, als vielmehr in einem letzten Akt der Selbstbestimmung, durch den Tod dem Schicksal zu entkommen[1].

Die Handlung entspricht auf biologischer Ebene der nächsten Embryonalphase, in dem sich der Differenzierungstrieb erstmals regt und sich die bisher geschlechtslosen Geschlechtsdrüsen umzubilden beginnen. Der Organismus wehrt sich gegen eine Teilung und die Aufhebung des Gleichgewichtszustandes, den *CREMASTER 1* noch zu erhalten wusste. In der Erzählstruktur knüpft Barney Assoziationen zwischen Gilmores Lebensgeschichte und seiner möglichen Verwandtschaft mit dem berühmten Magier und Entfesselungskünstler Harry Houdini sowie den Bienen, deren Thema er aus dem Wahrzeichen Utahs und der Mormonen ableitet[2]. In der Verbindung zum Sozialverhalten der Bienen findet Barney die Möglichkeit, die Handlung aus dem Jahre 1977 immer wieder in das Jahr 1893 schweifen zu lassen, als Houdini, der vielleicht Gilmores Großvater und für Gilmore der Inbegriff absoluter Freiheit war, auf der Chicagoer Weltausstellung sein berühmtes Entfesselungsstück aufführte. Im Verlauf der Handlung tritt Gilmore immer mehr in den Hintergrund, und das Bienenthema dominiert das weitere Geschehen. Barney verweist auf die Dynamik innerhalb des

***ENVELOPA:** Drawing Restraint 7 (Guillotine)*
1993
Rahmen | Frame 7-teilig, je | 7 parts, each 28,6 × 36,5 × 3,8 cm

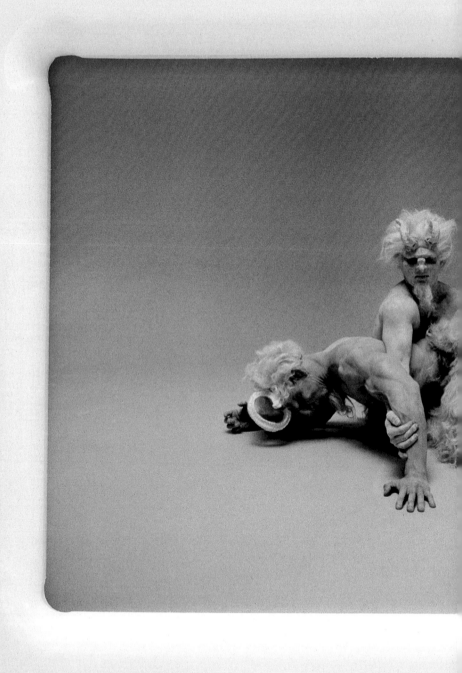

Bienenstocks und die Tatsache, dass die männliche Drohne nutzlos wird, sobald sie ihre Rolle, sich mit der Königin zu paaren, erfüllt hat. In Barneys Darstellung wird Gilmore aufgrund seines Triebes und der Umstände zu einer Drohne – eine Schlussfolgerung, die schließlich zu einer metaphysischen Auflösung der Geschichte führt. Houdini nannte seinen berühmtesten Trick ‚Metamorphose‘: Er ließ sich in eine Kiste einsperren, und als diese wieder geöffnet wurde, entstieg ihr eine Frau: „Gilmore will Houdini werden, um sich dann in dessen Frau zu verwandeln – als Frau kann er den Thron der Bienenkönigin besteigen und muss nicht sterben."[3] Die Figur des Magiers Houdini, der sich auf sagenhafte Weise aus den unmöglichsten Situationen zu befreien wusste, wird im *CREMASTER Cycle* zu einer immer wieder auftauchenden Erscheinung und über den Zyklus hinaus in Barneys Œuvre zur Personifikation von Selbstdisziplin und einem Katalysator für Kreativität – zu einem ‚Character of Positive Restraint‘.

1 Nancy Spector: „Nur die perverse Phantasie kann uns noch retten", in: *Matthew Barney: The CREMASTER Cycle*, Ausst.-Kat. Museum Ludwig, Köln; Musée d'Art Moderne de la Ville de Paris, Paris; Solomon R. Guggenheim Museum, New York, Ostfildern-Ruit 2002, S. 40.

2 Ebd., S. 36.

3 Matthew Barney: „Mein Kopf ist wie ein Cockpit", in: *Süddeutsche Zeitung Magazin*, Nr. 46, 1998, S. 38.

CREMASTER 2
1999
Filmstills

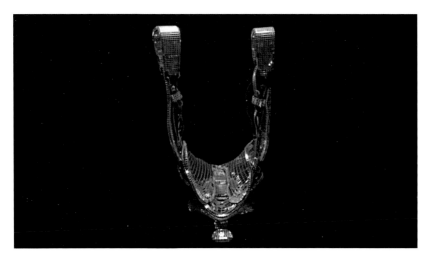

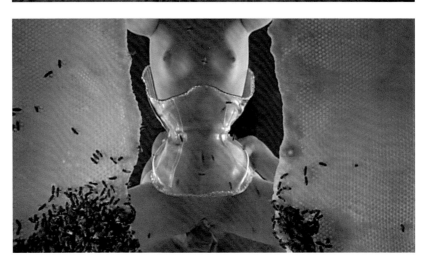

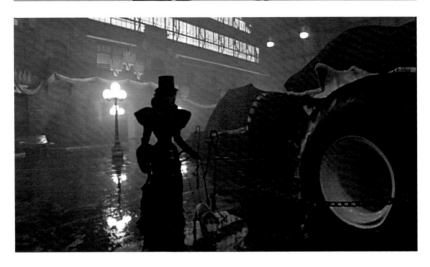

CREMASTER 2

A resistance, and with it a possible conflict not discernible in *CREMASTER 1*, surfaces in *CRE-MASTER 2*. Against the background of the Columbia Ice Field in Canada and the Bonneville Salt Flats in Utah, the action is based on the life story of Gary Gilmore, a murderer who was executed in Utah in the 1970s. Barney presents Gilmore's biography and his murder of a Mormon gas station owner in Orem, Utah, in a series of fantastic scenes. With a scene showing two cars linked to one another at the gas station, the artist visualizes the assumption that Gilmore was driven to his crime by the perverse wish for reunion with his girlfriend Nicole Baker. The linking of the two Mustangs of the same model, which Gilmore and Baker both happened to possess, explains Gilmore's confrontation with his own drive. In the course of events he climbs out of the car and leads the gas station owner to the restroom, where he shoots him twice in the back of the head. Gilmore does not feel the inner liberation he expected, and the crime results in his death sentence, which Gilmore then accepted without appeal. He opted for execution by firing squad, in accordance with the Mormon belief that redemption requires shedding the blood of the sinner. In his portrayal of the events, Barney transfers the announcement of the verdict to the Salt Lake City Tabernacle and stages the execution as a rodeo on the Bonneville Salt Flats. He shows Gilmore's death occurring at the same time as that of the rodeo bull. The viewer is left wondering whether Gilmore's motivation was less a matter of finding Mormon salvation than escaping fate through death, by a final act of self-determination.[1]

This action corresponds, on a biological level, to the next phase of embryonic development in which the drive to differentiation first stirs and begins to reshape the hitherto sexless sexual glands. The organism resists division and the abolition of its equilibrium, which in *CREMASTER 1* is still preserved. In the narrative structure Barney links associations between Gilmore's life story and his possible relation to the famous magician and escape artist Harry Houdini and also to bees, the later of which themes he derives from the emblem of Utah and the Mormons.[2] Using the connection to the social behavior of bees, Barney finds countless opportunities to transfer the actions of 1977 back to 1893, when Houdini, who may have been Gilmore's grandfather and his epitome of absolute freedom, performed his most famous escape trick at the Chicago World's Fair. In the course of the action, Gilmore recedes more and more into the background and the theme of bees comes to dominate further events. Barney points to the dynamics within the beehive and the fact that the masculine drone becomes useless as soon as it has fulfilled its role of mating with the queen bee. In Barney's presentation, Gilmore becomes a drone because of his drive and the circumstances – a conclusion that eventually leads the story to a metaphysical solution. Houdini called his most famous trick 'metamorphosis': he had himself locked up in a case and when this was opened again, out came a woman. "Gilmore wants to become Houdini in order to transform himself into a woman – as a woman he might ascend to the throne of the queen bee and doesn't have to die."[3] The figure of the magician Houdini, who was able to free himself from the most impossible situations, appears repeatedly in the *CREMASTER Cycle* and in other works of Barney's oeuvre, in which he becomes the personification of self-discipline and a catalyst for creativity – a 'character of positive restraint'.

1 Nancy Spector: *Nur die perverse Phantasie kann uns noch retten*, in: *Matthew Barney: The CREMASTER Cycle*, exh. cat. Museum Ludwig, Cologne; Musée d'Art Moderne de la Ville de Paris, Paris; Solomon R. Guggenheim Museum, New York, exh. cat., Ostfildern-Ruit: Hatje Cantz Verlag, 2002, p. 40.

2 Ibid., p. 36.

3 Matthew Barney: *Mein Kopf ist wie ein Cockpit*, in: *SZ Magazin*, no. 46, 1998, p. 38.

CREMASTER 3

CREMASTER 3 reflektiert die dritte Phase der biologischen Evolution und zeigt, dass eine Trennung der Geschlechter trotz Auflehnung nun nicht mehr aufzuhalten ist. Gleichzeitig impliziert sie das Sammeln der Kräfte für den bevorstehenden entropischen Prozess. Als Drehort wählte Barney New York City, wo er auch lebt und arbeitet. Autobiografische Anhaltspunkte, wie sie bereits in *CREMASTER 1* zu erkennen waren, werden auch hier sichtbar.

Die Handlung spielt vor dem Hintergrund der irischen Gewerkschaften und den Verbrecherorganisationen der Prohibitionszeit der 1930er-Jahre in New York. Farben der irischen Nationalflagge beherrschen das Szenenbild und verweisen auf die symbolische Vereinigung vermeintlicher Antipoden. Ähnlich der Farben Blau und Gelb in *CREMASTER 4* bringt Barney hier die Kombination bzw. Separation der Farben als Strukturelement in den Ablauf ein. Die Errichtung des Chrysler Building, das sich selbst als ein widerstreitende Kräfte in sich vereinigender Organismus offenbart, rückt in den Vordergrund der Erzählung. Der Wolkenkratzer, den sich der Automobilmagnat Walter P. Chrysler 1928 als Firmensitz errichten ließ, sollte mit einer Höhe von 282 Metern das höchste Bauwerk der Welt werden. Als jedoch der Entwurf wenig später durch den Bau des 283 Meter hohen Manhattan Tower an der Wall Street übertroffen zu werden drohte, fassten Chrysler und sein Architekt Van Alen, den Plan, den Turm mit einer 55 Meter hohen Nirosta-Nadel zu krönen und damit den Wettlauf für sich zu entscheiden. Wohl aufgrund der zu dieser Zeit in großer Anzahl existierenden Freimaurerlogen in New York nimmt die Handlung Bezug auf den Architekten Hiram Abiff, der, die Geheimnisse des Universums kennend, einst den Tempel des König Salomon erbaut haben und nach seiner Ermordung durch drei Lehrlinge von Salomon wieder zum Leben erweckt worden sein soll[1]. In *CREMASTER 3* findet nun, vor dem Hintergrund des Wettlaufs um das höchste Gebäude, der Konflikt in der Auseinandersetzung zwischen dem Architekten, gespielt von Richard Serra, und dem neu aufgenommen Lehrling der Freimaurerloge, Matthew Barney, Gestalt.

Nach einem von der keltischen Mythologie geprägten Prolog beginnt die Erzählung des dritten Teils unter den Fundamenten des noch nicht ganz vollendeten Chrysler Building. Eine Frauenleiche – der Untote Gary Gilmore, der sich, dem Entfesselungskunststück Houdinis nach, in eine Frau verwandelt hat – versucht, sich aus ihrem Grab zu befreien. Von Leichenträgern wird sie in die Eingangshalle des Chrysler Building getragen und auf den Rücksitz eines Chrysler Imperial New Yorker gelegt. Die Kamera zeigt den Lehrling, der mit einer Zementschicht die Tankverschlüsse der neueren Chrysler-Modelle bedeckt, die kurze Zeit später bei der Zerstörung des alten Chryslers im Foyer des Gebäudes als Rammböcke dienen werden. Der Konflikt nimmt im Folgenden seinen Lauf, als der Lehrling in der

DRAWING RESTRAINT 7: Storyboard drawing
1993
7 Zeichnungen, je | 7 drawings, each
7,62 × 12,5 cm

ENVELOPA: Drawing Restraint 7 (Guillotine)
1993
Rahmen | Frame 7-teilig,
je | 7 parts, each 28,6 × 36,5 × 3,8 cm

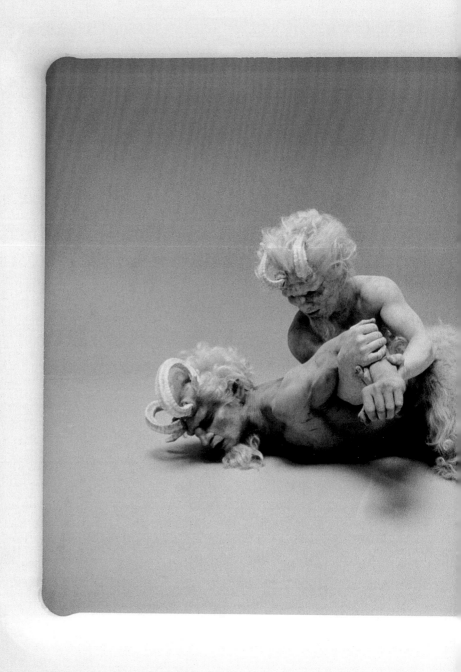

Anfertigung eines perfekten Quadersteins, der im Ritus der Freimaurer moralische Rechtschaffenheit bedeutet, das Meißeln umgeht und damit beim Übergangsritus zur nächst höheren der insgesamt fünf Stufen zum Meister betrügt. Mit seinem Vorgehen legt er nicht nur ein falsches Fundament für die Entwicklung seines Charakters, sondern sabotiert zugleich auch den Bau des Gebäudes. Logenmitglieder versammeln sich im Cloud Club des Gebäudes, um über sein Schicksal zu entscheiden. Währenddessen spielen sich an der Bar komödiantische Szenen ab, die von einer Frau im Nachbarseparee verursacht zu sein scheinen. Mit Klingen an ihren Schuhen schneidet sie Kartoffeln in fünfseitige Keile und schiebt sie unter das Fundament der Bar, um diese und damit das ganze Gebäude aus dem Gleichgewicht zu bringen. Ihre stille Präsenz und ihr Tun werden von Freimaurern im Nebenzimmer sorgsam mit Senkblei und Wasserwaage beaufsichtigt. Auf der Rennbahn von Saratoga Springs erfährt der Lehrling Vergeltung für seinen Betrug. Nachdem ihm die Zähne ausgeschlagen wurden, wird er in eine Arztpraxis geleitet, wo beim Entkleiden die Freimaurertracht des ersten Grades mit einem Schurz zum Vorschein kommt. Der Lehre der Freimaurer folgend, die den Schurz, der auf die Unschuld des Neugeborenen verweist, mit dem menschlichen Leib assoziiert, offenbart sich beim Lehrling ein Schurz aus Fleisch, unter dem sich anstelle von Genitalien ein Spritzmuster zeigt. Im nächsten Moment passt der Architekt dem Lehrling ein künstliches Gebiss – Metallzähne, die aus dem Schrott des zerstörten Imperial New Yorker gefertigt worden sind – ein, woraufhin dem Lehrling die Eingeweide durch das Rektum fallen und ihn auf diese Weise symbolisch vom niederen Teil seiner eigenen Person trennen. Der Schurz aus Fleisch verlängert sich bis unter die Leistengegend und deutet auf einen Aufstieg vom Lehrling zum Meister hin. Auf das dem *CREMASTER Cycle* zugrunde liegende biologische Modell verweisend, stellt sich der Lehrling hier als Teil eines Organismus dar, der mit seiner inneren Formwerdung ringt[2]. Während der Lehrling nun unbemerkt durch die Deckenplatte aus der Praxis entweicht und seinen Aufstieg zur Spitze des Wolkenkratzers fortsetzt, macht sich auch der Architekt auf den Weg und nähert sich in seinem Tun allmählich dem Schaffen eines Demiurgen an.

An dieser Stelle verlagert sich die Szenerie in die Architektur des Guggenheim-Museums, in dessen fünf Ebenen nun ein Fünfkampf unter dem Titel *The Order* ausgetragen wird. Der Lehrling, erkennbar am blutigen Mund und seinem Schurz, der sich mittlerweile zu einem hautfarbenen Kilt ausgewachsen hat, muss sich nun über die einzelnen Geschosse des Spiralbaus kämpfen und binnen einer vorgegebenen Zeit spezifische Aufgaben erledigen. Dabei scheint die Inszenierung eines jeden Geschosses Bezug auf jeweils einen *CREMASTER*-Film zu nehmen. Im dritten Geschoss wird der Lehrling mit seinem Alter Ego in Gestalt einer Gepardin konfrontiert, die ihm einen Blick in den Spiegel seiner Seele freigibt. Die folgende Umarmung des Lehrlings mit der Kriegerin führt für einen kurzen Moment zu einer völligen Einswerdung, bis sich das Alter Ego wieder in die Raubkatze verwandelt und den Lehrling angreift. Dieser tötet sie daraufhin und löst damit eine ganze Kette von Ereignissen aus. Die Kamera schwenkt zurück zum Architekten des Chrysler Building, der im selben Augenblick, in dem der Lehrling sein Alter Ego erschlägt, ebenfalls indirekt getötet wird, und mit ihm stirbt auch der Lehrling selbst. Das Chrysler Building bleibt, wie einst der Salomon-Tempel, unvollendet und wird schließlich an Höhe vom Manhattan Tower an der Wall Street übertroffen.

CREMASTER 3 endet, wie er begann, vor dem Hintergrund der keltischen Mythologie und verweist damit bereits auf den Schauplatz von *CREMASTER 4* – der Isle of Man.

1 *Polk's New York City Directory 1933–34*, New York: Polk & Company, 1932, S. 3885f., zit. nach: Nancy Spector: „Nur die perverse Phantasie kann uns noch retten", in: *Matthew Barney: The CREMASTER Cycle*, Ausst.-Kat. Museum Ludwig, Köln; Musée d'Art Moderne de la Ville de Paris, Paris; Solomon R. Guggenheim Museum, New York, Ostfildern-Ruit 2002, S. 44; Die Zunftlegende überliefert, dass Salomon beim Bau des Tempels an die 80.000 „masons" (früher Zusammenschluss von Freimaurern) beschäftigte. Vgl. Will-Erich Peuckert: *Geheimkulte*, Hildesheim 1988, S. 588.

2 Nancy Spector: „Nur die perverse Phantasie kann uns noch retten", in: *Matthew Barney: The CREMASTER Cycle*, Ausst.-Kat. Museum Ludwig, Köln; Musée d'Art Moderne de la Ville de Paris, Paris; Solomon R. Guggenheim Museum, New York, Ostfildern-Ruit 2002, S. 49.

CREMASTER 3
2002
Filmstills

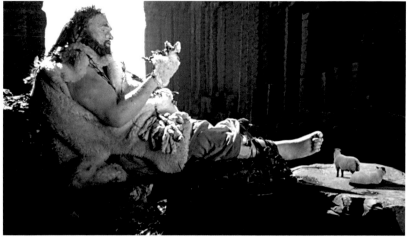

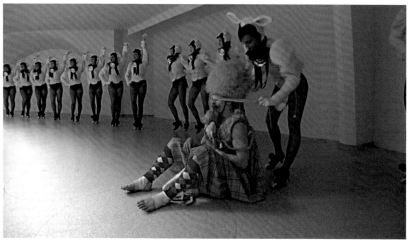

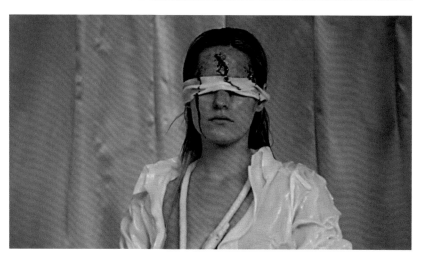

CREMASTER 3

CREMASTER 3 reflects the third phase of biological evolution and shows that the separation of the sexes cannot be stopped. At the same time, this phase implies the concentration of energy for the approaching process of entropy. The action takes place in New York City, where Barney lives and works. Autobiographical clues, already discernible in *CREMASTER 1*, are also visible here.

The action takes place against the background of the Irish unions and criminal organizations in New York during the last years of Prohibition in the 1930s. The colors of the Irish national flag dominate the scene and point out the symbolic union of supposed antipodes. Similar to the use of blue and yellow in *CREMASTER 4*, the combination or separation of colors is introduced as an element of structure in the cycle. The construction of the Chrysler Building, which is revealed as an organism that unites in itself conflicting forces, moves into the foreground of the story. The skyscraper, which the automobile magnate Walter P. Chrysler erected in 1929 as the company headquarters, was, at a height of 282 meters, intended to be the tallest building in the world. When, however, a little later the construction of the 283-meter high Manhattan Towers in Wall Street threatened to surpass the building, Chrysler and his architect Van Alen conceived the plan to crown their tower with a 55-meter high Nirosta spire to win the contest. Probably due to the large number of Masonic lodges that existed in New York at the time, the action focuses on the architect Hiram Abiff, who, according to history knew the secrets of the universe and built King Solomon's temple; apparently he was murdered and then brought back to life by Solomon.[1] *CREMASTER 3* focuses on the conflict between the architects, played by Richard Serra and Matthew Barney. Barney is a newly initiated Masonic apprentice and the race to build the world's tallest building forms the frame story.

After a prologue marked by Celtic mythology, the third part of the cycle begins beneath the foundations of the not yet completed Chrysler Building. A woman's corpse – the undead Gary Gilmore, who, as in Houdini's escape trick, has transformed himself into a woman – attempts to free herself from her grave. Pallbearers carry her into the entrance hall of the Chrysler Building and lay her on the back seat of a Chrysler Imperial New Yorker. The camera shows the apprentice, as he covers the fuel cap of the new Chrysler with a layer of cement. The car later serves as the battering ram for the destruction of the old Chrysler in the foyer. The conflict takes its course in the following scene, when the apprentice, set the task of making a perfect rectangular stone (which in Masonic ritual signifies moral rectitude) gets round using a chisel and so cheats in his test to the next of the five levels to master. With his action he not only undermines the development of his own character, he also sabotages the construction of the building. Lodge members assemble in the Cloud Club to decide over his fate. During the meeting, amusing scenes take place at the bar, which appear to be caused by a woman in a neighboring private room. With blades on her shoes, she cuts potatoes into five-sided wedges and pushes these under the basement of the bar in order to make the bar and with it the entire building lose balance. Her quiet presence and actions are carefully supervised by Masons in a side room using plumb line and spirit level. On the racetrack of Saratoga Springs, the

apprentice is punished for cheating. After his teeth are knocked out, he is led to a doctor's office where he undresses and reveals the Masonic apron of the First Grade. According to Masonic doctrine, the apron, which indicates the innocence of the newborn, is associated with the human body; the apprentice's apron is of flesh, under which, instead of genitals, there is a stencil. The architect then fits the apprentice with artificial dentures – metal teeth made of the scrap of the demolished Imperial New Yorker – whereupon the apprentice's entrails fall out of his rectum and in this way symbolically separate him from the lower part of his being. The apron elongates itself until it covers the genital region and indicates the ascent of apprentice to master. With reference to the biological model underlying the *CREMASTER Cycle*, the apprentice here represents a part of an organism that is wrestling with its inner formation.[2] While the apprentice, now unnoticed, escapes through the roof of the doctor's office and continues his ascent to the top of the skyscraper, the architect also sets off and approximates in his deeds the creativity of a demiurge.

At this point the scene shifts to the architecture of the Guggenheim Museum, on whose five levels a pentathlon is being conducted under the title *The Order*. The apprentice, recognizable from his bloody mouth and his apron, which has in the meantime grown into a skin-colored kilt, must now fight his way through the five floors and discharge specific tasks within a given time. The scene seems to refer on each floor to one of the *CREMASTER* films. On the third floor, the apprentice is confronted by his alter ego in the form of a female cheetah, which grants him a look into the mirror of his soul. The apprentice's ensuing embrace of the warrioress leads, for a short moment, to complete union, until her alter ego transforms her back into a predator and she attacks the apprentice. He kills her, and thus triggers an entire chain of events. The camera pans back to the architect of the Chrysler Building: at the same time that the apprentice slays his alter ego, the architect is indirectly killed, too, as is the apprentice. The Chrysler Building, like the temple of Solomon, remains uncompleted, and is finally surpassed in height by the Manhattan Tower. *CREMASTER 3* ends as it began, surrounded by Celtic mythology, and thus already hinting at the setting of *CREMASTER 4* – the Isle of Man.

1 Cf. *Polk's New York City Directory 1933-34*, New York: Polk & Company, 1932, p. 3885–86; a quote by Nancy Spector, "Nur die perverse Phantasie kann uns noch retten," in: *Matthew Barney: The CREMASTER Cycle*, Museum Ludwig, Cologne; Musée d'Art Moderne de la Ville de Paris, Paris; Solomon R. Guggenheim Museum, New York (cat.), Ostfildern-Ruit: Hatje Cantz Verlag, 2002, p. 44. The guild legend has it that Solomon employed 80,000 'masons' for the construction of his temple. Cf. Will-Erich Peuckert, *Geheimkulte*, Hildesheim 1988, p. 588.
2 Nancy Spector, *Nur die perverse Phantasie kann uns noch retten*, Matthew Barney: *The CREMASTER Cycle*, Museum Ludwig, Cologne; Musée d'Art Moderne de la Ville de Paris, Paris; Solomon R. Guggenheim Museum, New York, exh. cat., Ostfildern-Ruit: Hatje Cantz Verlag, 2002, p. 49.

CREMASTER 4

Steht noch im dritten Teil die Selbstreflexion im Vordergrund, wird sie in *CREMASTER 4* von der Tatsache überschattet, dass der Organismus – ganz im Sinne des biologischen Modells – trotz seines Widerstandes unaufhaltsam, dem Abstieg entgegeneilt. Die Handlung beginnt und endet in einem mit weißem Vinyl ausgekleideten Haus auf dem Queen's Pier. Drei Elfenhelferinnen statten hier den ,Loughton Candidate', einen rothaarigen Satyr mit weißem Anzug, gespielt von Matthew Barney, mit weißen Plastiksohlen und großen Perlen aus und bereiten ihn so auf seine Reise vor. Die vier Ein-buchtungen am Kopf des Loughton Candidate, die sich zu ebenso vielen Hörnern auswachsen wer-den, verweisen auf das auf der Isle of Man beheimatete Loughton-Schaf[1]. In der Krümmung ihrer Hörner – zwei sind nach oben, zwei nach unten gekrümmt – erkennt Barney den von ihm intendier-ten Zustand der Indifferenz. Parallel zum Geschehen auf dem Queen's Pier starten zwei Motorrad-teams – in Anspielung auf das auf der Isle of Man jährlich stattfindende Motorradrennen ,Tourist Trophy' (TT) – in entgegengesetzter Richtung ihre Umrundung der Insel. Die Tour beginnt im Tief-land, und da das gelbe Motorradteam im Uhrzeigersinn die Insel umrundet, durchquert es, in An-spielung auf das biologische Modell, als ,Ascending Hack' ein ,aufsteigendes Feld'. Das blaue Team des ,Descending Hack' hingegen bewegt sich in der entgegengesetzten Richtung und beschreibt ein ,absteigendes Feld'. Beide Mannschaften tragen in ihrem Logo das Triskelion-Emblem, das offi-zielle Wappenzeichen der Isle of Man. Nahaufnahmen der Fahrer zeigen gallenartige Geschlechts-drüsen, undifferenzierte Geschlechtsorgane, die aus den Schlitzen ihrer Anzüge hervorquellen. Inzwischen ist der Loughton Candidate aufgrund seines unermüdlichen Stepptanzes durch den Boden des Hauses gebrochen. Mit seinem Sturz ins Wasser erreicht die vorgeschlechtliche Einheit ihren Scheideweg. Der Candidate erreicht Land und kämpft sich nun mühevoll durch einen verschlungenen Stollen zur Ziellinie der ,Tourist Trophy', wo er auf eine Verschmelzung hofft, um seine biologische Determination zu überwinden. *CREMASTER 4* endet auf dem Queen's Pier, wo ein geteilter weißer Vorhang den Blick auf in Vaseline getauchte Hoden freigibt. Der hormonale Differenzierungstrieb hat sich entgegen dem Widerstand des Loughton Candidate durchgesetzt und eine männliche Form gewählt. Da der männliche Hoden nicht symmetrisch hängt und damit laut Barney in der klas-sischen und klassizistischen Kunst zur Kontrapost-Stellung des Mannes führte, sollen die Schnüre, die den Hoden mit den Motorrädern verbinden, den männlichen Körper wieder ins Gleichgewicht bringen.

1 James Lingwood: „Keeping Track of Matthew Barney", in: *The Art Magazine*, Nr. 6, 1995, S. 52f.

DRAWING RESTRAINT 7: Storyboard drawing
1993
7 Zeichnungen, je | 7 drawings, each
7,62 × 12,5 cm

ENVELOPA: Drawing Restraint 7 (Guillotine)
1993
Rahmen | Frame 7-teilig,
je | 7 parts, each 28,6 × 36,5 × 3,8 cm

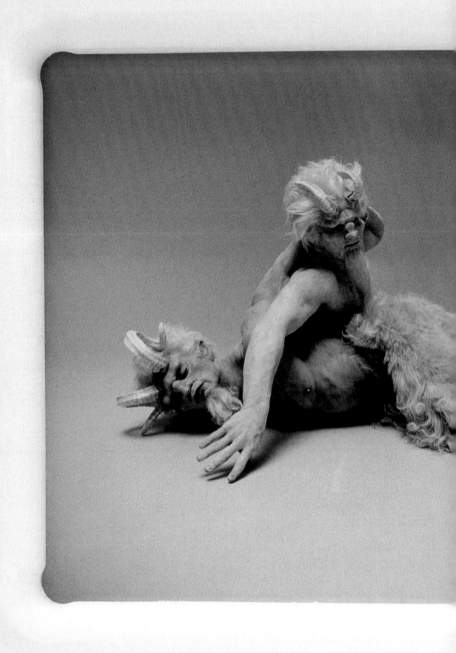

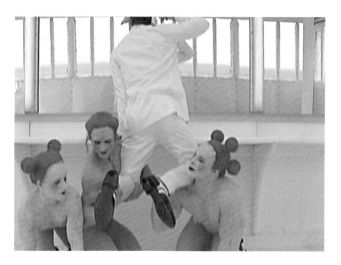

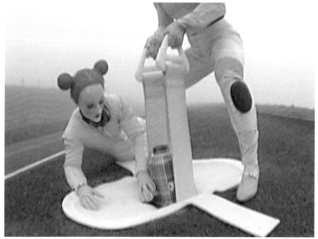

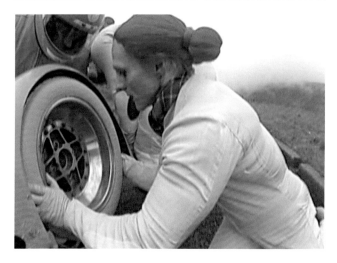

CREMASTER 4

While *CREMASTER 3* mainly deals with self-reflection, the first part of *CREMASTER 4* is overshadowed by the fact that the organism – adhering to its biological model – is rushing inexhorably towards its descent, in spite of its resistance. The action begins and ends in a house lined in white vinyl on the Queen's Pier. Three elf assistants are fitting out the 'Loughton Candidate', – a red-haired satyr in a white suit, played by Matthew Barney, with plastic soles and large pearls – in preparation for his journey. The four indentations on the head of the Loughton Candidate, which will grow into four horns, allude to the Loughton sheep, native to the Isle of Man.[1] In the curvature of their horns – two upwards, two downwards – Barney detects the state of sexual neutrality. While the Loughton Candidate is getting ready on the Queen's Pier, two motorcycle teams begin their circuit of the island in opposite directions – an allusion to the motorcycle race the Tourist Trophy (TT) which takes place every year on the Isle of Man. The tour begins in the lowlands, and the yellow motorcycle team circles the island in a clockwise direction, and, thus, in allusion to the biological model, traverses an 'ascending field' as 'ascending hack'. The blue team of the descending hack, on the other hand, moves in the opposite direction and illustrates a 'descending field'. Both teams bear the Manx Triskelion emblem, the official coat of arms of the Isle of Man, as part of their logo/insignia. Close-ups of the drivers show gall-like sex glands, undifferentiated sexual organs, which swell forth out of the slits in their suits. In the meantime, the Loughton Candidate has broken through the floor of the house by dint of his indefatigable tap dancing. With his fall into the water, the pre-sexual unity arrives at its crossroads. The Candidate reaches land and struggles through a tortuous tunnel to the goal line of the Tourist Trophy, where he hopes to find unity of opposites and resist his biological determination. *CREMASTER 4* ends at the Queen's Pier where open white curtains reveal testicles dipped in Vaseline. The hormonal drive to differentiation has asserted itself against the Loughton Candidate's resistance and chosen a masculine form. Since the testicles do not hang symmetrically and therefore, according to Barney, led to the contrapost position of the male figure in classical and neo-classical art, the function of the laces which tie the testicles to the motorcycles is to help balance the masculine body.

1 James Lingwood: *Keeping Track of Matthew Barney*, in: *The Art Magazine*, no. 6, 1995, pp. 52–53.

CREMASTER 4
1994
Filmstills

CREMASTER 5

CREMASTER 5, der letzte und abschließende Teil der Erzählung, schildert den Abstieg in Form einer tragischen Liebesoper, die den Erinnerungen der Queen of Chain, der ‚Königin der Ketten' zu entspringen und die biologischen Metaphern in Form von emotionalen Zuständen darzustellen scheint. Vor der romantischen Kulisse Budapests inszenieren die Königin, gespielt von Ursula Andress, ‚ihre Diva', ‚ihr Magier' und der ‚Riese' (alle drei Figuren werden von Matthew Barney gespielt) die im Zyklus erwartete Erlösung. Während die männliche Diva vor den Augen der Königin ihre Vorstellung gibt, ist diese in Gedanken bei ihrem Magier. Wie *CREMASTER 2* und *3*, erhält auch in *CREMASTER 5* die Figur des Harry Houdini eine entscheidende Rolle, umso mehr als Houdini 1874 unter dem Namen Erich Weisz in Budapest das Licht der Welt erblickte. Die Königin sieht vor ihrem geistigen Auge den Magier auf einem Brückensockel stehen und glaubt, er wolle sich das Leben nehmen. Doch dieser sucht in seinem Tun Transzendenz und damit einen Ort des Möglichen – frei von jedem deterministischen Zwang. Die Begleiterinnen der Königin lenken im folgenden Verlauf ihre Aufmerksamkeit wieder auf die Oper und ihren Blick auf die unter ihr sich befindenden Budapester Gellért-Bäder, die in diesem Moment von dem Riesen betreten werden. Wassergeister versammeln sich um ihn und befestigen an seinem Hodensack eine Girlande. Es kommt zu einem entscheidenden Augenblick, als sich im warmen Wasser des Thermalbades der Cremaster-Muskel entspannt und der Hoden absinkt. Das Aufsteigen der Tauben signalisiert das Erreichen eines völlig differenzierten Zustandes.

Im gleichen Moment kehren die Gedanken der Königin zu ihrem Magier zurück, und sie verliert das Bewusstsein. Die männliche Diva stürzt auf die Bühne, während der Magier auf den Grund des Flusses sinkt, wo ihm Wassernixen eine schwarze Perle in den Mund stecken – ein Begräbnisritual, das Verstorbenen ein langes Leben im Jenseits garantieren soll. Das Schicksal der anderen vor Augen, ist schließlich auch die Königin zum Sterben bereit, um sich im Tod mit ihrem Geliebten vereinigen zu können.

Der *CREMASTER Cycle* stellt ein hochkomplexes Schichtenmodell von Handlungsebenen dar, in dem sich historische und mystische Ereignisse mit architektonischen Vorstellungen und biologischen Modellen verbinden. Die Ausstattung der Filme variiert je nach Drehort und der dargestellten Zeitspanne, wobei Barney immer wieder spezifische Stilmerkmale einer Epoche, wie Tanzrevuen der 1930er- und 1940er-Jahre, viktorianische Körperkultur, Barockoper oder die Architektur des Art déco als visuelle Leitmotive für die Erzählung nutzt. Jeder Film kann seiner Form nach als selbstständiges Kunstwerk bestehen, bildet jedoch gleichzeitig mit den anderen Teilen ein geschlossenes System. Die Zeit fungiert als ein bestimmendes Bindeglied und schafft ein abstraktes Maß, das die für ge-

DRAWING RESTRAINT 7: Storyboard drawing
1993
7 Zeichnungen, je | 7 drawings, each
7,62 × 12,5 cm

ENVELOPA: Drawing Restraint 7 (Guillotine)
1993
Rahmen | Frame 7-teilig,
je | 7 parts, each 28,6 × 36,5 × 3,8 cm

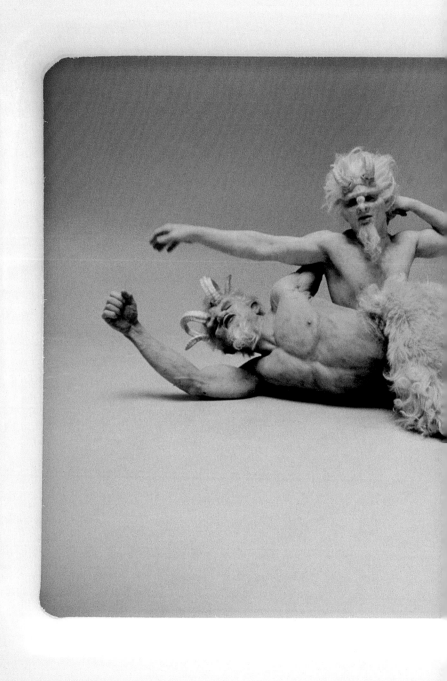

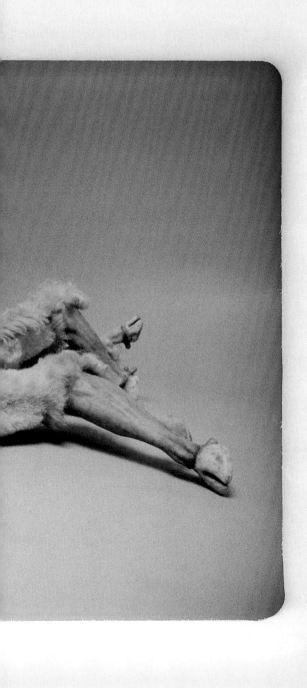

wöhnlich im Hintergrund erscheinenden Elemente wie Landschaft oder Kulisse nach vorne treten lässt. Matthew Barney versteht sich selbst mehr als Bildhauer denn als Regisseur. Die Filme dienen ihm in erster Linie, wie er selbst sagt, als Steinbruch, aus denen er einzelne Stücke herausbrechen kann, die dann in der Lage sind, für sich zu stehen. Die skulpturalen Requisiten erhalten eine inhaltliche Bedeutung, die den Erzählfluss der Handlung des *CREMASTER Cycle* maßgeblich bestimmt – gleichzeitig bilden diese ästhetischen Elemente ein geschlossenes Ganzes und lassen als „sekundäre Formen"[1] die skulpturale Intention des Künstlers deutlich zutage treten.

Die dem Zyklus zugrunde liegenden biologischen bzw. medizinischen und sportlichen Aspekte, die den Körper als zentrales Thema in den Vordergrund rücken, finden sich bereits in frühen Objekten und Installationen Barneys. Installative Arbeiten wie *unit BOLUS* (1991), *TRANSSEXUALIS* (1991) oder Videos wie *BLIND PERINEUM* (1991) lenken den Blick des Betrachters auf die Vision eines perfekt durchtrainierten Körpers und verweisen auf einen Organismus, der nach psychischer und physischer Transzendenz zu suchen scheint. Immer wieder personifiziert Barney die einzelnen Aspekte dieser Herangehensweise in der Gegenüberstellung zweier Figuren: Jim Otto, der legendäre Mittelmann des Football-Teams Oakland Raiders, und der Entfesselungskünstler Harry Houdini. Während sich Houdini in seinem Tun einer Differenzierung verweigert und seinen Körper durch extreme Disziplin und ein intuitives Verständnis für Fesselmechanismen kontrolliert, legt Jim Otto ein extrovertiertes Naturell an den Tag, dessen nach außen gerichtete Aggression ihn schließlich zum Erfolg führt.[2] Beide Männer verbindet der Wille zu körperlicher Omnipotenz, die sie auf gewisse Art und Weise als Helden kennzeichnet – Helden im Sinne tragischer Gestalten, deren Geschichten nie eine Auflösung erfahren.

Dieser unbetitelte Beitrag von Domenika Szope wurde erstmals veröffentlicht in: *fast forward. Media Art Sammlung Goetz*, hrsg. von Ingvild Goetz und Stephan Urbaschek, Ausst.-Kat. Sammlung Goetz, München; ZKM I Zentrum für Kunst und Medientechnologie Karlsruhe, München 2003, S. 84–99.

1 Matthew Barney: „Interview mit Jérôme Sans", in: *Faustrecht der Freiheit*, Ausst.-Kat. Kunstsammlung Gera; Neues Museum Weserburg Bremen, Gera 1996, S. 69.
2 Nancy Spector: „Nur die perverse Phantasie kann uns noch retten", in: *Matthew Barney: The CREMASTER Cycle*, Ausst.-Kat. Museum Ludwig, Köln; Musée d'Art Moderne de la Ville de Paris, Paris; Solomon R. Guggenheim Museum, New York, Ostfildern-Ruit 2002, S. 12.

CREMASTER 5
1997
Filmstills

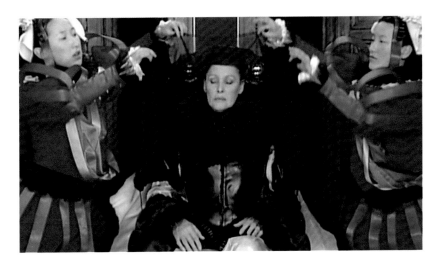

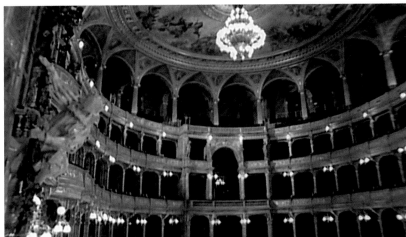

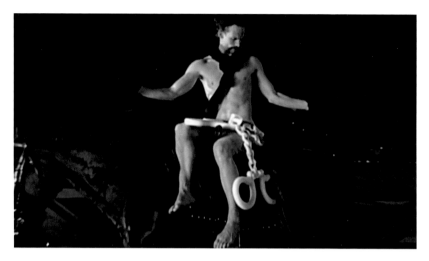

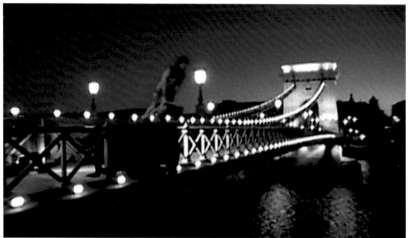

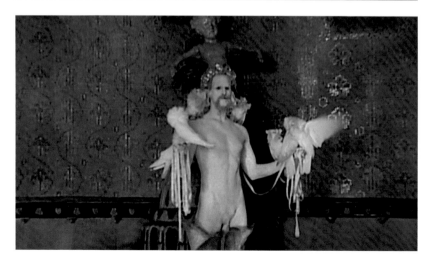

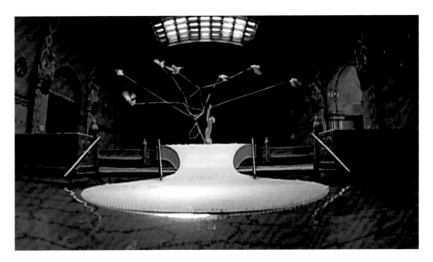

CREMASTER 5

CREMASTER 5, the last and concluding part of the narrative, describes the descent in the form of an opera about tragic love, which appears to have its source in memories of the 'Queen of Chains' and to represent the biological metaphor in the form of emotional states. Located in a romantic setting in Budapest, the Queen (played by Ursula Andress), 'Her Diva', 'Her Magician' and the 'Giant' (all played by Matthew Barney) stage out the redemption expected in the cycle. While the diva performs before the Queen, the thoughts of the latter are with her magician. As in *CREMASTER 2* and *3*, the figure of Harry Houdini plays a decisive role in this episode, too, all the more so as Houdini first saw the light of day in Budapest in 1874, where he was born as Erich Weisz. The Queen of Chains sees the magician in her mind's eye standing on a bridge and thinks he is about to take his own life when, in fact, he is seeking transcendence through his deed and thus a place for possibility – free of all deterministic pressure. In the following scenes, the Queen's companions again direct their attention to the opera, and then to the Budapest Gellért Baths below them, just as a giant enters. Water nymphs gather round him and attach a garland to his testicles. A decisive moment arrives when, in the warm water of the thermal bath, the cremaster muscle relaxes and the testicles sink. The ascent of doves signals the accomplishment of a wholly different state.

At the same moment, the Queen's thoughts return to her magician and she loses consciousness. The Diva collapses on the stage, while the Magician sinks to the bottom of the river, where water nixes place a black pearl in his mouth – a burying ritual that is supposed to guarantee the dead man a long afterlife. Remembering the fate of the others, the Queen is now ready to die, to finally be united with her lover through her death.

The *CREMASTER Cycle* represents a highly complex, intricate model of levels of action, in which historical and mystical events are bound up with architectural ideas and biological models. The design of the films varies according to the scene and the time frame, whereby Barney always uses specific stylistic traits from a specific period, such as the dance revues of the 1930s and 1940s, Victorian body culture, Baroque opera or the architecture of art deco, as visual leitmotifs for the narrative. Each film can exist as an independent work of art, but at the same time forms a closed cycle with the other parts. Time functions as a determining link and creates an abstract measure that emphasizes elements which usually appear in the background, such as landscape or scenery. Matthew Barney regards himself more as a sculptor than as a director. The films serve him, as he says, primarily as a quarry from which he can carve out individual pieces which also function on their own: Individual elements, which appear in a film as props or as parts of the scenery, become an installation. These are already sculptures in the strict sense. The sculptural props receive a meaning that decisively influences the narrative flow of the action; at the same time, these aesthetic elements form a closed system and allow the sculptural intention of the artist to come to light in "secondary forms."[1]

The *CREMASTER Cycle's* biological, medical and athletic themes, which focus on the central subject of the body, are already to be found in Barney's earlier objects and installations. Installative works such as *unit BOLUS* (1991), *TRANSSEXUALIS* (1991), or videos such as *BLIND PERINEUM* (1991), present the viewer with the vision of a perfectly trained body and indicate an organism that appears to seek both psychological and physical transcendence. Repeatedly Barney personifies the individual aspects of this approach in the opposition of two figures: Jim Otto, the legendary football player of the Oakland Raiders and the escape artist Harry Houdini. Whereas Houdini refuses differentiation and controls his body by extreme discipline and an intuitive understanding of escape techniques, Jim Otto uses his extravert nature and outward aggression to achieve a successful career.[2] Both men's desire for physical omnipotence gives them something in common, a characteristic which in a way marks the two men as heroes – heroes in the sense of tragic figures, whose stories never have a happy end.

Translation: Jonathan Uhlaner

This untitled essay by Domenika Szope was first published in: *fast forward. Media Art Sammlung Goetz*, editors: Ingvild Goetz and Stephan Urbaschek, Sammlung Goetz, Munich; ZKM I Zentrum für Kunst und Medientechnologie Karlsruhe, Munich 2003, pp. 457–460.

1 Matthew Barney: *Interview mit Jérôme Sans,* in: *Faustrecht der Freiheit,* exh. cat. Kunstsammlung Gera, Gera; Neues Museum Weserburg Bremen, exh. cat. Bremen, Gera 1996, pp. 66-71.

2 Nancy Spector, *Nur die perverse Phantasie kann uns noch retten*, Matthew Barney*: The CREMASTER Cycle*, exh. cat. Museum Ludwig, Cologne; Musée d'Art Moderne de la Ville de Paris, Paris; Solomon R. Guggenheim Museum, New York, Ostfildern-Ruit: Hatje Cantz Verlag, 2002, p. 12.

Zu DRAWING RESTRAINT 9

Karsten Löckemann

DRAWING RESTRAINT 9 ist das neunte Werk in einem Zyklus, der bereits in den 1980er-Jahren initiiert wurde und bis heute von Matthew Barney fortgesetzt wird. Das Projekt begann ursprünglich als Experiment im Atelier des Künstlers und hat im Laufe der Zeit immer narrativere Züge angenommen. Auf Einladung des 21st Century Museum of Contemporary Art im japanischen Kanazawa entstanden dieser Film und einige Skulpturen, die sich mit der japanischen Kultur aus der Perspektive eines abendländischen Beobachters auseinandersetzen.[1]

Fast die gesamte Handlung des technisch perfekt umgesetzten Werks spielt auf dem japanischen Walfangschiff Nisshin Maru. Der Betrachter wird auf dem Schiff mit zwei parallel erzählten Geschichten konfrontiert. Mit der Wahl dieses Drehorts wird auch indirekt die seit Jahrzehnten umstrittene Walfangpolitik Japans und die Zerstörung des ökologischen Gleichgewichts der Weltmeere durch menschliche Eingriffe thematisiert. Die Nisshin Maru steht seit Jahren auf der Roten Liste diverser Umweltschutzorganisationen.

Der Film beginnt mit einer Prozession vor einer japanischen Ölraffinerie. Von dem Werksgelände aus wird ein mit heißer Vaseline beladener Tanklastwagen zum örtlichen Hafen hinabgeleitet. Die Vaseline symbolisiert den Tran des Wals, der lange Zeit der Grundstoff für die Herstellung zahlreicher Produkte war. Hunderte von schaulustigen Japanern säumen den Weg des von Ochsen, Pferden, Hirschen und Wildschweinen gezogenen Tanklastwagens. Dieser Triumphzug führt den Betrachter in eine fremde und exotische Welt, verkörpert durch unzählige Menschen: Arbeiter, Tänzer, Perlentaucherinnen und kleine Kinder. Die heiße Vaseline wird auf das im Hafen liegende Walfangschiff verladen und an Deck in eine offene Gussform gepumpt. Daraufhin bricht das Schiff in antarktische Gewässer auf. Während der Fahrt kühlt die Flüssigkeit ab und erreicht ihren typischen halbfesten, von Farbe

DRAWING RESTRAINT 7: Storyboard drawing
1993
7 Zeichnungen, je | 7 drawings, each
7,62×12,5 cm

ENVELOPA: Drawing Restraint 7 (Guillotine)
1993
Rahmen | Frame 7-teilig,
je | 7 parts, each 28,6×36,5×3,8 cm

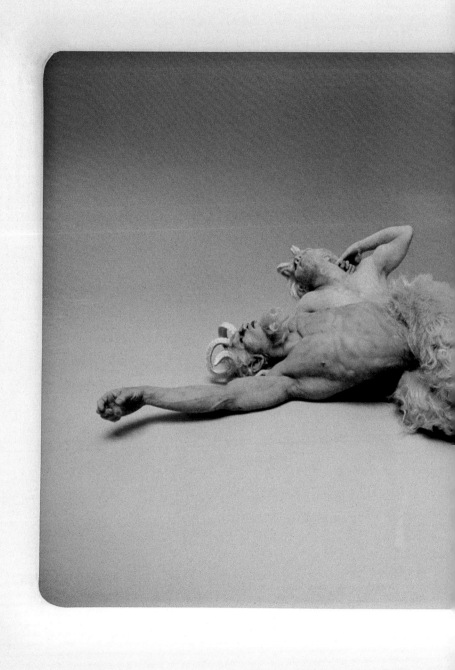

und Konsistenz an Walfett erinnernden Zustand. Mit den Methoden und Werkzeugen, die ansonsten bei der Verarbeitung von Walen zum Einsatz kommen, wird die getrocknete Masse in eine Skulptur in der Form eines Feldzeichens verwandelt. Das Feldzeichen steht als Signet für Barneys künstlerische Arbeit. Vor dem Hintergrund antarktischer Eisberge wird diese Skulptur schließlich aus ihrer Gussform gelöst.

Unter Deck des Schiffes spielt sich währenddessen eine Liebesgeschichte ab. Zwei westliche Gäste, verkörpert von Barney und seiner Lebensgefährtin Björk, lassen sich in die Geheimnisse des japanischen Teezeremoniells einweisen. Jede Bewegung, jedes Kleidungsstück, jede Geste und jeder Gegenstand hat während dieses Rituals seine eigene Bedeutung. Die streng geregelte Choreografie einer traditionellen Teezeremonie bildet den Rahmen für die Beziehung der beiden Gäste zueinander, die sich verlieben, während ihnen von der Schiffsbesatzung Tee serviert wird. Nach diesem eigenwilligen, exotischen Schauspiel kommt es zwischen den beiden Hauptdarstellern zu einer zärtlichen und gleichzeitig grausamen Verschmelzung in der Teestube, die zur ‚Teekanne' geworden ist und sich langsam mit Vaseline füllt. Angelehnt an das japanische Sashimi, beginnen Björk und Barney, beide mit scharfen Messern bewaffnet, sich gegenseitig die Beine zu filetieren und in Wale zu verwandeln. Die faszinierende Reise findet in diesen Bildern hier ihren Höhepunkt. Die finale Szene zeigt zwei Wale, die im antarktischen Meer davonschwimmen.

Untermalt werden die diversen Szenarien von einem ungewöhnlichen Soundtrack, der die Atmosphäre des Films maßgeblich prägt. Björk entwickelte für dieses Projekt eine Kombination aus traditionellen japanischen Klängen und eigenen Kompositionen.

Ähnlich wie im *CREMASTER Cycle* können auch hier Metamorphosen, Mutationen, Verflüssigungen, vergehende und werdende Formen entdeckt werden. Der Betrachter findet sich wie dort in *DRAWING RESTRAINT 9* inmitten des Kosmos und in den fantastischen Bildwelten von Matthew Barney, dieses Mal jedoch vor dem Hintergrund einer fernöstlichen Kulisse.

1 Nancy Spector: „in potentia. Matthew Barney und Joseph Beuys", in: *Matthew Barney and Joseph Beuys. All in the present must be transformed*, Ausst.-Kat. Deutsche Guggenheim, Berlin; Peggy Guggenheim Collection, Venedig 2006, S. 32.

DRAWING RESTRAINT 9
2005
Filmstills

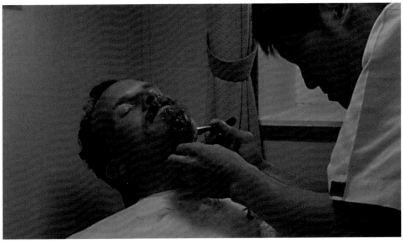

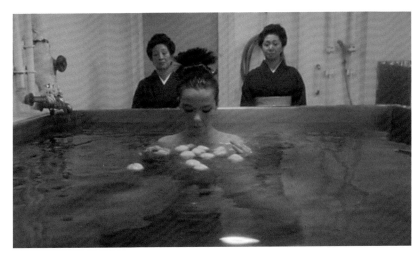

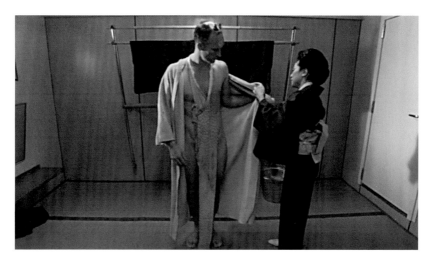

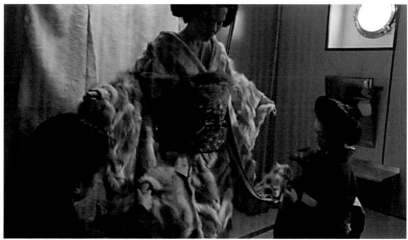

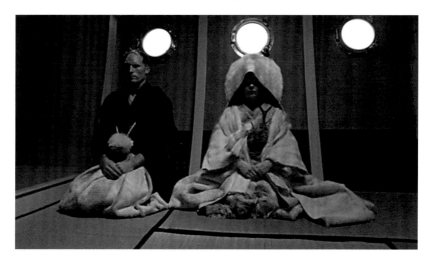

On DRAWING RESTRAINT 9

Karsten Löckemann

DRAWING RESTRAINT 9 is the ninth work in a series that Matthew Barney began in the 1980s and has continued to develop ever since. The project originally started out as an experiment in the artist's studio and, over the course of time, has taken on increasingly narrative traits. This film and some of the sculptures, engaging with Japanese culture from a western viewpoint, were created at the invitation of the 21st Century Museum of Contemporary Art in Kanazawa, Japan.[1]

Executed with technical perfection, the work is set almost entirely aboard the Japanese whaling vessel Nisshin Maru. Viewers are presented with two parallel narratives on the ship. The choice of location indirectly addresses Japan's long-controversial whaling policy and the destruction of the delicate marine eco-balance by human hand. For years now, the Nisshin Maru has been a thorn in the side of several environmental protection organizations.

The film opens with a procession at a Japanese oil refinery. A truck loaded with hot Vaseline is paraded down to the local port. The Vaseline symbolizes the whale oil that, for many years, was used as a raw material in the production of a wide variety of products. Hundreds of curious onlookers line the route of the truck, which is drawn by oxen, horses, deer and boars. This triumphal procession leads the viewer into a strange and exotic world, peopled by countless figures of workers, dancers, pearl-divers and little children. The hot Vaseline is loaded onto the docked whaling vessel and pumped into an open mold on deck. The ship then sets sail for Antarctic waters. During the voyage, the liquid cools down until it reaches its typically semi-solid consistency reminiscent of whale blubber. Using the tools and techniques of the whaling industry, the dried mass is transformed into a sculpture in the form of the field emblem that is the hallmark of Barney's artistic work. Finally, against the back-drop of Antarctic icebergs, the sculpture is released from the mold.

Meanwhile, below deck, a love story unfolds. Two western guests, played by Barney and his partner Björk, are being initiated into the mysteries of the Japanese tea ceremony. Every movement, every item of clothing and every object has its own special significance in this ritual. The stringently orchestrated choreography of the traditional tea ceremony sets the framework for the relationship between the two

guests, who fall in love while being served tea by the ship's crew. This strange and exotic performance culminates in the tender but brutal fusion of the two main characters in the tearoom, which has become a 'teapot' filling slowly with Vaseline. Björk and Barney, both wielding flensing knives, begin slicing each other's legs in echoes of Japanese sashimi, as they turn into whales. The fascinating journey reaches its climax in these images. The closing scene shows two whales swimming away in the Antarctic seas.

The various scenes in the film are underpinned by a remarkable soundtrack that sets the overall atmosphere of the film. For this project, Björk developed a combination of traditional Japanese sounds and her own compositions.

As in the *CREMASTER Cycle,* we find metamorphosis, mutation, liquefaction, and waxing and waning forms. In *DRAWING RESTRAINT 9,* too, the viewer is cast into the midst of Matthew Barney's cosmos of fantastical imagery – only this time, against a far-eastern backdrop.

Translation: Ishbel Flett

1 Nancy Spector: *"in potentia. Matthew Barney and Joseph Beuys",* in: *Matthew Barney and Joseph Beuys. All in the present must be transformed,* exh. cat. Deutsche Guggenheim, Berlin; Peggy Guggenheim Collection, Venice 2006, p. 32.

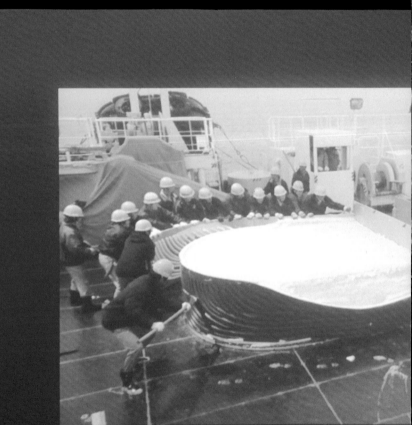

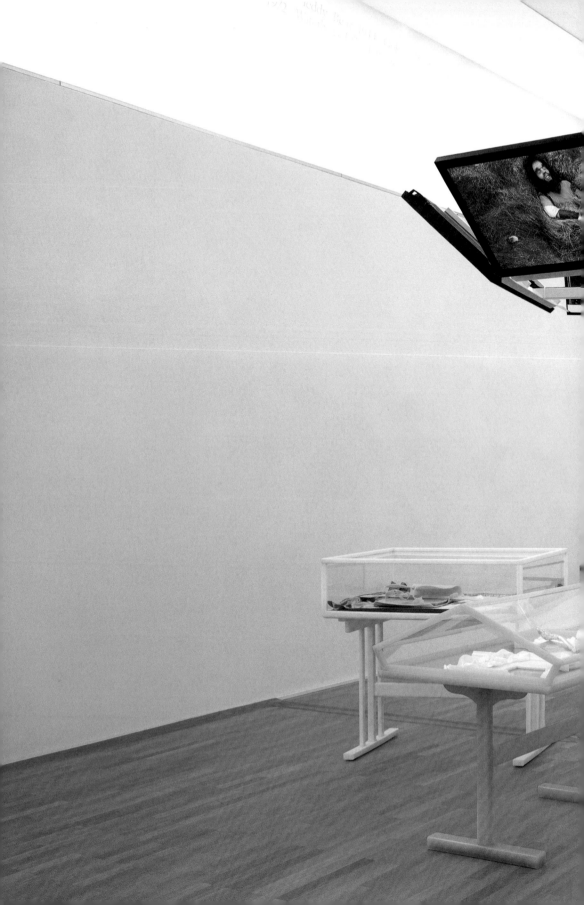

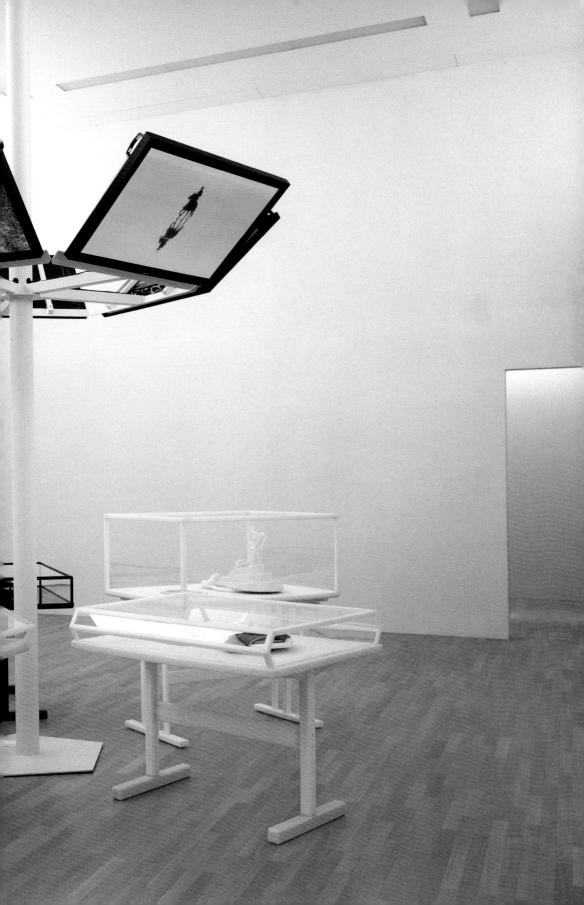

Verhängnisvolle Formeln für das Fleisch – Über den Sound im CREMASTER Cycle

Brandon Stosuy

Schließen Sie die Augen, wenn Sie den großen Ausstellungsraum im Untergeschoss der Sammlung Goetz betreten. Fünf Monitore, auf denen jeweils ein *CREMASTER*-Film zu sehen ist, lassen sich visuell unmöglich gleichzeitig wahrnehmen, doch der Ton ist leicht zu erfassen. Genaues Zuhören eröffnet einen neuen Zugang, eine neue Architektur oder zumindest einen anderen Weg, die Komplexität des *CREMASTER Cycle* zu verstehen. Außerdem ist es von zentraler Bedeutung für die Diskussion einer Sensibilität, für Themen wie Geräusch, Performance und Kooperation.

Matthew Barney hat erklärt, er habe sich biologischer Grundsätze bedient, um den *CREMASTER Cycle* zu organisieren und um Konflikte und Narrative in das System einzuführen (fünf Zustände, die durch eine einzige Linie miteinander verbunden sind). In der Fünf-Kanal-Installation *CREMASTER Cycle* spielt jeder Film eine Rolle, doch anders als bei einem biologischen System verändern sich diese Rollen ständig.

In der Fünf-Kanal-Installation des *CREMASTER Cycle*[1] fungieren die individuellen Filme als Gruppe, ohne dass dabei einer bevorzugt würde. Ein Film für sich genommen ist ein Solist, fünf sind eine opernhafte Collage.

Die Filme sind unterschiedlich lang, sodass Überschneidungen und Assoziationen ineinander übergehen. In einem Durchgang bilden der Stepptanz durch den Boden hindurch und der Sturz ins Meer des Loughton Candidate in *CREMASTER 4* eine Verdoppelung des Bienen-Beckens von *CREMASTER 2*. Im zweiten Durchlauf treffen sie überhaupt nicht aufeinander. Stattdessen bildet die Queen of Chain von *CREMASTER 5* ein Paar mit den Bienen, den Trommeln und dem Man in Black von *CREMASTER 2*. Bevor *CREMASTER 3* einmal vollständig gelaufen ist, haben die anderen Folgen bereits wieder angefangen. (Wenn man die eingebaute Pause überspringt, kann man die zeitliche Abfolge verändern.)

Regelmäßigkeit findet sich im steten Pulsieren hoher (Dudelsack), niedriger (Doppelbass) sowie im mittleren Spektrum angesiedelter Töne (menschliche Stimme). *CREMASTER 4* und *CREMASTER 1*,

die beiden Filme, für die Barney die Partitur größtenteils selbst verfasste, weisen das regelmäßigste Muster auf, das eine ständige Begleitung offeriert.

Spielt man die einzelnen Teile des *CREMASTER Cycle* jedoch mehrfach als ein Werk zugleich ab, wird es schwierig, genau zu bestimmen, welcher Film was macht: Klänge verschmelzen miteinander, Noten verunklären und Grenzen verwischen. Die Flachheit des einen wird durch die Opulenz des anderen verschoben (selbst wenn Innenräume nicht angetastet werden). Betrachtet man sie später einzeln, werden Phantom-Echos erzeugt, wie abgetrennte Gliedmaßen.

Das beste Ergebnis erzielt man, wenn man das System sowohl als miteinander verknüpfte als auch als individuelle Werke versteht.

Über die Struktur des *CREMASTER Cycle* – Ein Gespräch mit Matthew Barney, New York, August 2007

Brandon Stosuy: Warum hast du den *CREMASTER Cycle* nicht in der nummerischen Reihenfolge produziert?

Matthew Barney: Anfangs hatte das praktische Gründe. Ich begann, die allgemeine Struktur des *CREMASTER Cycle* aufzuzeichnen und die Schauplätze festzulegen, während von 1990 bis 1992 die Otto- bzw. Houdini-Werke[2] entstanden. In dieser Zeit fragte Artangel[3] bei mir an, ob ich daran interessiert sei, nach Großbritannien zu kommen und dort ein Projekt zu realisieren. Ich wusste, dass ich für das vierte Kapitel einen keltischen Schauplatz benutzen wollte, war mir aber über den genauen Ort noch nicht im Klaren. Das Projekt für Artangel war dann schließlich das Isle-of-Man-Kapitel. In Anbetracht der elliptischen Ambition des Zyklus fühlte es sich richtig an, das Projekt außerhalb der Sequenz zu machen. Die Tatsache, dass es außerhalb der Reihenfolge entstehen konnte, motivierte mich, und ich glaube, intuitiv beschloss ich, das Mittelstück bis zum Schluss aufzuheben, also ein Element, das sich zu diesem Rätsel entwickelte, einem X in der Mitte. Das Zentrum des *CREMASTER Cycle* ließ sich auf diese Weise beschreiben. [Barney steht auf und greift nach einem Holzstück mit einer Zeichnung darauf, auf die er während der Beschreibung des Folgenden hinweist.]

Während der Produktion von *CREMASTER 3* begann ich Linienzeichnungen zu machen, die den narrativen Bogen des gesamten Zyklus veranschaulichen sollten und die den Entstehungsprozess von *CREMASTER 3* auch wirklich geprägt haben. Ich wollte das Chrysler Building als facettenreichen Spiegel verwenden, als Mittelpunkt, der die beiden Hälften des Zyklus spiegeln sollte. In der Zeichnung kommt dies in der Figur Acht zum Ausdruck, die andeutet, dass alle Aspekte des Zyklus diesen Mittelpunkt durchlaufen sollen. Das X ist der Schnittpunkt in diesem elliptischen Loop, der zu der Figur Acht gedreht wurde. Alle diese auf dem Chor beruhenden Szenen, wie das Zerstörungsderby, die Zombie-Pferderennenszene und *The Order,* 2003, gehen auf diese Idee zurück, dass alle *CREMASTER*-Kapitel in *CREMASTER 3* repräsentiert sein würden.

So wie sich dieses Projekt über zehn Jahre organisch entwickelte, war diese X-Idee wie ein Rätsel für mich. Ich habe es mehr als einen psychologischen Zustand begriffen, als eine Art narzisstische Phase, die das Projekt durchlaufen musste. Es erschloss sich mir eigentlich erst, als ich mit diesen Zeichnungen begann. Es dauerte ein wenig, bis ich das Gefühl hatte, es sei okay, das Projekt als explizit autobiografisches zu betrachten oder als etwas, das mit der Herstellung von Selbstbildnissen zusammenhängt. Ich würde daher sagen, dass dies einer der Gründe ist, weshalb *CREMASTER 3* als Letztes realisiert wurde.

Inwiefern ist deine Biografie ansonsten in die Struktur eingeflossen?
Das *CREMASTER*-Projekt ist autobiografisch, auch wenn es den ganz bewussten Versuch gab, eine Art Gleichgewicht zwischen einerseits dem autobiografischen Material und andererseits dem mythologischen und intuitiveren abstrakten Material herzustellen. Es geht weniger darum, das Porträt eines Individuums zu schaffen, als um einen Komplex oder ein System, das eine individuelle Form beschreibt. Das wurde mir klarer, als ich 2005 mit der Gestaltung von *DRAWING RESTRAINT 9* begann, das, wie ich allmählich merkte, infolge meiner unsicheren Beziehung zu dem Container keine Beschreibung einer individuellen Form sein konnte. In Japan konnte ich keine Schnittstelle zur Umwelt finden, wie ich dies bei früheren Projekten getan hatte. Dass meine Sprache und der Schauplatz zwei separate Dinge bleiben würden, wurde tatsächlich zum Programm für das Werk. Es gibt einen Gastgeber bzw. Wirt und einen Gast, doch beide werden nie eins. Bei *CREMASTER* ist der Gast einem Virus vergleichbar, er steckt in dem Ding und wird Teil des Dings.

Wir haben über dein Interesse (und das des *CREMASTER Cycle*) gesprochen, den Unterschied zwischen Individuen zum Verschwinden zu bringen und darüber, in welchem Zusammenhang das mit dem Team und dem Umgang mit Unterschiedlichkeit unter eher psychoanalytischen Gesichtspunkten steht. Mir gefällt, dass dabei so vieles auf Football zurückgeht: die Teamarbeit, die laute, volkstümliche Unterhaltung, das Marschieren.
Stimmt. Es gibt da definitiv ein starkes Interesse daran, die Unterschiede zwischen einzelnen Elementen innerhalb des Systems verschwinden zu lassen. Das gilt für das gesamte Werk. Ich habe darüber gesprochen, dass die Figuren in den ‚Filmen‘ aus cineastischer Sicht kaum entwickelt sind. Ich möchte, dass sie auf eine ambivalente Weise gezwungen sind, zu tun, was sie tun und dass ihnen die emotionale Ausstrahlung fehlt, die eine Figur im Film normalerweise hat. Außerdem gibt es mehrere Szenen, in denen sich eine Figur verwandelt und zu einer Seite einer anderen Figur wird. Indem ich die Figuren so gestalte, hoffe ich, dass die Umwelt zur zentralen, emotionalen Figur werden kann. Und bei den Installationen ist es normalerweise so, dass die Beziehungen zwischen den Objekten genauso wichtig werden wie die Objekte selbst. Ich glaube, du hast recht, dass irgendwie alles auf Football zurückgeht. Vermutlich hat das u.a. damit zu tun, dass ich die mich prägenden Jahre auf dem Spielfeld zubrachte. Ich bin dort erwachsen geworden, sodass ein Großteil meiner Grundwerte und meiner Denkweise von der Leichtathletik beeinflusst ist.

Wie bist du von _Drawing Restraint 7_, eine Arbeit ohne Ton, zu _CREMASTER 4_ gekommen? Du hast mir erzählt, das sei dein erstes narratives Werk gewesen.

Wie bereits erwähnt, war ich 1992 zum ersten Mal auf der Isle of Man. Das war, bevor ich _Drawing Restraint 7_ machte. Die Loughton-Schafe mit ihren doppelten Hörnern (Abb. S. 64) auf der Isle of Man inspirierten das aufsteigende bzw. absteigende Horn-Motiv in _Drawing Restraint 7_. Während der Produktion von _Drawing Restraint 7_ wurde das aufsteigende bzw. absteigende Narrativ von _CREMASTER 4_ dann ausgestaltet.

Würdest du nochmals zu Videos ohne Ton zurückkehren?

Na klar. Die moderne Idee der Präsenz hat es mir nach wie vor sehr angetan, die Präsenz eines Objekts im Raum. Für mich hat diese Präsenz etwas mit Stille zu tun. Mir ist es am liebsten, wenn die ‚Filme' im Kino gezeigt werden, während die Videoarbeiten ohne Ton, die ich in der Vergangenheit gemacht habe, besser auf dem Monitor in einer Galerie aufgehoben sind, in der Nähe zum Objekt. Seit der Fertigstellung von _DRAWING RESTRAINT 9_ habe ich eine Reihe einfacher, tonloser _DRAWING-RESTRAINT_-Arbeiten gemacht (die Nummern 10 bis 15), und das war ein sehr gutes Gefühl.

Wir haben in der Vergangenheit ein paar Mal über dein Desinteresse an einer übertrieben aufwendigen Regieführung gesprochen im Hinblick auf den Slayer aus späterer Zeit oder die Death-Metal-Band Nile, bei der es um das Thema Ägypten geht. Was magst du an einem übertrieben aufwendig inszenierten Sound nicht?

Diese Frage ist schwieriger, als ich zunächst angenommen hatte. Es ist nicht so, dass eine aufwendige Produktion per se ein Problem ist. Problematisch wird es nur bei Material, das auf der inhaltlichen Ebene zu wünschen übrig lässt, vor allem bei Metal, wo die herkömmlichen Glocken und Pfeifen, deren man sich bedient, um die mangelnde Qualität zu kaschieren, so billig sind. Vielleicht ist ‚überdeterminiert' das bessere Wort. Irgendwie eliminiert eine überdeterminierte Form das Potenzial zu scheitern.

Wie wichtig ist dieses Potenzial des Scheiterns für den _CREMASTER Cycle_?

Eines der zentralen Themen des _CREMASTER Cycle_ ist die Entropie oder vielmehr das Ringen des _CREMASTER_-Systems mit seiner eigenen entropischen Natur. Es ist ein System, das sich entwickelt und gleichzeitig verfällt. In dem Narrativ gibt es viele Szenen, in denen das System vergeblich versucht, seinen entropischen Zustand zu überwinden. Auf performativer Ebene oder im Hinblick darauf, wie der Film unter dramatischen Gesichtspunkten funktioniert, gibt es eine andere Beziehung zum Scheitern. Ich glaube, ich bin sehr stark von der auf Mimik und Gestik beruhenden Komödie beeinflusst. Jener Art von Komödie, in der sich ein Gefühl der Erniedrigung durch ein momentanes Scheitern des Körpers oder eines Objekts in einer physischen Situation erzeugen lässt und in der die Erniedrigung subtil genug ist, um verinnerlicht zu werden.

Das Klangerlebnis des *CREMASTER Cycle* als Fünf-Kanal-Installation

Jeder *CREMASTER*-Film enthält Bereiche der Stille, die einem anderen Werk zu einem Solo verhelfen, es ihm erlauben, seinerseits die multivalente Partitur anzuführen. Nach 12 Minuten und 42 Sekunden, wenn alle Filme laufen, führt *CREMASTER 3* durch das Dröhnen des Theremins, wenngleich schwächer auch Goodyear (Abb. S. 26) und ihre Trauben zu hören sind. Nach 15 Minuten und 51 Sekunden herrscht die Sirk'sche melodramatische Musik im Bronco-Stadion aus *CREMASTER 1* vor. Nach etwa 22 Minuten weicht alles der Queen of Chain aus *CREMASTER 5*.

Eine weitere Hörübung besteht in dem Versuch, sich einzelne Töne herauszugreifen und verschiedene Paare mit ihnen zu bilden. In dem Diptychon *CREMASTER 4* und *CREMASTER 2* überlappt sich das Brummen des Dudelsacks mit dem der Orgel und später mit dem Summen der Bienen und der Motor-räder. Die Zyklen von *CREMASTER 4* verwandeln sich ebenfalls in Percussion, wenn man sie neben Dave Lombardos[4] Schlagzeug in der Bienen-Becken-Sequenz stellt (während das Klopfen des Satyrs einen Gegentakt[5] erzeugt). Steven Tuckers Stimme spiegelt die Zyklen, sodass ein Duett daraus wird. Sobald die Trommeln bzw. Zyklen innehalten, überbrücken die Dudelsäcke von *CREMASTER 4* die Stille. Wenn der Loughton Candidate dann durch den Boden ins Wasser fällt, wird sein Sturz zu einem ‚Becken-Platscher': die Glocke der Feen auf der Decke, die den Loughton Candidate bei seinem Rennen leitet, und ein Becken-Wirbel, der Lombardos Instrumentarium erweitert.

Synchronisiert man zwei verschiedene Filme, rücken andere Details in den Vordergrund: In dem Diptychon *CREMASTER 3* und *CREMASTER 2* bildet die Stille des Angestellten in der Mormonen-Tankstelle einen Gegensatz zum Zusammenprall der Fahrzeuge im Inneren des Chrysler Building. Das ist ein Beispiel für eine völlig andere Reihe von Verbindungen, eine neue Menge von Bindungen und Fokussierungen.

Die *CREMASTER*-Songs

CREMASTER 4, 1994 (42 Minuten)
Motoren und eine martialische Trommel lassen rasselnd einen hohen Dudelsackton erklingen. Nach einem stillen Übergang wird ein zunächst zögerliches, dann flüssiges Klopfgeräusch zunehmend rhythmischer. Motoren werden angelassen und heulen, den Dudelsackton aufnehmend, auf. Eine Glocke. Die Hauptgeräusche wechseln sich ab, bis das Stück mit einer Dreiwegeklimax endet.

CREMASTER 1, 1995 (40 Minuten)
Konservierte (oder live aufgeführte) sehr emotionale (oder heitere) Streicher werden von Stille (Raum), einer Music Box (kaum gefüllter Raum) und einem leichten Maschinensummen bzw. Hintergrundrhythmus unterbrochen. Zu viele Tusche, als dass sie sich zählen ließen. Eine nostalgische, spätabendliche Radiosendung.

Brandon Stosuy: Deine frühen Werke waren stumm. Warum hast du dich beim *CREMASTER Cycle* **entschieden, zum Ton überzugehen?**

Matthew Barney: Vor der Entstehung der *CREMASTER*-Filme habe ich mich für die Präsenz interessiert, die ein bewegtes Bild ohne Ton haben würde, wie das mit der Präsenz zusammengehen kann, die ein unbelebtes Objekt, die Skulptur, im Raum hat. Das ist eine komplizierte Frage, weil ich glaube, dass ich meiner Natur nach eher an der Präsenz der Skulptur interessiert bin. Skulpturen oder Installationen, die einen Soundtrack haben, interessieren mich z.B. überhaupt nicht. Als ich beschloss, Ein-Kanal-Werke zu machen, die in einem theatralischen Umfeld erlebt werden, die von Anfang bis Ende gesehen werden und die einen Soundtrack haben, eröffnete mir dies die Möglichkeit, mit anderen Dingen zu arbeiten, die mich interessieren, etwa Dissonanz und Simultaneität – nicht einfach nur der Bilder, sondern auch der Töne.

Vieles davon entfaltete sich, als ich Jonathan Bepler kennenlernte. Davor verwendete ich Umgebungsgeräusche und die Töne dessen, was man auf der Leinwand sieht, so wie es sich abspielt, und begriff diese durch den Prozess der Produktion sozusagen eher musikalisch. Doch da ich kein Musiker bin, hat sich das nie ernsthaft weiterentwickelt, bis ich ihn kennenlernte.

In *CREMASTER 4* spielt der Klang der Motorräder sicherlich eine wesentliche Rolle, bei dem Stepptanz und den Dudelsäcken war dies weniger der Fall. Ich bin mir nicht sicher, wie bewusst diese Entscheidung war, als ich diese Arbeit machte. Während der Nachbearbeitung bin ich mir darüber klarer geworden. Er enthält diese beiden verschiedenen Klangwelten, die sich in einem ständigen Konflikt miteinander befinden. Es gab da diese Idee der beiden gleichzeitig existierenden Räume. Sie sollten dieselbe zeitliche Grundlage haben und sich, nehme ich an, dadurch im Bewusstsein des Betrachters überschneiden. Natürlich dachte ich dabei nicht nur an das Umfeld des Loughton Candidate und das Geräusch des Stepptanzes, sondern auch an den Dudelsack, der gewissermaßen zu seinem Raum gehört, und wie das im Kontrast zu den Motorrädern funktionierte.

Zu Beginn der Zusammenarbeit zwischen Jonathan und mir war das Projekt in filmischer Hinsicht bereits in Gang gekommen. Die Werke wurden in Kinos gezeigt, und ich nahm Elemente in das Skript auf, die vom Ton und von der Musik motiviert wurden. Das Ergebnis weist dasselbe Gleichgewicht zwischen Klangdesign, Lärm und Komposition auf wie in Jonathans eigenem Programm.

Kannst du noch etwas genauer erklären, wie du mit dem Klang umgegangen bist oder wie du darüber dachtest, bevor du Jonathan getroffen hast?

Ich habe zwar nicht jede Menge Energie darauf verwendet, doch ich habe zumindest versucht, von Goodyear die Erlaubnis zu erhalten, für *CREMASTER 1* in einem ihrer Luftschiffe drehen zu dürfen, und das hätte natürlich die Sache wesentlich verändert. Das ganze Werk wäre dann vermutlich viel weniger zu so einer Art Konserven-Musical geworden. Es hätte vermutlich mehr von der Rohheit von *CREMASTER 4* gehabt. Als wir mit dem Bau der Sets begannen, habe ich angefangen, mir eher Busby-Berkeley-Filme[6] und die für sie typische Flachheit und Kontrolliertheit anzusehen. Es schien mir daher ganz folgerichtig, diese urheberrechtlich nicht geschützte Show-Melodiemusik zu benutzen, die etwas Flaches und zugleich Neutrales hatte.

Als Jonathan und ich uns kennenlernten, da hatte ich das Werk lustigerweise bereits mehr oder weniger geschnitten und diese Musikpartien eingefügt, die ziemlich schwer zu verkraften sind. [lacht] Ich fragte Jonathan, ob er einen Übergang für zwei von diesen Songs schreiben könne. Zum damaligen Zeitpunkt hatte ich keine Ahnung, wie sehr ich ihn damit beleidigte. [lacht]

Wenn man alle Filme zugleich laufen lässt, ist *CREMASTER 4* tendenziell der lauteste. Zwischen den anlaufenden Motoren, den Dudelsäcken und dem Stepptanz bietet er eine konstante bzw. nicht endende Klangquelle. Ich finde es interessant, dass das erste Werk, das du selbst gemacht hast, eine solche akustische Präsenz besitzt.
Ich glaube, viele der Dinge, von denen ich mich angezogen fühle, sind sehr laut, in musikalischer Hinsicht mit Sicherheit, aber auch was populäre Unterhaltung betrifft. Ich fühle mich von Dingen angezogen, die eine Dissonanz aufweisen, und ich glaube, die Entscheidungen, die bei *CREMASTER 4* getroffen wurden, haben damit etwas zu tun. Es gibt da auch die Idee von etwas, das keinen Anfang oder kein Ende hat, so wie die Dudelsackmärsche ursprünglich dazu dienten, eine militärische Formation von Punkt A nach Punkt B zu bringen. Natürlich gibt es Lieder für den Dudelsack, aber es handelt sich nicht um ein Instrument für Lieder. Es wurde entworfen, um eine Gruppe von Leuten in Marsch zu setzen. Die Dudelsäcke, die im Krieg verwendet wurden, sollten möglichst laut sein, um dem Gegner Angst einzujagen.

CREMASTER 5, 1997 (55 Minuten)

Eine vorwärtstreibende, orchestrale Musik und Hufe dominieren das Geschehen, geraten leicht aneinander und weichen einem Horn, Luftblasen und Blechblasinstrumenten höherer Tonlage. Ungarisch. Ein ausgelassen aufspielendes, dünnes Orchester und eine melancholische Oper, vermehrt um gelegentliche Umweltgeräusche: mit Flügeln schlagende Vögel, ein Band und Tropfen. Physikalität.

Brandon Stosuy: Wie passt die Oper von *CREMASTER 5* zu deinem Konzept des ,Songs'?
Matthew Barney: Meine Beziehung zur Oper hat definitiv etwas mit Raum, etwas mit organischer Architektur zu tun, damit, dass ein Opernhaus den Brustkorb und den Kehlkopf nachahmt und einen Schallraum erzeugt. Auf die gleiche Weise versucht der *CREMASTER Cycle* aus architektonischen, als narrative Schauplätzen fungierenden Zuständen Körper zu erzeugen. Das Opernhaus ist ein Körper, durch den eine Geschichte hindurchgeht.
Bei *CREMASTER 5* wurde mir klar, wie die Musik als Dialog des Films funktionieren kann. Dieser Prozess, die Musik zu entwickeln, während am Skript noch geschrieben wurde, sollte sich für die folgenden Filme als wichtig erweisen. Bei *CREMASTER 2* etwa mussten wir die Musik nur vor der Zeit für die Dave-Lombardo-Szene und die Patty-Griffin-Szene, in der die Musiker live vor der Kamera auftraten, einfrieren. Doch in der Zeit, in der viele der anderen Szenen aufgenommen wurden, hatte Jonathan bereits eine Skizze fertiggestellt, die allen Beteiligten zu einem besseren Verständnis der emotionalen Färbung und des Tempos der Szene verhalf. Zu Beginn des Rohschnitts war die Musik für eine solche Szene bereits fast fertig. Jetzt werden die meisten Szenen anhand eines fertigen oder fast fertigen Musikstücks geschnitten.

CREMASTER 2, 1999 (79 Minuten)

Orgel, Geflüster, Basschor, Bienen/Brummen, ein Anschwellen der Metal Music mit Doppelbass und Todesgesängen: „Die Geister sind auf mich niedergegangen und machen sich gewaltsam über mich her/Ich schlage sie nieder, aber sie schleichen sich wieder heran und klettern herein/Als die Dämonen, die sie sind, erzählen sie mir dreckige Witze/Sie wollen meinen Willen aussaugen, meine Stärke trinken, mir meine Hoffnung rauben/Verlorene leere widerliche Dämonenarschlöcher." Man hört das Geräusch einer Schusswaffe, denselben Chor, einen Trommelwirbel, ein klassisches Anschwellen der Musik gepaart mit einer Kuhglocke. Ein Tamburin führt einen schneidend-schroffen, gewundenen Twostepp mit weiblichen Stimmen an: einen Chor schmelzender Eistropfen. Trotz der Fülle von Tönen gibt es lange Abschnitte der Stille: der amerikanische Westen.

Brandon Stosuy: Hast du einmal versucht, dein spezifisches Interesse an Metal Music zu analysieren?
Matthew Barney: Ich habe mich schon immer von geronnenem Blut angezogen gefühlt. Ich fühle mich unmittelbar von allem angezogen, das ich nur auf einer instinktiven Ebene verstehen oder erfahren kann. Als ich jünger war, waren das Horrorfilme für mich. Death Metal, das ich mag, funktioniert nach diesem Prinzip, sowohl was die Intention bzw. die Texte betrifft als auch den Sound. Es ist nicht erzählerisch oder mit Mythologie verknüpft, wie dies bei Black Metal der Fall ist. Da ich ein erzählerischer Künstler bin, glaube ich, dass ich mich am stärksten zu Künstlern hingezogen fühle, deren Werke anders funktionieren als meine eigenen: Richard Serra, Cannibal Corpse usw. Das geht auf den Begriff der Feldsensibilität zurück. Das ist etwas, das es bei Metal und Lärm aller Art gibt und das ich brauche: ein instinktives, nicht hierarchisches, abstraktes Feld, eines, das eine emotionale Bandbreite hat, aber nicht mit dem Individuum zusammenhängt. Also keinen Sänger, der einen lesbaren Text von sich gibt, kein Gefühl der Neurose eines Individuums, kein emotionales Narrativ, sondern einfach nur ein ambivalentes Feld, wie es in der Natur vorkommt.

Wie führte dein Interesse an Lärm und Lautem zum Einsatz von Heavy Metal in *CREMASTER 2*?
Die Garry-Gilmore-Geschichte begann allmählich ein Teil des Skripts *von CREMASTER 2* zu werden. Er wechselte Briefe mit Nicole, seiner Freundin, während er in der Todeszelle saß, und einige von ihnen könnten, so wie sie geschrieben sind, direkt von einer Metal-Platte stammen. Wir hatten *CREMASTER 5* gerade abgeschlossen und dabei von mir verfasste Texte verwendet, die von einem Sopran gesungen wurden. Es war ein gutes Gefühl, dass in einem dieser Werke ein Text vorkommen konnte. Ich glaube also, ich hatte diesen Impuls, Text in der Musik zu verwenden. Ich hatte dabei das Gefühl, es sei eine Möglichkeit, diese Briefe in die Geschichte einzubeziehen.

Wie sehr musstest du die Briefe bearbeiten?
Nicht sehr. Manchmal wurden einzelne Zeilen oder Worte getilgt, um den Text singbarer zu machen. Es gab, glaube ich, einen Fall, in dem Teile der beiden unterschiedlichen Briefe zu einem Text kombiniert wurden.

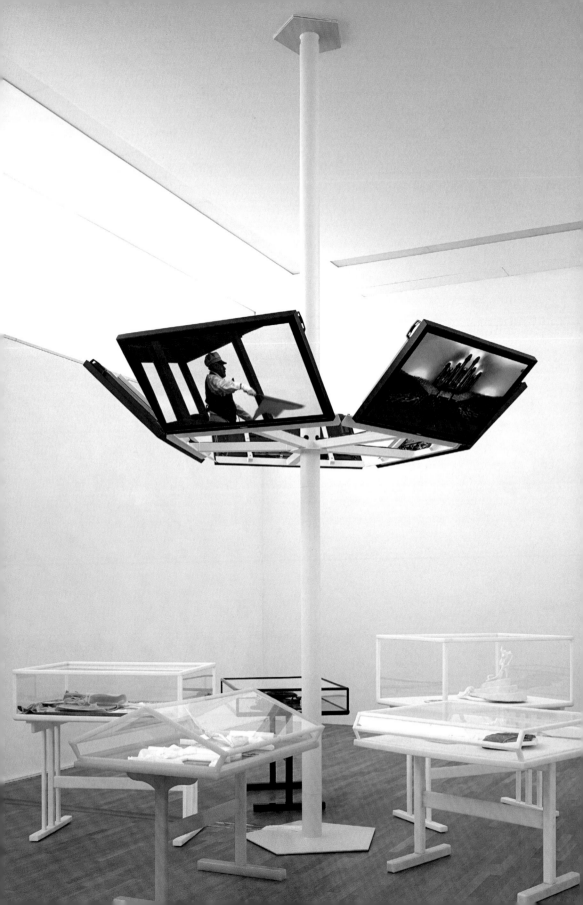

An welche Art von Metal haben dich die Briefe erinnert?

Nicht an echte zeitgenössische Metal Music. Gilmores Briefe haben mehr mit einer Musik wie der von Slayer zu tun, dieser Ära von Thrash Metal. Ich habe über Slayer sowohl unter dem Gesichtspunkt des stilistischen bzw. schauerromantischen Charakters mancher Briefe Garys nachgedacht als auch unter dem Gesichtspunkt paralleler väterlicher Konstellationen:

– von Mailer zu Gilmore, Gilmore zu Houdini,

– von Gilmore zu Johnny Cash, Cash zu Rick Rubin und Slayer zu Rubin und

– von mir zu Houdini und Mailer und Slayer.

Ich hatte die Wasatch Front[7] und die Bergkette der Rocky Mountains als väterlichen Charakter für mich identifiziert, und diese Beziehungen väterlicherseits wurden wichtige Gliederungselemente für mich.

Dieser Moment in der Metal Music, in dem die Gitarren so schnell sind, dass sie ein wenig wie Bienen klingen, hat auch etwas. Etwa bei *Hell Awaits*, bevor der Slayer-Sound auf überzogene Weise weiterbearbeitet wurde. Das war es also. Ich begann, unterschiedliche Ideen zu sammeln, wie man Bienen in das Narrativ einbeziehen könnte, was ziemlich leicht war, da die Biene in der Ikonografie der Mormonen allgegenwärtig ist. Aber ich wollte, dass sie in dem Werk überall vorkommen würde, ich wollte, dass es dort überall Sechsecke gäbe und Details von Bienen, die man nur unterschwellig wahrnehmen würde. Dann gab es da diesen Telefonanruf von Johnny Cash, der Gilmore während seiner letzten Tage in der Todeszelle anrief.

Ich würde sagen, dass die Szene von Anfang an um den Anruf herum organisiert war, aber mehrmals die Form wechselte. Das Originalskript sah vor, dass Johnny Cash in dieser Szene singen sollte, Rick Rubin am Mischpult steht, Slayer sich im Aufzeichnungsraum befindet und die Bienen in der Kabine sind, in der die Stimmen aufgenommen werden. Als wir von Cash und Rubin keine Antwort auf unsere Anfrage erhielten, sprachen Jonathan und ich über eine reduzierte Version. Mein Interesse begann sich auf Lombardo und auf die Frage zu konzentrieren, wie das Geräusch der Bienen in den Soundtrack des übrigen Films einfließen könnte. Statt eines Moments mit Gitarren, Schlagzeug und Bienen hat man dann einen Song. Es war gar nicht unbedingt nötig, dass es ein Song war. Es konnte ein Ort sein, an dem der Sound, der in dem Film bereits existierte, anschwillt, einen Augenblick lang einen deutlich erkennbaren Höhepunkt erreicht und dann wieder abebbt.

Diese Idee, einen Song zu vermeiden, finde ich interessant vor dem Hintergrund dieses Kommentars und deines Hinweises auf Dudelsäcke als Instrumente, um Truppen in Marsch zu setzen. Songs werden auch in den ständigen Verzögerungen von Murphy's Law und Agnostic Front in *CREMASTER 3* unterwandert. Man hört die Songs nie vollständig, immer handelt es sich um eine Art verspäteten Einsatz und einzelne Flecken der Stille.

Das hat etwas damit zu tun, dass ich die Filme unter skulpturalen Gesichtspunkten betrachte. Jeder Film ist ortsspezifisch und wird weitgehend von Eigenschaften bestimmt, die auf die Umgebung zurückgehen, in der die Geschichte spielt. Musik und Klangdesign funktionieren auf dieselbe Weise. Jonathan näherte sich den Szenen, für die er eine Partitur schrieb, immer

zunächst mit Fragen zum Ort. Unsere Diskussionen in der Phase vor der eigentlichen Produktion drehten sich häufig um die Frage, welche Geräusche dieser besondere architektonische Raum oder dieser Aspekt der Landschaft erzeugen würde. Ich habe das Gefühl, dass Geräusche und Lärm für Jonathan ebenso gute Ausgangspunkte sind wie alles andere.

Natürlich gab es spezifische Szenen, in denen Umgebungsgeräusche Musik werden (wie die Aufzugsschacht-Szene in *CREMASTER 3* oder, wie eben besprochen, die Bienen in *CREMASTER 2*). Aber sowohl Jonathan als auch ich wollten, dass die Musik und der Klang sich auf organische Weise aus der Form heraus entwickeln und nicht so wirken, als seien sie darüber gelegt. Das ist in etwa so wie die alte Debatte über das Bemalen einer Skulptur, bei dem man die einer Form innewohnende Eigenschaft und die Natur eines Materials mit aufgetragener Farbe bzw. applizierter Emotion maskiert. Bei Songs in Filmen verhält es sich für mich ein wenig so. Entweder sie wirken, als habe man sie darüber gelegt oder sie haben etwas mit der Emotion eines Charakters zu tun. Wie bereits erwähnt, sind die *CREMASTER*-Filme nicht von den Figuren her motiviert, sondern es wird der Versuch unternommen, der Umgebung die emotionale Hauptrolle zuzuweisen.

Es gibt noch andere Beispiele, bei denen Klang- bzw. Musik-Entscheidungen durch die Verwendung musikalischer Formen oder Instrumente getroffen wurden, die es in der Umgebung bereits gibt. Ich denke an die Dudelsäcke in *CREMASTER 4* oder Jonathans Interesse an dem Skalp-Songs der amerikanischen Ureinwohner, als er die Partitur für die Two-Step-Sequenz in *CREMASTER 2* verfasste, die mit dem Erscheinen der Bisons nach der Rodeo-Szene beginnt.

CREMASTER 3, 2002 (182 Minuten)

Biergetränktes Theremin, Dudelsack, Aufzugschacht (Harfe, Blasinstrument), eine Katze, zusammenprallende Autos, Signalhorn für Hindernisrennen, ein gälisch singender irischer Tenor, Orgel, Philharmonisches Orchester, Pfeifen, Cello, Fiedel, Trompeten, Posaunen, Saxophone, Kontrabassklarinette, Bass, Klavier, Trommeln, Vibrafon, Schlagzeug: „Dies ist das Lied des vertikalen Feldes,/ eine verheißungsvolle Senkrechte, die von der Silhouette herabgehängt wird." Es ist ein simultanes architektonisches Spiel im Spiel.

Brandon Stosuy: Das gesamte Klangdesign für *CREMASTER 3* ist komplex, aber *The Order*, 2003, ist besonders vertrackt. Es erinnert mich an einen hektischen Cartoon oder ein hektisches Videospiel.

Matthew Barney: Viele der ersten Gespräche, die ich mit Jonathan und den für die digitalen Effekte zuständigen Leuten geführt hatte, drehten sich um Videospiele, bis hin zu der Frage, wie die Szene in farblicher Hinsicht aussehen sollte. Ich wollte die Szene so stark dimmen wie möglich, damit sie ein wesentlicher Bestandteil der Geschichte würde, doch zugleich sollte sie ein völlig anderes Gefühl vermitteln, so wie das Gefühl der Live-Animation in *CREMASTER 4* oder *1*. Ursprünglich lautete der Vorschlag, *The Order* mittels der Spitze des Chrysler Building in die Geschichte zu übertragen. Das Chrysler Building diente als Empfänger für frühe Live-Übertragungen im Fernsehen. Alle Figuren in *The Order* waren als Vektoren konzipiert, darauf

programmiert, eine einzige Sache auszuführen, ohne jegliche emotionale Projektion – viel mehr noch als die Figuren im Film. Im Allgemeinen mussten die Figuren in diesen Geschichten etwas abstrakt bleiben, damit sich schließlich narrative Skulpturen aus der Geschichte herausziehen ließen. Ich glaube, diese Art des Vorenthaltens ist für mein Programm als Bildhauer wirklich wichtig.

Warst du dir, als du bei _CREMASTER 3_ angekommen warst, darüber im Klaren, wie die verschiedenen Filme sich überschneiden würden, wenn man sie gemeinsam präsentierte? Die akustischen Überschneidungen der fünf vorausgegangenen Filme sowie das Wiederauftauchen der Figuren usw. scheint eine gleichzeitige Vorführung nahezulegen.

The Order wurde vermutlich durch die Tatsache verkompliziert, dass ich bereits begonnen hatte, die Ausstellung im Guggenheim[8] zu planen und darüber nachzudenken, wie sich die Ausstellung in diesem Raum organisieren ließe und dass die verschiedenen Kapitel in dem Gebäude wie verschiedene Ränge sein könnten. Von dort ausgehend begann ich mich zu fragen, wie das an verschiedenen Orten in _CREMASTER 3_ passieren könnte, dass es da eine Art ‚Chorgesang‘ der verschiedenen Filme geben könnte, dass es Delegierte von jedem der einzelnen Kapitel in dem Zerstörungsderby, in dem Pferderennen, geben könnte.

Genau am Ende der Nachbearbeitung von _CREMASTER 2_ stand uns Dolby-Digital-Sound zur Verfügung. Wir haben diese Technik dann nicht mehr eingesetzt, aber ich erinnere mich, mit den Klangdesign-Leuten und Jonathan gesprochen und von den verschiedenen Möglichkeiten erfahren zu haben, den Klang mit einem Joystick durch die verschiedenen Lautsprecher im Kino zu bewegen und ganz individuelle Klangquellen einzusetzen, die aus verschiedenen Richtungen im Kino kamen. Wir begannen, uns darüber zu unterhalten, wie verschiedene Töne aus verschiedenen Lautsprechern in der _The-Order_-Szene funktionieren könnten, an der wir damals gerade arbeiteten. Das brachte uns darauf, die Idee der Simultaneität weiterzuentwickeln, die Idee, dass es Momente in den Szenen geben würde, in denen man alle fünf Klangströme gleichzeitig hört und andere Momente, in denen man sie einzeln hört. Auf der einen Ebene hörte man diese Ebene deutlicher und die anderen eher als Umgebungsgeräusche. Es war faszinierend zu erfahren, dass man die Wirkung wirklich mit den fünf Lautsprechern steuern kann. Ich kann mich noch an die ersten Tests erinnern, bei denen wir einfach Platten von Agnostic Front und Murphy's Law gleichzeitig auflegten und sie uns anhörten und daran, wie aufregend das war.

Etwas an dieser Szene fängt für mich den Charakter des ganzen Filmzyklus ein, in dem Sinne, dass die fünf Filmkapitel fünf simultane Datenströme sind. In meinem Kopf spielen sie sich zum selben Zeitpunkt ab. Ich glaube, das ist das Interessante an dieser Installation.

Ich war immer der Meinung, dass der _CREMASTER Cycle_ in die Tradition von Robert Smithson und der Earthworks-Strömung[9] gehört, weil das Werk als narrative Zeichnung visualisiert wurde, die über fünf Zustände in Landschaften gelegt wurde. Die fünf Erzählungen bewohnen diese fünf Orte und kehren von den Orten mit narrativen Skulpturen oder ‚non-sites‘[10] zurück.

Bevorzugst du es, wenn die *CREMASTER*-Filme gleichzeitig gezeigt werden?

Ich glaube, dass es für die Wiedergabe mehrere praktikable Möglichkeiten gibt. Meiner Meinung nach bieten sie alle jeweils einen unterschiedlichen und nützlichen Einstieg in die größere Form des Zyklus. Die Fünf-Kanal-Installation eignet sich gut, um die Idee der Simultaneität zu betonen oder um einen Körper zu beschreiben, der durch Vielfältigkeit gekennzeichnet ist, statt einen mit einem einzigen Zentrum. Wenn man die Filme der Reihe nach zeigt, werden die Beziehungen zwischen der jeweiligen als Gastgeber bzw. Wirt fungierenden Umwelt und der Sprache des Gastes bzw. Virus klarer.

Ein Gespräch mit dem *CREMASTER*-Komponisten Jonathan Bepler, New York, August 2007

Brandon Stosuy: Welche Fragen hast du im Hinblick auf *CREMASTER 5*, *CREMASTER 2* und *CREMASTER 3* gestellt?

Jonathan Bepler: Ich habe *CREMASTER 5* als Oper aufgefasst, die von der Figur der Königin in jener Periode und Zeit hätte gesungen werden können, in der sie sie sang. Es gab ein komplexes System von Raumwerten – drinnen, draußen, Zwischentöne –, die etwas mit dem Weg des Kletterers im Opernhaus zu tun hat. Diese habe ich mit Tonhöhen- bzw. Klangbeziehungen in Verbindung gebracht, die die Farbe der Komposition bestimmen. Für mich war es immer ein zeitgenössisches Werk, das irgendwann wieder aufgeführt werden wird.

In *CREMASTER 2* hatten wir die Ideen mit der Wüste, den Bienen und der Orgel (die auf den Mormonen-Tabernakel zurückgeht), der Musik der amerikanischen Ureinwohner, dem Country-Western, der amerikanischen Crime-and-Romance-Tradition und dem Geräusch, wie es ein Gletscher machen könnte. Ich stützte mich bei all dem auf meine eigenen Interessen. Die Briefe von Nicole, Gary Gilmores Freundin, führten zu Patty Griffin[11].

In *CREMASTER 3* gab es eine Horror-Exhumierungsszene, das Chrysler Building selbst, die Sprache der irischen Ballade und des irischen Tanzes, den urbanen Kontext der 1930er-Jahre (*Rhapsody in Blue*), einen zeremoniellen Tanz, New Yorker Show-Melodien, einen Akt mimischer und gestischer Komödie, Horror und Pferderennen, ein Videospiel, eine epische Herausforderung, eine gälische Ballade.

Häufig scheint es so, als würde jeder Schnitt oder jede Einstellung mit einem neuen Sound versehen. Das fiel mir vor allem in der Eingangssequenz von *CREMASTER 5* auf.

In vielen Fällen wurde das Bild zum Rhythmus der Musik geschnitten. Beim Ballett und in der Oper ist das natürlich der traditionelle Ansatz. Mit Sicherheit war dies bei *CREMASTER 5* so, weil die Musik fertig sein musste, bevor die Aufnahmen begannen, damit die Sänger und das Orchester auf der Leinwand ,spielen' konnten. Seither versuche ich zu vermeiden, Musik direkt für ein Bild zu schreiben, da ich das als ,Pornografie' empfinde. Ich finde das manipulativ, und es ist so schwierig, unter die verführerische Oberflächenwirkung der Musik zum Bild zu gelangen. Beim erzählerischen Film erlebt man das sehr häufig.

Es war mir immer sehr wichtig – und zwar vielleicht nicht nur aus egoistischen Gründen –, zu versuchen, das heikle Gleichgewicht zwischen der gesamten Musik- bzw. Klangsprache im Film zu bewahren und sie die Sprache und Logik des Werks selbst sein zu lassen, so seltsam oder abweichend das manchmal wirkt. Ich finde es aufregend, dass eine Sequenz als Klang-design, Partitur, Hymne oder Kommentar zu einem Song funktionieren kann. Wenn ein Film bekannte Songs enthält, zerstört dies manches davon – zumindest für mich. Ich mag einfach keine Soundtracks, die aus einer Anhäufung von Songs bestehen.

Ich weiß, dass viele Filmkomponisten darauf bestehen, erst anzufangen, wenn der Film definitiv im Kasten ist. Ich war sehr glücklich, dass ich bei den *CREMASTER*-Filmen schon in den ganz frühen Stadien an der Musik arbeiten konnte, schon als die Storyboards ausgearbeitet wurden und die Dinge noch ganz abstrakt waren. Wir konnten da Räume, Ereignisse und Narrative auf abstrakte Weise besprechen, und ich konnte damit beginnen, meine eigenen musikalischen Gedanken auf diese Abstraktionen zu beziehen. Während Matthew und ich zusammen oder getrennt arbeiteten, entwickelten sich verschiedene Schichten, da neue Ideen dazukamen, Tangenten verfolgt wurden. Mein musikalischer Bewegungsablauf führt tatsächlich ein Eigenleben. An vielen Stellen ist die Musik auf eine eigene Weise der Hauptdarsteller, die natürlich gut für mich war.

Kannst du einen dieser Augenblicke benennen?
In *CREMASTER 2*, als Baby Fay La Foe durch den Ausstellungssaal läuft: Das ist wie ein Duett mit etwas Großem.

Wie wichtig sind Umgebungstöne und -geräusche für deine künstlerische Praxis?
Vor allem die Musikalität der in der Natur vorkommenden Rhythmen und Melodien finde ich sehr aufregend. Ich habe einige Zeit damit zugebracht, automatische Instrumente herzustellen, Systeme, bei denen im Mittelpunkt der musikalischen ‚Entscheidungen‘ das Chaos steht. Ich habe auch an der Herstellung neuer Instrumente und an der Erzeugung von Klängen gearbeitet, die man nie zuvor gehört hat. Ich habe mich also bei der Idee, elektrische Gitarren durch Bienen oder das Knistern trocknenden Salzes durch Geigen zu ersetzen, ganz zu Hause gefühlt.

Kannst du mir noch mehr über die ‚automatischen Instrumente‘ und die neuen Instrumente erzählen, die du hergestellt hast? Hast du davon welche für den *CREMASTER Cycle* verwendet?
Ich hatte die Absicht, mit automatischen Instrumenten nicht wiederholbare Darbietungen zu schaffen, nicht mehr ganz funktionstüchtige Geräte zu benutzen und Systeme voller Chaos zu erzeugen. Man wusste nie, was als Nächstes passieren würde und hatte den Eindruck, hier sei irgendeine unbekannte Größe am Werk: Tuben, die von Haarföhnen mit Latexlippen gespielt wurden, Streichinstrumente, auf denen billige Motoren herumklimperten, die von der Wand herabhingen. Bei *CREMASTER 3* bauten wir ein 80-Fuß-Streichinstrument, das nur Obertöne spielte, eine Großversion des Instruments, das Glenn Branca[12] gemacht hatte, als ich mit ihm spielte. Es war ein wichtiger ‚Darsteller‘ im Chrysler Building in *CREMASTER 3*.

Wie hast du in den _CREMASTER_-Filmen einen quadrophonischen Sound eingesetzt?

In _CREMASTER 3_ hört der eine Teil des Publikums ganz andere Dinge als der andere. Anders gesagt, einige Leute ,verpassen' das, in dem andere im gleichen Moment gerade schwelgen. Experten sagen, so etwas solle man nie tun. Aber ich dachte, das sei ein Risiko, das es lohnen würde einzugehen.

Kannst du ein paar Beispiele nennen?

Ein Beispiel ist Teil der Eingangssequenz von _CREMASTER 3_. Diese wehklagenden Theremine erzeugen ,resultant tones'[13] oder Verzerrungen im Ohr, wenn sich die Töne vermengen. Die vier Theremine sind häufig jeweils nur in einem Lautsprecher zu hören, sodass die Vermischung im Raum selbst stattfindet und nicht in der Box. Diesen Klang finde ich wesentlich faszinierender. Das bedeutet, dass praktisch jedes Mitglied des Publikums ein anderes Geräusch hören wird. Die Person, die in der Nähe eines der Lautsprecher sitzt, wird eine intime Erfahrung mit dem Theremin 1 machen, aber das Theremin 3 möglicherweise kaum hören. Es bedeutet auch, dass es in jedem Kino einen anderen Klang geben und die ,Performance' anders wirken wird. Mir gefällt die Idee, den ,Live'-Charakter zu bewahren.

Hast du einmal über die sich ständig verschiebenden Klänge einer Mehr-Kanal-Installation des _CREMASTER Cycle_ nachgedacht und darüber, in welchem Verhältnis sie zueinander stehen, wenn die Filme gleichzeitig oder in verschiedenen Paaren vorgeführt werden?

Ich liebe die Idee, dass der _CREMASTER Cycle_ ein kumulatives Werk ist, für das es unterschiedliche Repräsentationsformen gibt. Vielleicht bedeutet dies ein simultanes, wechselhaftsynchrones Betrachten, einen Rücken-an-Rücken-Marathon oder eine der reduzierten Performances, die wir im Guggenheim gemacht haben. Wenngleich die Werke individuell entstanden, entwickelte sich im Verlauf der weiteren Zusammenarbeit zunehmend das Gefühl einer Wechselbeziehung. Am Anfang eines Projekts ist die Festlegung der Instrumentierung und der Klangpalette eine wirklich wichtige und manchmal sehr beschwerliche Aufgabe. Entscheidungen wurden häufig davon beeinflusst, ob sie auf einer Wellenlänge mit den Paletten und Bedeutungen anderer Werke lagen: den Dudelsäcken im Verhältnis zu der Orgel, den Show-Melodien in _CREMASTER 3_ und in _CREMASTER 1_. Ich liebe es, wenn die Dinge im selben Raum aufeinandertreffen.

Wie veränderte Dolby Digital deinen Ansatz bei _CREMASTER 3_, vor allem in _The Order_?

Nahezu alles in diesem Werk hat mit der physischen Platzierung und der Ausrichtung der Töne zu tun. _The Order_ war eine ziemlich komplexe Angelegenheit, eine Art Videospiel mit fünf Ebenen, von denen jede ihr eigenes System der Klangbewegung und ihre eigene Räumlichkeit besitzt. Alle können manchmal gleichzeitig gehört werden. Der sich bewegende ,Spieler'-Darsteller hat ein Antriebsthema, das sich stufenweise, je nach Erfolg bzw. Bewegungsablauf, verändert. Die oberste aller dieser Schichten ist die musikalische Partitur, eine Art Rahmen, der uns daran erinnert, dass dieses System ein Film ist. Das Finale läuft auf eine Konvergenz

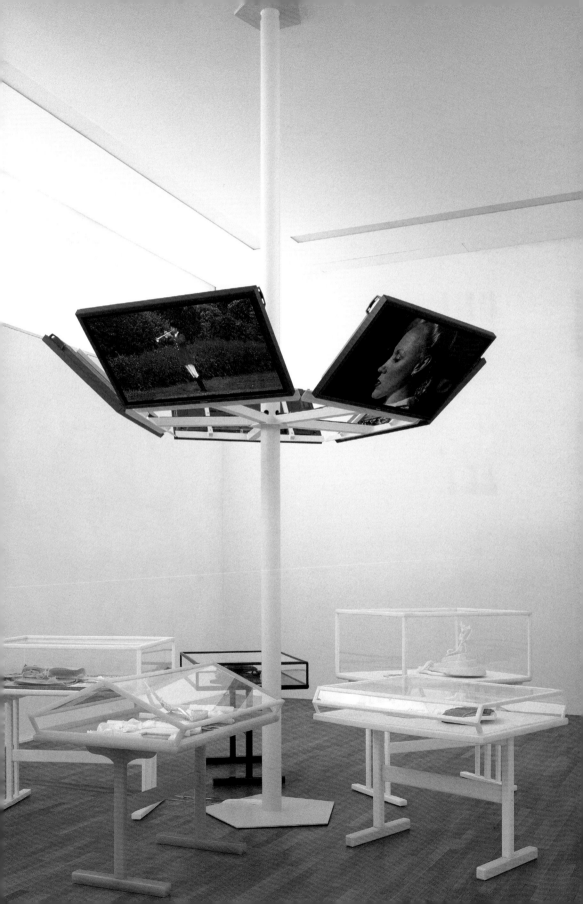

bzw. Auseinandersetzung aller dieser Elemente hinaus, die teilweise durch ein massives Rotieren des Klangs zum Ausdruck gebracht wird, bei dem es sich um einen Verweis auf den Raum des Guggenheim selbst handelt.

In *CREMASTER 2* wirst du als derjenige ausgewiesen, der für die ‚Bienenprogrammierung' zuständig war. Wie bist du bei dieser Sequenz mit den Bienen umgegangen?
Dave Lombardo spielt zusammen mit 200.000 Honigbienen. Ich habe verschiedene Bienengruppen und einige Solos aufgenommen, während die Bienen für die Dauer des Drehs in Matthews Atelier waren. Dann habe ich die Aufnahmen bearbeitet und Sampler verwendet, um spielbare Instrumente herzustellen, damit die Bienentöne so funktionieren wie die Gitarrenpartien beim Thrash Metal. Ich habe meine Performances auf diesen Instrumenten mit dem natürlichen Bienenklang kombiniert, um die Tracks zu bekommen, die dann Daves Schlagzeug begleiten sollte. Es gab aber auch ein paar ganz hübsche Momente mit ‚Bienensolos'. Später folgte dann noch der Gesang von Steve Tucker.

Was hältst du von den Songtexten, und in welcher Wechselbeziehung stehen sie zu deinen Kompositionen? Ich denke, bei *CREMASTER 5* ist das z.B. anders als bei *CREMASTER 2*.
Es ist eine andere Ebene in der Gesamtsprache. Die Kunst, Text zu vertonen interessiert mich sehr. Ein Großteil der Inspiration für die Musik kommt vom Text. Da Matthew und ich zusammen an dem Text arbeiten können, gibt es einen großen Spielraum. Mit ungarischen oder gälischen Texten zu arbeiten und auf Zeilen wie „tumbrel in a grey wood"[14] zu stoßen, ist sehr inspirierend.

In seinen Anmerkungen zur *CREMASTER 5*-CD spricht Arthur C. Danto über den Ton ohne Bild und kommt zu dem Schluss: „Beim Zuhören entdeckt man mehr und mehr von dem, was man zum Schluss im Film sehen wird, und dies in einem solchen Ausmaße, dass einem der Film, wenn man lange genug zugehört hat, genauso vertraut sein wird, wie etwas, das man in der Erinnerung wieder und wieder durchlebt, wie die Queen of Chain."[15]
Mir gefällt der Gedanke, dass einen die Musik in das Visuelle weiter hineinführen kann als das Visuelle allein. Es gibt einen Ort, an dem wir zugleich sehen und hören können, ohne uns des einen oder des anderen bewusst zu sein: ein Bewusstseinszustand ohne Konzentration, der nur bei dieser Form der Anhäufung von Elementen geschehen kann.

Das Klangerlebnis des *CREMASTER Cycle* als Fünf-Kanal-Installation

Verzichten Sie zeitweilig auf die Akkumulation, ignorieren Sie die Bilder und ihre Assoziationen und konzentrieren Sie sich auf den Klang. Laufen Sie durch die Galerie und lauschen Sie der mit marschierenden Metal-Bands vermanschten Morton-Feldman-Geräumigkeit, Busby Berkeley und den ungarischen Stimmen, die zu einem Duett zerfallen, Lautsprechern und Trauben, die sich unter Maschinen vergraben. Ein(e) langsame(s) Orgel/Theremin produziert ein Doppel-/Dreifach-Brummen.

Ein Schuss leitet einen neuen Tusch ein. Ein Platscher von einer Brücke ergießt sich in ein Schaumbad. Keltisches Gezwitscher zirpt zu Séance-Geflüster, und eine Diva kracht auf die Bühne. New Yorker Punks begrüßen die Streicherbegleitung.

Finden Sie den ersten Ton und den letzten, und achten Sie darauf, wie sie einander verschlingen: Trotz des fehlenden Dialogs sind dies keine Stummfilme.

Übersetzung: Nikolaus G. Schneider

1 http://www.cremaster.net, Stand: 29.09.2007.

2 Es handelt sich um eine Werktrilogie mit den Titeln *Facility of Incline* (1991), *OTTOshaft* (1992) und *Facility of Decline* (1991). Die primären Skulpturentitel dieses Werkkorpus lauten *Transsexualis, Repressia, Pace Car for the Hubris Pill, Al Davis Suite* und *Jayne Mansfield Suite*, die Titel der Video-Aktionen lauten *Flight with the Anal Sadistic Warrior, Delay of Game, OTTOshaft, Radial Drill* und *Blind Perineum.*

3 Artangel ist eine 1985 gegründete britische Organisation, die an verschiedenen Standorten einmalige Künstlerprojekte in Auftrag gibt. Zu den Künstlern, die solche Aufträge erhielten, zählen Janet Cardiff, Tony Oursler, Laurie Anderson/Brian Eno und Rachel Whiteread: http://www.artangel.org.uk, Stand: 20.09.2007.

4 Dave Lombardo (geb. 1965) ist ein in Kuba geborener Schlagzeuger der amerikanischen Thrash-Metal-Band Slayer.

5 Es handelt sich um einen Verweis auf den Stepptanz des Loughton Candidate (des rothaarigen, einen weißen Anzug tragenden Satyrs) in *CREMASTER 4.*

6 Busby Berkeley (1895–1976) war ein Hollywoodregisseur und -choreograf, der für seine komplexen extravaganten Tanzsequenzen mit einer großen Zahl von Showgirls bekannt war.

7 Als ‚Wasatch Front‘ bezeichnet man den städtischen Großraum von Santaquin bis Brigham City im US-Bundesstaat Utah.

8 Die Ausstellungstour begann im Museum Ludwig in Köln (06.06–01.10.2002), war anschließend im Musée d'Art Moderne de la Ville de Paris zu sehen (10.10.2002–05.01.2003) und endete im Solomon R. Guggenheim Museum in New York (21.02.–04.06.2003).

9 Der Begriff beschreibt häufig großformatige Werke der Land Art bzw. Earth Art, die im Freien und unter Verwendung von Materialien aus der natürlichen Umgebung hergestellt werden (Erde, Stöcke, Felsen, Blätter etc.). Diese künstlerische Strömung begann in den späten 1960er- bzw. frühen 1970er-Jahren und erlebte in diesem Zeitraum ihren Höhepunkt. Zu den wichtigsten Werken der Land Art bzw. Earth Art zählen Dennis Oppenheims *Salt Flat* (1968), Michael Heizers *Double Negative* (1969/70), Robert Smithsons *Spiral Jetty* (1970) und Walter De Marias *Lightning Field* (1977). Weitere Künstler, die mit dieser Kunstrichtung in Zusammenhang gebracht werden, sind Alice Aycock, Andy Goldsworthy, Nancy Holt, Richard Long und Robert Morris.

10 Von Robert Smithson geprägter Begriff zur Bezeichnung eines im Innenraum einer Galerie installierten Werks der Earth Art. Vgl. seinen Essay „A Provisional Theory of Non-Sites": http://www.robertsmithson.com/essays/provisional.htm, Stand: 20.09.2007.

11 Patty Griffin (geb. 1964) ist ein amerikanischer Country- bzw. Folksänger und Liedermacher, der in Old Town, Maine, geboren wurde: http://www.pattygriffin.com/, Stand: 20.09.2007.

12 Glenn Branca (geb. 1948) ist ein einflussreicher Avantgardegitarrist bzw. -komponist, der aufgrund seiner Beiträge zu verschiedenen Szenen (No Wave, Loft Rock, Symphonic Noise, Drone Rock, Drone) mit Downtown New York assoziiert wird. Er ist vermutlich am meisten für seine Gitarrenensembles bzw. -orchester bekannt.

13 Diese Zusatztöne entstehen aus der Kombination der Frequenzen zweier Töne. [A.d.Ü.]

14 Es ist eine mehrdeutige Zeile: ‚tumbrel‘ kann sowohl ‚Mistkarren‘ als auch ‚Schinderkarren‘, ‚Munitionskarren‘ oder ‚Tauchstuhl‘ (ein historisches Folterinstrument) bedeuten. [A.d.Ü.]

15 Arthur C. Danto: „Jonathan Bepler's Music For Cremaster 5" im Begleittext zur CD *CREMASTER 5*, 1998, S. 5 (Übersetzung Nikolaus G. Schneider).

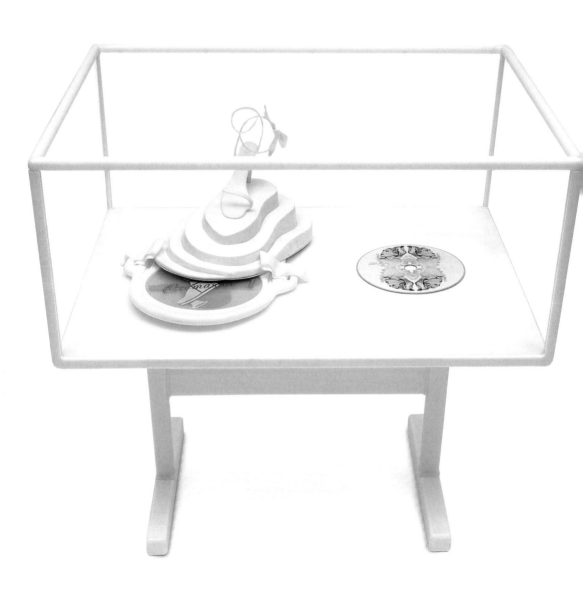

CREMASTER 1
1995/96
Vitrine | Vitrine 91×122×130 cm

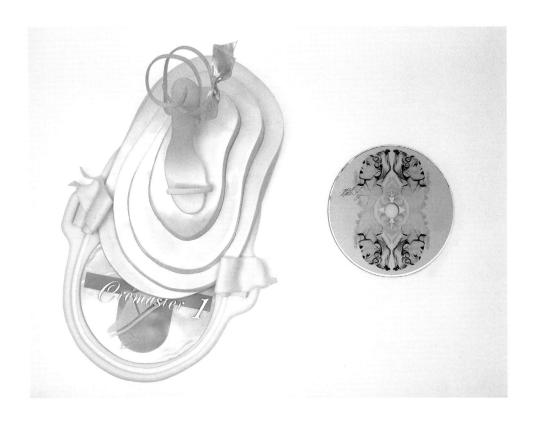

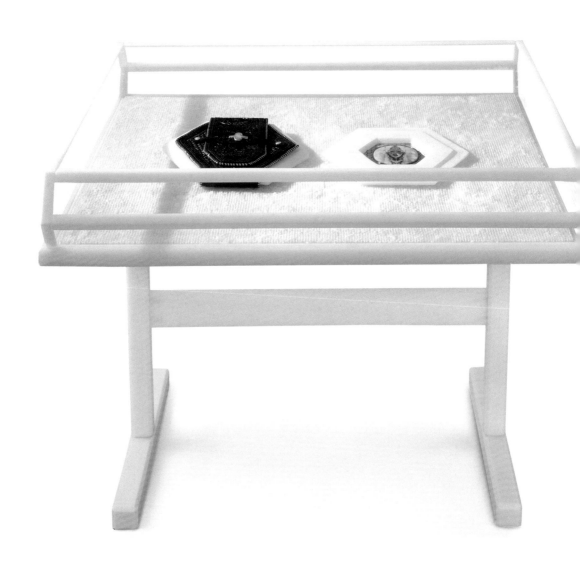

CREMASTER 2
1999
Vitrine | Vitrine 104,1×119,4×99,1 cm

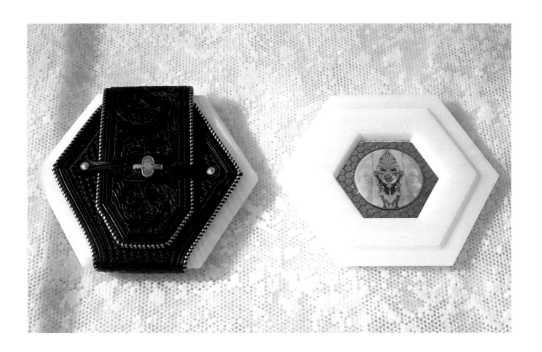

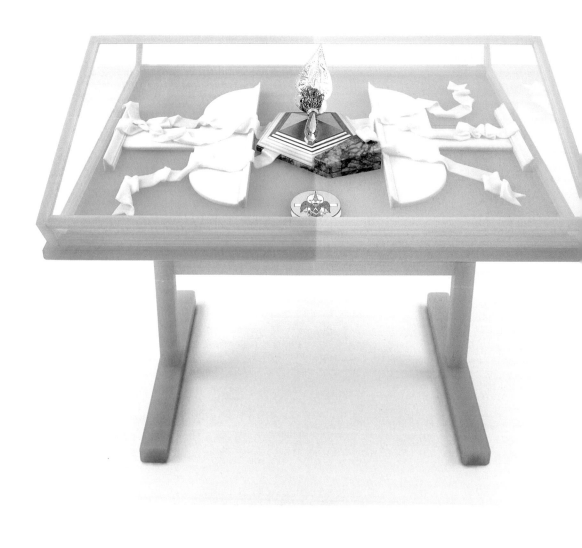

CREMASTER 3
2002
Vitrine | Vitrine 110,5×119,4×101,6 cm

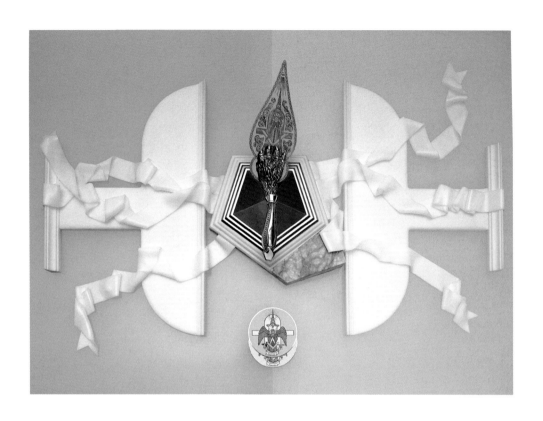

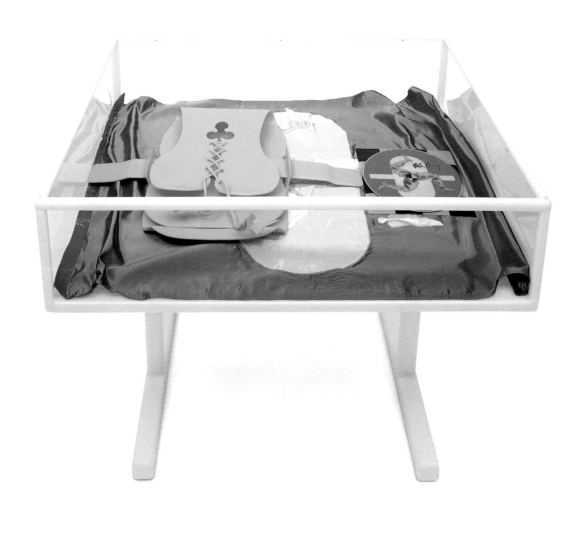

CREMASTER 4
1994/95
Vitrine | Vitrine 91,4×122×104,1 cm

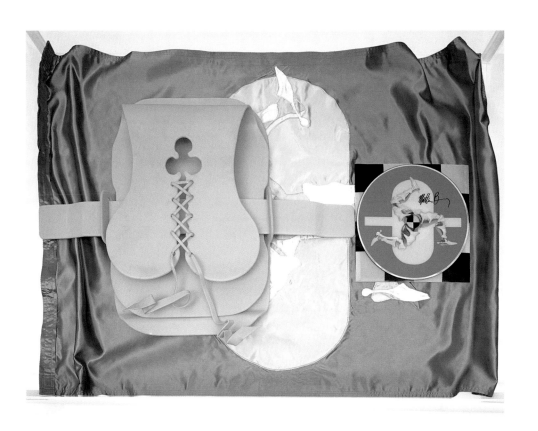

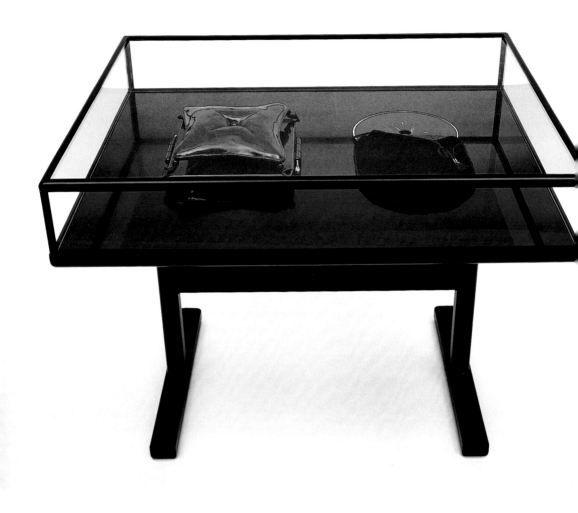

CREMASTER 5
1997
Vitrine | Vitrine 88,9×119,4×94 cm

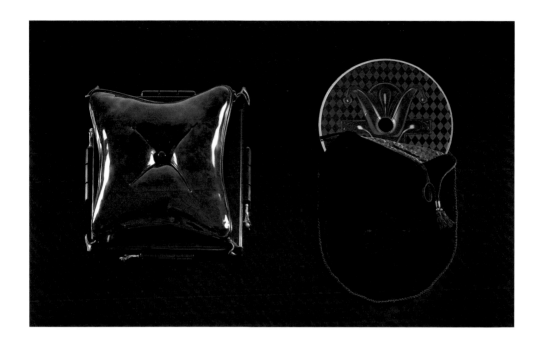

Formulas Fatal to the Flesh – On the Sound of the CREMASTER Cycle

Brandon Stosuy

When you walk into the big exhibition space downstairs in the Goetz Collection building, close your eyes. While it's visually impossible to keep up with five monitors – on each of which is one of the *CREMASTER* films running –, sounds are easily absorbed. Close listening offers a new point of entry, a new architecture, or at least another way to view the complexity of the *CREMASTER Cycle*. It's central, too, to a discussion of a field sensibility, issues of noise, performance, and collaboration.

Matthew Barney has said he used principles of biology to organize *CREMASTER* and as a way to introduce conflict and narrative into the system (five states connected by a single line). In the five-channel *CREMASTER*, each film has a role, though unlike a biological system, these roles continually shift.

In the five-channel *CREMASTER Cycle* installation,[1] the films function as a team without a prioritized 'individual'. A film alone is a soloist, five an operatic collage.

The films have different running times, so overlaps and associations remain in flux. On one pass, *CREMASTER 4*'s Loughton Candidate's tap-through-the-floor sea splash doubles the bee-metal cymbal of *CREMASTER 2*. On the second rotation they miss each other entirely; instead, *CREMASTER 5*'s Queen of Chain pairs with *CREMASTER 2*'s bees, drums, and The Man In Black. Even before *CRE-MASTER 3* makes it through a single rotation, the others have started spinning all over again. (If you skip its built-in intermission, you can switch the timeline.)

Regularity occurs in the steady pulse of highs (bagpipe), lows (double bass), and mid-range (human speech) sounds. *CREMASTER 4* and *CREMASTER 1*, the two films Barney scored largely on his own, exhibit the most regulated/rigid patterning, offering steady accompaniment.

But when the *CREMASTER Cycle* is repeatedly played together as one piece, it grows difficult to discern exactly which film is doing what: sounds melt into one another, smearing notes, blurring boundaries.

The flatness of one is shifted by the opulence of another (though internal spaces remain untouched). Watching them alone later creates phantom echoes, severed limbs.

For best results, it helps to understand the system both stitched together and as individual pieces.

On the Structure Of the *CREMASTER Cycle* – A Conversation with Matthew Barney, New York, August 2007

Brandon Stosuy: Why did you produce the *CREMASTER Cycle* non-sequentially?

Matthew Barney: In the beginning it was for practical reasons. I started to diagram the general structure of *CREMASTER* and to identify the locations while the Otto/Houdini pieces[2] were being made in 1990–1992. Around that time, Artangel[3] approached me and asked if I'd be interested in coming to Great Britain to do a project. I knew I wanted to use a Celtic site for the fourth chapter, but was still unsure of a specific location. The project with Artangel ended up being the Isle of Man chapter. Making the project out of sequence felt right given the elliptical ambition of the cycle. The fact that it could be done out of order motivated me, and I think, intuitively I decided to save the centerpiece for last, an element which developed into this riddle an 'X' in the center. The center of the *CREMASTER Cycle* could be described that way. [He gets up and grabs a piece of wood with a drawing on it and points to the drawing as he describes the following.]

While *CREMASTER 3* was in production, I started making line drawings that attempted to plot the narrative arc of the whole cycle, and which really informed how *CREMASTER 3* was made. I had an interest in using the Chrysler Building as a multi-faceted mirror – a center point which would reflect the two halves of the cycle. In the drawing this is expressed as a figure eight, suggesting that all aspects of the cycle would have to pass through this center point. The 'X' is the intersection in this elliptical loop that's been twisted into a figure eight. All of the chorus-based scenes, like the demolition derby, the zombie horserace scene, and *The Order, 2003*, came out of this idea; that all of the *CREMASTER* chapters would be represented in *CREMASTER 3* they would all have to pass through the mirror.

In the way that this project was developed organically over 10 years, this 'X' notion was like a riddle to me. I understood it more as a psychological state, a kind of narcissistic phase that the project would have to pass through. It didn't really make sense to me until I started doing these drawings. It took some time to feel comfortable identifying the project as explicitly autobiographical, or having anything to do with self-portraiture, so I'd say this had something to do with why *CREMASTER 3* was executed last. It was something like building an elaborate mirror over a ten-year period, arriving at the mirror, and being surprised to see your own reflection.

How else does your biography work into the structure?

The *CREMASTER* project is autobiographical, though there was a conscious attempt to balance autobiographical material against the mythological and the more intuitive abstract material.

It's not so much about creating a portrait of an individual, but rather a complex, or a system that describes an individual form. This is something that became clearer to me when I started developing *DRAWING RESTRAINT 9, 2005,* which I started to realize couldn't be a description of an individual form because of the uncertain relationship that I had with the container. In Japan, I couldn't interface with the environment in the same way that I had with past projects. That my language and the site would remain separate really became the program for the piece. There was a host and a guest and they would never become one thing. In *CREMASTER* the guest is viral – it's inside the thing, and it becomes part of the thing.

We've spoken about your (and the *CREMASTER Cycle's*) interest in eroding the difference between individuals, and how that relates to a team, as well as to the negation of difference in more psycho-analytical terms. I like how so many things go back to football: teamwork, loud popular entertainment, marching.

Right. There's definitely a strong interest in eroding the differences between individual elements within the system. This is true across the board. I've spoken about how the characters in the 'films' are underdeveloped in cinematic terms. I want them to be compelled to do what they do, in an ambivalent way, and to lack the emotional agency that a character has in standard cinema. There are also a number of scenes where one character transforms, becoming an aspect of another character. The hope is that by rendering characters this way, that the environment can become the central, emotional character. And with the installations, it is usually the case that relationships between objects become as important as the objects themselves. I think you're right that it all comes back to football in some way. As much as anything, I think this is due to the fact that my formative years were spent on the playing field. I became an adult there, so a lot of my basic values and way of thinking were influenced by athletics.

How did *Drawing Restraint 7*, which is silent, lead you toward *CREMASTER 4*? You told me it was your first narrative piece.

As I mentioned, I made my first site visit to the Isle of Man in 1992. This was before I made *Drawing Restraint 7*. The two-horned Loughton sheep (see: ill. p. 64) on the Isle of Man inspired the ascending/descending horn narrative in *Drawing Restraint 7*. During the production of *Drawing Restraint 7*, the ascending/descending *CREMASTER 4* narrative was fleshed out.

Would you ever return to silent videos?

Sure. I'm still very committed to the modernist notion of presence, the presence of an object in space. For me that presence has a silence about it. I feel most comfortable with the 'films' being shown in theaters, while the silent video works I have made in the past are more comfortable on the monitor in a gallery, in proximity to the object. Since *DRAWING RESTRAINT 9* was completed, I have made a number of simple, silent *Drawing Restraint* works (numbers 10–15), and this has felt quite good.

We've spoken a few times in the past about your disinterest in overproduction (regarding later-period Slayer or the Egyptian-themed death metal band, Nile). What turns you off to an 'over-produced' sound?

This is a more difficult question than I thought it would be. It's not exactly that a high production value is a problem. It's just a problem with material that lacks quality on the content level, especially with metal, where the conventional bells and whistles that are used to cover up the lack of quality are so cheesy. Maybe a better word is 'over-determined'. An over-determined form somehow eliminates the potential for failure.

How important is this potential for failure to *CREMASTER*?

One of the central themes of the *CREMASTER Cycle* is entropy, or more, the struggle the *CREMASTER* system has with its own entropic nature. It's a system that is developing and decaying simultaneously. The narrative is full of scenes where the system attempts and fails to overcome its entropic condition. On the level of performance, or the way the films function dramatically, I'd say there's another relationship to failure. I think I've been pretty influenced by physical comedy. In that form of comedy, the way a sense humiliation can be set up by a momentary failure of the body or an object in a physical situation, and where the humiliation is subtle enough to be internalized.

Listening to the Five-Channel *CREMASTER*

Each *CREMASTER* film includes zones of silence that allow another piece to solo, to take its turn leading the multivalent score. After 12 minutes 42 seconds, when all the films are playing, *CREMASTER 3* leads via Theremin drone, though you also hear, fainter, Goodyear (see: *CREMASTER 1: Goodyear*, 1995, ill. p. 26) and her grapes. By 15 minutes and 51 seconds, the Sirkian, melodramatic music at Bronco Stadium of *CREMASTER* 1 dominates. At around 22 minutes, everything drops out for *CREMASTER 5*'s Queen Of Chain.

As another listening exercise, try snatching discreet tones to create different pairings. In a *CREMASTER 4* and *CREMASTER 2* diptych, bagpipe drone overlaps with organ drone and then, later, the drone of bees and motorcycles. *CREMASTER 4*'s cycles also transform into percussion when placed alongside Dave Lombardo's[4] drums in *CREMASTER 2*'s bee-metal sequence (while the Satyr's tapping works out a counter beat[5]). Steve Tucker's voice mirrors the cycles, becoming a duet. If the drums/cycles stop, *CREMASTER 4*'s bagpipes bridge the silence. Then, when the Loughton Candidate falls through the floor into the water, his plunge becomes a cymbal splash; the faeries' bell on the blanket – leading the Loughton Candidate in his race – a cymbal ride that increases Lombardo's kit.

If you synch two different films, other details are prioritized: In a *CREMASTER 3* and *CREMASTER 2* diptych, the silence of the Mormon gas station attendant plays counter to the crash of vehicles

inside the Chrysler Building. That's one example of an entirely different series of alliances, a new set of fixations and focuses.

The *CREMASTER* Songs

CREMASTER 4, 1994 (42 minutes)

Motors and martial drum rattle a high bagpipe. After a silent bridge, a tap, tentative, then fluid grows increasingly rhythmic. Motors rev and squeal, mirroring the bagpipe. A bell. The main sounds alternate until the piece is finished with a three-way climax.

CREMASTER 1, 1995 (40 minutes)

Canned (or live) sappy (or cheery) strings are interrupted by silence (space), a music box (space barely filled), and a slight engine hum/background rhythm. Too many flourishes to count. A nostalgic, late-night radio broadcast.

Brandon Stosuy: Your early work was silent. With *CREMASTER*, why did you decide to move into sound?

Matthew Barney: Before the *CREMASTER* films were made, I was interested in the presence a moving image would have with no sound, how that can align itself with the presence that an inanimate object has – that sculpture has – in space. It's a complicated question because I think my nature is to be more interested in the presence of sculpture. For instance, I'm very uninterested in sculpture that has a soundtrack, or installations that have soundtracks. When I decided to create single-channel pieces that would be experienced in a theatrical setting, be seen from beginning to end, and have a soundtrack, it opened up the possibility of working with other things that interest me like dissonance and simultaneity […] not just of image but of sound.

A lot of that blossomed when I met Jonathan Bepler. Before that I was using ambiances and the sounds of what you're seeing on screen as it occurs, and thinking of those somewhat musically through the editing. Because I'm not a musician it never really grew until I met him.

Sound is certainly a character *in CREMASTER 4* with the motorcycles, less so with the tap dancing and the bagpipes. I'm not sure how conscious a decision that was when I was making the piece. I became more conscious of it during post-production. It has these two different sound worlds that are constantly in conflict. There was this notion of two spaces that would exist simultaneously. They would have the same sort of time-base, and in that way, I think, in your mind they would overlap: Of course, thinking not just of the ambience behind the Loughton Candidate and the sound of his tap dancing, but also the bagpipe that sort of belongs to his space and how that worked against the motorcycles.

Around the time Jonathan and I started working together, the project had started to gain some cinematic momentum – the pieces started to be shown in cinemas – and I started designing

elements into the script that were driven by sound and by music. The result has the same kind of balance between sound design, noise, and composition that Jonathan has in his own program.

Can you explain in more detail how you dealt with, or thought about sound, prior to meeting Jonathan?

I didn't spend a hell of a lot of energy on it, but I did try to get Goodyear to allow us to shoot on one of their blimps for *CREMASTER 1*, and of course, that would have changed things significantly. It may have made the piece much less of a kind of canned musical. It probably would have had more of the kind of rawness that *CREMASTER 4* had. When we started building sets I started looking more at the Busby Berkeley[6] films and the kind of flatness and control that they had. In that way, it felt logical to use this public-domain show tune music that also had a flatness and a neutrality to it.

It's funny, when Jonathan and I met, I had already more or less cut the piece and had these pieces of public domain music which are pretty hard to take [laughs]. I asked Jonathan if he could write a bridge between two of these songs and, at the time, I had no idea how offensive that was to him [laughs].

When you play all the films together, *CREMASTER 4* tends to be the loudest. Between the motorcycles revving, the bagpipes, and the tap dancing, it provides a constant, or unending sound source. Interesting to me that the first piece you did by yourself has such sonic presence.

I think a lot of the things that I gravitate toward, certainly musically, but also in popular entertainment, are quite loud. I gravitate toward things that have a dissonance and I think the choices that were made in *CREMASTER 4* have something to do with that. There's also the notion of something that doesn't really have a beginning or an end, in the way that bagpipe marches were originally used to bring a military group from point A to point B. There are certainly bagpipe songs, but it really isn't a song instrument. It was designed to transport a group of people. The war pipes were designed to be loud – to intimidate the opponent.

CREMASTER 5, 1997 (55 minutes)

A forward, orchestrated music and hooves switch dominance alongside a slight brushing, giving way to a horn, bubbles, and higher-pitched brass. Hungarian. A frolicking, watery orchestra and melancholic opera, augmented by occasional ambience: Birds flapping wings, a ribbon, and droplets. Physicality.

Brandon Stosuy: How does the opera of *CREMASTER 5* fit into your concept of 'song'?

Matthew Barney: My relationship to opera definitely has to do with space […] something to do with organic architecture, the way that an opera house mimics the body's chest cavity and voice box, creating a resonant chamber. In the same way the *CREMASTER Cycle* attempts to create bodies out of architectural conditions as narrative settings; the opera house is a body, through which a story passes.

CREMASTER 5 made it clear for me how the music could function as the film's dialogue. This process of starting to develop the music while the narrative was still being written became important for the subsequent films. For *CREMASTER 2*, for example, we only needed to lock the music ahead of time for the Dave Lombardo scene and the Patty Griffin scene, where the musicians were performing live for the camera. But by the time many of the other scenes were shot, Jonathan already had a sketch completed, which provided everyone involved with a greater understanding of the emotional color and pacing of the scene. By the time rough editing commenced, the music for a scene like that would be nearly finished. Now, most scenes are edited to a finished, or near finished piece of music.

CREMASTER 2, 1999 (79 minutes)

Pipe organ, whispering, a bass choir, bees/drones, a metal swell with double bass and death vocals: "The ghosts have descended and set upon me with a force/I smack 'em down but they sneak back and climb in/Demons that they are tell me foul jokes/They want to sap my will, drink my strength, drain my hope/Lost empty foul demon motherfuckers." There is the sound of a gun, that same choir, a drum roll, a classical lift paired with cowbell; a tambourine leads a scissoring, loopy two-step with female vocals – an ice-drip choir. Despite the number of sounds there are vast periods of silence: The American West.

Brandon Stosuy: Have you ever tried to analyze your specific interest in metal?
Matthew Barney: I have always been attracted to gore. I'm immediately attracted to anything I can only understand or experience on a visceral level. Horror films were like that for me when I was younger. The death metal I like functions this way, both in terms of its intention/lyrics, and its sound. It's not narrative or connected to mythology the way black metal is. Given that I'm a narrative artist, I think I'm often most attracted to artists whose work functions in a different way to mine: Richard Serra, Cannibal Corpse, etc. It goes back to the notion of a field sensibility. This is something available in metal and noise of all kinds, and this is something I need: a visceral, non-hierarchical, abstract field. One that has an emotional range but is not connected to an individual. No singer delivering a legible text – no sense of an individual's neurotic, emotional narrative – just an ambivalent field – like you find in nature.

How did an interest in noise and loudness lead toward the use of heavy metal in *CREMASTER 2*?
The Garry Gilmore story was starting to grow into the *CREMASTER 2* script: He wrote these letters back and forth to Nicole, his girlfriend, while he was on death row, and some of them are straight off of a metal record in terms of the way they're written. We'd just finished *CREMASTER 5* and had used texts I'd written, which had been sung by a soprano – that felt quite good to me, that there could be a text in one of these pieces. So I think I was having this impulse to use text in the music. It felt like a way to get those letters in there, into the story.

How much did you have to retool the letters?
Not much. There were cases where lines or words were deleted, to make the text more

singable, but nothing was rewritten. There was one case, I believe, where parts of two different letters were combined to make one piece of text.

What kind of metal did the letters remind you of?
Not really contemporary metal: Gilmore's letters are more aligned with music like Slayer, that era […] thrash metal. I was thinking about Slayer both in terms of the stylistic/gothic nature of some of Gary's letters, but also in terms of parallel paternal constellations:
– Mailer to Gilmore, Gilmore to Houdini
– Gilmore to Johnny Cash, Cash to Rick Rubin, and Slayer to Rubin
– Me to Houdini and to Mailer and to Slayer
I had identified the Wasatch Front and the Rocky Mountain range as a paternal character for me, and these constellations of paternal relationships became important structural elements for me.
There's also something about that moment in metal where the guitars got so fast they started sounding something like bees. Think about Hell Awaits, before the Slayer sound got highly produced. So there was that. I was starting to collect different notions of how to integrate bees into the narrative, which was pretty easy to do because the bee is present everywhere in Mormon iconography. But I really wanted it to be ubiquitous in the piece, I wanted there to be hexagons everywhere and bees in details you might only catch subliminally. Then there was the phone call Johnny Cash made to Gilmore in his final days on death row.
I would say that the scene was organized around that from the start, but it changed forms several times. The original script for the scene was to have Johnny Cash singing, Rick Rubin at the mixing board and Slayer in the recording room, and bees in the vocal booth. When I got no response from Cash or from Rubin, Jonathan and I discussed a more reductive approach. I became more interested in really focusing on Lombardo and how the sound of the bees could bleed into the soundtrack of the rest of the film, rather than a moment where you've got guitars, and drums, and bees, and there's a song. It wouldn't really have to be a song so much; it could be a place where the sound that already exists in the film wells, comes to an articulate head just for a moment, and then bleeds back out again.

This idea of avoiding a song is interesting to me in light of this comment and your reference to bagpipes as tools used to transport troops. Song is also subverted in Murphy's Law and Agnostic Front's constant delays in *CREMASTER 3* – you never hear their 'songs' fully; it's always a sort of delayed entrance and patches of silence.
This has something to do with thinking of the films in sculptural terms. Each film is site-specific, and is defined largely by qualities that come from the environment where the story takes place. Music and sound design function the same way. Jonathan has always first approached the scenes he's scoring with questions about the space. Our discussions in pre-production are often about asking what kinds of sounds this particular architectural space or that condition in the landscape would make. I have a feeling that sounds and noises are a starting point for Jonathan as much as anything else.

Of course, there have been specific scenes where ambient sounds become music (like the elevator shaft scene in *CREMASTER 3*, or, as we just discussed, the bees in *CREMASTER 2*). However, Jonathan and I both want the music and sound to come organically out of the form, and for it not to feel applied. This is something like the old debate about painting a sculpture, masking the inherent quality of a form and the nature of a material with applied color/applied emotion. Songs in films are something like this for me. They either feel applied, or they belong to the emotion of a character. As I mentioned earlier, the *CREMASTER* films are not character driven; rather, there's an attempt to give the primary emotional, leading role to the environment.

There are other examples where sound/music choices were made by using musical forms or instruments that already exist in that environment – I'm thinking of the bagpipes in *CREMASTER 4*, or Jonathan's interest in Native American scalp songs when he was scoring the 'two step' sequence in *CREMASTER 2*, which starts with the appearance of the buffalos after the rodeo scene.

CREMASTER 3, 2002 (182 minutes)

Beer-soaked Theremin, bagpipes, an elevator shaft (harp, wind instrument), a cat, cars crashing, steeplechase bugle, an Irish tenor in Gaelic, organ, Philharmonic Orchestra, pipes, cello, fiddle, trumpets, trombones, saxophones, contrabass clarinet, bass, piano, drums, vibraphone, percussion: "This is the song of the vertical field,/a promising plumb line draped down from the skyline." It's a simultaneous, architectural play within a play.

> **Brandon Stosuy: The overall sound design for *CREMASTER 3* is complex, but *The Order*, 2003, is especially involved. It reminds me of a hectic cartoon or video game.**
> Matthew Barney: A lot of the first conversations I had with Jonathan and the digital effects people for that scene were about video games – all the way to how the scene was color-timed. I wanted to flatten the scene out as much as possible to have it exist in the body of the story, but to have a completely different feel, like the live-animation feel of *CREMASTER 4* or *1*. The initial proposal was to broadcast *The Order* into the narrative using the needle on the spire of the Chrysler building. The Chrysler Building used to be a receiver for early, live television broadcasts. All of the characters in *The Order* were directed to be vectors, pre-programmed to do one thing, without any emotional projection much more so than the characters in the body of the film. In general, I need for the characters in these stories to remain somewhat abstract so that, eventually, narrative sculptures can be drawn from the story. I think this kind of withholding is really important to my program as a sculptor.

> **By the time you got to *CREMASTER 3*, were you aware of how the various films would overlap if placed together? The overlapping of sound from the five previous films, along with the characters resurfacing, etc., seems to suggest a simultaneous screening.**
> *The Order* was probably complicated by that fact that I was already starting to plan the exhibition at the Guggenheim[7] and thinking about how the exhibition could be organized in that space,

and that the different chapters could be like the different tiers in the building. From there I got interested in how that could happen in several places in *CREMASTER 3*, that there could be a kind of chorusing of the different films, that there could be delegates from each chapter in the demolition derby, in the horse race, in the Guggenheim.

Dolby Digital was available just at the end of the post-production on *CREMASTER 2*. We didn't end up using it, but I can remember talking with the sound design people and with Jonathan and learning about the possibilities, where you can use a joystick and move sound through the different speakers in the cinema and have very discreet sound sources coming from different places in the room. We started talking about how different sounds from different speakers could function in *The Order* scene, which we were developing at the time. That influenced us to develop the idea of simultaneity – the idea where there would be moments in the scenes where you're hearing all five streams and other moments where you would hear them individually. If you were on a level you would hear that level in a more present way, and you would hear the others in a more ambient way. It was fascinating to know that we could really control the effect with the five speakers I can remember the first tests we did with just taking Agnostic Front and Murphy's Law records and putting them on at the same time and listening to them and how exciting that was.

There's something about that scene that captures the quality of the whole film cycle for me in the sense that the five film chapters are five simultaneous streams. In my head they are happening at the same time. I think that's what's interesting about this installation.

I've always thought of *CREMASTER* belonging to the tradition of Robert Smithson and to the Earthworks movement[8], in the sense that it was visualized as a narrative drawing superimposed across five conditions in the landscape. The five narratives would inhabit these five places, and return from the places with narrative sculptures, or non-sites[9].

Do you prefer the *CREMASTER* films being shown simultaneously?
I think there are a number of viable options for playback. In my opinion, they all provide a different and useful entry point into the larger form of the cycle. The multi-channel installation is useful in emphasizing that notion of simultaneity, or describing a body that is defined by a multiplicity, rather than one that has a single center. Showing the films sequentially makes the relationships between the various host environments and the guest/viral language clearer.

A conversation with *CREMASTER* composer Jonathan Bepler, New York, August 2007

Brandon Stosuy: What sort of questions did you ask for *CREMASTER 5*, *CREMASTER 2*, and *CREMASTER 3*?
Jonathan Bepler: I thought of *CREMASTER 5* as an opera that could have been sung by the Queen character in the period and time in which she was singing it. There was a complex system

of space-values (inward, outward, shades in between) connected to the climber's trajectory in the opera house. I associated these with pitch/sound relationships, which determined the color of the composition. I always thought of it as a contemporary work, which might be performed again sometime.

In *CREMASTER 2* we had the ideas of the desert, the bees, and the pipe organ (originating from the Mormon Tabernacle), Native American music, Country Western, American crime and romance, and the sound a glacier might make. I drew on all my own interests in these things. The letters of Nicole (Gary Gilmore's girlfriend) led to Patty Griffin.[10]

In *CREMASTER 3* there was a horror disinterment scene, the Chrysler Tower itself, the Irish ballad and dance language, the 1930s urban context (*Rhapsody in Blue*), a ceremonial dance, New York show tunes, a physical comedy act, horror and horse racing, a video game, an epic challenge, a Gaelic ballad.

It often seems like each cut or framing receives a new sound. This struck me especially in the opening sequence of *CREMASTER 5*.

In many cases, the picture has been cut to the rhythm of the music. It's of course the approach traditionally taken in ballet and opera. Certainly in *CREMASTER 5*, because the music had to be finished before shooting began in order to enable the singers and orchestra to 'play' on-screen. It has since been a goal of mine to avoid what I think of as the 'pornography' of scoring music directly to picture. It feels manipulative to me, and it's so difficult to get below the seductive top layer effect of music on picture. That's what one sees so often in narrative film.

It was also always important to me (and perhaps not only for egoistic reasons) to try to keep control of the delicate balance of all the musical/sound language in the film, and to have it be the language and logic of the piece itself, as strange or divergent as it sometimes seemed. I'm excited that a sequence can function as sound design, score, an anthem, a song commentary. To have known songs in a film seems to destroy some of this (for me, anyway). I'm not really fond of song compilation soundtracks.

I know many film composers insist on not beginning until there is a final locked picture. I was very happy in the *CREMASTER* films to be able to begin working on the music in the very early stages, just as the storyboards were being developed, and things were still quite abstract. Then we could discuss spaces, events, and narratives in an abstract way, and I could start relating my own musical thoughts to these abstractions. As Matthew and I work together and separately, layers are accumulated as new ideas come in, tangents are followed. Thus, my musical trajectory really has it's own life. There are many places where the music is the main character, in a way, which has been great for me.

Can you name one of these moments?

In *CREMASTER 2*, when Baby Fay La Foe walks through the exhibition hall, it's like a duet with something big.

How important are ambient sounds and noises to your practice?

The musicality of naturally occurring rhythms and melodies particularly excites me. I spent some time making automatic instruments: systems where chaos is at the heart of musical 'choices'. I also worked on making new instruments, and pursuing sounds we have never heard before. So I was right at home with the idea of bees substituting for metal guitars, or representing the crinkle of drying salt with violins.

Can you tell me more about the 'automatic instruments' and the new instruments you've made? Have you used any of these in *CREMASTER*?

It was my intention with automatic instruments to create unrepeatable performances, to use somewhat faulty devices and create systems full of chaos. You never knew what would happen and there was a feeling of an unknown agent at work: tubas being blown by hair dryers with latex lips, strings being strummed by cheap motors dangling from the wall. During *CREMASTER 3*, we constructed an 80-foot string instrument that only played harmonics, a large version of an instrument Glenn Branca[11] had made when I played with him. This was an important 'character' in the Chrysler Tower in *CREMASTER 3*.

How have you used quadraphonic sound in the *CREMASTER* films?

In *CREMASTER 3* part of the audience hear completely different things from the other. In other words, some people 'miss' what others are basking in at that same moment. Experts say you should never do that. I thought it was a risk worth taking.

Can you give some examples?

One example is in the opening of *CREMASTER 3*. These wailing Theremins create 'resultant tones', or distortions in the ear, when the sounds mix together. The four Theremins are often each in one speaker only, so the mixing happens in the space itself, rather than in the box. This is a much more exciting sound to me. It means that practically each audience member will hear a different mix. The person sitting close to one of the speakers will have an intimate experience of Theremin 1, and perhaps barely hear Theremin 3 at all. It also means that each theater will have a different sound, the 'performance' will feel different. I like the idea of re-taining 'liveness'.

Have you ever thought about the constantly shifting sounds of a multi-channel *CREMASTER* and how they relate to one another when the films are being played simultaneously, or in different pairings?

I love the idea of the *CREMASTER Cycle* as a cumulative work with various ways of represent-ing itself. Maybe this means a simultaneous, shiftingly synchronous viewing, a back-to-back marathon, or one of the reductive performances we did at the Guggenheim. While the pieces were made individually, there was a growing feeling of interrelation as my involvement continued. At the beginning of a project, formulating instrumentation and a sound palette is a really important

and sometimes arduous stage. Choices were often influenced by how they resonated with the palettes and meanings of other pieces: the bagpipes relating to the pipe organ, the show tunes in *CREMASTER 3* and in *CREMASTER 1*. I love allowing things to fall together in the same space.

How did Dolby Digital shift your approach to *CREMASTER 3*, especially in *The Order*?
Just about every bit of that piece is concerned with physical placement and directionality of the sounds. *The Order* was a pretty complex thing – a bit like a video game that has five levels, each of which has its own system of sound movement and spatiality. All of these can sometimes be heard at once. The moving 'player' character has a propulsion theme that shifts gradually, depending on his success/trajectory. On top of all of these layers is the musical score, a kind of frame reminding us that this system is a film. The finale of this builds to a convergence/conflict of all these elements, which is expressed in part through a great rotation of the sounds in reference to the spiral of the Guggenheim space itself.

In *CREMASTER 2* you're credited with 'bee programming'. How did you deal with the bees for that bee-metal sequence?
Dave Lombardo plays along with 200,000 honeybees. I recorded various groups of bees, and some solos, while the bees were at Matthew's studio during shooting. I then edited the recordings, and used samplers to create playable instruments, to have the bee sounds function the way guitar parts do in Thrash metal. I combined my performances on these instruments with the raw bee sounds to get the tracks that accompany Dave's drums. There were also some pretty nice 'bee solo' moments in there. Steve Tucker later sang on top.

What do you think of lyrics and how they interact with your compositions? I realize this is different in, say, *CREMASTER 5* compared with *CREMASTER 2*, for instance.
It's another layer in the total language. I'm really interested in the art of setting text to music. The text is where so much of the inspiration for the music comes from. Because Matthew and I are able to work together on the text, there's a lot of room for play. Working with text in Hungarian or Gaelic, and having lines like "tumbrel a grey wood" is very inspiring.

In his notes to the *CREMASTER 5* CD, Arthur C. Danto discusses the sound, without image, noting that "as you listen, you will hear more and more of what you might finally see in the film, to the point where, if you have listened enough, the film will be as familiar as something you live through in memory, like the Queen of Chain, over and over."[12]
I like to think the music can take you farther into the visual than the visual alone can. There's a place where we can see and hear at the same time, without being aware of doing either: a state of awareness without concentration, which can only happen with this kind of accumulation of elements.

Listening to the five-channel *CREMASTER Cycle*

Temporarily dislodge the accumulation, ignore the images and their associations entirely and concentrate on sound. Wander through the gallery and listen to the Morton Feldman spaciousness mashed with marching metal bands; Busby Berkeley and Hungarian voices crumbling into duet; music boxes and grapes burrowing beneath engines. A slow, distended pipe organ/Theremin produces a double/triple drone. A gunshot introduces a new flourish. Splashing from a bridge spills into a bubble bath. Celtic twitters chirp to séance whispers, and a Diva crashes to the stage. New York punks welcome string accompaniment.

Find the first sound and the last and notice how they engulf one another: Despite a lack of dialogue, these are not silent films.

1 See: http://www.cremaster.net, date: 29.09.2007.

2 See: A trilogy of works, titled *Facility of Incline*, 1991, *OTTOshaft*, 1992, and *Facility of Decline*, 1991. Primary sculpture titles from this body of work: *Transexualis, Repressia, Pace Car for the Hubris Pill, Al Davis Suite*, and *Jayne Mansfield Suite*. Video action titles: *Flight with the Anal Sadistic Warrior, Delay of Game, OTTOshaft, Radial Drill*, and *Blind Perineum*.

3 Founded in 1985, Artangel is a British organization commissioning one-off artists' projects at various sites. Recipients include Janet Cardiff, Tony Oursler, Laurie Anderson/Brian Eno, and Rachel Whiteread. See: http://artangel.org.uk, date 08.10.2007.

4 Dave Lombardo (1965–today): Cuban-born drummer of American thrash metal band Slayer.

5 Reference to the tap dancing of the Loughton Candidate (red-haired, white suit-wearing Satyr character) in *CREMASTER 4*.

6 Busby Berkeley, (1895–1976) was a Hollywood director/choreographer known for his complex, flamboyant showgirl-packed dance sequences.

7 The exhibition tour started at the Museum Ludwig, Cologne (06.06.–01.09.2002), continued at the Musée d'Art Moderne de la Ville de Paris (10.10.2002–05.01.2003), and ended at the Solomon R. Guggenheim Museum, New York (21.02.–04.06.2003).

8 Term (often) describing large-scale Land/Earth Art, works existing outdoors, created with materials from the natural environment (soil, sticks, rocks, leaves, etc). The movement began, and was most active in the late 1960s and early 1970s. Major examples include Dennis Oppenheim's *Salt Flat*, 1968, Michael Heizer's *Double Negative*, 1969/70, Robert Smithson's *Spiral Jetty*, 1970, and Walter De Maria's *Lightning Field*, 1977. Associated artists include: Alice Aycock, Andy Goldsworthy, Nancy Holt, Richard Long, and Robert Morris.

9 Term coined by Robert Smithson to designate an indoor, gallery-installed Earthwork. See his essay "A Provisional Theory of Non-Sites": http://www.robertsmithson.com/essays/provisional.htm, date: 20.09.2007.

10 Patty Griffin (1964–today): American country/folk singer-songwriter born in Old Town, Maine. See: http://www.pattygriffin.com/, date: 20.09.2007.

11 Glenn Branca (1948–today): Influential avant-garde guitarist/composer associated with Downtown New York via contributions to various scenes (no wave, loft rock, symphonic noise, drone-rock, drone). Perhaps best known for his guitar ensembles/orchestras/armies.

12 Arthur C. Danto: *Jonathan Bepler's Music For Cremaster 5*, in the liner notes for *CREMASTER 5* [Soundtrack], 1998, p. 5.

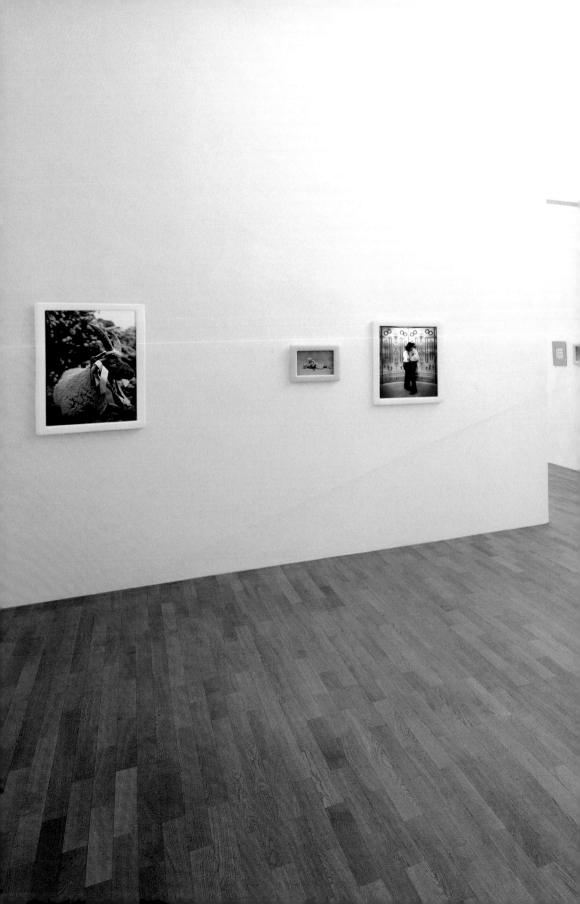

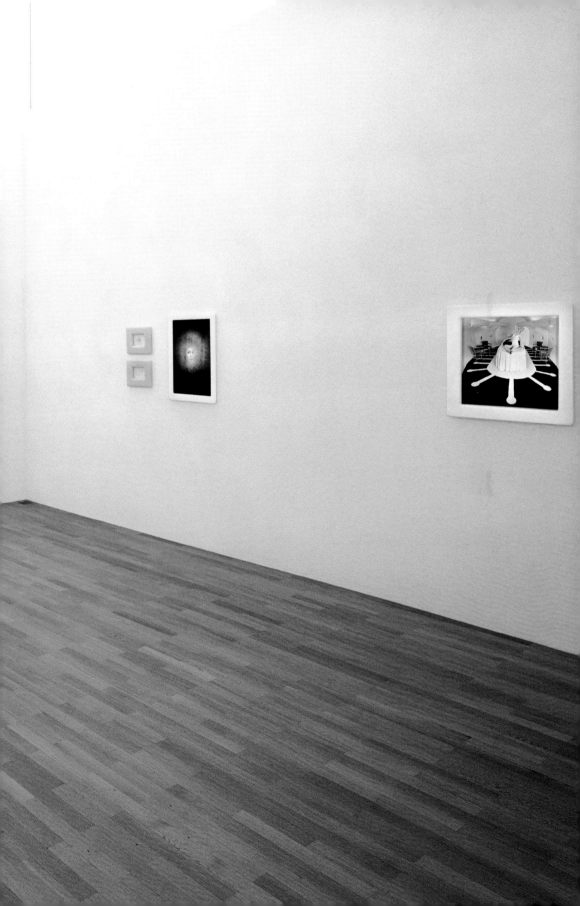

Glossar

Karsten Löckemann

Hiram Abiff Nach einer Freimaurerlegende ist Hiram Abiff der sagenhafte Erbauer von König Salomons Tempel in Jerusalem, der aber in der Bibel nicht genannt wird. Erwähnt wird hier ein Hiram von Tyrus, der von Salomon den Auftrag erhielt, den Tempel mit Metallverzierungen zu versehen. Nach der Legende wurde Hiram von einem Mann aus einer Gruppe dreier Gesellen ermordet, die ihn angriffen, um das Geheimnis zu erfahren, das der Baumeister mit sich trug. Es soll nie enthüllt worden sein. Sein Leichnam wurde außerhalb der Stadtmauern Jerusalems versteckt, bis König Salomon diesen auffand, ihn mit dem freimaurerischen Meistergriff aus dem Grab hob und ihn wieder zum Leben erweckte. Mord, Begräbnis und Auferstehung des Hiram Abiff wiederholen sich in der dreistufigen Initiation der ➜ Freimaurer: Der Novize steigt vom Lehrling zum Gesellen und zuletzt zum Meister auf. Der Baumeister wird in *CREMASTER 3* von Richard ➜ Serra verkörpert.

Ascending Hack/Descending Hack Das Motorradteam des Ascending Hack sticht mit seiner gelben Erkennungsfarbe hervor, startet das Rennen in *CREMASTER 4* im Tiefland der ➜ Isle of Man und durchquert während der Tour ein ständig ansteigendes Gebiet. Das Team des Descending Hack ist an der blauen Farbe zu erkennen. Seine Tour beginnt im Hochland der Insel und folgt einem absteigenden Parcours. Die Farb- und Formgebung dieser Teams ist in Barneys Bildsprache eine Metapher für die sexuelle Differenzierung. Blau steht für das männliche Prinzip, gelb für die weibliche Ausprägung.

Baby Fay La Foe So heißt die Figur der Seherin und fiktiven Großmutter von Gary ➜ Gilmore, unter deren Aufsicht sich seine Zeugung im zweiten Teil des *CREMASTER Cycle* vollzieht.

Baker, Nicole Sie ist die Freundin von Gary ➜ Gilmore.

Berkeley, Busby (1895–1976) war einer der einflussreichsten und stilbildenden amerikanischen Filmregisseure und Choreografen in Hollywood. Er war vor allem bekannt für seine musikalischen Produktionen mit komplexen geometrischen Figuren und machte das Filmmusical zu einer erfolgreichen Gattung der Unterhaltungsindustrie. Wie viele Regisseure seiner Zeit begann Berkeley seine Karriere als Theaterdirektor. Berühmt wurde er schließlich durch seine innovative und bahnbrechende Kameraführung. Er nutzte die Beweglichkeit der Kamera durch Kranfahrten, um dem Filmpublikum Perspektiven und Sichtweisen von Personen und Dingen zu ermöglichen, die für das Theaterpublikum durch die unveränderliche Lage der Bühne nicht möglich waren. Der Regisseur wurde zwischen 1935 und 1937 dreimal in Folge für einen Oscar in der Kategorie Best Dance Direction nominiert.

Bienen von Deseret Das Wort ‚Deseret' ist nach der mormonischen Lehre, die von Joseph Smith (1805–1844) begründet wurde, das einzige Wort, das von der Sprache Adams übrig geblieben ist. Smith hat dieses Wort mit Honigbiene übersetzt. Der Bienenstock ist zum Symbol Utahs und der ➜ Mormonen geworden, da die Biene die Tugenden mormonischen Lebens verkörpert.

Björk Die isländische Sängerin, Komponistin und Schauspielerin Björk Guðmundsdóttir wurde 1965 in Reykjavik in Island geboren. Das musikalische Spektrum ihrer Karriere bewegt sich zwischen Punk, Pop, Folk-Musik und klassischer Musik. 2005 erschien mit *The Music from ‚Drawing Restraint 9'* ein Soundtrack, den Björk für den gleichnamigen Film ihres Lebensgefährten Matthew Barney komponiert hat. Das Album besteht hauptsächlich aus Liedminiaturen, die mit Gesang durchsetzt sind. In dem gleichnamigen Film verkörpert sie neben Barney die zweite Hauptrolle.

Blutsühne Sie ist u. a. in der mormonischen Bewegung der ‚Kirche Jesu Christi der Heiligen der Letzten Tage‘ eine umstrittene Lehre, die von dem zweiten mormonischen Propheten Brigham Young (1801–1844) eingeführt wurde und die besagt, dass Sünden, wie Mord oder Ehebruch, nur durch Blutvergießen des Sünders gesühnt werden können. Dabei soll dessen Blut auf den Erdboden tropfen und versickern. Heute wird bei den ➜ Mormonen diese Lehre nicht mehr offiziell verkündet, sie wurde allerdings auch nie ausdrücklich aufgehoben. Unter anderem ist Utah aus diesem Grunde der einzige Staat in den USA, der bis heute die Hinrichtungsmethode des Erschießens genehmigt, wenn der Todeskandidat dies verlangt.

Bonneville Diese weitläufige Salzwüste ist eine Region westlich des Großen Salzsees im nördlichen Teil des US-Bundesstaats Utah. Sie entstand gegen Ende der letzten Eiszeit infolge der Austrocknung des Lake Bonneville, einem prähistorischen See, der sich westlich der Rocky Mountains ausdehnte. Heute erstreckt sich das Gebiet auf einer Fläche von rund 10.360 Quadratkilometern bis zur Staatsgrenze von Nevada.

Bronco-Stadium Das Footballstadion der Boise State University, Boise, Idaho, wurde 1970 erbaut. Barney hat in der Stadt für längere Zeit gelebt und hier auch seine Leidenschaft für Football entdeckt. Das Stadion hat 30.000 Sitzplätze und besitzt als einzige Sportarena der Welt ein Spielfeld mit blauem Astroturf, einem Kunstrasen. Es wird unter anderem für Leichtathletikveranstaltungen genutzt. Die Farben des Bronco-Teams sind Blau und Orange, ihr Maskottchen ist ein Bronco, ein wildes Pferd.

Budapest Die Hauptstadt und zugleich größte Stadt der Republik Ungarn hat etwa 1,61 Millionen Einwohner. Die Einheitsgemeinde Budapest entstand 1873 durch die Zusammenlegung der zuvor selbstständigen Städte Buda und Pest. Ein Jahr nach dieser Zusammenlegung der beiden Städte wurde hier Erich Weisz geboren, der später unter seinem Künstlernamen Harry ➜ Houdini berühmt wurde.

Chrysler Building Es ist einer der bekanntesten Wolkenkratzer und ein Wahrzeichen von New York City. Es befindet sich in der Lexington Avenue 405, Ecke 42. Straße. Das Gebäude des Architekten William Van Alen wurde von Walter P. Chrysler als Firmensitz in Auftrag gegeben und sollte mit 65 Stockwerken und einer Höhe von 282 Metern das höchste Bauwerk der Welt werden. Als der Tower der Bank of Manhattan diese Höhe kurze Zeit später übertreffen sollte, beschlossen Chrysler und sein Architekt Van Alen das Chrysler Building zusätzlich mit einer 55 Meter hohen Nirosta-Nadel zu bekrönen. Die Grundsteinlegung für das Gebäude fand am

19. September 1928 statt, am 28. Mai 1930 wurde es bereits eingeweiht. Der gesamte Film *CREMASTER 3* ist ein fantastischer Bericht über die Errichtung des Chrysler Building.

Cremaster Der Musculus cremaster (dt. Hodenheber) besteht aus Muskelfasern des Mannes, die aus zwei Muskeln des Unterbauchs abzweigen. Er kann die Hoden zum Körper heranziehen. Der Cremaster ist eine Komponente zur Thermoregulation für die Hoden. Wenn die Temperatur der Hoden zu hoch wird, entspannt sich der Musculus cremaster, sodass die Hoden weiter herabhängen und besser gekühlt werden. Werden die Hoden dagegen zu kühl, werden sie vom Cremaster näher an den wärmenden Körper herangezogen. Darüber hinaus schützt der Cremaster die Hoden vor Verletzungen (Cremaster-Reflex). Bei starker sexueller Erregung werden die Hoden ebenfalls kräftig zum Körper gezogen. Dadurch wird die Länge des Samenstrangs um bis zu 50 Prozent verringert und so der Weg der Spermien zur Eizelle deutlich verkürzt. Daher steigt die Wahrscheinlichkeit einer Befruchtung. Dieses biologische Gerüst wird im *CREMASTER Cycle* zur Grundlage für Matthew Barneys künstlerisches Konzept.

Drawing Restraint Die Idee, physische Grenzen überschreiten zu wollen, geht auf Barneys Erfahrung als Sportler zurück. Bereits in den frühesten Experimenten während seiner Collegezeit versuchte er, unter bestimmten Beschränkungen einen künstlerischen Prozess umzusetzen. Hier entstand unter Mitwirkung des physischen Widerstandes das Grundelement der Zeichnung. In seinem Atelier, das wie ein Kraftraum ausgestattet war, kletterte Barney auf Rampen, zog an Seilen usw. und schuf parallel einige Zeichnungen. Barney demonstrierte hier auf eindrucksvolle Weise, dass im sportlichen Wettstreit Triebe, wie Sexualität und andere Bedürfnisse, unterdrückt werden, die dem Siegeswillen im Wege stehen. Er begann hier erstmals, den Herstellungsprozess einer künstlerischen Arbeit per Videokamera aufzuzeichnen, worüber er dann immer mehr Gefallen am Medium Film fand. Aus der Grundidee von ‚Drawing Restraint‘ wurde ein mehrteiliges, bis heute nicht abgeschlossenes Projekt.

Drohne So wird die männliche Honigbiene, Hummel, Ameise, Wespe oder Hornisse bezeichnet. Alle diese staatenbildenden Insekten aus der Ordnung der Hautflügler unterscheiden die Königin, die Arbeiterin und die Drohne. Die Drohnen dienen ausschließlich der Begattung der Königin. Die Befruchtung einer jungen Bienenkönigin findet im Flug, oben in der Luft, statt. Hierbei wird der Geschlechtsapparat (Penis) der Drohne herausgestülpt, nach der Befruchtung fällt sie von der Königin ab und stirbt.

Dudelsack Die Sackpfeife oder der Dudelsack, ist ein selbst klingendes Rohrblattinstrument, dessen Luftzufuhr aus einem Luftsack über eine Windkapsel erfolgt. Sie wird von einem Sackpfeifer gespielt. Das Instrument hat eine Spielpfeife (manche auch mehrere), mit der Melodien gespielt werden und meist ein oder mehrere Bordunpfeifen (auch Brummer), die je einen andauernden Ton spielen. Die Töne in den Pfeifen werden durch je ein Rohrblatt (einfach oder doppelt) erzeugt. Dieses wird aus der Schilfart Arundo donax, in neuerer Zeit auch aus Kunststoff oder Metall hergestellt. Die Luftzufuhr zu allen Pfeifen erfolgt aus einem Luftsack aus abgedichtetem Leder oder aus einem synthetischen Material, der vom Spieler mit dem Mund durch ein Anblasrohr oder durch einen Blasebalg aufgeblasen wird. Der Luftvorrat im Sack ermöglicht die Erzeugung eines vom Atem unabhängigen Dauertons und die Aufrechterhaltung eines näherungsweise konstanten Luftdrucks.

Entered Apprentice/Fellow Craft/Master Mason Diese englischen Bezeichnungen der ➜ Freimaurer gelten für Lehrling, Geselle und Meister.

Feldzeichen Ganz zu Beginn seiner künstlerischen Tätigkeit hat Barney ein Symbol seiner Arbeit geschaffen. Mit diesem Feldzeichen in Form einer Ellipse, die von einem horizontalen Streifen durchtrennt wird, versinnbildlicht er die beiden Pole seines Werks: Einerseits den selbst auferlegten Widerstand bei der künstlerischen Arbeit, andererseits das kreative Potenzial, das während des Prozesses frei wird. Das Feldzeichen taucht als Signet des Künstlers immer wieder und in verschiedenen Ausprägungen in seinen Arbeiten auf.

Fingal Der traditionelle Name dieses schottischen Riesen lautet Benandonner. Barney hat ihn in Fingal umgetauft, nach der Höhle, in der er gelebt haben soll. (Fionn ➜ MacCumhail).

Fingalshöhle Sie ist eine durch die Kraft der Wellen geformte, 80 Meter lange und zehn Meter breite Höhle, die nach dem keltischen Sagenkönig ➜ Fingal benannt ist und auf der Isle of Staffa liegt, einer kleinen Felseninsel an der Westküste von Schottland.

Freimaurer Sie gehören zu einer weltweiten humanitären Initiationsgemeinschaft. Initiation bezeichnet die Einführung eines Außenstehenden in eine Gemeinschaft oder seinen Aufstieg in einen anderen Seinszustand, z. B. vom Novizen zum Priester oder vom Laien zum Schamanen. Die Wurzeln der Freimaurer reichen wahrscheinlich zu den mittelalterlichen Bauhütten zurück, deren Gebräuche und Gepflogenheiten bis heute in der freimaurerischen Tradition anklingen. Sie sind in Logen organisiert und vereinen Menschen aller sozialen Schichten und Bildungsgrade. Die Freimaurer streben die geistige und ethische Vervollkommnung ihrer Mitglieder an. Die wichtigste Aufgabe eines Freimaurers besteht in der karitativen Arbeit und der Förderung von Bildung und Aufklärung. Mithilfe von Zeremonien und Riten (Brauchtum, Tempelarbeit, freimaurerische Gesprächskultur) vermitteln die Freimaurer ihren Mitgliedern eine Lebensphilosophie, die sie dazu anhalten soll, den fünf Grundidealen der Gemeinschaft näher zu kommen: Freiheit, Gleichheit, Brüderlichkeit, Toleranz und Humanität. Die Freimaurer bedienen sich eines sehr komplexen allegorischen Systems bestehend aus Elementen aus Architektur, Geometrie und alten Mysterien.

Gellért-Bad Das im Sezessionsstil gebaute Gellért-Bad ist das berühmteste Bad ➜ Budapests. Seine Quellen wurden bereits im 13. Jahrhundert durch die Türken genutzt. Das Bad wurde zusammen mit dem Gellért-Hotel errichtet und 1918 eröffnet.

Giant's Causeway So heißt der sogenannte ‚Damm des Riesen', befindet sich an der nördlichen Küste Nordirlands und östlich des kleinen Städtchens Bushmills. Er besteht aus etwa 40.000 gleichmäßig geformten Basaltsäulen, die ein Alter von etwa 60 Millionen Jahren aufweisen. Die UNESCO rechnet ihn zum Weltnaturerbe. Nach einer irischen Legende soll der Damm vom Riesen Fionn ➜ MacCumhail erschaffen worden sein, der die Steine aufgetürmt hat, um trockenen Fußes nach Schottland zu kommen.

Gilmore, Gary Die Kindheit des amerikanischen Raubmörders (1940–1977) war geprägt von Missbrauch und Gewalt. Seine Jugend verbrachte er in Erziehungsanstalten. Von seinen letzten 21 Lebensjahren befand er sich 18 Jahre lang in Haft. Angeklagt wegen der Ermordung eines Tankwarts sowie eines Motelmanagers in Provo, Utah, verwahrte er sich gegen jeden Versuch einer Verteidigung und wies seinen Anwalt strikt an, für ihn die Todesstrafe zu fordern. Sein Verfahren trieb er mit aller Macht voran: Er wurde im Juli verhaftet, im Oktober verurteilt und am 17. Januar 1977 exekutiert. Der amerikanische Schriftsteller Norman ➜ Mailer verarbeitet die Geschichte von Gilmore in seinem 1979 erschienenen Tatsachenroman *The Executioner's Song* (*Gnadenlos*). Mailer stellt darin die Behauptung auf, dass Gilmores Großvater der Entfesselungs- und Zauberkünstler Harry ➜ Houdini war. Gary Gilmore wird im *CREMASTER Cycle* von Matthew Barney gespielt.

Goodyear Als Logo der Goodyear Tire & Rubber Company wählte der Firmengründer Frank Seiberling den Flügelschuh. Er ist das Attribut des Götterboten Merkur.

Der Götterbote galt als Überbringer guter Neuigkeiten, und Seiberling verband mit ihm alle Eigenschaften, die auch seine Goodyear-Produkte auszeichnete. Die verschiedensten Gummi-Erzeugnisse der Firma Goodyear sollten mit diesem Logo die Welt erobern.

Griechische Tragödie Die Tragödie (gr. *tragodia* = Bocksgesang) wurde in der griechischen Antike entwickelt und erlebte von 490 bis 406 v. Chr. ihre Blütezeit. Der Ursprung dieser Literaturgattung liegt in den rituellen Festen zu Ehren des Weingotts Dionysos begründet. Die antike Tragödie ist in fünf Akte mit einer klaren szenischen Steigerung gegliedert: 1. Akt Exposition, 2. Akt Konfliktaufbau, 3. Akt Kollision, 4. Akt Retardierung und Beschleunigung, 5. Akt Katastrophe und Versöhnung. *CREMASTER 5* ist in seiner Abfolge an diese Reihenfolge angelehnt.

Guggenheim Museum Das 1939 gegründete Museum für moderne Kunst liegt an der Upper East Side, zwischen dem Central Park und dem East River in New York City. Es wird von der Solomon R. Guggenheim Foundation betrieben. Das Museumsgebäude wurde von Frank Lloyd Wright entworfen und 1959 eröffnet. Die Rotunde des Museums ist Schauplatz für Barneys Film *CREMASTER 3*. Das Konzept der Performance im Museum knüpft an frühere Projekte des Künstlers an. Der Spiralbau wurde oft mit einem Bienenkorb verglichen und schlägt somit eine Verbindung zu *CREMASTER 2*, der bereits auf die Geschichte der ➔ Mormonen anspielt. Barneys Performance findet auf den fünf Ebenen des Museums statt, die symbolisch für die fünf Teile des Zyklus stehen.

Her Diva/Her Giant/Her Magician Hierbei handelt es sich um Gefolgsmänner der ➔ Queen of Chain, die alle von Matthew Barney selbst gespielt werden. Diese Fantasiegestalten verkörpern die unterschwelligen Wünsche und Begierden der vereinsamten Königin.

Houdini, Harry Der Entfesselungskünstler wurde am 24. März 1874 als Erich Weisz in ➔ Budapest geboren. Er war der Sohn des Rabbiners Mayer Samuel Weisz. Als Weisz vier Jahre alt war, wanderte seine Familie in die USA, nach Appleton, Wisconsin, aus. Später zog sie nach New York, wo Weisz im Alter von 17 Jahren begann, als Zauberkünstler aufzutreten. Er gab sich den Künstlernamen Harry Houdini als Hommage an sein Vorbild, den französischen Magier Jean Eugène Robert-Houdin. Den ersten Durchbruch hatte Houdini 1895 mit einem von betrügerischen Spiritisten adaptierten Entfesselungstrick mit einer Handschelle, den er pressewirksam im Polizeipräsidium einer Kleinstadt zeigte. Im Jahr 1901 begleitete er den Circus Corty & Althoff auf seiner Deutschlandtournee. Houdini wurde über Nacht zum bekanntesten Showstar Europas und feierte auch in Russland große Erfolge. Mit geschickten PR-Maßnahmen gelang es Houdini ab 1906, auch in der Neuen Welt ein Publikum zu begeistern. Inzwischen hatte er als Requisite die Zwangsjacke entdeckt, die noch dramatischere Entfesslungen zuließ, etwa kopfüber an Wolkenkratzern aufgehängt. Berühmt wurde Houdini durch das Verschwindenlassen eines Elefanten auf dem Times Square, als dieser in einer von Charles Morritt konstruierten Kiste ‚unsichtbar‘ wurde. Später kopierte er die Show eines Fakirs und behauptete, dass er jeden von einem Mann geführten Schlag in den Unterleib durch Anspannung seiner Bauchmuskulatur unversehrt überstehen könne. Der Student Jocelyn Gordon Whitehead suchte Houdini am 22. Oktober 1926 in Montreal in dessen Garderobe auf und soll ihm mehrere kräftige Hiebe in den Bauch versetzt haben. Es ist unwahrscheinlich, dass dieser Schlag ursächlich für einen später diagnosdizierten Blinddarmriss und eine Bauchfellentzündung war, doch nach zwei Operationen starb Houdini am 31. Oktober 1926 im Alter von 52 Jahren im Grace Hospital, Detroit. Der Name Houdini ist im Laufe der Zeit in der amerikanischen Alltagssprache zu einem Synonym für Flüchten geworden (‚to houdinize‘). Sein Mythos als unbesiegbarer Supermann machte ihn für Generationen von Amerikanern zum Idol. Er war außerdem lebenslanges Mitglied der ➔ Freimaurer und bekennender Antispiritist. Harry Houdini wird im *CREMASTER Cycle* vom Schriftsteller Norman ➔ Mailer verkörpert.

Hypertrophie Es (gr. *hyper* = über(mäßig), *trophe* = Nahrung) ist der medizinische Fachausdruck für die Vergrößerung eines Organs oder eines Gewebes durch Vergrößerung der Zellen. Der Begriff ist besonders gebräuchlich im Zusammenhang mit Krafttraining oder Bodybuilding. Durch das Muskelaufbautraining wird der Körper veranlasst, die Anzahl der Muskelfasern zu erhöhen und somit die Muskulatur zu vergrößern.

Isle of Man Die 572 Quadratkilometer große Isle of Man ist eine Insel in der Irischen See, die als autonomer Kronbesitz direkt der britischen Krone unterstellt ist. Die Insel gilt international als Steueroase und ist bekannt für das Motorradrennen ➔ Tourist Trophy. Die Bewohner bezeichnen sich und ihre Insel nach der keltischen Sprache als ‚Manx‘. Die Sagen und Mythen der Insel bilden die Grundlage für die Motive von *CREMASTER 4*.

Japanische Teezeremonie Sie steht in ihrem zugrunde liegenden Ablauf der Philosophie des Zen nahe. Diese Zusammenkunft, bei der ein oder mehrere Gäste von einem Gastgeber Tee und leichte Speisen gereicht bekommen, folgt bestimmten Regeln. Um dem Gast die

Möglichkeit zur inneren Einkehr zu bieten, findet das Ritual in einem bewusst schlicht eingerichteten Teehaus statt. Es besteht gewöhnlich aus zwei Räumen, einem, der zur Vorbereitung des Tees dient und einem anderen für die Teezeremonie selbst. Das Haus kann als eines der Geräte für die Teezeremonie gelten. Für eine Teezeremonie gibt es zwar feststehende Regeln, doch kann der Ablauf je nach den verschiedenen Schulen variieren. Während der Zeremonie nimmt der Gastgeber die Rolle des Teemeisters ein.

Kettenbrücke Die Brücke (Széchenyi Lánchíd, Graf Széchenyi-Kettenbrücke), die in ➜ Budapest die Donau überspannt, wurde in der Zeit von 1839 bis 1849 auf Anregung des ungarischen Reformers Graf István Széchenyi erbaut, dessen Namen sie trägt. Sie ist die älteste und bekannteste der neun Budapester Brücken. Außerdem war sie bei ihrer Einweihung 1849 die erste Donaubrücke südlich von Regensburg. Das klassizistische Bauwerk wird von zwei triumphbogenartigen Stützpfeilern getragen, durch die die eisernen Ketten des 375 Meter langen Brückenkörpers verlaufen, daher auch ihr Name. Die Pfeilertore haben eine Durchgangsbreite von 6,50 Metern, das Gewicht der Eisenkonstruktion beträgt 2.000 Tonnen.

Loughton Candidate So heißt der rothaarige Satyr mit weißem Anzug, an dessen Revers ein Zweig des Manx-Heidekrauts steckt. Er ist den Mischwesen aus *Drawing Restraint 7* verwandt und ein Nachfahre des Inselsatyrs Phynnodderree, der zu Vorzeiten die ➜ Isle of Man unsicher gemacht haben soll. Der Candidate hat vier Einbuchtungen am Kopf, die zu Hörnern auswachsen werden und auf seine Bocksnatur verweisen. Das auf der Insel beheimatete Loughton-Schaf stand hier motivisch Pate. Die Rolle wird im Film *CREMASTER 4* von Matthew Barney verkörpert.

Loughton Faerie/Ascending Faerie/Descending Faerie
Dieses Trio rothaariger androgyner Elfen tritt mit Haarknoten in verschiedenen Formationen auf. Die Elfen passen sich im Verlauf der Geschichte von *CREMASTER 4* wie ein Chamäleon ihrer Umgebung an und symbolisieren aufgrund ihrer Nacktheit und der fehlenden Geschlechtsorgane ein frühes embryonales Entwicklungsstadium.

Fionn MacCumhail So heißt der Riese aus der irischen Sagenwelt, der sich in die hübsche Riesin auf der benachbarten schottischen Insel Staffa verliebte. Um das Meer zu überwinden, schuf er eines Tages einen gewaltigen Damm und holte seine Angebetete zu sich herüber. Zu allem Unglück hatte jedoch bereits der Riese Benandonner ein Auge auf die Schöne geworfen und neidete ihnen das Glück. Voller Groll folgte

dieser ihnen bald darauf über den gewaltigen Damm nach Irland. Doch Fionn MacCumhail ersann eine kluge List: Er verkleidete sich als Säugling und legte sich in die Wiege seines bereits geborenen Kindes. Dem tobenden Benandonner erklärte die schöne Riesin daraufhin, dass das Kind in der Wiege der Sohn von ihr und Fionn MacCumhail sei, und er solle sich bei der Größe des Kindes erst einmal die Ausmaße des Vaters vorstellen. Da flüchtete Benandonner Hals über Kopf und zerschmetterte in seinem Zorn den steinernen Damm, dessen Überreste bis zum heutigen Tag an der Küste zu sehen sind.

Mailer, Norman Der amerikanische Schriftsteller (geb. 1923) wuchs im New Yorker Stadtteil Brooklyn als Sohn einer jüdischen Mutter auf und studierte bis zu seiner Einberufung zum Militärdienst Bautechnik an der Harvard-Universität. Seine Erlebnisse als Soldat verarbeitete er 1948 in seinem ersten erfolgreichen Roman *The Naked and the Death* (*Die Nackten und die Toten*). In weiteren Werken sind Gewaltbereitschaft und sexuelle Neurosen Themenschwerpunkte. Politisch links orientiert entwickelte sich Mailer zu einem scharfen Kritiker der US-amerikanischen Gesellschaft. Für seine Reportage über die amerikanische Protestbewegung gegen den Vietnamkrieg *Armies of the Night* (*Heere aus der Nacht*) erhielt er 1968 den Pulitzer-Preis, ebenso 1980 für *The Executioner's Song* (*Gnadenlos*), einen Tatsachenroman über den Mörder Gary ➜ Gilmore und dessen Hinrichtung.

Manx-Triskelion Die Triskele, auch der oder das Triskel (gr. = dreibeinig), ist ein Symbol in Form von drei in einem gleichschenkeligen Dreieck angeordneten Beinen. Das Symbol wird gewöhnlich der keltischen Geschichte zugeordnet, ist jedoch tatsächlich in annähernd allen Kulturen der Welt zu finden. Das Manx-Triskelion ist das nationale Symbol der ➜ Isle of Man. Bei der heutigen Deutung spielt die Zahl drei, die insbesondere in der keltischen Mythologie eine Bedeutung hat, eine große Rolle. So können verschiedene Zusammenhänge und Zyklen angenommen werden, wie die Triaden Vergangenheit – Gegenwart – Zukunft, Geburt – Leben – Tod, Körper – Geist – Seele und schließlich die Elemente Erde – Wasser – Luft.

Mormonen So wurden schon früh die Anhänger der 1830 von Joseph Smith (1805–1844) gegründeten Glaubensgemeinschaft bezeichnet, die seit 1838 ‚Kirche Jesu Christi der Heiligen der Letzten Tage‘ genannt wird. Der Name wurde ihnen aufgrund ihres Glaubens an das von Joseph Smith geschriebene *Buch Mormon* von Außenstehenden gegeben. In den USA zählen die Mormonen zu den fünf größten Religionsgemeinschaften. Sie haben heute ihren Hauptsitz in Salt Lake City. Mit-

glieder der Kirche verstehen ihren Glauben als eine durch Gott eingerichtete Wiederherstellung der Kirche, die, wie im Neuen Testament beschrieben, ursprünglich durch Jesus Christus gestiftet worden sei. Sie glauben, dass ihre Gemeinschaft durch fortlaufende Offenbarungen von Jesus Christus an ihre Propheten und Apostel direkt angeleitet wird. Der Präsident der Kirche Jesu Christi der Heiligen der Letzten Tage wird vom Kollegium der zwölf Apostel und von der gesamten Mitgliederschaft halbjährlich als Prophet, Seher und Offenbarer anerkannt und bestätigt. Lediglich Offenbarungen, die vom Präsidenten und vom Kollegium der zwölf Apostel als von Gott bezeugt sind, haben Bedeutung für die gesamte Mitgliederschaft und werden als Heilige Schrift kanonisch in das *Buch Lehre und Bündnisse* aufgenommen. Als weitere kanonische Schrift gilt die *Köstliche Perle*. Auch dieses Werk wurde wie schon das *Buch Mormon* von Smith verfasst und enthält u. a. auch autobiografische Daten des Kirchengründers.

Oper So (it. *opera in musica* = musikalisches Werk) bezeichnet man seit etwa 1650 eine musikalische Gattung, in der eine szenisch-dramatische Handlung durch Musik gestaltet wird. Die Florentiner Camerata, in der die Oper entwickelt wurde, war ein akademischer Gesprächskreis, in dem sich Dichter, Musiker, Philosophen, Adelige und Kunstmäzene zusammenfanden. Diese Humanisten versuchten, das antike Drama wiederzubeleben, indem Gesangssolisten, Chor und Orchester daran beteiligt wurden. Bereits im griechischen Theater der Antike verband man die szenische Handlung mit Musik. Der begleitende Chor übernahm hierbei eine tragende Rolle: Chorgesang wurde einerseits zu den pantomimischen Tänzen herangezogen, welche das Theaterstück in verschiedene Teile gliederten; andererseits hatte der Chor auch die Aufgabe, die Handlung kommentierend zu begleiten.

Otto, Jim Der legendäre Mittelmann (geb. 1938) des Footballteams der Oakland Raiders wurde während seiner Karriere mehrmals an den Knien operiert und beendete seine Profilaufbahn mit zwei künstlichen Kniegelenken.

Queen of Chain Die schweizerische Schauspielerin Ursula Andress (geb. 1936) erzielte ihren internationalen Durchbruch 1962 als das erste Bond-Girl in dem Film *James Bond jagt Dr. No*. Sie verkörpert in CREMASTER 5 die fiktive theatralische Figur, die in der Oper ihre Erinnerungen Revue passieren lässt.

Queen's Pier So heißt der Landungssteg, der in Ramsey auf der ➔ Isle of Man 400 Meter in die Irische See hineinragt und im viktorianischen Stil 1886 errichtet wurde.

Revue Ähnlich der Operette und dem Musical vereinigt die Revue Musik-, Tanz- und Wortbeiträge zu einer Gesamtdarbietung. Im Unterschied zu den erstgenannten Gattungen, fehlt jedoch ein durchgehender Handlungsstrang. Vielmehr dient ein allgemeines Thema, auch ein aktuelles oder historisches Ereignis, als Motto für eine lockere Aneinanderreihung von ‚Nummern‘, bei denen sich Solodarbietungen und Tanzensembles abwechseln. Die Revue feierte seit dem Ende des 19. Jahrhunderts von Paris ausgehend (Folies Bergère, Moulin Rouge) große Erfolge und war in den 1920er-Jahren weltweit die beliebteste Unterhaltungsform auf der Bühne. In Amerika wurden 1907 die Ziegfeld Follies dem französischen Vorbild nachempfunden, die bald darauf die erfolgreichsten Shows am Broadway zeigten. In den 1930er-Jahren nahm die Beliebtheit der Revue ab. In der Frühzeit des Fernsehens erlebte sie nochmals einen Aufschwung. Mit unterschiedlicher künstlerischer Ausprägung wird das Genre Revue heute vor allem noch von traditionellen Music Halls wie dem Lido de Paris, dem Casino de Paris, den Folies Bergère, dem Moulin Rouge – alle in Paris – und dem Friedrichstadtpalast in Berlin gepflegt, aber auch in Shows in Las Vegas.

Rodeo Es ist eine traditionelle, aus Brasilien stammende Sportart, die große Verbreitung auf dem nordamerikanischen Kontinent gefunden hat. Das Wort stammt von dem portugiesischen ‚rodear‘ ab, das so viel wie ‚umrunden‘ bedeutet. Beim Rodeo gibt es das Reiten auf halbwilden Pferden (‚bronc riding‘) und Bullen (‚bull riding‘), bei dem sich der Reiter möglichst lange auf dem Tier halten muss, ohne abgeworfen zu werden. In den Staatsgefängnissen von Texas und Oklahoma findet jährlich ein Gefängnisrodeo statt, an dem nur Häftlinge teilnehmen.

Salt Lake City Tabernacle Die große Kuppelhalle auf dem Tempelplatz in der Hauptstadt des Bundesstaates Utah, Salt Lake City, war bis zur Fertigstellung des Konferenzzentrums im Jahr 2000 die Hauptversammlungshalle der ➔ Mormonen. Der Raum bietet Platz für etwa 5.000 Menschen. Der Bau des Tabernakels wurde 1864 begonnen und 1867 fertiggestellt. Es wurde so konstruiert, dass ein Redner von jedem der Anwesenden gehört werden kann. Die Orgel gehört mit ihren 11.623 Pfeifen zu den 20 größten der Welt. In ihrer abgeschirmten, organischen Architektur gleicht die Halle einem Bienenkorb, dem Symbol der Glaubensgemeinschaft. Das Tabernakel dient in der katholischen Liturgie als Aufbewahrungsort der Hostie, die als Leib Christi verehrt wird. In CREMASTER 2 spielt die Urteilsverkündigung im Fall Gary ➔ Gilmore im Salt Lake City Tabernacle.

Sashimi So bezeichnet man in der japanischen Küche das Filetieren von frischem Fisch und Meeresfrüchten. Ein sehr scharfes Messer ist hierzu unerlässlich.

Satyr Der griechischen Mythologie zufolge sind die Waldgeister im Gefolge des Dionysos wollüstige Wesen von kräftiger Gestalt, mit struppigem Haar, stumpfer, aufgeworfener Nase, zugespitzten Ohren und einem Ziegenschwänzchen oder einem kleinen Pferdeschweif, die Nymphen jagen, um sie zu verführen. Sie verkörpern hemmungslose Fruchtbarkeit.

Schurz Als Schurz bezeichnet man die um die Hüfte getragene Kleidung eines ➜ Freimaurers. In vielen freimaurerischen Systemen ist der Schurz komplett weiß, in anderen hingegen sind nur die Schurze der Lehrlinge weiß und weisen bei höheren Rängen verschiedenfarbige Einfassungen, Verzierungen, Zeichen und Ähnliches auf. Da der Schurz ursprünglich einem Steinmetz als Schutz bei der Arbeit diente, war er häufig aus Leder, reichte bis zu den Knöcheln und hatte eine Klappe mit Knopfloch zur Befestigung an der Kleidung. Während der Geselle seine Klappe seinen noch nicht ausgereiften Fähigkeiten entsprechend an der Kleidung befestigen musste, ließ der Meister sie auf den Schurz herabfallen. Die Stellung der Klappe wird noch heute häufig als Rangabzeichen verstanden. Aus diesen Werkschurzen entwickelte sich der heutige rein symbolische Maurerschurz, den es seitdem in vielfältigen Varianten gibt.

Serra, Richard Er ist der bedeutendste noch lebende amerikanische Bildhauer (geb. 1939). Bekannt wurde er durch seine formal reduzierten Stahlskulpturen mit stringentem räumlichem Bezug. Nach einem Studienaufenthalt in Italien 1965/66, wo er im Sinne der Arte Povera mit Materialien wie Gummi, Blei und Neon arbeitete, steht seit 1969 das Material Stahl im Zentrum seiner Arbeit. Neben dem Spiel mit wechselnden Perspektiven und deren Wahrnehmung variiert Serra die Themen Schwerkraft und Gleichgewicht als physikalische Problematik von Körper und Raum. Im Jahr 2005 entstand die raumgreifende begehbare Installation *The Matter of Time*, bestehend aus acht gigantischen und tonnenschweren Stahlskulpturen als begehbaren Spiralen, Ellipsen und Schlangenformen für das Guggenheim-Museum in Bilbao. Das Werk ist einer der größten bildhauerischen Aufträge, die bislang in der Geschichte der Moderne für einen konkreten Raum entwickelt wurden.

Tourist Trophy Die jährlich auf der ➜ Isle of Man ausgetragene Tourist Trophy (TT) ist seit ihrer Gründung 1907 das wichtigste Motorradrennen der Welt. Die Teilnehmer müssen einen über 60 Kilometer langen Kurs bewältigen, der größtenteils über Landstraßen führt, auf denen es noch nie ein Tempolimit gegeben hat.

Ungarische Staatsoper Das Gebäude der Ungarischen Staatsoper ist eines der prachtvollsten Beispiele der Neorenaissance-Architektur im Stadtteil Pest der ungarischen Hauptstadt ➜ Budapest. Das von Miklós Ybl von 1875 bis 1884 erbaute Gebäude ist überaus reich geschmückt und gilt als herausragende architektonische Leistung sowohl in funktionaler als auch in ästhetischer Hinsicht.

Walfang Ziel des Walfangs ist seit jeher vor allem die Gewinnung von Tran, der als Brennstoff und als industrieller Grundstoff dient. Der Tran des Wals war früher ein wichtiger Rohstoff für künstliche Beleuchtung. Daneben wurden aus ihm Seifen, Salben, Suppen, Farben, Gelatine oder Speisefette (z.B. Margarine) sowie Schuh- und Lederpflegemittel hergestellt. Bereits in den 1930er-Jahren wurde erkannt, dass der Walbestand durch die starke Bejagung gefährdet war. Allein in den Jahren 1930/31 wurden 30.000 Blauwale getötet, mehr als heute in allen Ozeanen leben. Der Völkerbund beschloss 1931 ein Abkommen zur Begrenzung des Walfangs, das 1935 in Kraft trat. Allerdings war dieses Abkommen kaum effektiv, da bedeutende Walfangnationen wie Norwegen und Großbritannien keine Mitglieder des Völkerbundes waren. Der Walfang in japanischen Gewässern erreichte in den Jahren nach dem Zweiten Weltkrieg seinen Höhepunkt, als das Fleisch zur Versorgung der Not leidenden Bevölkerung gebraucht wurde. Im gesamten 20. Jahrhundert wurden ca. drei Millionen Wale gejagt. Der Walfang wird seit 1948 durch das Internationale Übereinkommen zur Regelung des Walfangs geregelt, in dem u.a. Fangquoten festgesetzt werden. Die Anpassungen der Quoten und die Definition von Schutzzonen erfolgen durch die 1946 gegründete Internationale Walfangkommission (IWC). Zuletzt wurden 1986 als sogenanntes ‚Moratorium‘ die Quoten für kommerziellen Walfang für alle Walarten und Jagdgebiete auf null gesetzt. Das Moratorium sollte zunächst bis 1990 gelten, wurde aber verlängert und gilt noch heute. Japan und Norwegen haben sich gegen das Moratorium ausgesprochen und ignorieren es. Fast die gesamte Handlung von *DRAWING RESTRAINT 9* spielt auf dem japanischen Walfangschiff Nisshin Maru.

Weltausstellung in Chicago Die 19. Weltausstellung fand vom 1. Mai bis zum 30. Oktober 1893 in Chicago statt. Sie hatte starken Einfluss auf die Architektur und Kunst der Zeit, vor allem bot sie aber der Stadt die Möglichkeit, ihr provinzielles Image loszuwerden. Die Dimension der Ausstellungsfläche umfasste über 268 Hektar (davon 81 überdacht) und zog sich 2,4 Kilometer am Seeufer entlang. 50.000 Aussteller aus 50 Ländern be-

teiligten sich. Auch der damals knapp 20-jährige, noch recht unbekannte Entfesselungskünstler Harry ➔ Houdini gastierte auf der Weltausstellung. Hier spielt die letzte Szene von *CREMASTER 2*.

Zeppelin Ein Luftschiff besteht aus einem aerodynamisch geformten Auftriebskörper, der Traggas enthält.

Als Traggas wird heute Helium verwendet, früher war es Wasserstoff. An seinem Auftriebskörper sind je nach Bauart eine oder mehrere Gondeln befestigt. Ferdinand Graf von Zeppelin konstruierte das erste nach ihm benannte lenkbare Starrluftschiff, das 1900 an den Start ging.

Neville Wakefield erstellte erstmalig ein Glossar zum Werk Matthew Barneys in dem Ausstellungskatalog *Matthew Barney. The Cremaster Cycle*, hrsg. von Nancy Spector, Ostfildern-Ruit 2002. Seine Idee und manchen Anhaltspunkt haben wir aufgegriffen, jedoch dieses Glossar unter anderen Gesichtspunkten erstellt und auf weitere Werke des Künstlers ausgedehnt.

CREMASTER: Field Suite
2002
Motiv | Motive 5-teilig, je | 5 parts, each 40 × 27,2 cm

Glossary

Karsten Löckemann

Hiram Abiff According to the legends of Freemasonry, Hiram Abiff is chief architect of King Solomon's Temple. He is not named in the Bible, which only mentions a certain Hiram of Tyre being contracted by Solomon to create ornamental metalwork for the Temple. ➔ Freemasons believe Hiram Abiff was murdered by one of three Fellowcrafts who tried in vain to make him divulge the arcane secret he carried with him. His body was concealed outside the city walls of Jerusalem until it was found by King Solomon and raised from the grave by Masonic power. The murder, burial and raising of Hiram Abiff are reflected in the tripartite hierarchy of the ➔ Freemasons: Apprentice, Fellowcraft and Master. In *CREMASTER 3* the Master Architect is embodied by Richard ➔ Serra.

Apron It is the garment worn around the hips by ➔ Freemasons. In many branches of Freemasonry the apron is completely white, whereas in others only the aprons of the Apprentices are white, while those of higher-ranking members feature a variety of colored borders, decorations, signs and symbols. Because the apron was originally a protective garment worn by stonemasons, it was often made of leather and ankle-length with a flap that could be fastened to the clothing by a buttonhole. Whereas the Apprentice had to fasten the apron flap to his clothing as a sign of his still immature skills, the Master wore his apron with the flap folded down. The position of the flap is still often regarded as a sign of rank. These working garments have developed into the purely symbolic Masonic Apron of today, which exists in many different variations.

Ascending Hack/Descending Hack In *CREMASTER 4*, the yellow Ascending Hack motorcycle team sets off from the lowlands of the ➔ Isle of Man on a constantly ascending route. The blue Descending Hack team sets of from the highest point of the island and takes a constantly descending route. In Barney's visual language, the colors and shapes of the two teams are a metaphor of sexual difference. Blue stands for the male principle, yellow for the female.

Baby Fay La Foe The psychic and fictitious grandmother of Gary ➔ Gilmore, under whose supervision he is conceived in the second part of the *CREMASTER Cycle*.

Bagpipe This is a reeded instrument of the aerophone class of instruments, fed by a constant supply of air from a bag, with a chanter, or melody pipe, (sometimes more than one) and one or more drones. The reed is made from the arundo donax reed, though modern reeds are sometimes made of plastic or metal. The air is supplied from an airtight bag made of leather or synthetic material which is filled by the player blowing through a blowpipe or pumping a bellows. The reservoir of air in the bag permits the player to produce a constant tone irrespective of breathing patterns and to maintain an almost constant air pressure.

Baker, Nicole She is Gary ➔ Gilmore's girlfriend.

Bees of Deseret According to the teachings of Mormonism, founded by Joseph Smith (1805–44), 'deseret' is the only remaining word of the language of Adam. Smith translated the word as bee. The beehive has become the symbol of Utah and the ➔ Mormons; the bee embodies the virtues of Mormon life.

Berkeley, Busby He was one of the most influential Hollywood film directors (1895–1976) and choreographers. Best known for his musical productions featuring complex geometric figures, he established the musical as a highly successful film genre. Like many directors of his day, Berkeley started out as a theatrical director. He achieved fame with his innovative and pioneering camerawork, exploiting the mobility of the camera to create angles and views of people and things that the fixed theater stage could not offer. In the years 1935 to 1937, he was nominated three times in succession for an Oscar in the Best Dance Direction category.

Björk Icelandic singer, composer and actress Björk Guðmundsdóttir was born in Reykjavik in 1965. Her career covers a musical spectrum that ranges from punk

and pop to folk and classic. In 2005, Björk released *The Music from 'Drawing Restraint 9'*, the soundtrack she had composed for the film of the same name by her partner Matthew Barney. The album consists mainly of miniature songs. In the film of the same name, she plays a leading role alongside Barney.

Blood atonement This is a controversial doctrine, introduced into the ➜ Mormon movement of the Church of Jesus Christ of Latter Day Saints by its leader Brigham Young (1801–1844), according to which a Mormon who commits murder or adultery can only atone for their sins by having their blood spilt on the ground. Although no longer officially recognized by the ➜ Mormons, the doctrine has never been expressly revoked. It is the reason why Utah is still the only state in the USA that continues to permit execution by firing squad at the request of the individual sentenced to death.

Bonneville The Bonneville Salt Flats in northern Utah to the west of the Great Salt Lake were created towards the end of the last Ice Age when the prehistoric Lake Bonneville extending west of the Rocky Mountains dried out. The area now covers some 10,360 square kilometers stretching as far as the Nevada border.

Bronco Stadium The football stadium of Boise State University, Boise, Idaho, built in 1970. Barney lived in the city for some time, and it was here that he discovered his passion for football. The 30,000-capacity stadium is the only one in the world with blue astroturf. It is also used for light athletics events. The Bronco team colors are blue and orange, and their mascot is a bronco.

Budapest Capital of the Republic of Hungary and the country's largest city with a population of 1.61 million. Formed in 1873 by the union of the two previously separate cities of Buda and Pest. One year later, Erich Weisz was born here. He went on to become famous under his stage name Harry ➜ Houdini.

Chain Bridge The Széchenyi Lánchíd, or Count Széchenyi Chain Bridge, better known as the Chain Bridge, was built across the Danube in 1839–49 at the behest of the Hungarian reformer Count István Széchenyi. It is the oldest and most famous of Budapest's nine bridges. At its inauguration it was the first bridge to span the Danube south of Regensburg. The neo-classical structure is supported by two piers in the form of triumphal arches, through which the iron chains of the 375-meter long bridge pass. The gateways of these arches are 6.50 meters wide and the structure weighs 2,000 tonnes.

Chrysler Building One of the world's most famous skyscrapers and a landmark of New York City. Located at 405 Lexington Avenue, at 42nd Street. Designed by architect William Van Alen, it was commissioned by Walter P. Chrysler as his company headquarters and was to be the highest building in the world at 282 meters with 65 floors. When the Bank of Manhattan was built even higher, Chrysler and his architect Van Alen decided to add a 55-meter steel needle. The foundation stone was laid on September 19, 1928 and the building was inaugurated on May 28, 1930. The entire *CREMASTER 3* film is a fantasy tale about the construction of the Chrysler Building.

Cremaster In human males, the cremaster muscle is a thin layer of skeletal muscle found in the inguinal canal and scrotum between the external and internal layers of spermatic fascia, surrounding the testis and spermatic cord. The cremaster muscle is a paired structure, there being one on each side of the body. Its function is to raise and lower the scrotum in order to regulate the temperature of the testis. In a cool environment the cremaster draws the testis closer to the body preventing heat loss, while when it is warmer the cremaster relaxes allowing the testis to cool. The cremasteric reflex which causes the cremaster muscle to contract rapidly and raise the testicle on one or both sides not only protects the scrotum against injury but also draws the testicles upwards during sexual arousal, thereby shortening the spermatic cord by as much as 50 percent in order to facilitate the passage of sperm to the egg, increasing the probability of conception. This biological structure forms the basis for the artistic concept of Matthew Barney's *CREMASTER Cycle*.

Drawing Restraint The notion of overcoming physical barriers is rooted in Barney's own experience as an athlete. In some of his earliest experiments as a student, he tried to realize an artistic process under specific constraints. In his studio, which was equipped as a gym, Barney climbed ramps, pulled on ropes etc., and did drawings at the same time. He demonstrated impressively how athletic competition suppresses drives such as sexuality and other urges that get in the way of the will to triumph. This was when he first began using a video camera to record the process of creating a work of art, and increasingly embraced the medium of film. The underlying concept of *Drawing Restraint* became a multi-part project that is still ongoing.

Drone A male honeybee, bumble bee, ant, wasp or hornet. All of these social insects of the hymenoptera family are divided into queen, workers and drones. The sole function of the drones is to fertilize the queen. Mating occurs in flight and results in the penis and associated abdominal tissues of the drone being ripped out, causing death.

Entered Apprentice/Fellow Craft/Master Mason
These are the names given to the three degrees of
➔ Freemasonry.

Field Emblem At the very beginning of his career as an
artist, Barney created a symbol of his work. The Field
Emblem, in the form of an ellipse bisected by a hori-
zontal line, symbolizes the two poles of his work: on the
one hand, the self-imposed resistance in his artistic
work and on the other hand the creative potential un-
leashed during the process. The Field Emblem occurs
repeatedly throughout Barney's works in a number of
variations, and is regarded as the artist's trademark.

Fingal's Cave An 80-meter long and 10-meter wide sea
cave on the island of Staffa off the west coast of
Scotland, hollowed out by the pounding waves. It takes
its name from the legendary Celtic king ➔ Fingal.

Fingal The mythical giant who is said to have lived
in Fingal's Cave was called Benandonner. Barney
has renamed him Fingal after the cave. (Fionn
➔ MacCumhail)

Freemasons They belong to a worldwide humanitarian
society involving membership through initiation. The
roots of Freemasonry are believed to lie in the medieval
guilds of stonemasons whose customs are still reflected
to some extent in the traditions of the Freemasons. They
are administratively organized in Lodges and include
people from all walks of life. The Freemasons seek to
achieve spiritual and ethical refinement. Their foremost
duty is charitable work and the promotion of education
and enlightenment. Through ceremonies and rituals
(custom, Temple work, discussion), the Freemasons
convey to their members a philosophy of life that pursues
the five fundamental ideals of the society: freedom,
equality, fraternity, tolerance and humanity. The Free-
masons have a highly complex allegorical system that
includes elements of architecture, geometry and arcane
mystery.

Gellért Baths ➔ Budapest's most famous spa, fed by
springs already used by the Turks in the thirteenth
century. The current Art Nouveau complex was in-
augurated, together with the Gellért Hotel, in 1918.

Gilmore, Gary American robber and murderer (1940–77),
who suffered a childhood of abuse and violence. He
spent much of his youth in reform schools and spent
18 of his last 21 years in prison. Accused of murdering
a gas station attendant and a motel manager in Provo,
Utah, he refused all offers of legal defence and instruct-
ed his attorney to demand the death penalty for him.
Insistent in pursuing his case, he was arrested in July,

condemned in October and executed on January 17,
1977. Norman ➔ Mailer reworked Gilmore's story in
his 1979 novel *The Executioner's Song,* in which he
asserts that Harry ➔ Houdini was Gilmore's grandfather.
Matthew Barney plays Gary Gilmore in the *CREMASTER
Cycle.*

Giant's Causeway It is situated on the north coast of
Northern Ireland, just to the east of the small town of
Bushmill. Comprising some 40,000 basalt columns
formed about 60 million years ago, it has been declared
a World Heritage Site by UNESCO. According to Irish
legend, it was created by the giant Fionn ➔ MacCumhail
so that he could walk to Scotland without getting his
feet wet.

Goodyear The winged shoe, attribute of the god Mercury,
was chosen as the Goodyear Tire & Rubber Company
logo by its founder Frank Seiberling. Mercury, messen-
ger of the gods, was considered the bringer of good news
and Seiberling associated him with all the characteristics
of his own Goodyear rubber products which went on
to conquer the world's markets with this logo.

Greek Tragedy The tragedy (Gr. tragōidiā; contracted
from trag(o)-aoidiā = 'goat song' from tragos = 'goat'
and aeidein = 'to sing') was developed in Ancient
Greece and had its heyday from 490 to 406 BC. The
origins of this literary genre lie in the ritual festivities in
honor of Dionysos, the god of wine. Greek Tragedy is
structured in five acts with a clear scenic evolvement:
1. exposition; 2. conflict; 3. collision; 4. retardation and
acceleration; 5. catastrophe and atonement. *CRE-
MASTER 5* is structured according to this sequence.

Guggenheim Museum It was founded in 1939 as a mu-
seum of modern art in New York City, located on the
Upper East Side, between Central Park and East River.
The museum is operated by the Solomon R. Guggenheim
Foundation. The building was designed by Frank Lloyd
Wright and opened in 1959. The rotunda of the mu-
seum is the setting for Barney's film *CREMASTER 3.*
The concept of the performance in the museum is a
development of some earlier projects by the artist. The
spiral structure has often been compared to a beehive,
and thus has affinities with *CREMASTER 2,* which refers
to the history of the ➔ Mormons. Barney's performance
takes place on the five levels of the museum, symboliz-
ing the five parts of the cycle.

Her Diva/Her Giant/Her Magician These figures form-
ing the entourage of the ➔ Queen of Chain are all
played by Matthew Barney himself. They are imaginary
characters embodying the subliminal wishes and de-
sires of the lonely queen.

Houdini, Harry Born Erich Weisz on March 24, 1874, the son of Rabbi Mayer Samuel Weisz went on to become an internationally famous escape artist. At the age of four, he emigrated to the USA with his family, settling in Appleton, Wisconsin. The family later moved to New York, where Weisz began performing as a magician when he was 17, taking the name Houdini in honor of the French magician Jean Eugène Robert-Houdin he so admired. Houdini's first major breakthrough came in 1895 when he escaped from handcuffs with the aid of a corrupt spiritualist and performed the trick to great media effect in a small-town police station. In 1901 he toured Germany with the Circus Corty & Althoff. Houdini soon became Europe's most famous showman, gaining a wide following of fans as far afield as Russia. Some cleverly targeted PR also brought him an enthusiastic audience in the New World from 1906 onwards. By this time, he had discovered the dramatic impact that could be achieved by using a straitjacket as a prop, especially when suspended upside-down from a skyscraper. Perhaps his most famous trick involved making an elephant disappear in Times Square, using a box constructed by Charles Morritt. He later copied the show of a fakir, claiming that he could withstand any blow to his midsection by tightening his abdominal muscles. Student Jocelyn Gordon Whitehead visited Houdini in his dressing room in Montreal on October 22, 1926 where he inflicted several heavy blows to his abdomen. Though it is unlikely that this assault was indeed the direct cause of the burst appendix and peritonis to which he succumbed soon afterwards, Houdini died at the Grace Hospital, Detroit, on October 31, 1926 at the age of 52, having undergone two surgical operations for his condition. Houdini's name has since become synonymous with escape (including the coining of the verb 'to houdinize'). His reputation as an invincible superman made him an idol for generations of Americans. He was a lifelong ➔ Freemason and committed anti-spiritualist. In the *CREMASTER Cycle*, Norman ➔ Mailer plays the role of Harry Houdini.

Hungarian State Opera The opera house in the Pest district of Budapest is one of the most magnificent examples of Neorenaissance architecture. Construction of this sumptuously ornamented building, designed by Miklós Ybl, lasted from 1875 to 1884. It is widely regarded as an outstanding architectural achievement, both functionally and aesthetically.

Hypertrophy This medical term describing the enlargement of an organ or tissue due to an increase in the size of the cells comes from the Greek 'hyper' (excessive) and 'trophe' (nutrition). The term is often used in connection with stamina training and body building. Muscle-building training causes the body to increase the number of muscle fibres, causing the muscles to enlarge.

Isle of Man Covering an area of just 572 square kilometers the Isle of Man is a self-governing Crown dependency in the Irish Sea. Known worldwide as a tax haven, the island is also famous for its ➔ Tourist Trophy motorcycle race. The motifs in *CREMASTER 4* are drawn from Manx legends and myths.

Japanese Tea Ceremony The procedure of the Japanese Tea Ceremony, in which tea and light snacks are served to one or several guests, is closely associated with Zen philosophy and follows a strict set of rules. In order to allow the guest every opportunity of introspective contemplation, the ritual takes place in a very simply furnished tea house consisting, for the most part, of two rooms: one in which the tea is prepared and one in which the actual tea ceremony is conducted. In spite of the strict rules, the tea ceremony can vary from school to school. During the ceremony the host plays the role of Master of Tea.

Loughton Candidate A red-haired satyr in a white suit with a sprig of Manx heather on the lapel. He is related to the hybrid creature from *Drawing Restraint 7* and a descendent of the satyr Phynnodderree that is said to have troubled the ➔ Isle of Man in ancient times. The Candidate has four impacted sockets on his head, which will grow into horns indicating his natural affinity with the Loughton Ram native to the island. In the film *CREMASTER 4* the role is played by Matthew Barney.

Loughton Faerie/Ascending Faerie/Descending Faerie This trio of red-haired, androgynous elves with their hair in buns appear in various formations. In the course of *CREMASTER 4*, the elves adapt chameleon-like to their surroundings, while their nudity and lack of sexual organs symbolize an early stage of embryonal development.

Fionn MacCumhail The Irish giant of Celtic mythology falls in love with an attractive giantess on the Scottish island of Staffa and creates a huge causeway by which to bring his beloved across the sea. But the giant Benandonner has his eye on her as well and, jealous of their happiness, follows them over the causeway to Ireland. But Fionn MacCumhail cleverly tricks Benandonner by putting on baby clothes and lying in his child's cradle. When the beautiful giantess claims that this is Fionn MacCumhail's son, Benandonner flees at the very thought of how huge the father must be. In his fury, he smashes up the stone causeway, the remains of which can still be seen at the coast.

Mailer, Norman The American writer, born in 1923, grew up in Brooklyn as the son of a Jewish mother and studied aeronautical engineering at Harvard until he was drafted into military service. He recounted his experiences as a soldier in his successful 1948 novel *The Naked and the Dead*. Later works explore themes of violence and sexual neurosis. A left-wing thinker, Mailer became a sharp critic of US society. His report on the American anti-Vietnam movement, *Armies of the Night,* won him the Pulitzer Prize in 1968, which he was awarded again in 1980 for *The Executioner's Song*, a novel based on the true story of murderer Gary → Gilmore and his execution.

Manx Triskelion (Gr. = three-legged) is a symbol in the form of three legs forming an equilateral triangle. Although this symbol is generally associated with Celtic culture, it can in fact be found in almost every civilization throughout the world. The Manx Triskelion is the symbol of the → Isle of Man. Current interpretations place importance on the number three, which is of great significance in Celtic mythology, relating to the triads of past/present/future, birth/life/death, body/mind/soul and the elements earth/water/air.

Mormons Adherents of the religious movement founded in 1830 by Joseph Smith (1805–44) and known since 1838 as the Church of Jesus Christ of Latter Day Saints. They are known as Mormons because of the central importance to their faith of Joseph Smith's *Book of Mormon*. In the USA the Mormons are one of the five biggest religious communities. Their church has its headquarters in Salt Lake City. Its members believe that the church is a restoration of the church originally instituted by Jesus Christ and that their community is directly guided by continuous revelations given by Jesus Christ to their prophets and apostles. The president of the Church of Jesus Christ of Latter Day Saints is revered as a prophet, seer and revelator, and this is confirmed twice yearly by the entire community. Only revelations witnessed by the president and the twelve apostles as being from God are of significance to the community as a whole and are incorporated into the scriptural canon of their *Doctrine and Covenants*. Another canonical book is the *Pearl of Great Price*, which, like the *Book of Mormon*, was written by Smith and also contains autobiographical data about the founder of the church.

Opera (ital. opera in musica = musical work) is a term used since around 1650 to describe the musical genre in which a staged spectacle is structured by music. The Florentine Camerata, in which opera was developed, was an elite humanist circle of academics, writers, musicians, philosophers, nobles and art patrons who sought to revive the classical Greek drama involving solo singers, choir and orchestra. Ancient Greek theater combined spectacle with music, while the chorus took on an important role: accompanying the intermittent dances with their singing and commentating on the development of the plot.

Otto, Jim The legendary American Football League player, born in 1938, was a center for the Oakland Raiders and underwent several knee operations in the course of his career, ending his professional footballing days with two artificial kneecaps.

Queen of Chain Swiss actress Ursula Andress, born in 1936, came to fame in 1962 with her role in the first James Bond movie, *Dr. No*. In *CREMASTER 5* she plays a fictitious theatrical figure who relives her memories in the opera.

Queen's Pier A Victorian landing stage built in 1886 in Ramsey on the → Isle of Man, jutting 400 meters into the Irish sea.

Revue Like operettes and musicals, revues are a blend of music, dance and the spoken word. But unlike the other two genres, revue has no plot continuity. Instead, there is a general theme, such as a current or historical event, linking the various numbers involving solo and ensemble performances. After it started in the late nineteenth century in Paris (Folies Bergère, Moulin Rouge), the revue became hugely successful, and by the 1920s it was the most popular form of stage entertainment worldwide. In America, the Ziegfield Follies, founded in 1907 in the style of the French revue, presented Broadway's most successful shows. In the 1930s, the popularity of the revue began to decline, but had something of a renaissance in the early days of television. Today, the revue as an art form is mainly found in traditional music halls such as the Lido de Paris, the Casino de Paris, the Folies Bergère, the Moulin Rouge – all in Paris – and the Friedrichstadtpalast in Berlin, as well as some shows in Las Vegas.

Rodeo A traditional sport originating in Brazil, rodeo has become widely popular throughout North America. The word comes from the Portuguese *rodear,* which means 'to surround' or 'go around'. Rodeo includes bronc riding, in which the rider has to stay on a bucking horse as long as possible without falling off, and bull riding on a fully grown bull instead of a horse. The state penitentiaries of Texas and Oklahoma hold an annual Prison Rodeo in which only prison inmates take part.

Salt Lake Tabernacle The large domed hall on Temple Square in Salt Lake City, the state capital of Utah, was the main place of assembly for the → Mormons until

the construction of the Conference Center in 2000. Construction of the Tabernacle, which has a capacity of 5,000, began in 1864 and was completed in 1867. Its acoustics are such that a speaker can be heard by everyone in the congregation. The organ, with its 11,623 pipes, is one of the 20 largest in the world. Architecturally, the hall resembles the beehive that is the symbol of this religious community. In Catholicism, the Tabernacle is a receptacle used to hold the host which is revered as the body of Christ. In *CREMASTER 2* the sentencing of Gary ➜ Gilmore takes place in the Salt Lake Tabernacle.

Sashimi A Japanese delicacy of thinly sliced, very fresh raw fish and seafoods. An extremely sharp knife is required to prepare this dish.

Satyr In Greek mythology, satyrs, the companions of Dyonisus, are woodland spirits of heavy build with dishevelled hair, a snub nose, pointed ears and the tail of a goat or horse, who pursue nymphs in order to seduce them. They embody unbridled fertility.

Serra, Richard Born in 1939, he is the foremost living American sculptor. He became famous for his formally reduced steel sculptures with their stringent spatial references. After spending a study year in Italy in 1965–66, where he worked with materials such as rubber, lead and neon in the spirit of Arte Povera, he began to focus on working with steel. Apart from exploring different perspectives and the way they are perceived, Serra also explores the theme of gravity and balance as a physical problem of volume and space. In 2005 he created his huge installation *The Matter of Time* for the Guggenheim Museum in Bilbao. Consisting of eight gigantic curved, elliptical and spiralling steel sculptures, each weighing many tonnes, through which visitors can walk, this work is the largest sculptural piece ever commissioned in modern times for a specific space.

Tourist Trophy This annual motorcycle event on the ➜ Isle of Man has been regarded as the world's most important road race since its inception in 1907. Participants in the ➜ Isle of Man Tourist Trophy have to complete a course of some 60 kilometers, mainly on country roads where no speed limit has ever been imposed.

Whaling The primary aim of whaling has always been to harvest the whale oil used both as fuel and as an industrial raw material. Whale oil was formerly used as fuel for lamps and also in the production of soaps, creams, paints, gelatine and edible fats (such as margarine) as well as polish for shoes and leather goods. By the 1930s it had already become evident that overhunting was endangering the whale population. In 1930–31 alone some 30,000 blue whales were killed – more than the total number now surviving worldwide. In 1931 the League of Nations drew up a Convention for the Regulation of Whaling, which came into force in 1935 but proved largely ineffective. In the years immediately following the Second World War, whaling increased dramatically in Japanese waters, where whale meat was used as a source of nutrition for the starving population. In the course of the twentieth century, some three million whales were hunted. Since 1948, the whaling industry has been regulated by the International Agreement for the Regulation of Whaling, which also specifies quotas. Catch limits and exclusion zones are determined by the International Whaling Commission (IWC). In 1986 the IWC adopted a moratorium on commercial whaling, suspending quotas for all species of whale and all hunting grounds until 1990. The moratorium was later extended and is still in place today. Japan and Norway have protested against the moratorium and continue to ignore it. Almost the entirety of *DRAWING RESTRAINT 9* is set on the Japanese whaler Nisshin Maru.

Chicago World's Fair The nineteenth World's Fair (also known as the World's Columbian Exposition) was held in Chicago from May 1, to October 30, 1893. It had an enormous influence on the art and architecture of the day and helped the city shake off its provincial image. Covering an exhibition area of more than 268 hectares, 81 of them covered, the grounds of the World's Fair stretched out along the lakeshore. The then relatively unknown 20-year-old escape artist ➜ Harry Houdini performed at the Chicago World's Fair, which is the setting for the last scene of *CREMASTER 2*.

Zeppelin An airship consisting of an aerodynamically shaped fuselage containing lighter-than-air gas – formerly hydrogen, and more recently helium. Depending on the specific design of the airship, it has one or several gondolas, also known as nacelles, attached to the fuselage. The first rigid-frame dirigible airship was built by Ferdinand Graf von Zeppelin, from whom it takes its name, and was launched in 1900.

Translation: Ishbel Flett

Neville Wakefield was the first to compile a glossary for Matthew Barney's work in the exh. cat. *Matthew Barney. The Cremaster Cycle*, edited by Nancy Spector, Ostfildern-Ruit 2002. Although we have taken up his idea and some of its cornerstones, this glossary takes a different approach and has been extended to other works by the artist.

"/40 cx 74 - Vienna Exposition [signature] , 80

"/40 cx Vienna [signature] , 72

Publikationen, Ausstellungsliste | Publications, Exhibition Checklist

Katharina Vossenkuhl

Das Ausstellungs- und Abbildungsverzeichnis entspricht unserem gegenwärtigen Stand der Recherche. Es bezieht sich im Fall von Editionen nicht ausschließlich auf die Ausgabe der Sammlung Goetz, sondern versucht, einen allgemeinen Überblick über die Ausstellungsgeschichte des Werks zu geben.
Angesichts der zahlreichen Publikationen zum Werk Matthew Barneys beschränkt sich die Bibliografie auf eine Auswahl. Folgende Webseiten geben einen hervorragenden Überblick und umfassende Hintergrundinformationen zu dem *CREMASTER Cycle* sowie zu dem Film *DRAWING RESTRAINT 9* und auch weitere bibliografische Informationen:
http://www.cremaster.net, Stand 09.10.2007.
http://www.drawingrestraint.net, Stand 09.10.2007.
http://www.gladstonegallery.com, Stand 09.10.2007.
http://www.guggenheim.org/exhibitions/past_exhibitions/barney/index.html, Stand 09.10.2007.

The index of exhibitions and reproductions reflects our present state of research and in case of editions does not refer solely to the works in the Goetz Collection, but intends to convey a general overview of a work's exhibition history. Due to the wide range of publications on Matthew Barney, the bibliography concentrates on a small selection. The following websites provide an excellent overview and comprehensive background information on the *CREMASTER Cycle* and on the film *DRAWING RESTRAINT 9* as well as further bibliographical information:
http://www.cremaster.net, date 09.10.2007.
http://www.drawingrestraint.net, date 09.10.2007.
http://www.gladstonegallery.com, date 09.10.2007.
http://www.guggenheim.org/exhibitions/past_exhibitions/barney/index.html, date 09.10.2007.

Alle abgebildeten Werke stammen aus dem Bestand der Sammlung Goetz, außer die mit * gekennzeichneten.
All the works reproduced in this catalogue are part of the Goetz Collection unless marked by *.

Werke, markiert mit **, sind nicht ausgestellt. | Works marked ** are not exhibited.

C2: The Drones' Exposition
1999
Rahmen | Frame 34,4×38,8×1,2 cm

C2: Deseret
1999
Rahmen | Frame 34,4×38,8×1,2 cm

Matthew Barney

geboren I born 1967 in San Francisco, CA, USA

1989 BA, Yale University New Haven, New Haven, CT, USA

Matthew Barney lebt und arbeitet I lives and works in New York, NY, USA.

Ausstellungen, Auswahl | Selected Exhibitions

1988
Scab Action
New York: Video exhibition for the New York City Rainforest Alliance, Open Center 1988.

1989
Field Dressing
New Haven: Payne Whitney Athletic Complex, Yale University 1989.

1990
Viral Infection: The Body and its Discontents
Buffalo: Hallwalls Contemporary Arts Center 1990.

1991
Matthew Barney
New York: Barbara Gladstone Gallery 1991;
Los Angeles: Stuart Regen Gallery 22.05.–22.06.1991.
Matthew Barney: New Work
San Francisco: San Francisco Museum of Modern Art 1991.

1992
DOCUMENTA IX
Kassel: Fridericianum 13.06.–20.09.1992.
Post Human
Lausanne: FAE Musée d'Art Contemporain 1992;
Castello di Rivoli 1992;
Athen: The Deste Foundation Centre For Contemporary Art Dezember 1992.
Hamburg: Deichtorhallen Hamburg 1992.

1993
45. La Biennale di Venezia. Aperto '93
Venedig: Biennale 13.06.–10.10.1993.
Whitney Biennial
New York: Whitney Museum of American Art 1993.

1994
Hors Limites
Paris: Centre Georges Pompidou 09.11.1994–23.01.1995.
Portraits from CREMASTER 4
Los Angeles: Regen Projects 03.11.–03.12.1994.

1995
Altered States: American Art in the 90's
St. Louis: Forum for Contemporary Art 1995.
Art Now: Matthew Barney: OTTOshaft
London: Tate Britain 02.05.–18.06.1995.
Matthew Barney. CREMASTER 4
New York: Barbara Gladstone Gallery 1995;
Paris: Fondation Cartier pour l'Art Contemporain 03.03.–16.04.1995.

1995/1996
Drawing on Chance: Selections from the Collection
New York: The Museum of Modern Art 12.10.1995–23.01.1996.
Matthew Barney. Pace Car for the Hubris Pill
Rotterdam: Museum Boijmans Van Beuningen Rotterdam 1995;
Bordeaux: Le CAPC Musée d'art contemporain 1995;
Bern: Kunsthalle Bern 1996.

1996
Art at Home, Ideal Standard Life
Tokio: The Spiral Garden 1996.
Hybrids
Amsterdam: De Appel 01.06.–18.08.1996.
Transexualis and REPRESSIA. CREMASTER 1 and CREMASTER 4
San Francisco: San Francisco Museum of Modern Art 1996.
Matthew Barney – Tony Oursler – Jeff Wall
München: Sammlung Goetz 22.07.–20.12.1996.
10th Biennale of Sydney
Sydney: Biennale Juli 1996.

1996/97
The Hugo Boss Prize Exhibition
New York: Guggenheim SoHo 19.11.1996–16.02.1997.

1997
A Rrose is a Rrose is a Rrose: Gender Performance in Photography
New York: Solomon R. Guggenheim Museum 17.01.–07.05.1997;
Pittsburgh: Andy Warhol Museum 1997.
De-Genderism Detruire Dit-Elle/ il
Tokio: Setagaya Art Museum 08.02.–23.03.1997.
Lange Nacht der Museen
Berlin: Nationalgalerie im Hamburger Bahnhof. Museum für Gegenwart 23.08.–01.09.1997.
Matthew Barney. CREMASTER 5
Frankfurt/Main: Portikus 19.06.–10.08.1997;
Budapest: C3, Center for Culture and Communication 03.07.–25.07.1997;
New York: Barbara Gladstone Gallery 1997.
Une Seconde Peau
Paris: Galerie Thaddaeus Ropac 08.03.–12.04.1997.

1997/98

Matthew Barney. CREMASTER 1
Wien: KUNSTHALLE wien 28.11.1997–08.02.1998;
Basel: Öffentliche Kunstsammlung Basel, Museum für
Gegenwartskunst 28.03.–28.06.1998.

1998

CREMASTER 5
Los Angeles: Regen Projects 07.03.–11.04.1998.
*Die Rache der Veronika. Aktuelle Perspektiven der
zeitgenössischen Fotografie. Die Fotosammlung Lambert*
Hamburg: Deichtorhallen Hamburg
27.02.–01.06.1998.
Matthew Barney. CREMASTER 5
Madrid: Fundació "la Caixa" 1998.
*Wounds: Between Democracy and Redemption in
Contemporary Art*
Stockholm: Moderna Museet 14.02.–19.04.1998.

1998/99

*Emotion. Junge britische und amerikanische Kunst aus
der Sammlung Goetz*
Hamburg: Deichtorhallen Hamburg
30.10.1998–17.01.1999.
*Global Vision, New Art from the 90's – with new
acquisitions from the Dakis Joannou Collection*
Athen: The Deste Foundation Centre For Contemporary
Art 07.05.1998–30.01.1999.

1999/2000

CREMASTER 2: The Drones' Exposition
Minneapolis: Walker Art Center 07.03.–13.07.1999;
San Francisco: San Francisco Museum of Modern Art
20.05.–05.09.2000.
Regarding Beauty
Washington, DC: Hirshhorn Museum and Sculpture
Garden 07.10.1999–17.01.2000.

2000

*Age of Influence: Reflections in the Mirror of American
Culture*
Chicago: Museum of Contemporary Art 2000.
Between Cinema and a Hard Place
London: Tate Modern 12.05.–03.12.2000.
*Matthew Barney. Der Cremaster-Zyklus: Cremaster 1,
Cremaster 4*
München: filmmuseum münchen 10.11.–11.11.2000.
Matthew Barney, Jennifer Pastor, Charles Ray
New York: Barbara Gladstone Gallery 2000.
Outbound: Passages from the 90's
Houston: Contemporary Arts Museum
04.03.–07.05.2000.
voilà – le monde dans la tête
Paris: Musée d'Art Moderne de la Ville de Paris
15.06.–29.10.2000.

2000/01

*Hypermental. Wahnhafte Wirklichkeit 1950–2000.
Von Salvador Dalí bis Jeff Koons*
Zürich: Kunsthaus Zürich 07.11.2000–21.01.2001;
Hamburg: Hamburger Kunsthalle 16.02.–06.05.2001.
seeing time
Karlsruhe: ZKM I Zentrum für Kunst und Medien-
technologie Karlsruhe 30.11.2000–22.04.2001.
Shanghai Biennale 2000
Shanghai: Biennale 06.11.2000–06.01.2001.

2001

American Art from the Goetz Collection, Munich
Prag: Galerie Rudolfinum 24.05.–02.09.2001.
Arte Contemporaneo Internacional
Mexico City: Museo dc Arte Moderno 2001.
Uniform: Order and Disorder
New York: P.S.1 Contemporary Art Center
20.05–30.09.2001.

2001/02

Shortcuts: Works from The Dakis Joannou Collection
Athen: The Deste Foundation Centre For Contemporary
Art 28.11.2001–31.03.2002.

2002

HAUTNAH. Die Sammlung Goetz
München: Museum Villa Stuck 30.05.–18.08.2002.
Tempo
New York: The Museum of Modern Art
29.06.–09.09.2002.

2002–2004

*Die Wohltat der Kunst. Post\Feministische Positionen
der neunziger Jahre aus der Sammlung Goetz*
München: Sammlung Goetz 14.09.–10.11.2002.
*Just Love Me. Post\Feminist Positions of the 1990's
from the Goetz Collection*
Bergen: Bergen Kunstmuseum 22.08.2003–25.10.2003;
Leeuwarden: Fries Museum 24.04.–21.06.2004.

2002/03

Matthew Barney: The CREMASTER Cycle
Köln: Museum Ludwig 06.06.–01.09.2002;
Paris: Musée d'Art Moderne de la Ville de Paris
10.10.2002–05.01.2003;
New York: Solomon R. Guggenheim Museum
21.02.–11.06.2003.
Moving Pictures
New York: Solomon R. Guggenheim Museum
28.06.2002–12.01.2003.

2002–2004

Sand in der Vaseline
Krefeld: Kaiser Wilhelm Museum
27.10.2002–09.02.2003;

Darmstadt: Hessisches Landesmuseum
23.03.–09.06.2003;
Nürnberg: Neues Museum Nürnberg
19.12.2003–29.02.2004.

2003

50. La Biennale di Venezia
Venedig: Biennale 15.06.–02.11.2003.
Matthew Barney: The CREMASTER Cycle
Oslo: Astrup Fearnley Museet 13.09.–07.12.2003.
Imperfect Innocence
Baltimore: Contemporary Museum 15.03.–15.06.2003.

2003/04

fast forward. Media Art Sammlung Goetz
Karlsruhe: ZKM I Zentrum für Kunst und Medien-
technologie Karlsruhe 10.10.2003–06.03.2004.

2004

Everything is Connected, he, he, he
Oslo: Astrup Fearnley Museet 22.06.–15.08.2004.
VIDEO – Bildsprache des 21. Jahrhunderts
Düsseldorf: NRW-Forum 24.01.–18.04.2004.

2004/05

Utopia Station
München: Haus der Kunst 07.10.2004–16.01.2005.

2005

Gabríela Fridriksdóttir & Matthew Barney
Island: Akureyri Art Museum 14.05.–05.06.2005.
KunstFilmBiennale Köln 2005
Köln: KunstFilmBiennale Köln 19.10.–24.10.2005.
Les Grands Spectacles
Salzburg: Museum der Moderne Salzburg
17.06.–03.10.2005.
(my private) Heroes
Herford: MARTa Herford 07.05.–21.08.2005.
Quartet: Barney, Gober, Levine
Minneapolis: Walker Art Center 17.04.–11.12.2005.

2005/06

Dada's Boys
Edinburgh: Fruitmarket Gallery 27.02.2005.–16.07.2006.
Goetz meets Falckenberg
Hamburg: Phoenix Kulturstiftung
04.11.2005.–30.04.2006.
Matthew Barney. DRAWING RESTRAINT
Kanazawa: 21st Century Museum of Contemporary Art
02.07.–25.08.2005;
Seoul: Leeum, Samsung Museum of Art
13.10.2005–08.01.2006;
San Francisco: San Francisco Museum of Modern Art
23.06.–19.09.2006.
Video II: Allegorie
Düsseldorf: NRW-Forum 17.09.2005–08.01.2006.

2006

Das Achte Feld/The Eighth Square
Köln: Museum Ludwig 19.08.–12.11.2006.
Drawn into the World
Chicago: Museum of Contemporary Art
08.07.–15.10.2006.
Figures in the Field
Chicago: Museum of Contemporary Art
04.02.–30.04.2006.
Matthew Barney: DRAWING RESTRAINT
San Francisco: San Francisco Museum of Modern Art
23.06.–17.09.2006.
Matthew Barney. The Occidental Guest
New York: Barbara Gladstone Gallery
07.04.–13.05.2006.
what makes you and I different
Glasgow: Tramway 24.02.–26.03.2006.
Shanghai Biennale 2006
Shanghai: Biennale 05.09.–05.11.2006.

2006/07

DEFAMATION OF CHARACTER
Long Island: P.S.1 29.10.2006–08.01.2007.
MASCARADA/MASQUERADE
Salamanca: Domus Artium 2002
06.10.2006–07.01.2007.
*Matthew Barney and Joseph Beuys. All in the present
must be transformed.*
Berlin: Deutsche Guggenheim 28.10.2006–12.01.2007.
THE GUGGENHEIM
Bonn: Kunstmuseum Bonn 21.07.2006–07.01.2007.

2007

Live/Work: Performance into Drawing
New York: The Museum of Modern Art
31.01.–07.05.2007.
Manchester International Festival 2007
Manchester: Festival 28.06.–15.07.2007.
Matthew Barney
London: Sadie Coles HQ 02.10.–17.11.2007.
*Matthew Barney and Joseph Beuys. All in the present
must be transformed.*
Venedig: Peggy Guggenheim Collection
06.06.–02.09.2007.
MYTHOS
Bregenz: Kunsthaus Bregenz 02.06.–09.09.2007.
PRISON
London: Bloomberg SPACE 31.03.–12.05.2007.
Role Exchange
New York: Sean Kelly Gallery 29.06.–03.08.2007.
TOMORROW NOW
Luxemburg: Musée d'Art Moderne Grand-Duc Jean
25.05.–24.09.2007.

2007/08

Matthew Barney
Goslar: Mönchehaus-Museum
06.10.2007–01.01.2008.

Matthew Barney. DRAWING RESTRAINT
London: Serpentine Gallery 20.09.–11.11.2007.
Wien: KUNSTHALLE wien 07.03.–08.06.2008.

Publikationen, Auswahl | Selected Publications

1991

Matthew Barney: New Work, Ausst.-Kat. | Exh.cat. San
Francisco Museum of Modern Art, San Francisco 1991.
Beitrag von | Contribution by Robert R. Riley
Roberta Smith: *Matthew Barney's Objects and Actions*,
in: *The New York Times*, 25.10.1991, n.p.

1992

Sabine B. Vogel: *Matthew Barney. Sport, Sex und
Kunst*, in: *Artis*, Juni 1992, pp. 40–42.

1993

Glenn O'Brien: *Dividing the Sheep from the Goats*,
in: *Artforum*, Mai 1993, p. 8.
Glen Helfand: *Matthew Barney*, in: *Shift Magazine*,
No. 02, 1993, pp. 36–41.
Jane Rankin-Reid: *Pocket Pool*, in: *Art + Text*, No. 45,
1993, pp. 42–46.

1994

Neville Wakefield: *Matthew Barney's Fornication with the
Fabric of Space*, in: *Parkett*, No. 39, 1994, pp. 118–124.

1995

Altered States. American Art in the 90's, Ausst.-Kat. |
Exh.cat. Forum for Contemporary Art, St. Louis 1995.
Beiträge von | Contributions by Jeanne Greenberg,
Robert Nickas
Drawing Restraint 7, Hatje Cantz, Ostfildern 1995.
Beitrag von | Contribution by Klaus Kertess
James Lingwood: *Keeping Track of Matthew Barney*,
in: *TATE. The Art Magazine*, No. 06, Sommer 1995,
pp. 52–53.
Matthew Barney. CREMASTER 4, Ausst.-Kat. | Exh.cat.
Fondation Cartier pour l'art contemporain, Paris; Artangel,
London; Barbara Gladstone Gallery, New York 1995.
Beitrag von | Contribution by James Lingwood
Matthew Ritchie: *Matthew Barney*, in: *Flash Art*, No. 184,
1995, p. 105.
Michel Onfray: *Manieristische Bemerkungen zu Matthew
Barney*, in: *Parkett*, No. 45, 1995, pp. 42–64.
Norman Bryson: *Matthew Barneys Gonadotrope
Kavalkade*, in: *Parkett*, No. 45, 1995, pp. 36–40.
Thyrza Nichols Goodeve: *Matthew Barney is the Mytho-
grapher*, in: *Artforum*, Mai 1995, n.p.
Thyrza Nichols Goodeve: *Matthew Barney 95*, in:
Parkett, No. 45, 1995, pp. 70–73.

1996

1996. The Hugo Boss Prize Exhibition, Ausst.-Kat. |
Exh.cat. Guggenheim Museum SoHo, New York 1996.
Beiträge von | Contributions by Peter Littmann, Nancy
Spero, Jon Ippolito u.a.
Anne Erfle: *Das alternative Geschlecht*, in: *Süddeutsche
Zeitung*, 07.07.1996, n.p.
Christoper Doswald: *Der Körper als Instrument*, in:
Kunstforum, Oktober 1996–Januar 1997, No. 135,
pp. 313–321.
Fremdkörper, Ausst.-Kat. | Exh.cat. Öffentliche
Kunstsammlung Basel, Museum für Gegenwartskunst,
Basel 1996.
Beitrag von | Contribution by Theodora Vischer
Gerhard Mack: *Ein Glibbern und Geschmiere*, in:
Süddeutsche Zeitung, 13.06.1996, p. 12.
Jerry Saltz: *The Next Sex*, in: *Art in America*, No. 10,
Oktober 1996, pp. 82–91.
Matthew Barney – Tony Oursler – Jeff Wall, Ausst.-Kat. |
Exh.cat. Sammlung Goetz, München 1996.
Beiträge von | Contributions by Ingvild Goetz, Christiane
Meyer-Stoll, Jerry Saltz u.a.
Matthew Barney. Pace Car for the Hubris Pill, Ausst.-Kat. |
Exh.cat. Museum Boijmans Van Beuningen Rotterdam,
Rotterdam; Le CAPC Musée d'art contemporain, Bordeaux;
Kunsthalle Bern, Bern 1996.
Beiträge von | Contributions by Ulrich Loock, Neville
Wakefield, Richard Flood
The 20th Century Art Book, Phaidon, London 1996, p. 29.
Beiträge von | Contributions by Donald Burton Kuspit,
Lynn Gamwell u.a.

1997

Anne Erfle: *Matthew Barneys Plazentäre
Phantasmagorien*, in: *nbk*, No. 04, 1997, pp. 49–52.
CREMASTER 1, Ausst.-Kat. | Exh.cat. KUNSTHALLE
wien; Öffentliche Kunstsammlung Basel, Museum für
Gegenwartskunst, Basel 1997.
Beiträge von | Contributions by Alexander Horwarth,
Gerald Matt
Christoper Doswald: *Der Körper als Instrument*, in:
Kunstforum, Oktober 1996–Januar 1997, No. 135,
pp. 313–316.
CREMASTER 5, Ausst.-Kat. | Exh.cat. Portikus,
Frankfurt/Main; C3, Center for Culture and Communica-
tion, Budapest; Barbara Gladstone Gallery, New York
1997.
Beitrag von | Contribution by Thyrza Nichols Goodeve
David Frankel: *Hungarian Rhapsody*, in: *Artforum*,
Oktober 1997, pp. 76–79.
Hybrids, Ausst.-Kat. | Exh.cat. De Appel Fondation,
Amsterdam 1997.
Beiträge von | Contributions by Saskia Bos, Clive
Kellner, Adam Szymczyk u.a.
Ken Johnson: *Eyes on the Prize*, in: *Art in America*,
No. 04, 1997, pp. 41–45.
Roberta Smith: *From a Fantasy Film, Luxury Transformed*,
in: *The New York Times*, 14.11.1997, n.p.

Sous le Manteau, Ausst.-Kat. | Exh.cat. Galerie Thaddeus Ropac, Paris 1997.
Beitrag von | Contribution by Caroline Smulders
Steven Henry Madoff: *After the Roaring 80's in Art, A Decade of Quieter Voices*, in: *The New York Times*, 02.11.1997, pp. 45–46.

1998

Alexander Horwath: *Le Crémystère*, in: *noëma*, No. 46, 1998, pp. 30–39.
Christian Kämmerling: *Mein Kopf ist wie ein Cockpit*, in: *Süddeutsche Zeitung Magazin*, No. 46, Edition Matthew Barney, 13.11.1998, pp. 4–33.
CREMASTER 1. Matthew Barney, Ausst.-Kat. | Exh.cat. Museum für Gegenwartskunst Basel, Basel 1998.
Beiträge von | Contributions by KUNSTHALLE wien, Theodora Vischer
Die Rache der Veronika. Perspektiven der zeitgenössischen Fotografie, Ausst.-Kat. | Exh.cat. Deichtorhallen Hamburg, Hamburg 1998.
Beiträge von | Contributions by Zdenek Felix, Marion Lambert, Elizabeth Janus u.a.
Emotion. Junge britische und amerikanische Kunst aus der Sammlung Goetz, Ausst.-Kat. | Exh.cat. Deichtorhallen Hamburg, Hamburg 1998.
Beiträge von | Contributions by Iwona Blazwick, Yilmaz Dziewior, Carl Freedman u.a.
Florian Illies: *Muskelspiel einer neuen Mythologie*, in: *Frankfurter Allgemeine Zeitung*, 10.01.1998, p. 33.
Global Vision. New Art from the 90's Part III, Ausst.-Kat. | Exh.cat. The Deste Foundation Centre For Contemporary Art, Athen 1998.
Beitrag von | Contribution by Katerina Gregos
Hans-Ulrich Obrist and Nancy Spector: *Matthew Barney*, in: *Cream: Contemporary Art in Culture*, Phaidon, London 1998, pp. 64–67.
Isabel Carlisle: *Cremaster 5*, in: *Tate Summer*, 1998, n.p.
Jean-Christophe Ammann: *Matthew Barney als 'Anal Sadistic Warrior' – Gedanken zu Cremaster 5*, in: *Das Glück zu sehen – Kunst beginnt dort, wo Geschmack aufhört*, Lindiger und Schmid, Regensburg 1998, pp. 103–108.
Mark Sladen: *Unspeakable Beautiful*, in: *Art Monthly*, No. 217, Juni 1998, n.p.
Matthew Ritchie: *Barney's Cremaster 5*, in: *Flash Art*, Januar/Februar 1998, n.p.
Melissa E. Feldman: *Sex and Death etc*, in: *Art Monthly*, No. 213, 1998, pp. 6–9.

1999

Art at the Turn of the Millennium, Herausgeber | editor Burkhard Riemschneider, Uta Grosenick, Taschen, Köln 1999.
Beiträge von | Contributions by Burkhard Riemschneider, Uta Grosenick, Lars Bang Larsen u.a.
CREMASTER 2, Ausst.-Kat. | Exh.cat. Walker Art Center, Minneapolis 1999.
Beiträge von | Contributions by Richard Flood, Norman Mailer

Hajo Schiff: *Emotion and Sensation*, in: *Kunstmagazin*, No. 38, 1999, pp. 44–49.
Jay Tobler: The American Art Book, Phaidon, London 1999, p. 26.
Lance Goldberg: *Matthew Barney's Great Escape*, in: *WeeklyPlanet*, 25.03.1999, n.p.
Katy Siegel: *Nurture Boy: Matthew Barney's Cremaster 2*, in: *Artforum*, Sommer 1999, pp. 132–135.
Michael Rush: *New Media in Late 20th-Century Art*, Thames & Hudson, London und New York 1999, pp. 93, 150–151, 165.
Michael Kimmelman: *The Importance of Matthew Barney*, in: *The New York Times Magazine*, 10.10.1999, pp. 62–69.
New Media in Late 20th-Century Art, Thames & Hudson, London und New York 1999.
Beitrag von | Contribution by Michael Rush
Seeing Time. Selections from the Pamela and Richard Kramlich Collection of Media Art, Ausst.-Kat. | Exh.cat. San Francisco Museum of Modern Art, San Francisco 1999.
Beiträge von | Contributions by David A. Ross, Robert R. Riley, Marita Sturken u.a.
Thomas Girst: *Sex, art, and videotape*, in: *National Post*, 30.01.1999, n.p.

2000

Anke Sterneborg: *Das kühle Objekt der Begierde*, in: *Süddeutsche Zeitung*, 16.02.2000, p. 18.
Beth Coleman: *Soft Machines*, in: *Artbyte Magazine*, September/Oktober 2000, n.p.
Heinz Schütz: *Beauty Now: Die Schönheit in der Kunst des 20. Jahrhunderts*, in: *Kunstforum*, No. 151, Juli–September 2000, pp. 381–384.
Hypermental. Wahnhafte Wirklichkeit 1950–2000. Von Salvador Dalí bis Jeff Koons, Ausst.-Kat. | Exh.cat. Kunsthaus Zürich, Zürich; Hamburger Kunsthalle, Hamburg 2000.
Beiträge von | Contributions by Bice Curiger, Griselda Pollock, Peter Weibel u.a.
Modern Art Despite Modernism, Ausst.-Kat. | Exh.cat. The Museum of Modern Art, New York 2000, pp. 95, 217.
Beitrag von | Contribution by Robert Storr
Outbound: Passages from the 90's, Ausst.-Kat. | Exh.cat. Contemporary Arts Museum, Houston 2000.
Beiträge von | Contributions by Dana Friis-Hanson, Lynn M. Herbert, Marti Mayo u.a.
Stefan Heidenreich: *Was will der Tankwart*, in: *Frankfurter Allgemeine Zeitung*, 16.02.2000, n.p.
Ulrike Knöfel: *Showmaster der Mutanten*, in: *Spiegel*, Juli 2000, pp. 236–238.
voilà – le monde dans la tête –, Ausst.-Kat. | Exh.cat. Musée d'Art Moderne de la Ville de Paris, Paris 2000.
Beiträge von | Contributions by Suzanne Pagé, Béatrice Parent, Hans-Ulrich Obrist u.a.
Wiebke Hüster: *Wo sich Gedächtnis und Halluzination durchdringen*, in: *Baseler Zeitung*, 28.02.2000, n.p.

2001

Performance Art: From Futurism to the Present, Thames &
Hudson, London und New York 2001, pp. 222–223.
Beitrag von I Contribution by RoseLee Goldberg
American Art from the Goetz Collection, Munich,
Ausst.-Kat. I Exh. cat. Galerie Rudolfinum, Prag 2001.
Beiträge von I Contributions by Ingvild Goetz, Rainald
Schumacher, Noemi Smolik u. a.
*A Twentieth-Century Enigma: Matthew Barney's
OTTOshaft*, Ausst.-Kat. I Exh. cat. Tate Britain, London
1995; Tate Foundation, London 2001.
Beitrag von I Contribution by Sean Rainbird

2002

Amine Haase: *Bilder wuchern wie Nachtgewächse*,
in: *Kunstforum*, No. 162, November / Dezember 2002,
pp. 325–329.
Anthony Downey: *Matthew Barney & Cremaster 3*, in:
contemporary, Oktober 2002, pp. 54–57.
Art Now. 137 Artists at the Rise of the New Millennium,
Taschen, Köln 2002, pp. 18–19.
Beiträge von I Contributions by Uta Grosenick, Burkhard
Riemschneider
David Rimanelli: *Matthew Barney: The CREMASTER
Cycle*, in: *Artforum*, Mai 2002, No. 09, n. p.
*Die Wohltat der Kunst. Post\Feministische Positionen der
neunziger Jahre aus der Sammlung Goetz*, Ausst.-Kat. I
Exh. cat. Sammlung Goetz, München 2002.
Beiträge von I Contributions by Thomas Meinecke,
Rainald Schumacher, Matthias Winzen u. a.
HAUTNAH. Die Sammlung Goetz, Ausst.-Kat. I Exh. cat.
Museum Villa Stuck, München 2002.
Beiträge von I Contributions by Ingvild Goetz, Jo-Ann
Birnie Danzker u. a.
Holger Liebs: *Manns genug*, in: *Süddeutsche Zeitung*,
06.06.2002, p. 15.
Holger Liebs: *Muskelspiel des Lebens*, in: *Süddeutsche
Zeitung*, 03.06.2002, p. 14.
Jordan Mejias: *Kletterpartie in den Weltuntergang*,
in: *Frankfurter Allgemeine Zeitung*, 31.05.2002,
No. 102, p. 51.
Massimiliano Gioni: *Matthew Barney*, in: *Flash Art*,
No. 225, Juli–September 2002, pp. 92–95.
Matthew Barney. CREMASTER 3, Ausst.-Kat. I Exh. cat.
Solomon R. Guggenheim Museum, New York 2002.
Matthew Barney. The CREMASTER Cycle, Ausst.-Kat. I
Exh. cat. Museum Ludwig, Köln; Musée d'Art Moderne
de la Ville de Paris, Paris; Solomon R. Guggenheim
Museum, New York 2002.
Beiträge von I Contributions by Nancy Spector, Neville
Wakefield
Matthew Barney. The Order. The CREMASTER Cycle,
Ausst.-Kat. I Exh. cat. Museum Ludwig, Köln; Musée
d'Art Moderne de la Ville de Paris, Paris; Solomon R.
Guggenheim Museum, New York 2002.
Beitrag von I Contribution by Nancy Spector
Neville Wakefield on Matthew Barney: *The passenger*,
in: *frieze*, No. 67, Mai 2002, pp. 72–77.

Off Limits. 40 Artangel Projects, Merrell Publishers
Limited, London 2002.
Beiträge von I Contributions by Marina Warner u. a.
Peter Richter: *Hoden runter*, in: *Frankfurter Allgemeine
Zeitung*, 26.05.2002, p. 21.
Roberta De Righi: *Kopfüber in die Dunkelheit*, in:
Abendzeitung, 05.06.2002, p. 23.
Rüdiger von Naso: *Magie der Maslosigkeit*, in: *Madame*,
Dezember 2002, pp. 118–120.
Thomas Wagner: *Zauberlehrlings Muskelspiele*, in:
Frankfurter Allgemeine Zeitung, 03.06.2002, p. 39.
Ulf Poschardt: *Schläge für den Menschenpark*, in:
Süddeutsche Zeitung, 01.10.1999, n. p.
Ulf Poschardt: *Wegbereiter der Evolution*, in: *Welt am
Sonntag*, 02.06.2002, p. 59.
Ute Thon: *Matthew Barney*, in: *art*, Mai 2002, pp. 62–71.
Verena Kuni: *Aufsteigende Bewegungen mit kalkulierten
Abgängen: Der Cremaster-Zyklus ist komplett*, in: *Kunst-
Bulletin*, No. 10, 2002, pp. 28–33.

2003

Calvin Tomkins: *His Body, Himself*, in: *The New Yorker*,
27.01.2003, pp. 50–59.
Guggenheim Guide. Matthew Barney, Ausst.-Kat. I
Exh. cat. Solomon R. Guggenheim Museum, New
York 2003.
Beitrag von I Contribution by Nancy Spector
Charmaine Picard: *The Eternal Return: Matthew
Barney Zone of Potential*, in: *Art Nexus*, No. 49, 2003,
pp. 98–103.
fast forward. Media Art Sammlung Goetz, Ausst.-Kat. I
Exh. cat. ZKM I Zentrum für Kunst und
Medientechnologie Karlsruhe 2003.
Beiträge von I Contributions by Ingvild Goetz, Mark
Nash, Peter Weibel u. a.
Hans-Ulrich Obrist: *Mathew Barney*, in: *Interviews.
Volume 1*, Edizioni Charta, Mailand 2003, pp. 69–77.
Javier Hernando: *Spaces for Art and Photography.
Appropriation and Updating of a Traditional Pictorial
Genre*, in: *Exit*, No. 09, 2003, pp. 36–49.
*Just Love Me. Post\Feminist Positions of the 1990's
from the Goetz Collection* Ausst.-Kat. I Exh. cat. Bergen
Kunstmuseum, Bergen; Fries Museum, Leeuwarden,
Verlag der Buchhandlung Walther König, Köln 2003.
Beiträge von I Contributions by Thomas Meinecke,
Rainald Schumacher, Matthias Winzen
Michael Kimmelman: *Free to play and be gooey*, in: *The
New York Times. Weekend*, 21.02.2003, pp. 39–43.
N. N.: *IVAM*, in: *tema celeste*, No. 99, September /
Oktober 2003, p. 122.
Tim Griffin: *Matthew Barney: The Cremaster Cycle*, in:
Artforum, No. 09, Mai 2003, pp. 162–163.
Wayne Bremser: *Matthew Barney versus Donkey Kong*,
in: *Game Girl Advance Online*, 23.05.2003, pp. 1–11.
Verena Kuni: *Von der Magie der Kunst in der Politik*, in:
Kunstforum, No. 163, Januar / Februar 2003, pp. 37–53.
video art, Herausgeber Ieditor Michael Rush, Thames &
Hudson, London und New York 2003.
Beitrag von I Contribution Michael Rush

2004

Holger Liebs: *Busby Berkeley auf Dope*, in: *Süddeutsche Zeitung*, 09.07.2004, p. 13.
José Luis Pardo: *The Rule of the Game*, in: *Exit*, No. 15, 2004, pp. 58–61.
Matthew Barney: *Transcript of Lecture*, in: *Tokion*, Januar/Februar 2004, pp. 70–75.
Monument to now. The Dakis Joannou Collection, Ausst.-Kat. I Exh.cat. The Deste Foundation Centre For Contemporary Art, Athen 2004.
Beiträge von I Contributions by Dan Cameron, Jeffrey Deitch, Alison M. Gingeras u.a.
Performance. Live Art Since the 60's, Thames & Hudson, London und New York 2001.
Beiträge von I Contributions by Laurie Anderson, RoseLee Goldberg
Matthew Barney vs. Jeff Koons, in: *Black Book*, Oktober 2004, pp. 82–87.

2005

Lydia Schmid und Annemarie Ballschmiter: *Der Bilder Stürmer*, in: *Elle*, Juni 2005, pp. 24–30.
Goetz meets Falckenberg, Ausst.-Kat. I Exh.cat. Sammlung Falckenberg, Hamburg 2005.
Beiträge von I Contributions by Ingvild Goetz, Harald Falckenberg, Zdenek Felix u.a.
Matthew Barney. Drawing Restraint. VOL I, 1987–2002, Ausst.-Kat. I Exh.cat. 21st Century Museum of Contemporary Art, Kanazawa; Leeum Samsung Museum of Art, Seoul; San Francisco Museum of Modern Art, San Francisco 2005.
Beitrag von I Contribution by Hans-Ulrich Obrist
Matthew Barney. Drawing Restraint. VOL II, Ausst.-Kat. I Exh.cat. 21st Century Museum of Contemporary Art, Kanazawa; Leeum Samsung Museum of Art, Seoul; San Francisco Museum of Modern Art, San Francisco 2005.
Beiträge von I Contributions by Yuko Hasegawa, Luc Steels, Shinichi Nakazawa
Matthias Heine: *Ein Trip wie kein anderer*, in: *Welt kompakt*, 06.10.2005, p. 22.
Michael Althen: *Tausend Tonnen Walfett*, in: *Frankfurter Allgemeine Zeitung*, 05.09.2005, p. 33.
Midori Matsui: *Matthew Barney*, in: *Flash Art*, No. 244, Oktober 2005, p. 123.
Works from Collezione Sandretto Re Rebaudengo, Herausgeber I editor Patrizia Sandretto Re Rebaudengo, Skira, Mailand 2005.
Beiträge von I Contributions by Patrizia Sandretto Re Rebaudengo, Francesco Bonami

2006

Alexandra Keller und Fraser Ward: *Matthew Barney and the Paradox of the Neo-Avantegarde Blockbuster*, in: *Cinema*, No. 45, Winter 2006, pp. 3–16.
Broken Screen. 26 conversations with Doug Aitken, Herausgeber I editor Noël Daniel, D.A.P. Distributed Art Publishers, Inc., New York 2006.
Beitrag von I Contribution by Doug Aitken

Das achte Feld. Geschlecher, Leben und Begehren in der Kunst seit 1960, Ausst.-Kat. I Exh.cat. Museum Ludwig, Köln 2006.
Beiträge von I Contributions by Frank Wagner, Judith Butler, Julia Friedrich u.a.
Dietmar Dath: *Füßchengeschnetzeltes im Traumboot*, in: *Frankfurter Allgemeine Zeitung*, 07.06.2006, p. 37.
Matthew Barney and Joseph Beuys. All in the present must be transformed, Ausst.-Kat. I Exh.cat. Deutsche Guggenheim, Berlin; Peggy Guggenheim Collection, Venedig 2006.
Beiträge von I Contributions by Nancy Spector, Mark C. Taylor, Nat Trotman u.a.
Bridget Goodbody: *Sea Change*, in: *Timeout New York*, 30.05.2006, p. 64.
David Fear: *Reviews. Drawing Restraint 9*, in: *Timeout New York*, 29.05.2006, n.p.
Eva Karcher: *Spiel mir das Lied auf der Sho*, in: *Monopol*, No. 03, 2007, n.p.
Eva Karcher: *Der Klang der Perlenfischerinnen beim Auftauchen*, in: *Monopol*, No. 02, 2006, pp. 59–68.
Fritz Göttler: *Zu Gast im Wal*, in: *Süddeutsche Zeitung*, 10.11.2006, p. 12.
Holger Liebs: *Durch Mark und Bein*, in: *Süddeutsche Zeitung*, 16.02.1006, p. 13.
Julie Belcove: *Barney's Voyage*, in: *W Magazine*, Mai 2006, pp. 190–199.
Josef Engels: *Ein Walfangschiff ist für mich politische Architektur*, in: *Die Welt*, 08.06.2006, n.p.
Linda Yablonsky: *A Satyr Wrapped In an Enigma*, in: *Artnews*, Juni 2006, pp. 131–133.
Matthew Barney and Arthur C. Danto on Joseph Beuys: *A Dialogue on Blood & Iron*, in: *Modern Painters*, September 2006, p. 62.
Michael Althen und Peter Körte: *Vaseline oder die Kunst, die Praktiken des Walfangs zu ignorieren*, in: *Süddeutsche Zeitung*, 08.06.2006, p. 51.
N.N.: *Politisch aufgeladen*, in: *Spiegel*, No. 23, 2006, p. 127.
Neville Wakefield: *DRAWING RESTRAINT 9*: Matthew Barney, in: *Art Review*, Mai 2006, pp. 97–101.
Randy Kennedy: *The Björk-Barney Enigma Machine*, in: *The New York Times*, 09.04.2006, n.p.
Stephen Holden: *Adrift in Japanese Waters with Whales and a Wedding*, in: *The New York Times*, 29.03.2006, p. E5.

2007

Matthew Barney, Herausgeber I editor Massimiliano Gioni, Mondadori Electa S.p.A., Mailand 2007.
Beitrag von I Contribution by Massimiliano Gioni
Matthew Barney. Drawing Restraint Volume IV, Ausst.-Kat. I Exh.cat. Barbara Gladstone Gallery, New York 2007.
Matthew Barney. Drawing Restraint Volume V, Ausst.-Kat. I Exh.cat. Serpentine Gallery, London; KUNSTHALLE wien, Wien 2007.
Beiträge von I Contributions by Matthew Barney, Kitty Scott, Neville Wakefiled u.a.

Ausstellungsliste | Exhibition Checklist

OTTOshaft (manual) F
1992
Grafitstift, Wachs und Silikon in Rahmen aus Prothesen-Kunststoff | Grafite, wax and silicon rubber on paper in prosthetic plastic frame
Motiv | Motive 14×21,5 cm
Rahmen | Frame 33×38,1×1,9 cm

Abbildungen | Illustrations
A Twentieth-Century Enigma: Matthew Barney's OTTOshaft, Ausst.-Kat. | Exh.cat. Tate Britain, London 1995; Tate Foundation, London 2001.
Matthew Barney, Ausst.-Kat. | Exh.cat. Sammlung Goetz München, 2007, p. 25.

Ausstellungen | Exhibitions
Bisher nicht ausgestellt | Not exhibited yet
2007/08 *Matthew Barney*
München: Sammlung Goetz 05.11.2007–29.03.2008.

ENVELOPA: Drawing Restraint 7 (Guillotine)
1993
Farbfotografien in Nylon-Rahmen | Color photographs in nylon frame
Motiv | Motive 19×26 cm
Rahmen | Frame 7-teilig, je | 7 parts, each 28,6×36,5×3,8 cm
Edition 8/10 (+ 2 a.p.)

Abbildungen | Illustrations
Altered States. American Art in the 90's, Ausst.-Kat. | Exh.cat. Forum for Contemporary Art, St. Louis 1995, p. 24.
Drawing Restraint 7, Hatje Cantz, Ostfildern 1995, n.p.
Matthew Barney – Tony Oursler – Jeff Wall, Ausst.-Kat. | Exh.cat. Sammlung Goetz, München 1996, pp. 6, 10–11.
Hybrids, Ausst.-Kat. | Exh.cat. De Appel Fondation, Amsterdam 1997, p. 39.
Die Rache der Veronika. Perspektiven der zeitgenössischen Fotografie, Ausst.-Kat. | Exh.cat. Deichtorhallen Hamburg, Hamburg 1998, pp. 166–167.
Performance. Live Art Since the 60's, Thames & Hudson, London und New York 2001, pp. 124–125.
Die Wohltat der Kunst. Post\Feministische Positionen der neunziger Jahre aus der Sammlung Goetz, Ausst.-Kat. | Exh.cat. Sammlung Goetz, München 2002, pp. 40–43.
Just Love Me. Post\Feminist Positions of the 1990's from the Goetz Collection Ausst.-Kat. | Exh.cat. Bergen Kunstmuseum, Bergen; Fries Museum, Leeuwarden, Verlag der Buchhandlung Walther König, Köln 2003, pp. 42–45.
Matthew Barney, Ausst.-Kat. | Exh.cat. Sammlung Goetz München, 2007, pp. 9, 22–23, 90–91, 102–103, 112–113, 122–123, 128–129, 138–139.

Ausstellungen | Exhibitions
1996 *Hybrids*
Amsterdam: De Appel 01.06.–18.08.1996.
1998 *Die Rache der Veronika. Aktuelle Perspektiven der zeitgenössischen Fotografie. Die Fotosammlung Lambert*
Hamburg: Deichtorhallen 27.02.–01.06.1998.
1998/99 *Emotion. Junge britische und amerikanische Kunst aus der Sammlung Goetz*
Hamburg: Deichtorhallen Hamburg 30.10.1998–17.01.1999.
2002 *Die Wohltat der Kunst. Post\Feministische Positionen der neunziger Jahre aus der Sammlung Goetz*
München: Sammlung Goetz 14.09.–10.11.2002.
2003/04 *Just Love Me. Post\Feminist Positions of the 1990's from the Goetz Collection*
Bergen: Bergen Kunstmuseum 22.08.–25.10.2003;
Leeuwarden: Fries Museum 24.04.–21.06.2004.
2007/08 *Matthew Barney*
München: Sammlung Goetz 05.11.2007–29.03.2008.

CREMASTER 4: LOUGHTON RAM
1994
C-Print in Rahmen aus selbstschmierendem Kunststoff | C-print in self-lubricating plastic frame
Motiv | Motive 74,2×49,4 cm
Rahmen | Frame 84,5×59,7×3,8 cm
Edition 4/6 (+ 1 a.p.)

Abbildungen | Illustrations
Matthew Barney. CREMASTER 4, Ausst.-Kat. | Exh.cat. Fondation Cartier pour l'art contemporain, Paris; Artangel, London; Barbara Gladstone Gallery, New York 1995, n.p.
Matthew Barney – Tony Oursler – Jeff Wall, Ausst.-Kat. | Exh.cat. Sammlung Goetz, München 1996, pp. 6, 18.
Jerry Saltz: *The Next Sex*, in: *Art in America*, No. 10, Oktober 1996, p. 90.
Emotion. Junge britische und amerikanische Kunst aus der Sammlung Goetz, Ausst.-Kat. | Exh.cat. Deichtorhallen Hamburg, Hamburg 1998, p. 95.
HAUTNAH. Die Sammlung Goetz, Ausst.-Kat. | Exh.cat. Museum Villa Stuck, München 2002, p. 23.
Off Limits. 40 Artangel Projects, Merrell Publishers Limited, London 2002, p. 42.
Goetz meets Falckenberg, Ausst.-Kat. | Exh.cat. Sammlung Falckenberg, Hamburg 2005, pp. 38, 126–127.
Matthew Barney, Ausst.-Kat. | Exh.cat. Sammlung Goetz München, 2007, pp. 9, 64.

Ausstellungen | Exhibitions
1996 *Matthew Barney – Tony Oursler – Jeff Wall*
München: Sammlung Goetz 22.07.–20.12.1996.
1998/99 *Emotion. Junge britische und amerikanische Kunst aus der Sammlung Goetz*
Hamburg: Deichtorhallen Hamburg 30.10.1998–17.01.1999.
2002 *HAUTNAH. Die Sammlung Goetz*
München: Museum Villa Stuck 30.05.–18.08.2002.

2005/06 *Goetz meets Falckenberg*
Hamburg: Sammlung Falckenberg
04.11.2005.–30.04.2006.
2007/08 *Matthew Barney*
München: Sammlung Goetz 05.11.2007–29.03.2008.

CREMASTER 4: The Isle of Man
1994
2 C-Prints in Rahmen aus Stoff (Manx Karo), selbst-
schmierendem Kunststoff und Prothesen-Kunststoff
und 3 C-Prints in Rahmen aus selbstschmierendem
Kunststoff | 2 C-prints in Manx tartan and self-
lubricating and prosthetic plastic frames and 3 C-prints
in self-lubricating plastic frames
Motiv | Motive 5-teilig | 5 parts:
22×18 cm (2×);
74×59 cm (2×);
59×74 cm (1×)
Rahmen | Frame 5-teilig | 5 parts:
42×38,1×3,8 cm (2×);
70×84,5×3,8 cm (2×);
84,5×70×3,8 cm (1×)
Edition 3/3 (+ 1 a.p.)

Abbildungen | Illustrations
Matthew Barney. CREMASTER 4, Ausst.-Kat. | Exh.cat.
Fondation Cartier pour l'art contemporain, Paris;
Artangel, London; Barbara Gladstone Gallery, New York
1995, n.p.
Fremdkörper, Ausst.-Kat. | Exh.cat. Öffentliche
Kunstsammlung Basel, Museum für Gegenwartskunst,
Basel 1996, pp. 22–25.
Matthew Barney – Tony Oursler – Jeff Wall, Ausst.-Kat. |
Exh.cat. Sammlung Goetz, München 1996, p. 14.
Matthew Barney. Pace Car for the Hubris Pill, Ausst.-Kat. |
Exh.cat. Museum Boijmans Van Beuningen Rotterdam,
Rotterdam; Le CAPC Musée d'art contemporain,
Bordeaux; Kunsthalle Bern, Bern 1996, n.p.
Anne Erfle: *Matthew Barneys Plazentäre
Phantasmagorien*, in: *nbk*, No. 04, 1997, p. 99.
*Emotion. Junge britische und amerikanische Kunst aus
der Sammlung Goetz*, Ausst.-Kat. | Exh.cat.
Deichtorhallen Hamburg, Hamburg 1998, pp. 6, 100.
Hajo Schiff: *Emotion and Sensation*, in: *Kunstmagazin*,
No. 38, 1999, p. 49.
Amine Haase: *Bilder wuchern wie Nachtgewächse*, in:
Kunstforum, No. 162, November/Dezember 2002, p. 325.
HAUTNAH. Die Sammlung Goetz, Ausst.-Kat. | Exh.cat.
Museum Villa Stuck, München 2002, pp. 24–25.
Ute Thon: *Matthew Barney*, in: *art*, Mai 2002, p. 68.
Charmaine Picard: *The Eternal Return: Matthew Barney
Zone of Potential*, in: *Art Nexus*, No. 49, 2003, p. 98.
Matthew Barney. The CREMASTER Cycle, Ausst.-Kat. |
Exh.cat. Museum Ludwig, Köln; Musée d'Art Moderne
de la Ville de Paris, Paris; Solomon R. Guggenheim
Museum, New York 2002, pp. 334–335, 349.
Goetz meets Falckenberg, Ausst.-Kat. | Exh.cat. Samm-
lung Falckenberg, Hamburg 2005, pp. 52, 126–127.

Linda Yablonsky: *A Satyr Wrapped In an Enigma*, in:
Artnews, Juni 2006, p. 130.
Matthew Barney, Ausst.-Kat. | Exh.cat. Sammlung
Goetz München, 2007, pp. 66–67.

Ausstellungen | Exhibitions
1995/96 *Matthew Barney. Pace Car for the Hubris Pill*
Rotterdam: Museum Boijmans Van Beuningen
Rotterdam 1995;
Bordeaux: Le CAPC Musée d'art contemporain 1995;
Bern: Kunsthalle Bern 1996.
1996 *Matthew Barney – Tony Oursler – Jeff Wall*
München: Sammlung Goetz 22.07.–20.12.1996.
1998/99 *Emotion. Junge britische und amerikanische
Kunst aus der Sammlung Goetz*
Hamburg: Deichtorhallen Hamburg
30.10.1998–17.01.1999.
2002 *HAUTNAH. Die Sammlung Goetz*
München: Museum Villa Stuck 30.05.–18.08.2002.
2002/03 *Matthew Barney: The CREMASTER Cycle*
Köln: Museum Ludwig 06.06.–01.09.2002;
Paris: Musée d'Art Moderne de la Ville de Paris
10.10.2002–05.01.2003;
New York: Solomon R. Guggenheim Museum
21.02.–11.06.2003.
2005/06 *Goetz meets Falckenberg*
Hamburg: Sammlung Falckenberg
04.11.2005.–30.04.2006.
2007/08 *Matthew Barney*
München: Sammlung Goetz 05.11.2007–29.03.2008.

CREMASTER 4: T1: ascending HACK descending HACK
1994
C-Print in Rahmen aus selbstschmierendem Kunststoff |
C-print in self-lubricating plastic frame
Motiv | Motive 89,5×59 cm
Rahmen | Frame 100,3×70×3,8 cm
Edition 3/6 (+ 1 a.p.)

Abbildungen | Illustrations
Jerry Saltz: *The Next Sex*, in: *Art in America*, No. 10,
Oktober 1996, p. 85.
Matthew Barney. CREMASTER 4, Ausst.-Kat. | Exh.cat.
Fondation Cartier pour l'art contemporain, Paris;
Artangel, London; Barbara Gladstone Gallery, New York
1995, n.p.
Matthew Barney – Tony Oursler – Jeff Wall, Ausst.-Kat. |
Exh.cat. Sammlung Goetz, München 1996, p. 16.
Ute Thon: *Matthew Barney*, in: *art*, Mai 2002, p. 69.
Matthew Barney. The CREMASTER Cycle, Ausst.-Kat. |
Exh.cat. Museum Ludwig, Köln; Musée d'Art Moderne
de la Ville de Paris, Paris; Solomon R. Guggenheim
Museum, New York 2002, p. 353.
Matthew Barney, Herausgeber | editor Massimiliano
Gioni, Mondadori Electa S.p.A., Mailand 2007, p. 67.
Matthew Barney, Ausst.-Kat. | Exh.cat. Sammlung
Goetz München, 2007, p.68.

Ausstellungen | Exhibitions
1996 *Matthew Barney – Tony Oursler – Jeff Wall*
München: Sammlung Goetz 22.07.–20.12.1996.
1998/99 *Emotion. Junge britische und amerikanische*
Kunst aus der Sammlung Goetz
Hamburg: Deichtorhallen Hamburg
30.10.1998–17.01.1999.
2002 *HAUTNAH. Die Sammlung Goetz*
München: Museum Villa Stuck 30.05.–18.08.2002.
2002/03 *Matthew Barney: The CREMASTER Cycle*
Köln: Museum Ludwig 06.06.–01.09.2002;
Paris: Musée d'Art Moderne de la Ville de Paris
10.10.2002–05.01.2003;
New York: Solomon R. Guggenheim Museum
21.02.–11.06.2003.
2007/08 *Matthew Barney*
München: Sammlung Goetz 05.11.2007–29.03.2008.

CREMASTER 4: Three Legs of Mann
1994
C-Print in Rahmen aus selbstschmierendem Kunststoff |
C-print in self-lubricating plastic frame
Motiv | Motive 59×90,1 cm
Rahmen | Frame 71,1×101,6×2,5 cm
Edition 6/6 (+ 1 a.p.)

Abbildungen | Illustrations
Matthew Barney. CREMASTER 4, Ausst.-Kat. | Exh.cat.
Fondation Cartier pour l'art contemporain, Paris;
Artangel, London; Barbara Gladstone Gallery, New York
1995, n.p.
Jerry Saltz: *The Next Sex*, in: *Art in America*, No. 10,
Oktober 1996, p. 91.
Matthew Barney – Tony Oursler – Jeff Wall, Ausst.-Kat. |
Exh.cat. Sammlung Goetz, München 1996, p. 19.
Beiträge von | Contributions by Ingvild Goetz, Christiane
Meyer-Stoll, Jerry Saltz u.a.
Anne Erfle: *Matthew Barneys Plazentäre*
Phantasmagorien, in: *nbk*, No. 04, 1997, pp. 50.
Emotion. Junge britische und amerikanische Kunst aus
der Sammlung Goetz, Ausst.-Kat. | Exh.cat.
Deichtorhallen Hamburg, Hamburg 1998, p. 101.
HAUTNAH. Die Sammlung Goetz, Ausst.-Kat. | Exh.cat.
Museum Villa Stuck, München 2002, p. 23.
Matthew Barney. The CREMASTER Cycle, Ausst.-Kat. |
Exh.cat. Museum Ludwig, Köln; Musée d'Art Moderne
de la Ville de Paris, Paris; Solomon R. Guggenheim
Museum, New York 2002, pp. 106, 392–393.
Matthew Barney, Ausst.-Kat. | Exh.cat. Sammlung
Goetz München, 2007, pp. 9, 69.

Ausstellungen | Exhibitions
1996 *Matthew Barney – Tony Oursler – Jeff Wall*
München: Sammlung Goetz 22.07.–20.12.1996.
1998/99 *Emotion. Junge britische und amerikanische*
Kunst aus der Sammlung Goetz
Hamburg: Deichtorhallen Hamburg
30.10.1998–17.01.1999.

2002 *HAUTNAH. Die Sammlung Goetz*
München: Museum Villa Stuck 30.05.–18.08.2002.
2002/03 *Matthew Barney: The CREMASTER Cycle*
Köln: Museum Ludwig 06.06.–01.09.2002;
Paris: Musée d'Art Moderne de la Ville de Paris
10.10.2002–05.01.2003;
New York: Solomon R. Guggenheim Museum
21.02.–11.06.2003.
2007/08 *Matthew Barney*
München: Sammlung Goetz 05.11.2007–29.03.2008.

CREMASTER 4

CREMASTER 4
1994
35-mm-Film (auf Film mit Dolby-SR-Sound
transferiertes digitales Farbvideo) | 35-mm film (color
video transferred to film with Dolby SR sound
Laufzeit | Duration 42' 16"

CREMASTER 4
1994/95
Siebdruck-Laserdisk in Hülle aus Zwiebelschalen,
Prothesen-Kunststoff, Satinfahne und Manx-Karo in
Vitrine aus selbstschmierendem Kunststoff und Acryl |
Silkscreened laser disk in onionskin sleeve, prosthetic
plastic, bridal-satin banner and Manx tartan in self-
lubricating plastic and acrylic vitrine
Vitrine | Vitrine 91,4×122×104,1 cm
Edition 7/10 (+ 2 a.p.)

Abbildungen | Illustrations
Matthew Barney. CREMASTER 4, Ausst.-Kat. | Exh.cat.
Fondation Cartier pour l'Art Contemporain, Paris 1995,
zahlreiche Abbildungen | numerous illustrations.
Matthew Barney. Pace Car for the Hubris Pill, Ausst.-Kat. |
Exh.cat. Museum Boijmans Van Beuningen Rotterdam,
Rotterdam; Le CAPC Musée d'art contemporain,
Bordeaux; Kunsthalle Bern, Bern, n.p.
Matthew Ritchie: *Matthew Barney*, in: *Flash Art*, No. 184,
1995, p. 105.
Michel Onfray: *Manieristische Bemerkungen zu Matthew*
Barney, in: *Parkett*, No. 45, 1995, pp. 46, 49.
1996. The Hugo Boss Prize Exhibition, Ausst.-Kat. |
Exh.cat. Guggenheim Museum SoHo, New York 1996,
p. 45.
Jerry Saltz: *The Next Sex*, in: *Art in America*, No. 10,
Oktober 1996, pp. 82, 86.
Matthew Barney – Tony Oursler – Jeff Wall, Ausst.-Kat. |
Exh.cat. Sammlung Goetz, München 1996, pp. 20–21,
22–33.
Christoper Doswald: *Der Körper als Instrument*, in:
Kunstforum, Oktober 1996–Januar 1997, No. 135,
pp. 313, 316.
Emotion. Junge britische und amerikanische Kunst aus
der Sammlung Goetz, Ausst.-Kat. | Exh.cat.
Deichtorhallen Hamburg, Hamburg 1998, p. 99.
Isabel Carlisle: *Cremaster 5*, in: *Tate Summer*, 1998,
n.p.

Seeing Time. Selections from the Pamela and Richard Kramlich Collection of Media Art, Ausst.-Kat. | Exh.cat. San Francisco Museum of Modern Art, San Francisco 1999, p. 23.
Heinz Schütz: Beauty Now: Die Schönheit in der Kunst des 20. Jahrhunderts, in: Kunstforum, No. 151, Juli–September 2000, p. 383.
Matthew Barney: THE CREMASTER Cycle, Ausst.-Kat. | Exh.cat. Museum Ludwig, Köln; Musée d'Art Moderne de la Ville de Paris, Paris; Solomon R. Guggenheim Museum, New York, Ostfildern-Ruit: Hatje Cantz, 2002, zahlreiche Abbildungen | numerous illustrations.
Off Limits. 40 Artangel Projects, Merrell Publishers Limited, London 2002, pp. 42–47.
Rüdiger von Naso: Magie der Maslosigkeit, in: Madame, Dezember 2002, pp. 118–120.
Ute Thon: Matthew Barney, in: art, Mai 2002, pp. 62–71.
Just Love Me. Post\Feminist Positions of the 1990's from the Goetz Collection Ausst.-Kat. | Exh.cat. Bergen Kunstmuseum, Bergen; Fries Museum, Leeuwarden, Verlag der Buchhandlung Walther König, Köln 2003, pp. 84–87.
Das achte Feld. Geschlecher, Leben und Begehren in der Kunst seit 1960, Ausst.-Kat. | Exh.cat. Museum Ludwig, Köln 2006, pp. 258–259.
Goetz meets Falckenberg, Ausst.-Kat. | Exh.cat. Sammlung Falckenberg, Hamburg 2005, p. 124.
Matthew Barney, Herausgeber | editor Massimiliano Gioni, Mondadori Electa S.p.A., Mailand 2007, p. 68.
Matthew Barney, Ausst.-Kat. | Exh.cat. Sammlung Goetz München, 2007, pp. 6, 124, 176–177.

Ausstellungen | Exhibitions
1995 Matthew Barney. CREMASTER 4
New York: Barbara Gladstone Gallery 1995;
Paris: Fondation Cartier pour l'Art Contemporain 03.03.–16.04.1995.
1995/96 Matthew Barney. Pace Car for the Hubris Pill
Rotterdam: Museum Boijmans Van Beuningen Rotterdam 1995;
Bordeaux: Le CAPC Musée d'art contemporain 1995;
Bern: Kunsthalle Bern 1996.
1996 Transexualis and REPRESSIA. CREMASTER 1 and CREMASTER 4
San Francisco: San Francisco Museum of Modern Art 1996.
1996/97 Matthew Barney – Tony Oursler – Jeff Wall
München: Sammlung Goetz 22.07.–20.12.1996.
1997 Lange Nacht der Museen
Berlin: Nationalgalerie im Hamburger Bahnhof, Museum für Gegenwart 23.08.–01.09.1997.
1998/99 Emotion. Junge britische und amerikanische Kunst aus der Sammlung Goetz
Hamburg: Deichtorhallen Hamburg 30.10.1998–17.01.1999.
1999/2000 Matthew Barney, Der Cremaster-Zyklus, Cremaster 5, Cremaster 4
München: filmmuseum münchen 06.12.1999;

Cremaster 1, Cremaster 4
München: filmmuseum münchen 10.11.–11.11.2000.
2000/01 seeing time
Karlsruhe: ZKM | Zentrum für Kunst und Medientechnologie Karlsruhe 30.11.2000–22.04.2001.
2002 HAUTNAH. Die Sammlung Goetz
München: Museum Villa Stuck 30.05.–18.08.2002.
2002/03 Matthew Barney: THE CREMASTER Cycle
Köln: Museum Ludwig 06.06.–01.09.2002;
Paris: Musée d'Art Moderne de la Ville de Paris 10.10.2002–05.01.2003;
New York: Solomon R. Guggenheim Museum 21.02.–11.06.2003.
2003/04 fast forward. Media Art Sammlung Goetz
Karlsruhe: ZKM | Zentrum für Kunst und Medientechnologie Karlsruhe 10.10.2003–06.03.2004.
Just Love Me. Post\Feminist Positions of the 1990's from the Goetz Collection
Bergen: Bergen Kunstmuseum 22.08.–25.10.2003;
Leeuwarden: Fries Museum 24.04.–21.06.2004.
2004 Matthew Barney, Der Cremaster-Zyklus
München: filmmuseum münchen 09.07.–10.07.2004 (Chronologische Vorführung) 23.07.–25.07.2004 (Nummerische Vorführung).
2005/06 Goetz meets Falckenberg
Hamburg: Sammlung Falckenberg 04.11.2005.–30.04.2006.
2007/08 Matthew Barney
München: Sammlung Goetz 05.11.2007–29.03.2008.

CREMASTER 1: Goodyear
1995
Gelatine-Silberdruck in Rahmen aus selbstschmierendem Kunststoff | Gelatin-silver print in self-lubricating plastic frame
Motiv | Motive 72×97 cm
Rahmen | Frame 83,3×109,2×2,5 cm
Edition 2/6 (+ 2 a.p.)

Abbildungen | Illustrations
Jerry Saltz: The Next Sex, in: Art in America, No. 10, Oktober 1996, p. 89.
Matthew Barney. Pace Car for the Hubris Pill, Ausst.-Kat. | Exh.cat. Museum Boijmans Van Beuningen Rotterdam, Rotterdam; Le CAPC Musée d'art contemporain, Bordeaux; Kunsthalle Bern, Bern 1996, n.p.
CREMASTER 5, Ausst.-Kat. | Exh.cat. Portikus, Frankfurt/Main; Barbara Gladstone Gallery, New York 1997, zahlreiche Abbildungen | numerous illustrations.
Alexander Horwath: Le Crémystère, in: noëma, No. 46, 1998, p. 35.
Emotion. Junge britische und amerikanische Kunst aus der Sammlung Goetz, Ausst.-Kat. | Exh.cat. Deichtorhallen Hamburg, Hamburg 1998, p. 96.

Art at the Turn of the Millennium, Herausgeber | editor Burkhard Riemschneider, Uta Grosenick, Taschen, Köln 1999, p. 60.
Amine Haase: *Bilder wuchern wie Nachtgewächse*, in: *Kunstforum*, No. 162, November/Dezember 2002, p. 327.
Verena Kuni: *Aufsteigende Bewegungen mit kalkulierten Abgängen: Der Cremaster-Zyklus ist komplett*, in: *Kunst-Bulletin*, No. 10, 2002, p. 32.
Charmaine Picard: *The Eternal Return: Matthew Barney Zone of Potential*, in: *Art Nexus*, No. 49, 2003, p. 101.
Matthew Barney. The CREMASTER Cycle, Ausst.-Kat. | Exh.cat. Museum Ludwig, Köln; Musée d'Art Moderne de la Ville de Paris, Paris; Solomon R. Guggenheim Museum, New York 2002, pp. 122–123.
Matthias Heine: *Ein Trip wie kein anderer*, in: *Welt kompakt*, 06.10.2005, p. 22.
Matthew Barney, Herausgeber | editor Massimiliano Gioni, Mondadori Electa S.p.A., Mailand 2007, p. 34.
Matthew Barney, Ausst.-Kat. | Exh.cat. Sammlung Goetz München, 2007, p. 26.

Ausstellungen | Exhibitions
1997/98 *Matthew Barney. CREMASTER 5*
Wien: KUNSTHALLE wien 28.11.1997–08.02.1998;
Basel: Öffentliche Kunstsammlung Basel, Kunstmuseum Basel 1998.
1998/99 *Emotion. Junge britische und amerikanische Kunst aus der Sammlung Goetz*
Hamburg: Deichtorhallen Hamburg
30.10.1998–17.01.1999.
2001 *American Art from the Goetz Collection, Munich*
Prag: Galerie Rudolfinum 24.05.–02.09.2001.
2002/03 *Matthew Barney: The CREMASTER Cycle*
Köln: Museum Ludwig 06.06.–01.09.2002;
Paris: Musée d'Art Moderne de la Ville de Paris
10.10.2002–05.01.2003;
New York: Solomon R. Guggenheim Museum
21.02.–11.06.2003.
2007/08 *Matthew Barney*
München: Sammlung Goetz 05.11.2007–29.03.2008.

CREMASTER 1: Goodyear Lounge
1995
C-Print in Rahmen aus selbstschmierendem Kunststoff | C-print in self-lubricating plastic frame
Motiv | Motive 50×50 cm
Rahmen | Frame 2-teilig, je | 2 parts, each
60,3×65,4×2,5 cm
Edition 2/3 (+ 1 a.p.)

Abbildungen | Illustrations
CREMASTER 1, Ausst.-Kat. | Exh.cat. KUNSTHALLE wien; Öffentliche Kunstsammlung Basel, Museum für Gegenwartskunst, Basel 1997.
Emotion. Junge britische und amerikanische Kunst aus der Sammlung Goetz, Ausst.-Kat. | Exh.cat. Deichtorhallen Hamburg, Hamburg 1998, p. 97.

American Art from the Goetz Collection, Munich, Ausst.-Kat. | Exh.cat. Galerie Rudolfinum, Prag 2001, p. 23.
Matthew Barney, Ausst.-Kat. | Exh.cat. Sammlung Goetz München, 2007, pp. 32–33.

Ausstellungen | Exhibitions
1997/98 *Matthew Barney. CREMASTER 1*
Wien: KUNSTHALLE wien 28.11.1997–08.02.1998;
Basel: Kunstmuseum – Öffentliche Kunstsammlung Basel 28.03.–28.06.1998.
1998/99 *Emotion. Junge britische und amerikanische Kunst aus der Sammlung Goetz*
Hamburg: Deichtorhallen Hamburg
30.10.1998–17.01.1999.
2001 *American Art from the Goetz Collection, Munich*
Prag: Galerie Rudolfinum 24.05.–02.09.2001.
2007/08 *Matthew Barney*
München: Sammlung Goetz 05.11.2007–29.03.2008.

CREMASTER 1: Orchidella
1995
C-Print in Rahmen aus selbstschmierendem Kunststoff | C-print in self-lubricating plastic frame
Motiv | Motive 124,5×99,5 cm
Rahmen | Frame 136,5×111×2,5 cm
Edition 2/6 (+ 2 a.p.)

Abbildungen | Illustrations
Matthew Barney – Tony Oursler – Jeff Wall, Ausst.-Kat. | Exh.cat. Sammlung Goetz, München 1996, p. 43.
Matthew Barney. Pace Car for the Hubris Pill, Ausst.-Kat. | Exh.cat. Museum Boijmans Van Beuningen Rotterdam, Rotterdam; Le CAPC Musée d'art contemporain, Bordeaux; Kunsthalle Bern, Bern 1996, n.p.
Anne Erfle: *Matthew Barneys Plazentäre Phantasmagorien*, in: *nbk*, No. 04, 1997, p. 50.
CREMASTER 1, Ausst.-Kat. | Exh.cat. KUNSTHALLE wien; Öffentliche Kunstsammlung Basel, Museum für Gegenwartskunst, Basel 1997, zahlreiche Abbildungen | numerous illustrations.
Sous le Manteau, Ausst.-Kat. | Exh.cat. Galerie Thaddeus Ropac, Paris 1997, n.p.
Die Rache der Veronika. Perspektiven der zeitgenössischen Fotografie, Ausst.-Kat. | Exh.cat. Deichtorhallen Hamburg, Hamburg 1998, p. 183.
Florian Illies: *Muskelspiel einer neuen Mythologie*, in: *Frankfurter Allgemeine Zeitung*, 10.01.1998, p. 33.
American Art from the Goetz Collection, Munich, Ausst.-Kat. | Exh.cat. Galerie Rudolfinum, Prag 2001, p. 23.
Roberta De Righi: *Kopfüber in die Dunkelheit*, in: *Abendzeitung*, 05.06.2002, p. 23.
Matthew Barney. The CREMASTER Cycle, Ausst.-Kat. | Exh.cat. Museum Ludwig, Köln; Musée d'Art Moderne de la Ville de Paris, Paris; Solomon R. Guggenheim Museum, New York 2002, p. 153.

Broken Screen. 26 conversations with Doug Aitken,
Herausgeber I editor Noël Daniel, D.A.P. Distributed Art
Publishers, Inc., New York 2006, p. 73.
Linda Yablonsky: *A Satyr Wrapped In an Enigma*, in:
Artnews, Juni 2006, p. 132.
Matthew Barney, Ausst.-Kat. I Exh.cat. Sammlung
Goetz Munchen, 2007, p. 29.

Ausstellungen I Exhibitions
1995/96 *Matthew Barney. Pace Car for the Hubris Pill*
Rotterdam: Museum Boijmans Van Beuningen
Rotterdam 1995;
Bordeaux: Le CAPC Musée d'art contemporain 1995;
Bern: Kunsthalle Bern 1996.
1996 *Matthew Barney – Tony Oursler – Jeff Wall*
München: Sammlung Goetz 22.07.–20.12.1996.
1997 *Une Seconde Peau*
Paris: Galerie Thaddaeus Ropac 08.03.–12.04.1997.
1997/98 *Matthew Barney. CREMASTER 1*
Wien: KUNSTHALLE wien 28.11.1997–08.02.1998;
Basel: Kunstmuseum – Öffentliche Kunstsammlung
Basel 28.03.–28.06.1998.
1998 *Die Rache der Veronika. Aktuelle Perspektiven der
zeitgenössischen Fotografie. Die Fotosammlung Lambert*
Hamburg: Deichtorhallen Hamburg
27.02.–01.06.1998.
1998/99 *Emotion. Junge britische und amerikanische
Kunst aus der Sammlung Goetz*
Hamburg: Deichtorhallen Hamburg
30.10.1998–17.01.1999.
2001 *American Art from the Goetz Collection, Munich*
Prag: Galerie Rudolfinum 24.05.–02.09.2001.
2002/03 *Matthew Barney: The CREMASTER Cycle*
Köln: Museum Ludwig 06.06.–01.09.2002;
Paris: Musée d'Art Moderne de la Ville de Paris
10.10.2002–05.01.2003;
New York: Solomon R. Guggenheim Museum
21.02.–11.06.2003.
2007/08 *Matthew Barney*
München: Sammlung Goetz 05.11.2007–29.03.2008.

CREMASTER 1: The Goodyear Waltz
1995
1 C-Print und 8 Gelatine-Silberdrucke in Rahmen
aus selbstschmierendem Kunststoff I 1 C-print and
8 gelatin-silver prints in self-lubricating plastic frames
Motiv I Motive 9-teilig I 9 parts:
74×59 cm (1×)
49×39 cm (8×);
Rahmen I Frame 9-teilig I 9 parts:
85,7×70×2,5 cm (1×)
64,1×54,6×2,5 cm (8×);
Edition 2/3 (+ 2 a.p.)

Abbildungen I Illustrations
Matthew Barney – Tony Oursler – Jeff Wall, Ausst.-Kat. I
Exh.cat. Sammlung Goetz, München 1996, pp. 42–43.
Matthew Barney. Pace Car for the Hubris Pill, Ausst.-Kat. I
Exh.cat. Museum Boijmans Van Beuningen Rotterdam,
Rotterdam; Le CAPC Musée d'art contemporain,
Bordeaux; Kunsthalle Bern, Bern 1996, n.p.
CREMASTER 1, Ausst.-Kat. I Exh.cat. KUNSTHALLE
wien; Öffentliche Kunstsammlung Basel, Museum für
Gegenwartskunst, Basel 1997, n.p.
Art at the Turn of the Millennium, Herausgeber I editor
Burkhard Riemschneider, Uta Grosenick, Taschen, Köln
1999, p. 60.
Holger Liebs: *Manns genug,* in: *Süddeutsche Zeitung,*
06.06.2002, p. 15.
Matthew Barney. The CREMASTER Cycle, Ausst.-Kat. I
Exh.cat. Museum Ludwig, Köln; Musée d'Art Moderne
de la Ville de Paris, Paris; Solomon R. Guggenheim
Museum, New York 2002, p. 31.
N.N.: *IVAM,* in: *tema celeste,* No. 99, September/
Oktober 2003, p. 122.
José Luis Pardo: *The Rule of the Game,* in: *Exit,* No. 15,
2004, p. 60.
Works from Collezione Sandretto Re Rebaudengo,
Herausgeber I editor Patrizia Sandretto Re Rebaudengo,
Skira, Mailand 2005, pp. 128–129.
Matthew Barney, Ausst.-Kat. I Exh.cat. Sammlung
Goetz München, 2007, pp. 30–31.

Ausstellungen I Exhibitions
1995/96 *Matthew Barney. Pace Car for the Hubris Pill*
Rotterdam: Museum Boijmans Van Beuningen
Rotterdam 1995;
Bordeaux: Le CAPC Musée d'art contemporain 1995;
Bern: Kunsthalle Bern 1996.
1996 *Matthew Barney – Tony Oursler – Jeff Wall*
München: Sammlung Goetz 22.07.–20.12.1996.
1997/98 *Matthew Barney. CREMASTER 1*
Wien: KUNSTHALLE wien 28.11.1997–08.02.1998;
Basel: Kunstmuseum – Öffentliche Kunstsammlung
Basel 28.03.–28.06.1998.
1998/99 *Emotion. Junge britische und amerikanische
Kunst aus der Sammlung Goetz*
Hamburg: Deichtorhallen Hamburg
30.10.1998–17.01.1999.
2001 *American Art from the Goetz Collection, Munich*
Prag: Galerie Rudolfinum 24.05.–02.09.2001.
2002/03 *Matthew Barney: The CREMASTER Cycle*
Köln: Museum Ludwig 06.06.–01.09.2002;
Paris: Musée d'Art Moderne de la Ville de Paris
10.10.2002–05.01.2003;
New York: Solomon R. Guggenheim Museum
21.02.–11.06.2003.
2003/04 *Just Love Me. Post\Feminist Positions of the
1990's from the Goetz Collection*

Bergen: Bergen Kunstmuseum 22.08.–25.10.2003;
Leeuwarden: Fries Museum 24.04.–21.06.2004.
2007/08 *Matthew Barney*
München: Sammlung Goetz 05.11.2007–29.03.2008.

[PIT] Field of the Descending Faerie
1995
Silikon, Prothesen-Kunststoff, hydraulischer
Wagenheber, Polyester, Vaseline und Satin-Band |
Silicone, prosthetic plastic, hydraulic jack, polyester,
petroleum jelly and satin ribbon
25,5×150×200 cm
Sockel | Plinth: 67×305,5×213 cm

Abbildungen | Illustrations
Matthew Barney. CREMASTER 4, Ausst.-Kat. | Exh.cat.
Fondation Cartier pour l'art contemporain, Paris;
Artangel, London; Barbara Gladstone Gallery, New York
1995, n.p.
Matthew Barney – Tony Oursler – Jeff Wall, Ausst.-Kat. |
Exh.cat. Sammlung Goetz, München 1996, pp. 6, 37.
Christoper Doswald: *Der Körper als Instrument*, in: *Kunst-
forum*, Oktober 1996–Januar 1997, No. 135, p. 315.
Hajo Schiff: *Emotion and Sensation*, in: *Kunstmagazin*,
No. 38, 1999, p. 49.
Matthew Barney. The CREMASTER Cycle, Ausst.-Kat. |
Exh.cat. Museum Ludwig, Köln; Musée d'Art Moderne
de la Ville de Paris, Paris; Solomon R. Guggenheim
Museum, New York 2002, p. 385.
Goetz meets Falckenberg, Ausst.-Kat. | Exh.cat. Samm-
lung Falckenberg, Hamburg 2005, pp. 125, 126–127.
Matthew Barney, Ausst.-Kat. | Exh.cat. Sammlung
Goetz München, 2007, p. 9.

Ausstellungen | Exhibitions
1995 *Matthew Barney. CREMASTER 4*
New York: Barbara Gladstone Gallery 1995;
Paris: Fondation Cartier pour l'Art Contemporain
03.03.–16.04.1995.
1996 *Matthew Barney – Tony Oursler – Jeff Wall*
München: Sammlung Goetz 22.07.–20.12.1996.
1998/99 *Emotion. Junge britische und amerikanische
Kunst aus der Sammlung Goetz*
Hamburg: Deichtorhallen Hamburg
30.10.1998–17.01.1999.
2002/03 *Matthew Barney: The CREMASTER Cycle*
Köln: Museum Ludwig 06.06.–01.09.2002;
Paris: Musée d'Art Moderne de la Ville de Paris
10.10.2002–05.01.2003;
New York: Solomon R. Guggenheim Museum
21.02.–11.06.2003.
2005/06 *Goetz meets Falckenberg*
Hamburg: Sammlung Falckenberg
04.11.2005.–30.04.2006.
2007/08 *Matthew Barney*
München: Sammlung Goetz 05.11.2007–29.03.2008.

CREMASTER 1

CREMASTER 1
1995
35-mm-Film (auf Film mit Dolby-SR-Sound trans-
feriertes digitales Farbvideo) | 35-mm film (color video
transferred to film with Dolby SR sound)
Laufzeit | Duration 40' 30"

CREMASTER 1
1995/96
Siebdruck-Laserdisk, gegossenes Polyester, Prothesen-
Kunststoff und Glanzvinyl in Vitrine aus selbstschmieren-
dem Kunststoff und Acryl | Silkscreened laser disk, cast
polyester, prosthetic plastic and patent vinyl in self-
lubricating plastic and acrylic vitrine
Vitrine | Vitrine 91×122×130 cm
Edition 1/10 (+ 2 a.p.)

Abbildungen | Illustrations
Thyrza Nichols Goodeve: *Matthew Barney is the
Mythographer*, in: *Artforum*, Mai 1995, n.p.
Thyrza Nichols Goodeve: *Matthew Barney 95*, in:
Parkett, No. 45, 1995, p. 71.
Jerry Saltz: *The Next Sex*, in: *Art in America*, No. 10,
Oktober 1996, p. 88.
Matthew Barney – Tony Oursler – Jeff Wall, Ausst.-Kat. |
Exh.cat. Sammlung Goetz, München 1996, pp. 40–41.
Matthew Barney. Pace Car for the Hubris Pill, Ausst.-Kat. |
Exh.cat. Museum Boijmans Van Beuningen Rotterdam,
Rotterdam; Le CAPC Musée d'art contemporain,
Bordeaux; Kunsthalle Bern, Bern 1996, n.p.
Christoper Doswald: *Der Körper als Instrument*, in:
Kunstforum, Oktober 1996–Januar 1997, No. 135,
pp. 318–319.
Ken Johnson: *Eyes on the Prize*, in: *Art in America*,
No. 04, 1997, p. 41.
CREMASTER 1, Ausst.-Kat. | Exh.cat. KUNSTHALLE
wien; Öffentliche Kunstsammlung Basel, Museum für
Gegenwartskunst, Basel 1997, zahlreiche Abbildungen |
numerous illustrations.
Alexander Horwath: *Le Crémystère*, in: *noëma*, No. 46,
1998, pp. 30–39.
*Emotion. Junge britische und amerikanische Kunst aus
der Sammlung Goetz*, Ausst.-Kat. | Exh.cat.
Deichtorhallen Hamburg, Hamburg 1998, p. 98.
Global Vision. New Art from the 90's, Part III, Ausst.-Kat. |
Exh.cat. The Deste Foundation Centre For
Contemporary Art, Athen 1998, n.p.
*Seeing Time. Selections from the Pamela and Richard
Kramlich Collection of Media Art*, Ausst.-Kat. | Exh.cat.
San Francisco Museum of Modern Art, San Francisco
1999, p. 7.
*Hypermental. Wahnhafte Wirklichkeit 1950–2000.
Von Salvador Dalí bis Jeff Koons*, Ausst.-Kat. | Exh.cat.
Kunsthaus Zürich, Zürich; Hamburger Kunsthalle,
Hamburg 2000, p. 65

Ulrike Knöfel: *Showmaster der Mutanten*, in: *Spiegel*, Juli 2000, pp. 236–238.
American Art from the Goetz Collection, Munich, Ausst.-Kat. | Exh.cat. Galerie Rudolfinum, Prag 2001, p. 22.
Holger Liebs: *Manns genug*, in: *Süddeutsche Zeitung*, 06.06.2002, p. 15.
Matthew Barney. The CREMASTER Cycle, Ausst.-Kat. | Exh.cat. Museum Ludwig, Köln; Musée d'Art Moderne de la Ville de Paris, Paris; Solomon R. Guggenheim Museum, New York 2002, zahlreiche Abbildungen | numerous illustrations.
Rüdiger von Naso: *Magie der Maslosigkeit*, in: *Madame*, Dezember 2002, pp. 118–120.
Roberta De Righi: *Kopfüber in die Dunkelheit*, in: *Abendzeitung*, 05.06.2002, p. 23.
Verena Kuni: *Aufsteigende Bewegungen mit kalkulierten Abgängen: Der Cremaster-Zyklus ist komplett*, in: *Kunst-Bulletin*, No. 10, 2002, p. 32.
Charmaine Picard: *The Eternal Return: Matthew Barney Zone of Potential*, in: *Art Nexus*, No. 49, 2003, p. 102.
Just Love Me. Post\Feminist Positions of the 1990's from the Goetz Collection Ausst.-Kat. | Exh.cat. Bergen Kunstmuseum, Bergen; Fries Museum, Leeuwarden, Verlag der Buchhandlung Walther König, Köln 2003, p. 41
fast forward. Media Art Sammlung Goetz, Ausst.-Kat. | Exh.cat. ZKM | Zentrum für Kunst und Medientechnologie Karlsruhe 2003, pp. 88–91.
Holger Liebs: *Busby Berkeley auf Dope*, in: *Süddeutsche Zeitung*, 09.07.2004, p. 13.
José Luis Pardo: *The Rule of the Game*, in: *Exit*, No. 15, 2004, p. 61.
Monument to now. The Dakis Joannou Collection, Ausst.-Kat. | Exh.cat. The Deste Foundation Centre For Contemporary Art, Athen 2004, p. 24.
Broken Screen. 26 conversations with Doug Aitken, Herausgeber | editor Noël Daniel, D.A.P. Distributed Art Publishers, Inc., New York 2006, pp. 71, 73.
Linda Yablonsky: *A Satyr Wrapped In an Enigma*, in: *Artnews*, Juni 2006, p. 132.
Matthew Barney, Ausst.-Kat. | Exh.cat. Sammlung Goetz München, 2007, pp. 6, 94–96, 170–171.

Ausstellungen | Exhibitions
1995 *New York Video Festival*
New York: Walter Reade Theater 07.10.–09.10.1995.
1995/96 *Matthew Barney. Pace Car for the Hubris Pill*
Rotterdam: Museum Boijmans Van Beuningen Rotterdam 1995;
Bordeaux: Le CAPC Musée d'art contemporain 1995;
Bern: Kunsthalle Bern 1996.
1996 *Transexualis and REPRESSIA. CREMASTER 1 and CREMASTER 4*
San Francisco: San Francisco Museum of Modern Art 1996.
10th Biennale of Sydney
Sydney: Biennale Juli 1996.

1996/97 *Matthew Barney – Tony Oursler – Jeff Wall*
München: Sammlung Goetz 22.07.–20.12.1996.
1997/98 *Matthew Barney. CREMASTER 1*
Wien: KUNSTHALLE wien 28.11.1997–08.02.1998;
Basel: Kunstmuseum – Öffentliche Kunstsammlung Basel 1998.
1998/99 *Emotion. Junge britische und amerikanische Kunst aus der Sammlung Goetz*
Hamburg: Deichtorhallen Hamburg 30.10.1998–17.01.1999.
2000 *Matthew Barney, Der Cremaster-Zyklus, Cremaster 1, Cremaster 4*
München: filmmuseum münchen 10.11.–11.11.2000.
2000/01 *Hypermental. Wahnhafte Wirklichkeit 1950–2000. Von Salvador Dalí bis Jeff Koons*
Zürich: Kunsthaus Zürich 07.11.2000–21.01.2001;
Hamburg: Hamburger Kunsthalle 16.02.–06.05.2001.
2001 *American Art from the Goetz Collection, Munich*
Prag: Galerie Rudolfinum 24.05.–02.09.2001.
seeing time
Karlsruhe: ZKM | Zentrum für Kunst und Medientechnologie Karlsruhe 30.11.2000–22.04.2001.
2002 *Die Wohltat der Kunst. Post\Feministische Positionen der neunziger Jahre aus der Sammlung Goetz*
München: Sammlung Goetz 14.09.–10.11.2002.
2002/03 *Matthew Barney: The CREMASTER Cycle*
Köln: Museum Ludwig 06.06.–01.09.2002;
Paris: Musée d'Art Moderne de la Ville de Paris 10.10.2002–05.01.2003;
New York: Solomon R. Guggenheim Museum 21.02.–11.06.2003.
2003/04 *fast forward. Media Art Sammlung Goetz*
Karlsruhe: ZKM | Zentrum für Kunst und Medientechnologie Karlsruhe 10.10.2003–06.03.2004.
2003/04 *Just Love Me. Post\Feminist Positions of the 1990's from the Goetz Collection*
Bergen: Bergen Kunstmuseum 22.08.2003–25.10.2003.
2004 *Matthew Barney, Der Cremaster-Zyklus*
München: filmmuseum münchen 09.07.–10.07.2004 (Chronologische Vorführung) 23.07.–25.07.2004 (Nummerische Vorführung).
2007/08 *Matthew Barney*
München: Sammlung Goetz 05.11.2007–29.03.2008.

CREMASTER 5

CREMASTER 5
1997
35-mm-Film (auf Film mit Dolby-SR-Sound transferiertes digitales Farbvideo) | 35-mm film (color video transferred to film with Dolby SR sound)
Laufzeit | Duration 54' 30"

CREMASTER 5
1997
Siebdruck-Laserdisk, Polyester, Acryl, Samt und
Sterlingsilber in Acryl-Vitrine, mit 35-mm-Druck I
Silkscreened laser disk, polyester, acrylic, velvet and
sterling silver in acrylic vitrine, with 35-mm print
Vitrine I Vitrine 88,9×119,4×94 cm
Edition 3/10 (+ 2 a.p.)

Abbildungen I Illustrations
Anne Erfle: *Das alternative Geschlecht*, in: *Süddeutsche
Zeitung*, 07.07.1996, n.p.
Anne Erfle: *Matthew Barneys Plazentäre
Phantasmagorien*, in: *nbk*, No. 04, 1997, pp. 49–52.
CREMASTER 5, Ausst.-Kat. I Exh.cat. Portikus,
Frankfurt/Main; C3, Center for Culture and Communica-
tion, Budapest; Barbara Gladstone Gallery, New York
1997, zahlreiche Abbildungen I numerous illustrations.
David Frankel: *Hungarian Rhapsody*, in: *Artforum*,
Oktober 1997, p. 77.
Isabel Carlisle: *Cremaster 5*, in: *Tate Summer*, 1998, n.p.
Mark Sladen: *Unspeakable Beautiful*, in: *Art Monthly*,
No. 217, Juni 1998, n.p.
Steven Henry Madoff: *After the Roaring 80's in Art.
A Decade of Quieter Voices*, in: *The New York Times*,
02.11.1997, pp. 45–46.
Lance Goldberg: *Matthew Barney's Great Escape*, in:
WeeklyPlanet, 25.03.1999, n.p.
Michael Rush: *New Media in Late-Twentieth-Century Art*,
Thames & Hudson, London und New York 1999, p. 151.
New Media in Late 20th-Century Art, Thames & Hudson,
London und New York 1999, p. 151.
Ulrike Knöfel: *Showmaster der Mutanten*, in: *Spiegel*,
Juli 2000, pp. 236–238.
Outbound: Passages from the 90's, Ausst.-Kat. I Exh.cat.
Contemporary Arts Museum, Houston 2000, p. 22
Amine Haase: *Bilder wuchern wie Nachtgewächse*, in:
Kunstforum, No. 162, November/Dezember 2002, p. 328.
Matthew Barney. The CREMASTER Cycle, Ausst.-Kat. I
Exh.cat. Museum Ludwig, Köln; Musée d'Art Moderne
de la Ville de Paris, Paris; Solomon R. Guggenheim
Museum, New York 2002, zahlreiche Abbildungen I
numerous illustrations.
fast forward. Media Art Sammlung Goetz, Ausst.-Kat. I
Exh.cat. ZKM I Zentrum für Kunst und
Medientechnologie Karlsruhe 2003, pp. 92–93.
Michael Kimmelman: *Free to play and be gooey*, in: *The
New York Times. Weekend*, 21.02.2003, pp. 39, 43.
Works from Collezione Sandretto Re Rebaudengo,
Herausgeber I editor Patrizia Sandretto Re Rebaudengo,
Skira, Mailand 2005. pp. 180–181.
Broken Screen. 26 conversations with Doug Aitken,
Herausgeber I editor Noël Daniel, D.A.P. Distributed Art
Publishers, Inc., New York 2006, p. 61.
Matthew Barney, Herausgeber I editor Massimiliano
Gioni, Mondadori Electa S.p.A., Mailand 2007, p. 75.
Matthew Barney, Ausst.-Kat. I Exh.cat. Sammlung Goetz
München, 2007, pp. 15, 18, 131–133, 178–179.

Ausstellungen I Exhibitions
Matthew Barney. CREMASTER 5
Frankfurt/Main: Portikus 19.06.–10.08.1997;
Budapest: C3, Center for Culture and Communication
03.07.–25.07.1997;
New York: Barbara Gladstone Gallery 1997.
1998 *Matthew Barney. CREMASTER 5*
Madrid: Fundació "la Caixa" 1998.
1998/99 *Emotion. Junge britische und amerikanische
Kunst aus der Sammlung Goetz*
Hamburg: Deichtorhallen Hamburg
30.10.1998–17.01.1999.
2000 *Outbound: Passages from the 90's*
Houston: Contemporary Arts Museum
04.03.–07.05.2000.
2002/03 *Matthew Barney: The CREMASTER Cycle*
Köln: Museum Ludwig 06.06.–01.09.2002;
Paris: Musée d'Art Moderne de la Ville de Paris
10.10.2002–05.01.2003.
2003/04 *fast forward. Media Art Sammlung Goetz*
Karlsruhe: ZKM I Zentrum für Kunst und Medientechno-
logie Karlsruhe 10.10.2003–06.03.2004.
2004 *Matthew Barney, Der Cremaster-Zyklus*
München: filmmuseum münchen
09.07.–10.07.2004 (Chronologische Vorführung)
23.07.–25.07.2004 (Nummerische Vorführung).
2005/06 *Video II: Allegorie*
Düsseldorf: NRW-Forum 17.09.2005–08.01.2006.
2007/08 *Matthew Barney*
München: Sammlung Goetz 05.11.2007–29.03.2008.

CREMASTER 5: Elválás
1997
2 C-Prints und 1 Gelatine-Silberdruck in Acryl-Rahmen I
2 C-prints and 1 gelatin-silver print in acrylic frames
Motiv I Motive 3-teilig I 3 parts:
74,5×59,5 cm (2×);
89,5×72 cm (1×)
Rahmen I Frame 3-teilig I 3 parts:
90×75,2×2,5 cm (2×);
105,1×87,6×2,5 cm (1×)
Edition 3/6 (+ 1 a.p.)

Abbildungen I Illustrations
Anne Erfle: *Matthew Barneys Plazentäre
Phantasmagorien*, in: *nbk*, No. 04, 1997, pp. 49–52.
CREMASTER 5, Ausst.-Kat. I Exh.cat. Portikus,
Frankfurt/Main; C3, Center for Culture and Communica-
tion, Budapest; Barbara Gladstone Gallery, New York
1997, n.p.
David Frankel: *Hungarian Rhapsody*, in: *Artforum*,
Oktober 1997, p. 78.
*Emotion. Junge britische und amerikanische Kunst aus
der Sammlung Goetz*, Ausst.-Kat. I Exh.cat.
Deichtorhallen Hamburg, Hamburg 1998, p. 102.
Melissa E. Feldman: *Sex and Death etc.*, in: *Art Monthly*,
No. 213, 1998, p. 8.

Outbound: Passages from the 90's, Ausst.-Kat. I Exh.cat.
Contemporary Arts Museum, Houston 2000, p. 24.
Performance. Live Art Since the 60's, Thames &
Hudson, London und New York 2001, p. 203.
Matthew Barney. The CREMASTER Cycle, Ausst.-Kat. I
Exh.cat. Museum Ludwig, Köln; Musée d'Art Moderne
de la Ville de Paris, Paris; Solomon R. Guggenheim
Museum, New York 2002, pp. 69, 453.
Matthew Barney, Ausst.-Kat. I Exh.cat. Sammlung
Goetz München, 2007, pp. 72–73.

Ausstellungen I Exhibitions
1998/99 *Emotion. Junge britische und amerikanische
Kunst aus der Sammlung Goetz*
Hamburg: Deichtorhallen Hamburg
30.10.1998–17.01.1999.
2002/03 *Matthew Barney: The CREMASTER Cycle*
Köln: Museum Ludwig 06.06.–01.09.2002;
Paris: Musée d'Art Moderne de la Ville de Paris
10.10.2002–05.01.2003;
New York: Solomon R. Guggenheim Museum
21.02.–11.06.2003.
2007/08 *Matthew Barney*
München: Sammlung Goetz 05.11.2007–29.03.2008.

Ereszkedés
1998
Zeichnungen: Grafit und Vaseline auf geprägtem Papier
in Acryl- und Vivak-Rahmen in Vitrine I Drawings:
Graphite and petroleum jelly on embossed paper in
acrylic and Vivak frames
Vitrine aus selbstschmierendem Kunststoff I Self-
lubricating plastic vitrine
Motiv I Motive 3-teilig, je I 3 parts, each 25,7×21 cm
Rahmen I Frame 3-teilig, je I 3 parts,
each 45,5×40,4×3,2 cm
Vitrine I Vitrine 76,3×97×76 cm; 18,7×176,3×95,7 cm

Abbildungen I Illustrations
Matthew Barney. The CREMASTER Cycle, Ausst.-Kat. I
Exh.cat. Museum Ludwig, Köln; Musée d'Art Moderne
de la Ville de Paris, Paris; Solomon R. Guggenheim
Museum, New York 2002, pp. 450, 452, 454.
Matthew Barney, Ausst.-Kat. I Exh.cat. Sammlung
Goetz München, 2007, p. 70.

Ausstellungen I Exhibitions
1998 *CREMASTER 5*
Los Angeles: Regen Projects 07.03.–11.04.1998.
1998/99 *Emotion. Junge britische und amerikanische
Kunst aus der Sammlung Goetz*
Hamburg: Deichtorhallen Hamburg
30.10.1998–17.01.1999.
2002/03 *Matthew Barney: The CREMASTER Cycle*
Köln: Museum Ludwig 06.06.–01.09.2002;
Paris: Musée d'Art Moderne de la Ville de Paris
10.10.2002–05.01.2003;

New York: Solomon R. Guggenheim Museum
21.02.–11.06.2003.
2007/08 *Matthew Barney*
München: Sammlung Goetz 05.11.2007–29.03.2008.

CREMASTER 2: The Executioner's Song
1998
C-Print in Acryl-Rahmen I C-print in acrylic frame
Motiv I Motive 58×47 cm
Rahmen I Frame 71,1×61×2,5 cm
Edition 5/40 (+ 6 a.p.)

Abbildungen I Illustrations
CREMASTER 2, Ausst.-Kat. I Exh.cat. Walker Art
Center, Minneapolis 1999.
Thomas Girst: *Sex, art, and videotape*, in: *National Post*,
30.01.1999, n.p.
Works from Collezione Sandretto Re Rebaudengo,
Herausgeber I editor Patrizia Sandretto Re Rebaudengo,
Skira, Mailand 2005, p. 205.
Matthew Barney, Ausst.-Kat. I Exh.cat. Sammlung
Goetz München, 2007, p. 34.

Ausstellungen I Exhibitions
CREMASTER 2: The Drones' Exposition
Minneapolis: Walker Art Center 07.03.–13.07.1999;
San Francisco: San Francisco Museum of Modern Art
20.05.–05.09.2000.
2007/08 *Matthew Barney*
München: Sammlung Goetz 05.11.2007–29.03.2008.

CREMASTER 2: The Royal Cell of Baby Fay
1998
C-Print in Acryl-Rahmen I C-print in acrylic frame
Motiv I Motive 59,5×39 cm
Rahmen I Frame 71,1×50,8×2,5 cm
Edition 40/40 (+ 6 a.p.)

Abbildungen I Illustrations
Christian Kämmerling: *Mein Kopf ist wie ein Cockpit*,
in: *Süddeutsche Zeitung Magazin*, No. 46, Edition
Matthew Barney, 13.11.1998, p. 7.
CREMASTER 2, Ausst.-Kat. I Exh.cat. Walker Art
Center, Minneapolis 1999, n.p.
Matthew Barney, Ausst.-Kat. I Exh.cat. Sammlung
Goetz München, 2007, p. 39.

Ausstellungen I Exhibitions
CREMASTER 2: The Drones' Exposition
Minneapolis: Walker Art Center 07.03.–13.07.1999;
San Francisco: San Francisco Museum of Modern Art
20.05.–05.09.2000.
2007/08 *Matthew Barney*
München: Sammlung Goetz 05.11.2007–29.03.2008.

CREMASTER 2

CREMASTER 2
1999
35-mm-Film (auf Film mit Dolby-SR-Sound
transferiertes digitales Farbvideo) | 35-mm film (color
video transferred to film with Dolby SR sound)
Laufzeit | Duration 79'

CREMASTER 2
1999
Siebdruck-Digital-Video-Disk, Nylon, Sattelleder, Sterling-
silber, Bienenwachs und Bienenwabe aus Polycarbonat
in Vitrine aus Nylon und Acryl, mit 35-mm-Druck |
Silkscreened digital video disk, nylon, tooled saddle
leather, sterling silver, beeswax and polycarbonate honey-
comb in nylon and acrylic vitrine, 35-mm print
Vitrine | Vitrine 104,1×119,4×99,1 cm
Edition 2/10 (+ 2 a.p.)

Abbildungen | Illustrations
Christian Kämmerling: *Mein Kopf ist wie ein Cockpit*,
in: *Süddeutsche Zeitung Magazin*, No. 46, Edition
Matthew Barney, 13.11.1998, pp. 4–33.
CREMASTER 2, Ausst.-Kat. | Exh.cat. Walker Art Center,
Minneapolis 1999, zahlreiche Abb. | numerous ills.
Katy Siegel: *Nurture Boy: Matthew Barney's Cremaster 2*,
in: *Artforum*, Sommer 1999, pp. 132–135.
Michael Kimmelman: *The Importance of Matthew Barney*,
in: *The New York Times Magazine*, 10.10.1999,
pp. 62–69.
Thomas Girst: *Sex, art, and videotape*, in: *National Post*,
30.01.1999, n.p.
Ulf Poschardt: *Schläge für den Menschenpark*, in:
Süddeutsche Zeitung, 01.10.1999, n.p.
Ulrike Knöfel: *Showmaster der Mutanten*, in: *Spiegel*,
Juli 2000, pp. 236–238.
Anke Sterneborg: *Das kühle Objekt der Begierde*, in:
Süddeutsche Zeitung, 16.02.2000, p. 18.
Wiebke Hüster: *Wo sich Gedächtnis und Halluzination
durchdringen*, in: *Baseler Zeitung*, 28.02.2000, n.p.
voilà – le monde dans la tête –, Ausst.-Kat. | Exh.cat.
Musée d'Art Moderne de la Ville de Paris, Paris 2000,
p. 21.
Matthew Barney. The CREMASTER Cycle, Ausst.-Kat. |
Exh.cat. Museum Ludwig, Köln; Musée d'Art Moderne
de la Ville de Paris, Paris; Solomon R. Guggenheim
Museum, New York 2002, zahlreiche Abbildungen |
numerous illustrations.
Charmaine Picard: *The Eternal Return: Matthew Barney
Zone of Potential*, in: *Art Nexus*, No. 49, 2003, p. 102.
fast forward. Media Art Sammlung Goetz, Ausst.-Kat. |
Exh.cat. ZKM | Zentrum für Kunst und Medientechno-
logie Karlsruhe 2003, pp. 94–95.
*Just Love Me. Post\Feminist Positions of the 1990's
from the Goetz Collection* Ausst.-Kat. | Exh.cat. Bergen
Kunstmuseum, Bergen; Fries Museum, Leeuwarden, Verlag
der Buchhandlung Walther König, Köln 2003, pp. 94–95.
Michael Kimmelman: *Free to play and be gooey*, in: *The
New York Times. Weekend*, 21.02.2003, pp. 39, 43.

Tim Griffin: *Matthew Barney: The Cremaster Cycle*, in:
Artforum, No. 09, Mai 2003, p. 162.
video art, Herausgeber |editor Michael Rush, Thames &
Hudson, London und New York 2003, pp. 194–195.
*Matthew Barney and Joseph Beuys. All in the present
must be transformed*, Ausst.-Kat. | Exh.cat. Deutsche
Guggenheim, Berlin; Peggy Guggenheim Collection,
Venedig 2006, n.p.
Broken Screen. 26 conversations with Doug Aitken,
Herausgeber | editor Noël Daniel, D.A.P. Distributed Art
Publishers, Inc., New York 2006, pp. 63, 65.
Matthew Barney, Herausgeber | editor Massimiliano
Gioni, Mondadori Electa S.p.A., Mailand 2007, p. 42.
Matthew Barney, Ausst.-Kat. | Exh.cat. Sammlung
Goetz München, 2007, pp. 105–107, 172–173.

Ausstellungen | Exhibitions
1999/2000 *CREMASTER 2: The Drones' Exposition*
Minneapolis: Walker Art Center 07.03.–13.07.1999;
San Francisco: San Francisco Museum of Modern Art
20.05.–05.09.2000.
2000 *voilà – le monde dans la tête*
Paris: Musée d'Art Moderne de la Ville de Paris
15.06.–29.10.2000.
2002/03 *Matthew Barney: The CREMASTER Cycle*
Köln: Museum Ludwig 06.06.–01.09.2002;
Paris: Musée d'Art Moderne de la Ville de Paris
10.10.2002–05.01.2003;
New York: Solomon R. Guggenheim Museum
21.02.–11.06.2003.
2003/04 *fast forward. Media Art Sammlung Goetz*
Karlsruhe: ZKM | Zentrum für Kunst und Medien-
technologie Karlsruhe 10.10.2003–06.03.2004.
*Just Love Me. Post\Feminist Positions of the 1990's
from the Goetz Collection*
Bergen: Bergen Kunstmuseum 22.08.–25.10.2003;
Leeuwarden: Fries Museum 24.04.–21.06.2004.
2004 *Matthew Barney, Der Cremaster-Zyklus*
München: filmmuseum münchen
09.07.–10.07.2004 (Chronologische Vorführung)
23.07.–25.07.2004 (Nummerische Vorführung).
2005 *(my private) Heroes*
Herford: MARTa Herford 07.05.–21.08.2005.
2007 *Matthew Barney and Joseph Beuys. All in the
present must be transformed.*
Berlin: Deutsche Guggenheim 28.10.2006–12.01.2007.
2007/08 *Matthew Barney*
München: Sammlung Goetz 05.11.2007–29.03.2008.

CREMASTER 2: Genealogy
1999
C-Print in Acryl-Rahmen | C-print in acrylic frame
Motiv | Motive 3-teilig | 3 parts:
44×44 cm (2×)
59×48 cm (1×)
Rahmen | Frame 3-teilig | 3 parts:
55,2×55,2×2,5 cm (2×)
71,1×60,3×2,5 cm (1×)
Edition 2/3 (+ 2 a.p.)

Abbildungen | Illustrations
Christian Kämmerling: *Mein Kopf ist wie ein Cockpit*, in: *Süddeutsche Zeitung Magazin*, No. 46, Edition Matthew Barney, 13.11.1998, pp. 30–31.
Katy Siegel: *Nurture Boy: Matthew Barney's Cremaster 2*, in: *Artforum*, Sommer 1999, p. 134.
Art Now. 137 Artists at the Rise of the New Millennium, Taschen, Köln 2002, pp. 18–19.
CREMASTER 2, Ausst.-Kat. | Exh.cat. Walker Art Center, Minneapolis 1999.
Anthony Downey: *Matthew Barney & Cremaster 3*, in: *contemporary*, Oktober 2002, p. 56.
Matthew Barney. The CREMASTER Cycle, Ausst.-Kat. | Exh.cat. Museum Ludwig, Köln; Musée d'Art Moderne de la Ville de Paris, Paris; Solomon R. Guggenheim Museum, New York 2002, pp. 35, 242.
Ulf Poschardt: *Wegbereiter der Evolution*, in: *Welt am Sonntag*, 02.06.2002, p. 59.
Verena Kuni: *Von der Magie der Kunst in der Politik*, in: *Kunstforum*, No. 163, Januar/Februar 2003, p. 52.
Matthew Barney, Herausgeber | editor Massimiliano Gioni, Mondadori Electa S.p.A., Mailand 2007, p. 45.
Matthew Barney, Ausst.-Kat. | Exh.cat. Sammlung Goetz München, 2007, pp. 36–37.

Ausstellungen | Exhibitions
CREMASTER 2: The Drones' Exposition
Minneapolis: Walker Art Center 07.03.–13.07.1999;
San Francisco: San Francisco Museum of Modern Art 20.05.–05.09.2000.
2002/03 *Matthew Barney: The CREMASTER Cycle*
Köln: Museum Ludwig 06.06.–01.09.2002;
Paris: Musée d'Art Moderne de la Ville de Paris 10.10.2002–05.01.2003;
New York: Solomon R. Guggenheim Museum 21.02.–11.06.2003.
2007/08 *Matthew Barney*
München: Sammlung Goetz 05.11.2007–29.03.2008.

C2: Deseret
1999
Radierung auf Arches Bütten | Etching on Arches paper
Motiv | Motive 30,5×35,2 cm
Rahmen | Frame 34,4×38,8×1,2 cm
Edition 11/40 (+ 12 a.p. + 2 p.p. + 1 m.p.)
Gedruckt von | Printed by Todd Norsten, Minneapolis
Herausgegeben von | Published by Walker Art Center, Minneapolis

Abbildungen | Illustrations
Bisher nicht abgebildet | Not illustrated yet
Matthew Barney, Ausst.-Kat. | Exh.cat. Sammlung Goetz München, 2007, p. 214.

Ausstellungen | Exhibitions
1999/2000 *CREMASTER 2: The Drones' Exposition*
Minneapolis: Walker Art Center 07.03.–13.07.1999;
San Francisco: San Francisco Museum of Modern Art 20.05.–05.09.2000.

2007/08 *Matthew Barney*
München: Sammlung Goetz 05.11.2007–29.03.2008.

C2: The Drones' Exposition
1999
Radierung auf Arches Bütten | Etching on Arches paper
Motiv | Motive 30,5×35,2 cm
Rahmen | Frame 34,4×38,8×1,2 cm
Edition 11/40 (+ 12 a.p. + 2 p.p. + 1 m.p.)
Gedruckt von | Printed by Todd Norsten, Minneapolis
Herausgegeben von | Published by Walker Art Center, Minneapolis

Abbildungen | Illustrations
Bisher nicht abgebildet | Not illustrated yet
Matthew Barney, Ausst.-Kat. | Exh.cat. Sammlung Goetz München, 2007, p. 214.

Ausstellungen | Exhibitions
1999 *CREMASTER 2: The Drones' Exposition*
Minneapolis: Walker Art Center 07.03.–13.07.1999.
2007/08 *Matthew Barney*
München: Sammlung Goetz 05.11.2007–29.03.2008.

The Ballad of Nicole Baker
1999
Grafit und Vaseline auf Papier in Nylon-Rahmen | Graphite and petroleum jelly on paper in nylon frame
Motiv | Motive 10×14,8 cm
Rahmen | Frame 23,3×29,8×3,8 cm

Abbildungen | Illustrations
CREMASTER 2, Ausst.-Kat. | Exh.cat. Walker Art Center, Minneapolis 1999, n.p.
Matthew Barney. The CREMASTER Cycle, Ausst.-Kat. | Exh.cat. Museum Ludwig, Köln; Musée d'Art Moderne de la Ville de Paris, Paris; Solomon R. Guggenheim Museum, New York 2002, p. 211.
Matthew Barney, Ausst.-Kat. | Exh.cat. Sammlung Goetz München, 2007, p. 41.

Ausstellungen | Exhibitions
1999/2000 *CREMASTER 2: The Drones' Exposition*
Minneapolis: Walker Art Center 07.03.–13.07.1999;
San Francisco: San Francisco Museum of Modern Art 20.05.–05.09.2000.
2000 *voilà – le monde dans la tête*
Paris: Musée d'Art Moderne de la Ville de Paris 15.06.–29.10.2000.
2002/03 *Matthew Barney: The CREMASTER Cycle*
Köln: Museum Ludwig 06.06.–01.09.2002;
Paris: Musée d'Art Moderne de la Ville de Paris 10.10.2002–05.01.2003;
New York: Solomon R. Guggenheim Museum 21.02.–11.06.2003.
2007/08 *Matthew Barney*
München: Sammlung Goetz 05.11.2007–29.03.2008.

The Nuptual Flight
1999
Grafit auf Papier in Nylon-Rahmen | Graphite on paper
in nylon frame
Motiv | Motive 10×15 cm
Rahmen | Frame 24,1×29,8×3,8 cm

Abbildungen | Illustrations
Christian Kämmerling: *Mein Kopf ist wie ein Cockpit*,
in: *Süddeutsche Zeitung Magazin*, No. 46, Edition
Matthew Barney, 13.11.1998, p. 6.
CREMASTER 2, Ausst.-Kat. | Exh.cat. Walker Art
Center, Minneapolis 1999, n.p.
Matthew Barney. The CREMASTER Cycle, Ausst.-Kat. |
Exh.cat. Museum Ludwig, Köln; Musée d'Art Moderne
de la Ville de Paris, Paris; Solomon R. Guggenheim
Museum, New York 2002, p. 511.
Matthew Barney, Ausst.-Kat. | Exh.cat. Sammlung
Goetz München, 2007, p. 40.

Ausstellungen | Exhibitions
CREMASTER 2: The Drones' Exposition
Minneapolis: Walker Art Center 07.03.–13.07.1999;
San Francisco: San Francisco Museum of Modern Art
20.05.–05.09.2000.
2002/03 *Matthew Barney: The CREMASTER Cycle*
Köln: Museum Ludwig 06.06.–01.09.2002;
Paris: Musée d'Art Moderne de la Ville de Paris
10.10.2002–05.01.2003;
New York: Solomon R. Guggenheim Museum
21.02.–11.06.2003.
2007/08 *Matthew Barney*
München: Sammlung Goetz 05.11.2007–29.03.2008.

CREMASTER 3: Chrysler Imperial**
2001
C-Print in zweifarbigem Acryl-Rahmen | C-print in two
colored acrylic frame
Motiv | Motive 49,5×59,5 cm
Rahmen | Frame 61×71,1×3,8 cm
Edition 23/50 (+ 10 a.p.)

Abbildungen | Illustrations
Matthew Barney. CREMASTER 3, Ausst.-Kat. | Exh.cat.
Solomon R. Guggenheim Museum, New York 2002, n.p.
Matthew Barney, Ausst.-Kat. | Exh.cat. Sammlung
Goetz München, 2007, p. 61.

Ausstellungen | Exhibitions
Bisher nicht ausgestellt | Not exhibited yet

CREMASTER 3: Plumb Line
2001
C-Print in zweifarbigem Acryl-Rahmen | C-print in two
colored acrylic frame
Motiv | Motive 59,5×49 cm
Rahmen | Frame 71×61×3 cm
Edition 23/50 (+ 10 a.p.)

Abbildungen | Illustrations
Bisher nicht abgebildet | Not illustrated yet
Matthew Barney, Ausst.-Kat. | Exh.cat. Sammlung
Goetz München, 2007, p. 60.

Ausstellungen | Exhibitions
Bisher nicht ausgestellt | Not exhibited yet
2007/08 *Matthew Barney*
München: Sammlung Goetz 05.11.2007–29.03.2008.

CREMASTER 3

CREMASTER 3
2002
35-mm-Film (auf Film mit Dolby-SR-Sound
transferiertes digitales Farbvideo) | 35-mm film (color
video transferred to film with Dolby SR sound)
Laufzeit | Duration 181' 59"

CREMASTER 3
2002
2 Siebdruck-Digital-Video-Disks, rostreier Stahl, innen
geschmierter Kunststoff, Marmor, Sterlingsilber in Acryl-
Vitrine, mit 35-mm-Druck | 2 silkscreened digital video
disks, stainless steel, internally lubricated plastic, marble
and sterling silver in acrylic vitrine with 35-mm print
Vitrine | Vitrine 110,5×119,4×101,6 cm
Edition 1/10 (+ 2 a.p.)

Abbildungen | Illustrations
Amine Haase: *Bilder wuchern wie Nachtgewächse*, in:
Kunstforum, No. 162, November/Dezember 2002, p. 328.
Anthony Downey: *Matthew Barney & Cremaster 3*, in:
contemporary, Oktober 2002, p. 54.
Holger Liebs: *Muskelspiel des Lebens*, in: *Süddeutsche
Zeitung*, 03.06.2002, p. 14.
Holger Liebs: *Manns genug*, in: *Süddeutsche Zeitung*,
06.06.2002, p. 15.
Massimiliano Gioni: *Matthew Barney*, in: *Flash Art*,
No. 225, Juli–September 2002, pp. 92–95.
Jordan Mejias: *Kletterpartie in den Weltuntergang*,
in: *Frankfurter Allgemeine Zeitung*, 31.05.2002,
No. 102, p. 51.
Neville Wakefield on Matthew Barney: *The passenger*,
in: *frieze*, No. 67, Mai 2002, pp. 72–77.
Matthew Barney. CREMASTER 3, Ausst.-Kat. | Exh.cat.
Solomon R. Guggenheim Museum, New York 2002,
zahlreiche Abbildungen | numerous illustrations.
Matthew Barney. The CREMASTER Cycle, Ausst.-Kat. |
Exh.cat. Museum Ludwig, Köln; Musée d'Art Moderne
de la Ville de Paris, Paris; Solomon R. Guggenheim
Museum, New York 2002, zahlreiche Abbildungen |
numerous illustrations.
Peter Richter: *Hoden runter*, in: *Frankfurter Allgemeine
Zeitung*, 26.05.2002, p. 21.
Rüdiger von Naso: *Magie der Maslosigkeit*, in: *Madame*,
Dezember 2002, pp. 118–120.

Verena Kuni: *Aufsteigende Bewegungen mit kalkulierten Abgängen: Der Cremaster Zyklus ist komplett*, in: *Kunst-Bulletin*, No. 10, 2002, pp. 28–31.
Calvin Tomkins: *His Body, Himself*, in: *The New Yorker*, 27.01.2003, pp. 51, 54–55.
fast forward. Media Art Sammlung Goetz, Ausst.-Kat. | Exh.cat. ZKM | Zentrum für Kunst und Medientechnologie Karlsruhe 2003, pp. 96–99.
Guggenheim Guide. Matthew Barney, Ausst.-Kat. | Exh.cat. Solomon R. Guggenheim Museum, New York 2003, pp. 4–5, 7.
Matthew Barney. CREMASTER 3, Ausst.-Kat. | Exh.cat. Solomon R. Guggenheim Museum, New York 2002, zahlreiche Abbildungen | numerous illustrations.
Javier Hernando: *Spaces for Art and Photography. Appropriation and Updating of a Traditional Pictorial Genre*, in: *Exit*, No. 09, 2003, p. 36.
Just Love Me. Post\Feminist Positions of the 1990's from the Goetz Collection Ausst.-Kat. | Exh.cat. Bergen Kunstmuseum, Bergen; Fries Museum, Leeuwarden, Verlag der Buchhandlung Walther König, Köln 2003, pp. 96–99.
Michael Kimmelman: *Free to play and be gooey*, in: *The New York Times. Weekend*, 21.02.2003, pp. 39, 43.
Works from Collezione Sandretto Re Rebaudengo, Herausgeber | editor Patrizia Sandretto Re Rebaudengo, Skira editore, Mailand 2005, pp. 288–289.
Matthew Barney and Joseph Beuys. All in the present must be transformed, Ausst.-Kat. | Exh.cat. Deutsche Guggenheim, Berlin; Peggy Guggenheim Collection, Venedig 2006, p. 62.
Matthew Barney, Herausgeber | editor Massimiliano Gioni, Mondadori Electa S.p.A., Mailand 2007, pp. 41, 52–60.
Matthew Barney, Ausst.-Kat. | Exh.cat. Sammlung Goetz München, 2007, pp. 116–117, 174–175.

Ausstellungen | Exhibitions
2002 *CREMASTER 3*
New York: Ziegfeld Theatre 01.05.2002.
2002/03 *Matthew Barney: The CREMASTER Cycle*
Köln: Museum Ludwig 06.06.–01.09.2002;
Paris: Musée d'Art Moderne de la Ville de Paris 10.10.2002–05.01.2003;
New York: Solomon R. Guggenheim Museum 21.02.–11.06.2003.
2003/04 *fast forward. Media Art Sammlung Goetz*
Karlsruhe: ZKM | Zentrum für Kunst und Medientechnologie Karlsruhe 10.10.2003–06.03.2004.
Just Love Me. Post\Feminist Positions of the 1990's from the Goetz Collection Bergen: Bergen Kunstmuseum 22.08.2003–25.10.2003;
Leeuwarden: Fries Museum 24.04.–21.06.2004.
2004 *Matthew Barney, Der Cremaster-Zyklus*
München: filmmuseum münchen
09.07.–10.07.2004 (Chronologische Vorführung)
23.07.–25.07.2004 (Nummerische Vorführung).

2007 *Matthew Barney and Joseph Beuys. All in the present must be transformed*
Berlin: Deutsche Guggenheim 28.10.2006–12.01.2007;
München: filmmuseum münchen 23.07.–25.07.2007.
2007/08 *Matthew Barney*
München: Sammlung Goetz 05.11.2007–29.03.2008.

CREMASTER: Field Suite**
2002
5 Radierungen auf Hahnemühle Kupferstichpapier in Polypropylen Box | 5 etchings on Hahnemühle Copperplate paper in polypropelene box
Motiv | Motive 5-teilig, je | 5 parts, each 40×27,2 cm
Box | Box 45,5×33×3,5 cm
Edition 3/40 (+ 10 a.p. + 4 p.p. + 1 b.a.t.)

Abbildungen | Illustrations
Matthew Barney. THE CREMASTER Cycle, Ausst.-Kat. | Exh.cat. Museum Ludwig, Köln; Musée d'Art Moderne de la Ville de Paris, Paris; Solomon R. Guggenheim Museum, New York 2002, zahlreiche Abbildungen | numerous illustrations.
Matthew Barney, Ausst.-Kat. | Exh.cat. Sammlung Goetz München, 2007, pp. 206–207.

Ausstellungen | Exhibitions
2002/03 *Matthew Barney: The CREMASTER Cycle*
Köln: Museum Ludwig 06.06.–01.09.2002;
Paris: Musée d'Art Moderne de la Ville de Paris 10.10.2002–05.01.2003;
New York: Solomon R. Guggenheim Museum 21.02.–11.06.2003.

CREMASTER 3: Eisléireacht Garbh Mar Bhunsraith**
2002
Fotogravur | Photogravure
Motiv | Motive 39,2×58,8 cm
Edition II/XVII (Edition 40 + 12 a.p. + 3 p.p. + 6 t.p. + 2 c.t.p. + 1 b.a.t. + I–XVIII)
Herausgegeben von | Published by Jean-Yves Noblet

Abbildungen | Illustrations
Bisher nicht abgebildet | Not illustrated yet
Matthew Barney, Ausst.-Kat. | Exh.cat. Sammlung Goetz München, 2007, p. 58.

Ausstellungen | Exhibitions
Bisher nicht ausgestellt | Not exhibited yet

DRAWING RESTRAINT 9

DRAWING RESTRAINT 9
2005
35-mm-Film (auf Film mit Dolby-SR-Sound transferiertes Farbvideo) | 35-mm film (color video transferred to film with Dolby SR sound)
Laufzeit | Duration 145'

DRAWING RESTRAINT 9
2005
Skulptur, Video und Zeichnungen | Sculpture, video and drawing
Polycaprolactone thermoplastic, aquaplast, and self-lubricating plastic
Gesamt | Total 93×290×203 cm
Edition 6/10 (+ 2 a. p.)

Abbildungen | Illustrations
Lydia Schmid und Annemarie Ballschmiter: *Der Bilder Stürmer*, in: *Elle*, Juni 2005, pp. 24–30.
Matthew Barney. Drawing Restraint. VOL II, Ausst.-Kat. | Exh. cat. 21st Century Museum of Contemporary Art, Kanazawa; Leeum Samsung Museum of Art, Seoul; San Francisco Museum of Modern Art, San Francisco 2005, zahlreiche Abbildungen | numerous illustrations.
Michael Althen: *Tausend Tonnen Walfett*, in: *Frankfurter Allgemeine Zeitung*, 05.09.2005, p. 33.
Midori Matsui: *Matthew Barney*, in: *Flash Art*, No. 244, Oktober 2005, p. 123.
Matthew Barney and Joseph Beuys. All in the present must be transformed, Ausst.-Kat. | Exh. cat. Deutsche Guggenheim, Berlin; Peggy Guggenheim Collection, Venedig 2006, pp. 32–34.
David Fear: *Reviews. Drawing Restraint 9*, in: *Timeout New York*, 29.05.2006, n. p.
Dietmar Dath: *Füßchengeschnetzeltes im Traumboot*, in: *Frankfurter Allgemeine Zeitung*, 07.06.2006, p. 37.
Eva Karcher: *Der Klang der Perlenfischerinnen beim Auftauchen*, in: *Monopol*, No. 02, 2006, pp. 60–66.
Holger Liebs: *Durch Mark und Bein*, in: *Süddeutsche Zeitung*, 16.02.1006, p. 13.
N. N.: *Politisch aufgeladen*, in: *Spiegel*, No. 23, 2006, p. 127.
Linda Yablonsky: *A Satyr Wrapped In an Enigma*, in: *Artnews*, Juni 2006, p. 130. (Abbildung der Skulptur | Illustration of the sculpture)
Neville Wakefield: *Drawing Restraint 9*. Matthew Barney, in: *Art Review*, Mai 2006, pp. 97–101.
Randy Kennedy: *The Björk-Barney Enigma Machine*, in: *The New York Times*, 09.04.2006, n. p.
Stephen Holden: *Adrift in Japanese Waters with Whales and a Wedding*, in: *The New York Times*, 29.03.2006, p. E5.
Matthew Barney, Herausgeber | editor Massimiliano Gioni, Mondadori Electa S. p. A., Mailand 2007, pp. 86–93.
Matthew Barney. Drawing Restraint Volume V, Ausst.-Kat. | Exh. cat. Serpentine Gallery, London; KUNSTHALLE wien, Wien 2007, n. p.
Matthew Barney, Ausst.-Kat. | Exh. cat. Sammlung Goetz München, 2007, p. 77–78, 141–143.

Ausstellungen | Exhibitions
2005 *Internationale Filmfestspiele Venedig*
Venedig: Filmfestspiele 31.08.–10.09.2005.
2005/06 *Matthew Barney. Drawing Restraint*
Kanazawa: 21st Century Museum of Contemporary Art 02.07.–25.08.2005;

Seoul: Leeum Samsung Museum of Art: 13.10.2005–08.01.2006;
San Francisco: San Francisco Museum of Modern Art 23.06.–19.09.2006.
2006 *Internationale Filmfestspiele Berlin*
Berlin: Filmfestspiele 09.02.–19.02.2006.
Matthew Barney. The Occidental Guest
New York: Barbara Gladstone Gallery 07.04.–13.05.2006.
2006/07 *Matthew Barney and Joseph Beuys. All in the present must be transformed*
Berlin: Deutsche Guggenheim 28.10.2006–12.01.2007.
2007/08 *Matthew Barney*
München: Sammlung Goetz 05.11.2007–29.03.2008.

Inner Roji
2006
Grafitstift auf Papier in Rahmen aus selbstschmierendem Kunststoff | Grafite on paper in self-lubricating plastic frame
Motiv | Motive 20×14 cm
Rahmen | Frame 34,3×29,2×3,2 cm

Abbildungen | Illustrations
Matthew Barney. Drawing Restraint Volume IV, Ausst.-Kat. | Exh. cat. Barbara Gladstone Gallery, New York 2007, p. 26.
Matthew Barney, Ausst.-Kat. | Exh. cat. Sammlung Goetz München, 2007, p. 75.

Ausstellungen | Exhibitions
Matthew Barney. The Occidental Guest
New York: Barbara Gladstone Gallery 07.04.–13.05.2006.
2007/08 *Matthew Barney*
München: Sammlung Goetz 05.11.2007–29.03.2008.

Pacific
2006
Grafitstift auf Papier in Rahmen aus selbstschmierendem Kunststoff | Grafite on paper in self-lubricating plastic frame
Motiv | Motive 20×14 cm
Rahmen | Frame 34,3×29,2×3,2 cm

Abbildungen | Illustrations
Matthew Barney. Drawing Restraint Volume IV, Ausst.-Kat. | Exh. cat. Barbara Gladstone Gallery, New York 2007, p. 51.
Matthew Barney, Ausst.-Kat. | Exh. cat. Sammlung Goetz München, 2007, p. 74.

Ausstellungen | Exhibitions
Matthew Barney. The Occidental Guest
New York: Barbara Gladstone Gallery 07.04.–13.05.2006.
2007/08 *Matthew Barney*
München: Sammlung Goetz 05.11.2007–29.03.2008.

CREMASTER CYCLE
2007
Säule, 5 Flachbildschirme, CREMASTER 1–5: Filme
und Vitrinen I Pole, 5 flat screens, CREMASTER 1–5:
films and vitrines
Säulenhöhe I Pole height 556 cm
Säulendurchmesser I Pole diameter 310 cm

Abbildungen I Illustrations
Bisher nicht abgebildet I Not illustrated yet
Matthew Barney, Ausst.-Kat. I Exh. cat. Sammlung
Goetz München, 2007, pp. 12–13, 150–151, 160,
167, 188–189.

Ausstellungen I Exhibitions
Bisher nicht ausgestellt I Not exhibited yet
2007/08 *Matthew Barney*
München: Sammlung Goetz 05.11.2007–29.03.2008.

Leihgaben I Loans

CREMASTER 3: Mahabyn
2002
C-Print in Acryl-Rahmen I C-print in acrylic frame
Linkes und rechtes Foto I Left and Right Panels:
Motiv I Motive 103×75 cm
Rahmen I Frame 107×86 cm
Mittleres Foto I Center Panel:
Motiv I Motive 103×125,7 cm
Rahmen I Frame 112×137 cm
a. p. Edition 3 (+ 1 a. p.)

Abbildungen I Illustrations
Matthew Barney, Ausst.-Kat. I Exh. cat. Sammlung Goetz
München, 2007, pp. 62–63.

DRAWING RESTRAINT 7: Storyboard drawing**
1993
7 Zeichnungen, je I 7 drawings, each 7,62×12,5 cm

Abbildungen I Illustrations
Matthew Barney, Ausst.-Kat. I Exh. cat. Sammlung Goetz
München, 2007, pp. 20, 88, 100, 110, 120, 126, 136.

Filmpremieren I Film Premieres

CREMASTER 4
1995 *Matthew Barney. CREMASTER 4*
Paris: Fondation Cartier pour l'Art Contemporain
03.03.–16.04.1995.

CREMASTER 1
1995 *New York Video Festival*
New York: Walter Reade Theatre 07.–09.10.1995.

CREMASTER 5
1997 *Matthew Barney. CREMASTER 5*
Frankfurt/Main: Portikus 19.06.–10.08.1997.

CREMASTER 2
1999 *CREMASTER 2: The Drones' Exposition*
Minneapolis: Walker Art Center 07.03.–13.07.1999.

CREMASTER 3
2002 *CREMASTER 3 Premiere*
New York: Ziegfeld Theatre 01.05.2002.

DRAWING RESTRAINT 9
2005 *Matthew Barney. DRAWING RESTRAINT*
Kanazawa: 21st Century Museum of Contemporary Art
02.07.–25.08.2005.

Installationsaufnahmen | Installation views

pp. 12/13
CREMASTER Cycle, 2007

pp. 46/47
OTTOshaft (manual) F, 1992
ENVELOPA: Drawing Restraint 7 (Guillotine), 1993
The Ballad of Nicole Baker, 1999
The Nuptual Flight, 1999
CREMASTER 2: The Royal Cell of Baby Fay, 1998
ENVELOPA: Drawing Restraint 7 (Guillotine), 1993
CREMASTER 1: Goodyear, 1995

pp. 48/49
CREMASTER 1: The Goodyear Waltz, 1995
CREMASTER 2: Genealogy, 1999

pp. 50/51
CREMASTER 4: Three Legs of Mann, 1994
ENVELOPA: Drawing Restraint 7 (Guillotine), 1993
CREMASTER 3: Plumb Line, 2001
ENVELOPA: Drawing Restraint 7 (Guillotine), 1993
CREMASTER 3: Mahabyn, 2002

pp. 52/53
CREMASTER 1: Goodyear Lounge, 1995
CREMASTER 4: T-l: ascending HACK descending HACK, 1994
CREMASTER 3: Plumb Line, 2001
ENVELOPA: Drawing Restraint 7 (Guillotine), 1993

pp. 54/55
CREMASTER 4: T-l: ascending HACK descending HACK, 1994
CREMASTER 4: Three Legs of Mann, 1994
ENVELOPA: Drawing Restraint 7 (Guillotine), 1993
[PIT] Field of the Descending Faerie, 1995

pp. 56/57
CREMASTER 4: The Isle of Man, 1994
CREMASTER 1: Goodyear Lounge, 1995
CREMASTER 4: T-l: ascending HACK descending HACK, 1994
[PIT] Field of the Descending Faerie, 1995

pp. 82/83
CREMASTER 5: Elválás, 1997
ENVELOPA: Drawing Restraint 7 (Guillotine), 1993
CREMASTER 1: Orchidella, 1995
Ereszkedés, 1998

pp. 84/85
CREMASTER 5: Elválás, 1997
CREMASTER 5: Elválás, 1997
Ereszkedés, 1998

pp. 86/87
DRAWING RESTRAINT 9, 2005
Pacific, 2006
Inner Roji, 2006
ENVELOPA: Drawing Restraint 7 (Guillotine), 1993

pp. 146/147
DRAWING RESTRAINT 9, 2005

pp. 148/149
DRAWING RESTRAINT 9, 2005

pp. 150/151
CREMASTER Cycle, 2007

p. 160
CREMASTER Cycle, 2007

p. 167
CREMASTER Cycle, 2007

pp. 188/189
CREMASTER Cycle, 2007

pp. 196/197
CREMASTER 4: LOUGHTON RAM, 1994
ENVELOPA: Drawing Restraint 7 (Guillotine), 1993
CREMASTER 2: The Executioner's Song, 1998
OTTOshaft (manual) F, 1992
ENVELOPA: Drawing Restraint 7 (Guillotine), 1993
The Ballad of Nicole Baker, 1999
The Nuptual Flight, 1999
CREMASTER 2: The Royal Cell of Baby Fay, 1998
CREMASTER 1: Goodyear Lounge, 1995

Impressum | Imprint

Matthew Barney

3. November 2007 – 29. März 2008

Herausgeber | Publisher
Ingvild Goetz, Stephan Urbaschek

Redaktion | Editor
Karsten Löckemann, Stephan Urbaschek

Redaktionsassistenz | Editorial Assistance
Katharina Vossenkuhl

Recherche | Research
Karsten Löckemann, Claudia Seelmann,
Susanne Touw

Lektorat | Copy Editing
Kirsten Rachowiak
Sarah Trenker

Übersetzung | Translation
Ishbel Flett
Nikolaus G. Schneider

Gestaltung | Layout
WIGEL, München

Fotoredaktion | Photo Editor
Nora Wagner, Christoph Kölbl

Reproduktion | Reproduction
Reproline Genceller, München

Druck und Bindung | Printed and bound by
Sellier, Freising

Auflage I Copies: 2.500

© 2007 Kunstverlag Ingvild Goetz GmbH,
Autoren und Künstler I Authors and Artists

ISBN 978-3-939894-09-4

Printed in Germany

Wir möchten allen danken, die bei der Verwirk-
lichung dieser Ausstellung und des Katalogs
geholfen haben. Besonders danken wir Matthew
Barneys Atelier sowie seiner Galerie, die uns
unterstützt haben.

We would like to thank all individuals, whose
assistance greatly contributed to the exhibition
and the completion of the book. Especially we
would like to thank Matthew Barney's studio and
his gallery for their support.

Registrar
Katharina Vossenkuhl

Ausstellungsaufbau | Exhibition installation
Daniel Becker
Lorena Herrera
Alexander Kammerhoff
Gerhard Lehenberger
Björn Wallbaum

Restauratorin | Conservator
Marianne Parsch

Assistenz | Assistant
Anita Peintinger
Susanne Touw
Sabine Weingartner

Sammlung Goetz
Oberföhringer Straße 103
81925 München
Tel. + 49-89-9593969-0
Fax + 49-89-9593969-69
info@sammlung-goetz.de
www.sammlung-goetz.de

Fotografen und Fotonachweis
Photographers and Credits
Raimund Koch, New York: pp. 34, 39, 214
Ellen Labenski, New York: pp. 170, 172, 173,
175, 176, 177, 178, 179
Larry Lamay, New York pp. 20, 88, 100, 110,
120, 126, 136
Thomas J. Meyer, München: p. 9
Wilfried Petzi, München: pp. 22, 23, 25, 36, 37,
41, 58, 60, 61, 70, 90, 91, 102, 103, 112, 113,
122, 123, 128, 129, 138, 139, 206, 207
David Regen, New York: pp. 74, 75, 77, 78
Philipp Schönborn, München: p. 6
Nic Tenwiggenhorn, Berlin: pp. 12, 13, 46, 47,
48, 49, 50, 51, 52, 53, 54, 55, 56, 57, 82, 83,
84, 85, 86, 87, 146, 147, 148, 149, 150, 151,
160, 167, 188, 189, 196, 197
Joshua White, New York: pp. 64, 68, 69
Franz Wimmer, München: p. 1
Zindman/Fremont, New York: pp. 29, 30, 31, 171

VG Bild-Kunst, Bonn: pp. 6, 12, 13, 46, 47, 48,
49, 50, 51, 52, 53, 54, 55, 56, 57, 82, 83, 84,
85, 86, 87, 146, 147, 148, 149, 150, 151, 160,
167, 188, 189, 196, 197